Voice and New Writing, 1997–2007

Voice and New Writing, 1997–2007

Articulating the Demos

Maggie Inchley
Queen Mary University of London, UK

First published 2015 by
PALGRAVE MACMILLAN

Palgrave Macmillan in the UK is an imprint of Macmillan Publishers Limited, registered in England, company number 785998, of Houndmills, Basingstoke, Hampshire, RG21 6XS.

Palgrave Macmillan in the US is a division of St Martin's Press LLC, 175 Fifth Avenue, New York, NY 10010.

Palgrave is the global academic imprint of the above companies and has companies and representatives throughout the world.

Palgrave® and Macmillan® are registered trademarks in the United States, the United Kingdom, Europe and other countries.

ISBN 978–1–137–43232–2

This book is printed on paper suitable for recycling and made from fully managed and sustained forest sources. Logging, pulping and manufacturing processes are expected to conform to the environmental regulations of the country of origin.

A catalogue record for this book is available from the British Library.

A catalog record for this book is available from the Library of Congress.

Typeset by MPS Limited, Chennai, India.

Contents

List of Figures

Acknowledgements

Many thanks to Helen Freshwater for her wisdom and support. I am also grateful for the feedback of Aoife Monks and Jen Harvie, which contributed to the book's development. In addition I would like to thank Clare Wallace, Anja Müller, Jane Boston and Maria Delgado, who have all helped me on the way to realising this project. An adapted section of this book was included as 'David Greig and the Return of the Native Voice', in *Transnational Identities in David Greig's Plays,* edited by Anja Müller and Clare Wallace (Prague: Litteraria Pragensia, 2011). Versions of its chapters were adapted for two journal articles, 'Hearing Young Voices on the London Stage: "Shit Bein' Seventeen Int it? Never Take Us Serious"', *Contemporary Theatre Review,* 22 (2012), 327–43, and 'Hearing the Unhearable: the Representation of Women Who Kill Children', *Contemporary Theatre Review,* 23 (2013), 192–205. Sincere thanks also to my many colleagues at Queen Mary, Birkbeck and at the University of Surrey for supporting me both personally and in my scholarly endeavour.

I wish to acknowledge and thank Lucy Prebble, Hannah Davies, Joel Horwood, Dennis Kelly, Anthony Banks, Ben Jancovich and Ruth Little for their generosity in talking to me – all of you helped me enormously to attend to the voice in new and enlightening ways. Many thanks also to Claire Rushbrook and to Claire-Louise Cordwell, whose photographs appear on the front cover; to Eleanor Novick and other staff at the Lebrecht Music and Arts Photo Library; and for the generosity of Cicely Berry and help of Michelle Morton at the Royal Shakespeare Company.

At Palgrave Macmillan the feedback of the anonymous reader has vastly improved this book. The continued support and advice of my editor, Paula Kennedy, and the help of Peter Cary, have been invaluable.

Finally, I would like to thank my mother and father, Alan Francis for his particular input on matters Scottish, my friends for their indulgence and interest, and all my colleagues, students and collaborators for your writing and your voices.

Introduction: Articulating the Demos

A fundamental creative and communicative faculty, the voice makes the sounds and language that enable an individual to articulate her identity and establish a position within the spaces and structures of society around her. From the earliest age the voice allows us to make contact with others, gives us the means to cause physical pleasure or discomfort, and plays a vital role in the dynamics of our personal, social and cultural relationships. It is both physiological, creating sound through the manipulation and exhalation of air through the vocal apparatus, and metaphorical, allowing the human person to extend beyond itself or be invoked as a symbolic presence – a 'voice' in political and cultural discourses.[1] In the Arts, where voice is carried through language, rhythm, sound and a sense of unique personal interpretation, it is of fundamental importance as a creative and expressive instrument in poetry, theatre, singing and writing. In terms of speech, the voice carries both sound and meaning, materially constituting the language that Raymond Williams formulates as 'an indissoluble element of human self-creation'.[2] In our political lives, the voice is an instrument of decision-making. As the *OED* reminds us, it is 'the right to have a part or share in the control of or deciding something': the idea of 'having a voice' is a crucial aspect of the democratic process.[3] Through our voices we thus articulate our identities, express ourselves creatively, and establish a degree of personal and political agency, processes that contribute to what I term in this book our cultural audibility. For all these reasons, the voice is a complex, interdisciplinary critical tool, yet has rarely been placed at the centre of scholarly practice in the study of drama and performance – perhaps partly because of this very complexity.

In our responses to performance the language that voices use and the sounds they make both elicit and intervene in assumptions regarding

the identity of speakers, whether they sound familiar to us, or strange, alien or 'other'. Writers' and actors' choices of dialect, accent, pitch, pace and intonation, although sometimes elusive and ephemeral in per-formance, form a physical texture which our ears, finely attuned to the signals that attach to such features, process with degrees of complexity and complacency. Politically speaking, an actor's labile and dexterous articulacy can heighten and amplify the voices of those that often go unheard or are misrepresented, as well as enable them to negotiate the systems or structures through which they may have been marginalised. The care and craft exerted by practitioners in the acts of listening to, scripting and speaking voices for theatre are therefore not only artistic but also political and ethical matters and processes, especially where claims of articulating non standard or rarely heard voices with authen-ticity and accuracy are made. How such voices were included and rep-resented in new theatre writing in culturally prestigious theatre venues known for the development and programming of new writing, such as the National Theatre, the Royal Court, the Traverse, Hampstead Theatre and Soho Theatre when Tony Blair was Prime Minister of Britain from 1997–2007 will form the subject of this book. It argues that despite tendencies to familiarise, police or neutralise the sounds, textures and impacts of voices in theatre, the vocal articulation of identity through these processes provided challenge to and scrutiny of cultural and political representative practices.

In the late 1990s there appeared to be a broad shift in the cultural position of voices that had been marginalised. After New Labour's land-slide victory in 1997 over John Major's Conservative government, as Chapter 1 of this book will describe, an inclusive and pluralistic House of Commons seemed to emerge. The party's chief ideological and philo-sophical architect, Anthony Giddens, claimed that a democratic society must give 'equal ranking' to each voice, and ensure 'participation'.[4] In so doing, he recalled the fundamental role of the voice in expressing a person's political will – 'the right to have a part or share in the control of or deciding something'.[5] Giddens advocated the devolution of power to socially active and responsible citizens, by giving the means to indi-viduals 'to make their voices heard'.[6] As for other New Labour thinkers, a compassionate and tolerant society was dependent on the perception of 'fairness', an 'emotional education' coming from the recognition of 'legitimate diversity'.[7] Empathy towards diverse voices was therefore put forward as a fundamental principle of citizenship in an evolving and devolving society. In the broad political context however, as politi-cal scientist Carol Johnson has pointed out, ideology that encouraged

the vocal expression and legitimisation of identities was a feature of many Western democracies in the late twentieth century, and allowed states covertly to impose behavioural norms on their citizens through a 'regime of empathy'.[8] In theatre, where the practice of empathy appears to be so fundamental – particularly to the modes of realistic drama that this book will be exploring – the extension of empathy can be contingent on what is perceived as 'real' or 'authentic', concepts that have preoccupied critical discourse concerned with a crisis in representation, and which when applied to voices seem to imply their legitimation only if they conform to the norms of representation approved by mainstream sensibilities and ideologies.[9] Such is the implication of what Janine Hauthal terms the 'documentary contract' that enlists the empathy of audiences by observing norms regarding vocal authenticity.[10] In the time of New Labour, it seems possible to think of empathy partly as an administrative procedure that regulated the newly included members of the demos. In common with Liz Tomlin who has addressed the status of representative drama fifteen years after Hans-Thies Lehman's *Postdramatic Theatre* (1999), I believe that new writing of a primarily realist mode can challenge traditions of cultural ownership and dominant practice by articulating the reality of marginalised communities.[11] Unlike Tomlin, I do not refer to these realities as 'alternative', but rather negotiated and permeable by structures associated with mainstream practice and response.

Activities I discuss in this book such as voice training and creative writing programmes tend to associate the voice in theatre with freedom and self-expression. There is a danger in such thinking that encourages the delusion that vocal empowerment helps individuals to avoid the regulatory norms of society. This tradition of liberty and enlightenment is often associated with claims that in staging contemporary writing, theatres provide free spaces of open debate, akin to the 'public sphere' of Jürgen Habermas and his 'dialogic democracy'. This was a model extremely influential not only to Giddens during this period, but was also prevalent in the rhetoric and thinking of theatre practitioners.[12] The model, with its assumption of a transparent and honest expression of a group of 'sincerely' expressed voices, draws attention towards the positive moral value that is associated with 'free' oral expression, and away from the complex processes and mediations of identity that the representative process entails. Like Ric Knowles, whose *Reading the Material Theatre* (2004) excludes the voice from his discussion of the transformation of the political unconscious through material phenomena, I am interested in the interrelationships between production

and reception, and specifically in how these interact with the voices of practitioners, and the voices of those their writing represents.[13] In the context of the New Labour government under Blair, where cultural inclusion of marginalised individuals was highly conditional on an institutionalised set of behaviours and values, the practices associated with 'finding' and 'giving' voices in theatre made audible the negotiations made by individuals under New Labour's including and devolving regime, as well as the practices and ethics of political and artistic representative processes.

In British theatre there has long been a tradition of including voices whose rich diversity of dialect and sound express and represent a society of different classes, regions and races. There have been many plays, as Dan Rebellato notes in his assessment of the impact of John Osborne's *Look Back in Anger* (1956), which have included authentic sounding voices of the socially marginalised, oppressed or excluded.[14] In the early decades of the twentieth century, the plays of D. H. Lawrence, such as *The Daughter-in-Law* (1912), or *Love on the Dole* (1934) by Walter Greenwood, are in some senses documents of the social realities of their times. Shelagh Delaney's *A Taste of Honey*, whose central character is a working-class Salford teenage girl, emerged from Joan Littlewood's Theatre Workshop in 1958, and in 1974, David Rudkin's play about Black Country fruit pickers, *Afore Night Come* (1962) became the first non Shakespeare play to be staged at The Other Place at the Royal Shakespeare Company (RSC). Plays by white writer Barrie Keefe in the 1970s at Soho Poly and Greenwich Theatre, *Sus*, *Gimme Shelter* and *Barbarians*, gave voice to the authentic sounding speech and concerns of underprivileged youths, both black and white. In the 1990s, as the years of Conservative rule were giving way to the New Labour period, the characters of Winsome Pinnock's *Mules* (1996) at the Royal Court, and Rebecca Prichard's *Essex Girls* (1994) and *Yard Gal* (1998) used black dialects and street voices. Irvine Welsh's stage adaptation of *Trainspotting* (1996) and his play *You'll Have Had Your Hole* (1998) combined some formal experimentation with voices that were unremittingly demotic. To a greater or lesser extent such plays have used the accurate representation of the vocal features of speakers in particular cultural contexts to change or challenge the sounds and bounds of the structures and attitudes that have pervaded the spaces of theatres and beyond.

In the late 1990s, Pinnock implied the importance of extending this tradition, arguing that if theatre was to be a 'microcosm' of society, it must programme a range of work by a diverse range of citizens.[15] Nearly a decade on, Artistic Director of the Royal Shakespeare Company,

Michael Boyd pronounced that 'theatre provides a voice for the voices that are not normally heard'.[16] Boyd accords theatre a role as 'provider', the 'giver' of voice, and implies an ethical responsibility to make audible the voices of the marginalised. In 2002, the year after Blair's second General Election victory, playwright John McGrath went beyond the problematic implications of patronage of this laudable sentiment, by emphasising not only theatre's responsibility to marginalised voices but also their importance to mainstream society. By 'giving a voice' to 'the excluded', 'the minority', 'the oppositional' and 'the less equal', he argued, theatre played a role in 'celebrating and scrutinising the values within the borders of the demos'.[17] While Raymond Williams argues that realist drama expands the sphere of representation (as further discussed in Chapter 2), McGrath emphasises not only that an inclusive and diverse society is valuable in itself, but also the value of marginalised voices in providing society with a means of self-scrutiny. Tellingly, his voices are positioned *within* a *demos* – inside a democracy of participants – implying the legitimisation of voices in dialogue with others, but also, crucially, the capacity of these voices to challenge and change the constituency of that dialogic sphere itself.

The voices that this book largely explores are taken from a body of 'new writing' – a term that is commonly but rather loosely used to refer to the kind of work that emerged from the boom associated with a growth in the structures of literary management within subsidised theatres from the mid 1990s. 'New writing', says Aleks Sierz, a major 'voice' in theatre scholarship of the period, is 'characterized by the distinctiveness of the author's individual voice' and the 'contemporary flavor' of its 'language and themes'.[18] In its emphasis both on the individual voice *and* the contemporary, Sierz's terms are perhaps reminiscent of New Labour's Third Way philosophies, marrying an aspiration to refresh and renew the sphere of representation with a system of competitive individualism, with all its moral and market potentials. An emphasis on the unique voice of the writer arguably feeds fetishistic attitudes towards literary prowess, and fails to attend to the ways that writers draw on vocal and aural material from 'exterior' sources in their representation of others. It also underemphasises the polyvalence inherent in dramatic performance, which as well as articulating something distinct, mediates identity through several consciousnesses and bodies.[19] As Mikhail Bakhtin has influentially suggested, voices in literature seek to articulate themselves through a dynamic process of negotiation of the structures of language and society.[20] When writing is performed, not only are the voice of its writer and its characters already intersubjective entities,

its speaking involves a further regard for the physical delivery of the voice in material space, and a negotiation of social expectations and responses. With regard to this book, it is not so much the so-called unique qualities of writers' individual voices that have influenced the selection of its content, as the negotiations made in their work by the articulation of identities through material, social and representative spaces, norms and practices.

The voice, subjectivity and society

In thinking of the voice as a creative and critical tool it is helpful to consider how voices have been perceived to articulate the subject in relation to society and its political structures. Scholarly work by Steven Connor and by the Lacanian influenced philosopher Mladen Dolar has emphasised the voice as a psychological and physiological entity connecting its subject, and particularly the pre-linguistic unconscious, with society and space. To Connor, voice 'is me, it is my way of being me in my going out from myself'.[21] Roland Barthes has influentially described the tradition in cultural discourse of the perception of speech as the 'fresh, natural, spontaneous, truthful' expression of 'pure interiority'. The tradition is predicated on a human subject whose interior is somehow private, separate and pure, pre-existing the oppressive structures of society within which she lives.[22] Unsurprisingly, these concepts have been treasured in the training of actors' voices. In 1906, Elsie Fogerty, founder of the Royal Central School of Speech and Drama (Central), described the speech carried by the voice as both 'unconsciously ours' and 'intimately our own'.[23] Fogerty's phrases suggest not only the mechanisms of subjectivity, but almost a sense of private internal dialogue between self and speech. In acting, the idea of an 'inner self' associates the voice with the creative expression of 'truthful' emotions and the 'transparent' passage of normally private and potentially subversive feelings into the 'open'. For the Russian director Konstantin Stanislavski, whose methods continue to influence conservatoire training, 'acting is above all inward, psychological, subconscious', requiring the expulsion of 'the truth of the passions' and 'secret thoughts and experiences'.[24] This is not a perception of the voice that tends to emphasise its intersubjective aspects (although as I will explore in Chapter 2 much of the work of voice teachers heightens the penetrative and affective capacities of actors' voices), but suggests rather this persistent and popularly recognised tradition of an inherently individual self that is preciously private, and retains an apartness from society. Frequently, the expression

and acknowledgement of this self allows a speaker to be perceived as a 'human' and 'individual', and therefore innately free and virtuous, rather than as a 'subject' or 'citizen' regulated by the fixed or written structures of the state or other authority.

In *Presentation of the Self* (1959) sociologist Erving Goffman reflects on the familiar idea that there is a distinction between the 'true' or 'real' self, and the self that the individual projects, performs and presents to the world.[25] In performance, this 'gap', as Philip Auslander discusses, links back to the tradition that acting in the theatre is based on a virtuous revelation to the audience of 'truth', or of something that is 'real'.[26] Such concepts as 'truth' and 'authenticity' have been deeply contested in critical discourse, but attending to the range of strategies the idea of the gap yields to both actors and writers is fruitful. One only has to think of the problems it causes to politicians, for whom a perceived gap between the real and performed self can be a sign of malign intent or untrustworthy practices, to recognise its power and currency as a concept. Closing the gap, often by ensuring congruence between language and feeling, produces the effect of transparency, a vocal quality often praised in the performance of Shakespeare, as well as highly prized by political speakers. With regard to previously marginalised speakers, a *playing* of the apparent gap between a true and performed self can be used to imply that a naturally 'good' inner self is being forced into wrongful allegiances through 'bad' language (as I explore in subsequent chapters on black and young speakers), or as a means to make audible the complex negotiations made in entering mainstream society or culturally privileged space.

Major critical thought on subjectivity and selfhood in the twentieth century, including that of Michel Foucault, Pierre Bourdieu and Judith Butler, explores the formation of the subject through social fabrics that permeate the individual rather than disguise the inner self. The work of these theorists thus challenges the idea that the voice can express a self that is 'free' or separate from society. For Bourdieu, linguistic and vocal features relating to society's structures, such as grammatical forms, vocabulary, accent, intonation and delivery, are physically engrained within an individual's 'bodily hexis'.[27] This does not necessarily mean however that the individual voice is entirely swallowed by social structures. In Butler for example, agency is achieved through the body working through or against social ritual. In *Excitable Speech* (1997), where she questions the apparent authority of language over the body, Butler finds that language can be 'the condition of possibility for the speaking subject.'[28] In such a light, linguistic structures can be

seen as offering the individual opportunity to transform the self and its relations with others, a potential extremely important to marginalised voices, as well as to actors whose work on character inevitably negotiates subjectivity through the relationship of text and its physical realisation through embodied practice.[29] Whether we think of the voice as emanating from inside the body, as in models influenced by a psychological approach, or as a technology that operates through the body in constituting subjectivity in relation to society, the voice seems to offer possibilities of subversion, resistance or challenge, as well as of agency and transformation.

Yet in spite of its conceptualisation as the means that the individual physically crafts her speaking self in the world, or as the individual's mechanism of resistance to exterior evils, the voice makes and carries the language and sound that exert normalising influences. From the 1930s, the Prague structuralists who developed Saussurean thought on language as a semiotic system, showed that even the fluid accents of the voice could be categorised, potentially fixing a speaker's identity according to society's preconceptions regarding the exterior features of their speech.[30] Their work made the 'paralinguistic' features that had eluded Saussure such as intonation, pitch and volume available to semiotic analysis – and thus prone to becoming the kinds of apparently fixed attributes that Goffman argued are used to judge the 'virtual social identity' of stigmatised individuals.[31] In acting, as semiotician Keir Elam admits in *The Semiotics of Theatre and Drama* (1980), the systemisation of sound can encourage a repertoire based on 'crude stereotypes'.[32] A host of vocal caricatures based on race, age, gender or sexuality can be used, for example, to provoke ridicule, distrust or a sense of inferiority. Building on J. L. Austin's discussion of speech acts, Bourdieu addresses the issue of cultural audibility by seeing it as a function of power. The illocutionary force of an utterance will depend on the power of the speaker within a given cultural context and its norms and standards of features such as grammar, accent and dialect. These contexts may enforce selective, hierarchical or hegemonising structures, which act to control, delimit or suppress the authority and the agency of the speaker.

A wide range of work in the field of sociolinguistics, which explores the potentially damaging consequences of the attachment of moral judgement to speech for non-standard English speakers, suggests that the sounds carried by the voice are prone to the mechanisms of social regulation.[33] In the mid to later decades of the last century for example there was a strong tradition in southern England that presumed that middle-class speech was morally neutral or good, and that speaking

well in public involved the clear articulation of the Queen's or of BBC English. Sociolinguist Peter Trudgill argues in *Introducing Language and Society* (1992) that such attitudes can even extend to speakers' evaluation of their own voices, and leads non-standard speakers to develop 'linguistic insecurity', 'linguistic self-hatred', and become 'inarticulate and reluctant to express themselves'.[34] Strategies to cope with this self-perception of inferiority include the adoption of the covert prestige of certain stigmatised dialects, such as the 'urban voice' widely adopted by the young and theorised in Paul Foulkes and Gerard J. Docherty's volume *Urban Voices* (1999), or the use of 'anti-languages' that deliberately flout the norms of polite bourgeois speech.[35] Personal and group identity, especially of marginalised speakers, can thus be articulated in vocal allegiances.[36] In some cases, as Bourdieu describes, an individual or group can refuse to speak at all in order to differentiate themselves from the norms and values of the mainstream. Consideration of such factors, in combination with the ethical responsibility to an 'accurate' or 'authentic' construction of accent and dialect, inform the construction of the identities of non standard or marginalised speakers by writers and actors, and also serve to remind us that theatre itself as a social and cultural practice fosters distinct, identifiable and potentially excluding ways of speaking. Resistance to the norms of speech and vocal delivery on the other hand, as I will discuss in relation in subsequent chapters on writing by black writers and on the representation of young voices, can reposition the hearing of audiences, causing temporary realignments that imply differently nuanced orders of articulation and audibility.[37]

In the efforts made by many speakers to fine tune their voices we can find evidence for Barthes' claims that speech is inherently 'tactical' and 'theatrical', subject to 'a whole collection of cultural and oratorical codes', or of cultural theorist Walter Ong's view that human communication is 'shaped in its very form and content by anticipated response'.[38] Because voices are inevitably constructed according to the ways in which their speakers believe they will be received, there is a way in which likely reception becomes a pre-emptive condition of production – and may lead to the temptation to construct a voice according to broad expectations of its speaker. Again, this is not to imply that identity is merely a conjuration of social expectations. Multiple roles and identities become possible through 'code switching' – a practice common amongst many marginalised social groups – depending on one's interlocutors, the context of vocal delivery and the norms that govern it. While a positive view of vocal adaptability may seem to conflict with the role of the voice in expressing a true or fixed inner self, the

performative capacity of the voice can therefore be seen as providing a means of transformation or mobility that enables an individual to adapt to new contexts and situations, enabling speakers to demonstrate not only impressive vocal dexterity, but also to articulate an evolving or transforming identity that interacts consciously and creatively with the linguistic and social roles it negotiates.

In the latter part of the twentieth century a philosophical interest in the interaction between individuals suggests the importance of transparency in vocal communication, somewhat shifting its importance as a quality that aids self-expression. In his unfinished final project of the early 1980s, 'Technologies of the Self', Foucault assesses the historical importance to the individual of self-disclosure, and of the 'verbalization' that provides a self-reflexive means 'to constitute, positively, a new self'.[39] Foucauldian thought surfaces in *The Consequences of Modernity* (1990), where Giddens emphasises the importance of being open and being heard to the development of a self-reliant, well-adjusted citizenry in a modern democracy. For Giddens, 'self-actualisation' (a term also used in the influential work of psychologist Abraham Maslow) addresses the individual's emotional needs, and is only possible if accompanied by the '"opening out" of the self to the other', a 'mutuality of self-disclosure'.[40] Replacing the role identified by Foucault played by traditional institutions such as the church, the 'ontological security' of the self according to Giddens is assured particularly through intimate relationships, and the quality of trust on which democracy is dependent.[41] This assumes that a speaking subject will be listened to as her subjectivity emerges through her opening out to another, placing acute pressure on the importance of trust and transparency between interlocutors. It also implies a convergence between personal intimacy and the political representative process, and the affirmation of transparency as a dominant norm. This norm, as this book explores, also permeated the practices and spaces of theatre, often influencing the degree and quality of empathy received by speakers.

The voice in critical enquiry

The body of scholarship that has accumulated around this period of British theatre often either explicitly or implicitly shares the ideological emphases on inclusion and diversity that were characteristic of the New Labour period. Many volumes have followed *Stage Right* (1994), John Bull's account of the depoliticisation of British new writing in the 1980s and early 1990s, reflecting and responding to the apparently

more polyvocal theatrical climate that developed after New Labour's accession.[42] In their volume of essays on the early 1990s, *Cool Britannia* (2008), editors Rebecca D'Monté and Graham Saunders deliberately avoid attempting to create a new canon, locating an 'authentic' and 'representative' portrayal of British culture in the 'sheer plethora of British voices'.[43] Similarly in tune with the diversifying and devolutionary politics of New Labour, Jen Harvie consciously practices her own diverse and devolved approach in selecting her material in *Staging the UK* (2005).[44] Steve Blandford's book, *Film, Drama and the Break-Up of Britain* (2007), systematically covers the constituent elements of the United Kingdom, unlike Harvie conceding the growing obsolescence and inutility of the idea of Britishness.[45] Aleks Sierz' *Modern British Playwriting: the 1990s* (2012) is impressive in its enumeration of the wide range of writers and performers in British theatre in the 1990s, while arguably contributing to the selective canonisation of four of its most 'iconic'.[46] The subtitle of each volume of the Methuen series 'Decades', of which Sierz's book on the 1990s is one, promises 'Voices / Documents / New Interpretations'. These works go far to interrogate and celebrate the political principles of inclusion and devolution, yet the tendency to refer to playwrights as 'voices', particularly in the field of new writing, remains largely unexamined.

Other work has engaged with the ways that groups of individuals in society have been included and interpellated as political subjects, arguably by these very including and diversifying practices. John Deeney's article on the National Theatre's New Connections plays for example explores the conjuration through theatre of young citizens according to state sanctioned economic and philosophical models.[47] Many of the essays in Dimple Godiwala's volume, *Alternatives Within the Mainstream* (2006), acknowledge the ways in which the work of newly included black artists was articulated through structures that imposed hegemonising conditions.[48] Scholarship on Scottish theatre, such as the work of Adrienne Scullion and David Pattie, discusses the re-orientation of the individual within shifting global and national frameworks following devolution in 1998.[49] While this work often explores the articulation of individual identity, it rarely attends in depth to the choices made by writers and performers regarding voice and language, and what these might reveal about the processes of theatre themselves as well as wider spheres in the formation of subjectivity.[50]

Andrew M. Kimbrough's book, *Dramatic Theories of Voice in the Twentieth Century* (2011), which attends to the voice through a range of theoretical frameworks, unpacks the ambiguous position of the voice at

the notorious divides of speech and writing, and performance and text, which associate its action both with the freedom and spontaneity of speech and the oppression and social rigidity of language.[51] The association of the voice with the latter has been particularly problematic, leading to a tendency, as scholar Alexandro Portelli notes in *The Text and the Voice* (1994), for literary theory to borrow terms from theories of orality (a point I extend to the discourse of both theatre practitioners and politicians in this book).[52] A further evasion is suggested in performance studies by the dominance of 'visualism', which contributes to the 'unacknowledged, unrecognised and uncredited' role of the voice.[53] The point is evidenced in Susan Melrose's description of how actors make the emotions and psyche 'visible' to the spectators' 'gaze'.[54] There is a shift here that obscures – or mutes – the work done by vocal performance. In a wider sense it signals a critical lacuna in exploring sufficiently the work of voice practitioners with actors, and their interventions into the text-performance paradigm that imaginatively combine aural, kinesthetic and visual strategies through voice work – processes to which I attend in Chapter 2. Accordingly, in order to evade the dominance of the visual in critical vocabulary, I have often tried to avoid common critical terms such as 'illustrate' and 'see' in favour of 'attend to', 'make audible', 'articulate', and 'hear'.

From the last decades of the twentieth century a body of scholarship has emerged that mounts a challenge to the 'anti-ocular' strain in Western thought. Such scholarship seeks to attend to the phenomenology of the oral and aural, and often articulates the coalescent phenomenological and political aspects of voice and hearing. Jean-Luc Nancy's *Listening* (2002) for example draws attention to the rhythmic and sonorous role of the voice in the formation, interpenetration and potential hegemonisation of subjects.[55] In the field of literary studies, Charles Bernstein's volume *Close Listening* (1998) suggests the importance of aural and sonic in the making and interpretation of poetic voice, challenging the traditional primacy of text over performance.[56] Addressing the voice's 'relegation to insignificance' by her discipline in *For More Than One Voice* (2005), philosopher Adriana Cavarero's 'politics of the voice' offers the individually embodied and intersubjective voice of a speaker as a means to reconfigure the traditional dominance of semantic authority.[57] These scholarly works attend to and value the voice largely because of its intimate and apparently inalienable relation to the individual as a political subject. Nick Couldry's volume *Voice Matters* (2010) in particular, which attributes a 'crisis of the voice' to the workings of neoliberalism, asserts the role of the voice in the processes

through which an individual is heard, and as a fundamental indicator of political organisation.[58]

Like many of these scholars, I am interested in the ways that voice is valued, and believe that the practices of artists that pay *attention* play not only an aesthetic, but also a political and social role. In researching this book, I have found that the sense of having an 'individual' voice often associates a writer or performer with the uniqueness of creative and artistic expression, but may also help to position her, and the audience members who attend to her voice, as a basic unit of liberal democracy within a capitalistic economy. Acknowledging the oral and written as distinct but related means of expression through which voices are mediated, I argue that the 'fusion' and 'gaps' of the linguistic, affective and sonic folds of vocal communication can be used by practitioners to articulate, distinguish and amplify the voices of individuals, and to scrutinise the conditions within which subjectivity is articulated. Rather than thinking of the dynamics of the rehearsed/performed and spontaneous/ real aspects of the voice as contradictory and self-stymieing, I hear them as an artistic *palate* with which to articulate identity in negotiation with physical, cultural and discursive spaces and structures.

In attending to the expression and articulation of identity through the voice I am following Williams' endeavour to find a method of testing a 'cultural hypothesis' – or 'structure of feeling'. My approach uses the voice as 'cultural evidence' – an appropriate strategy given Williams' interest in the 'articulation of presence' and his elucidation of such structures as 'elements of impulse, restraint, and tone'.[59] As a physical and material substance, a voice enters a fluid, dynamic and social orchestration in which speakers identify themselves and are identified by others. In performance it expresses, heightens, mediates or sculpts the feeling and experience of a speaker, and elicits responses from listeners or interlocutors that further modulate the structures of understanding and communication that exist between them. In thinking about the different contexts in which the voice is heard, I have found it useful to coin the term *voicescapes* to refer to and differentiate the dynamic material and conceptual fields of cultural audibility.[60] A given voicescape makes audible the individual's efforts to articulate identity, to assert agency, and her interactions with the cultural and political norms and values that exert influence over who speaks and who is heard. This distribution and flow of expression and audibility varies in a given voicescape, whether it tends to the physical and intimate as in the communication of lovers or friends; takes place within a neighbourhood, community or industry where voices are often known but not always present to

each other; is articulated within a theatre space, where audibility may be enhanced or fetishised; or resounds in the much wider economic or conceptual spaces where competition for vocal expression and audibility may be extreme.

In theatre, where there is a generally empathetic regime, voices that are censured elsewhere are often given temporary licence. A criminal, working class or transgressive voice for example may be constructed 'authentically' by an actor, and seem to be empowered, but remain severely stigmatised in general society. Theatre's voicescapes may thus appear to offer an alternative 'distribution of the sensible' – to borrow Jacques Rancière's highly influential concept – producing textures of audibility that differ from those of wider society.[61] As this Introduction has discussed however, many values permeate through rehearsal and response to the voice from wider society, suggesting fields of articulation that influence and overlap rather than being distinct. Vocal practice may be influenced by real or anticipated public responses that affect, modify or even censor expression. Henri Lefebvre's insight that an 'illusion of transparency' disguises the production of social space is also helpful here in understanding how voices constructed according to aesthetic or creative qualities, or with a sense that they are unique or free, also negotiate normative attitudes, competitive structures of status and prestige, systems of economic exchange, and national and international political ideologies.[62] The praise that writers receive for the use of demotic voices in theatre, for example, will not only contradict the censure these voices receive under more normal circumstances, but also supply practitioners with a means to increase the cultural status of their own voices and their own personal economic success (a point that suggests that theatre's apparent intervention in the textures of cultural audibility in fact reinforces more powerful distributions).

Including voices

In the field of political rhetoric, where the 'anti-theatrical prejudice' traced by Jonas Barish back to Plato is easily triggered, a voice that appears to be excessively divergent from perceptions of the speaker's origins can work to invalidate the speaker.[63] In the 2010s, some commentators have heard the glottal stopping and colloquial delivery of Conservative politicians as a decoy to distract attention from the structures of privilege of which their 'original' or 'natural' accents are supposedly symptomatic.[64] The voices of Blair's government, and particularly that of the Prime Minister, as a variety of commenters have

observed, were also highly prone to popular perceptions and reception. In *New Labour New Language* (2000) Norman Fairclough claimed presciently that Blair's vocal features were a 'public construction of normalness', carefully pitched with popular appeal in mind.[65]

Writing in 2014 it is hard to get beyond this perception of the Blair decade in power as an extended con. Feelings of betrayal and disappointment have pervaded political, academic and cultural discourse, and have outlasted and overshadowed the entire New Labour project.[66] A very strong reaction indeed against the perception of 'spin' in New Labour's relations to the public has resulted in a potentially irreparably damaging loss of trust in the democratic process in Britain (even when the Arab Spring was widely reported in 2012 as a positive evidence of the widespread popular demand for democracy). According to a MORI poll in June 2013 political cynicism in Britain reached its highest level ever.[67] It is hard to re-imagine the sense of political optimism of the 1990s, the feeling that a new era of 'Cool Britannia' was dawning, and the fondly remembered sense of 'freshness' of the times that seemed to buck the trend to political disaffection in the West.[68] Since then, it has come to be generally accepted that the New Labour government's behaviour represented what cultural theorist Stuart Hall described as a 'profound contempt' for the electorate.[69] We seem to have come to expect disguise, deceit or evil intent in the voices of our representatives, and the parody of politicians' smooth, amenable delivery is another crude stereotype.

New Labour's connection with the New Democrats in the USA has been used to suggest the conflation of New Labour's political ideology with their marketing strategy. In *Clinton and Blair: The Political Economy of the Third Way* (2006), political economist Flavio Romano reminds us that the key political concept of 'the Third Way' was not only the subject of Blair's own pamphlet, *The Third Way* (1998), and of a large number of Giddens' publications of the 1990s and 2000s, but can also be traced in the statements of the New Democrats in the run up to their election triumph in 1993.[70] The Third Way has been presented not so much as a *philosophy*, but rather as a *language* of the left that sought to disguise the activities of an essentially capitalist government.[71] As such, Romano identifies a 'consensus' (within which David Hare's 1993 play, *The Absence of War*, can be located), that Blair's repositioning of the Labour Party was more concerned with style and perception than the development of a coherent set of political principles.[72] This allows New Labour's policies themselves to be discredited as a black art of political manipulation, a form of spin. Viewed with these suspicions, New

Labour's language (as political theorists Paul Cammack and Fairclough prove with the aid of discourse analysis) becomes a 'way with words', a rephrasing of capitalism to sound like social democracy.[73]

This narrative arc from trust to betrayal is important and compelling, and it informs the contents and structure of this book, along with many of the points made by New Labour's detractors. Yet such a response is itself partly elicited by a political philosophy and tone that accorded moral probity a central role in the democratic process. Alwyn W. Turner reports Jack Straw's 1996 comment that Blair's biggest burden was the expectation of bringing 'a different ethical order'.[74] To dismiss the New Labour regime as spin, and the Third Way entirely as a rhetoric with no substance, is to continue the emotional cycle, and make less audible what the regime did do to include diverse individuals or groups, and the democratic dialogue they contributed. Amongst practitioners and scholars, the sense of disappointment and betrayal has provided much fuel to the belief that theatre has a responsibility to provide representative strategies that are ethically sound, and somehow more 'transparent' than those of politics. The sense of betrayal from which many suffered during the tail end of the Blair years and beyond, has also affected our hearing of marginalised voices, and modified the practices of theatre makers with regard to the inclusive principles with which the era had begun. This book accounts for the critique of the ideology of inclusion and the reassertion of a Habermasian model of theatre practice as a self-reflexive response to the sense of betrayal after the 'transparency' in the Prime Minister's voice had become discredited, and a desire on behalf of theatre makers to ensure that the representative processes of theatre retained their ethical integrity.

Chapter 1 discusses in more detail the ways in which Tony Blair and New Labour presented and instituted their idea of an inclusive, diverse and participatory democracy. It surveys a range of materials, including party manifestos, policy documents and initiatives, and the discourse of politicians and practitioners that illustrate the role of the Arts and other sectors in New Labour's apparently inclusive but also regulatory project. Both journalistic and scholarly material is used to show how responses to the delivery of Blair's voice reflected disillusionment with the notions of universal audibility and democratic transparency. Chapter 2 focuses more tightly on theatre practitioners, attending to how writing and acting processes and forms mediated voices of characters in a Giddensian climate, and how contradictory pressures towards individualism and a transparent representative process were exerted. Material drawn from the discourse of and interviews with practitioners and managers reveals

the ideologies and practices of literary management at the Royal Court, where the commitment to 'new voices' was explicit, at the Soho Theatre, which continues to support new writing through its annual Verity Bargate prize, and at the National, which included new work by voices previously little heard in the mainstream, notably by black British writers. A review of the practice and discourse of prominent voice teachers such as Cicely Berry, Patsy Rodenburg and Kristin Linklater amongst others, attends to the ways voices are constructed through the intersensory and attentive practices of voice training, and identifies the shifts in the practice and values of vocal performance during the Blair years towards diverse 'authentic' voices 'transparently' delivered.

Four case study chapters illustrate the ways in which a range of previously marginalised voices provided scrutiny of the demos in the New Labour years. Chapter 3 examines the expression of voices in the context of Scottish devolution, and its implication of a major repositioning of the specific sounds, tones and associations of Scots voices, which previously had often carried the political charge of resistance and opposition. I attend to the 'authentic' demotic of Gregory Burke's working-class voices, as well as to the ways in which David Greig's migrant characters test the apparent link between locale and voice in a globalised environment. Chapter 4 turns its attention to black British voices, which during this decade negotiated a presence in theatre's most prestigious and institutionalised mainstream spaces. It examines the representation of voices by writers Kwame Kwei-Armah, debbie tucker green and Roy Williams, noting both the appetite for and resistance to the 'authentic' tones of British indigenous black voices in a period when journalistic theatre criticism was still largely written, according to National Theatre Artistic Director Nicholas Hytner, by 'dead white males'.[75] The chapter explores the scripting of the sonic equivalent of a black 'cultural lens', the articulation of anxieties with regard to inclusion and assimilation, and the frequent performance of a sense of 'fake' identity.[76] As a black woman in British drama tucker green in particular could be seen as typifying New Labour's inclusive and diversifying project. Yet her work is profoundly discomforting, and implies a critique of racial or other bounded categories of identity, which I am aware could be extended to my own categorisation of her work within a chapter that deals with 'black' voices.[77]

Chapter 5 attends to the inclusion of young voices, which had been marginalised both from mainstream cultural space and from political suffrage. Historically dismissed as deviant or criminal, their voices prone to swearing and slang, mumbling and lazy elocution, young people increasingly gained representation in cultural space in the 1990s and

2000s. Tanika Gupta's *White Boy* (2007), Mark Ravenhill's *Citizenship* (2005), and Enda Walsh's *Chatroom* (2005) all represented young characters in prestigious venues. The chapter notes the tendency in the Giddensian context to use inclusion in adult space as a therapeutic solution to the anxieties felt by adults towards the young. Its discussion of theatre's responsibilities towards vulnerable voices is continued in Chapter 6, which considers the representation and hearing of women who most clearly defied the nurturing role of the female voice by killing children. Using the new version of Euripides' *Medea*, directed by Deborah Warner and performed by Fiona Shaw in 2001 I attend to the ways that the portrayal of women's voices in empathetic theatre space might substitute 'real' experience with stereotyped or limited versions of female identity. The chapter also discusses Beatrix Campbell and Judith Jones' *And All the Children Cried* (2002), and Dennis Kelly's mock verbatim play *Taking Care of Baby* (2007), to show how cultural response to the transgressive female voice revolves around perceptions of trust, deceit and betrayal. It suggests that by the end of the period the deceitful female voice had become a metaphor for the act of representation itself. Here, the narrative of betrayal that dominates perceptions of the Blair period can be heard in the degradation of transparency in the performance of voices in public space.

Throughout the case studies the responses of critics and journalists to the voices of actors are included to instantiate the specific ways in which voices were validated within the theatre industry, and contrast with the ways that the sociolinguistic material I have drawn on suggests that voices were validated or delegitimised in wider society. This approach aims to understand the ways that theatre's voicescapes empower its voices within a narrow context, but also to trouble the apparent separation of this context from wider society. In common with scholarly practice that acknowledges the contribution of the audience in the making of meaning, and in keeping with the idea that the voice is constructed partly in relation to how it is heard, I also refer to the ways that audience members both as individuals and as a body responded to the voices they heard in live performance. This widens the narrow terms or fixed preferences within which critics, journalists and sometimes scholars, may validate voices. Often, audience responses can affect the impulses, restraints and tone of vocal performance, and confirm theatre's voicescapes as shifting and evolving fields in which a structure of feeling can be heard – especially where a new audience demographic gains access to theatre space.

In this period, new writing was commonly associated with challenge and scrutiny. It seemed to provide a means to extend the reach of theatre as a democratic forum, giving a voice to writers previously unproduced in mainstream and culturally prestigious space. It offered inclusion and representation to voices from wider society, providing a medium to articulate the complex nature of previously marginalised experience, and to rehearse the shifting conditions of life not only in particular national contexts, but in an increasingly globalised environment. If theatre in the time of New Labour 'gave' a voice to the previously marginalised however, it also risked replicating the structures of selection, exclusion and inequality by which the wider cultural economy seemed to function, and to threaten the independence of voices by imposing the ideology of inclusion and a culture of prestige and status. This book attempts to assess how theatre's voices emerged through the negotiation that occurs during these processes. Through its endeavour to understand this dialogue it hopes to assert the role of the voice, and the diverse sounds of its speakers, in the democratic function of theatre.

1
New Labour, New Voicescapes, 1997–2007

In the 1980s Margaret Thatcher's voice had seemed to carry an iron authority that had firmly kept political opponents in their place. Headlines in the popular *Sun* newspaper screamed of bashing the miners, routing the 'Argies' and smashing the Unions, and Thatcher's tactic seemed to be to squash, silence and suppress. When she banned the direct voices of Sinn Fein politicians in the late 1980s however, the rich actor's voice that spoke the words of Gerry Adams seemed to stoke more fascination for the muted voice of the political leader. As a North–South divide split the country, Yosser Hughes' Liverpudlian mantra 'Gizza job' echoed through the age like a plaintive symptom of the unemployed man's alienation.[1] Alternative voices in magazines *Spare Rib* and *Marxism Today,* or of the women of Greenham Common, seemed to be a part of this marginalised, but nevertheless substantial culture of dissent. Thatcher's own infamously crafted voice, lowered in tone to downplay the semiotics of a feminine presence, spoke both of the social mobility of the educated conservative as well as of the ways she exercised her authority according to the male norms of the period. Her use of the Lincolnshire dialect word 'frit' in 1983 seemed to be designed not to remind the voters of her relatively humble background, but to scare the Opposition benches with the Boedecian credentials of the Iron Lady.[2] As the Prime Minister's resoundingly decisive tones more than matched the belligerence of Barnsley Trade Unionist Arthur Scargill, the voices of political leaders seemed decisively linked to the fractious and oppositional political character of the times.

In the period succeeding Thatcher and preceding the accession of New Labour, the sounds and delivery of the voices of political leaders were perhaps more amenable, but arguably less effectual. Thatcher's consummately monotone, less combative successor John Major, eschewed the

idea of changing his vocal delivery in the interest of political image making.[3] The Major paradigm – of an apparently 'ordinary' voice coupled with social mobility – pleased voters, but his failure to unite the party led to his resignation in 1995. His voluble Labour opponent, Neil Kinnock, was unhelpfully dubbed the 'Welsh windbag' by *Private Eye* magazine and the satirical TV puppet show *Spitting Image*, and following the Labour party's unexpected defeat in 1992, Kinnock's voice came to be associated with feeble and irrelevant rhetoric.[4] His successor, John Smith, who succeeded in ending Trade Union block voting at Labour Party conferences in 1993, possessed a trustworthy Scottish accent (many years before the banking crisis), but died before the perception of his leadership potential could be tested with the electorate. It was not until Blair, with his apparently classless but carefully crafted accent and informal delivery, was elected Party leader that a Labour politician seemed to strike the right – or perhaps I should say central – chord with the electorate. Many were hopeful that a New Labour government would put an end to both the conflict of the Thatcher government and such affairs as the very damaging 'Cash for Questions' scandal that had undermined confidence in the integrity of Westminster.

A new political era seemed to be heralded by Tony Blair's trust-inspiring tones. Smith's reforms of Labour and introduction of the principle of one member one vote had already reduced the power of the collective unionised voice, giving the impression of a more 'direct' and 'transparent' relationship between party representatives and individual voters. Blair's further reforms in the shape of a revision of Clause Four and the ditching of the Party's commitment to common ownership in 1995 seemed to confirm his strong leadership potential and suggested a voice strong enough to see off any trouble with potentially recalcitrant Trade Union leaders. In a clever contrast, his voter-facing one-on-one 'sofa style' vocal delivery – said to be modelled on the informal and empathetic style of US President Bill Clinton – seemed to reflect the 'promise of democracy' elucidated by Giddens in *The Transformation of Intimacy* (1992), which advocated the necessity of the trust and intimacy of a sexual relationship in the national democratic process.[5] Adapting his vocal style for television, at a time when interactivity online was in its very earliest stages, Blair seemed to be in intimate conversation with each individual, using his voice to suggest a transparent, trustworthy, but also reasonable and reciprocal relationship with voters.

This opening chapter will give a sense of a national voicescape, attending to the tensions between New Labour's aspirations to an inclusive and diverse political model, and its attempts to manage the nation

and its voices through ideology, legislation and policy. A tolerant and empathetic political tone linked with Blair's political style and New Labour ideologies greeted the voices of the previously marginalised, and permeated through the nation's institutions, including those of the arts. The chapter will show however how the tone of the nation's voicescape dramatically changed over the decade corresponding to Blair's period as Prime Minister, and how it was gravely affected both by fears over security, and by the crisis in confidence in his voice and the processes of democracy that came about after the Iraq war. A less consensual, more internally fractious voicescape emerged with reactionary and dissenting elements. By the end of the period, the public's continuing investment in the ideals of transparency and inclusivity in the representative system seemed to articulate a collective and powerful fantasy, which damned it to disillusionment and betrayal.

Sounding different

A diverse and inclusive society was central to New Labour's vision, replacing the systems of privilege, hierarchy and exclusiveness that had been perceived to be features of the outgoing government and an outmoded Britain. The 1997 Labour Manifesto explicitly stated the Party's commitment to 'the equal worth of all' and to 'fairness and justice'.[6] Accordingly, when Blair came to power, Britain seemed to sound different. In the House of Commons, more women than ever became MPs, and the presence of the diverse tones of speaker Betty Boothroyd, and eminent ministers such as Claire Short, Baroness Amos, Trevor Phillips, Mo Mowlam, Ron Davies, John Prescott and David Blunkett seemed to suggest that the various parts of the nation were to be fairly included and represented.[7] On a grand scale, devolution of power was introduced with the setting up of the Scottish Parliament and Welsh Assembly, apparently supporting the Giddensian concept of 'self-actualisation' for the citizens of the constituent parts of the UK. During Blair's first term, The Human Rights Act (1998) was introduced, asserting rights to freedom of thought and expression, and prohibiting discrimination on the grounds of sex, race or religion. In 2000 *The Parekh Report* recommended measures to ensure the 'equal moral worth' of all citizens through respect for cultural difference, and in 2001 the Race Relations Act made it law for all public bodies to promote equality of opportunity and good race relations.[8] Repeal of Section 28 in 2003 removed a prohibition on the promotion of homosexuality, a measure that was widely believed to lead to the suppression of certain individual's voices

and self-censorship. In contrast to the previous top-down leadership style favoured by Thatcher, the use of focus groups and initiatives such as the Big Conversation Project, public voting for the awards of public subsidies, and new technologies such as interactive web pages began to suggest the dawn of a new era of political listening, public empathy and civil audibility.[9] Despite the cynicism that has been expressed towards some of these developments, as initiatives they implied a remixing of the power within the nation's voicescape, changing its dynamics and mechanisms with measures to support and empower the voices of all citizens as equally important individuals in rational dialogue with their political representatives.[10]

Along with these changes came broad shifts in cultural attitudes towards the way voices sounded. Regional accents were no longer only connected to the political dissent of the North–South rift of the Thatcher years, nor were immigrants' accents and dialects simply parodied or considered inferior. Indeed they were often respected and enjoyed as signs of an individual's cultural origins and identity. The popular BBC television show, *The Kumars at Number 42*, for example, celebrated the British Asian voice as a legitimate and colourful element of mainstream British culture.[11] Cumbrian broadcaster Melvyn Bragg's radio series *The Routes of English* (1999), and Simon Elmes' book *Talking for Britain* (2005), based on a BBC Voices survey, highlighted the contribution of dialect to the development of the English language. In the 2000s, both the BBC's *Your Voice* project and the British Library's *Sounds Familiar* website dedicated public resources to placing a wide range of regional accents and hybrid versions of English online.[12] In sociolinguistics, English was now 'polycentric', and the standard English voice one amongst many varieties rather than a standard against which others were measured.[13] In keeping with the dominant political ideologies, Richard Watts and Peter Trudgill's book *Alternative Histories of English* (2002) was predicated on the concept of 'fairness'.[14] Their approach suggested that all speakers, whatever their origin, were to be respected as legitimate, and had the right to individual expression within mainstream British culture. The British voice itself, it seemed, had become destandardised.[15]

The increasing aural tolerance of signs of vocal diversity in terms of region and race was countered with a tendency for voices to converge in terms of class. This was seen in the phenomenon of 'accent levelling' thought to accompany a flatter class structure.[16] A variety of commentators pointed out the frequent use of the glottal stop, a characteristic seen as improper by the traditionally minded, by both Diana Spencer and the public school educated new prime minister. Even the Queen's

English drifted towards the Estuary, a shift that elicited both approving and censorious responses.[17] Although a cultural premium associated with speaking well remained, a trace of a regional accent or 'roughness' in speech seemed to demonstrate that the speaker was in touch with the people. While John Prescott's grammatical slips were affectionately parodied in the media, his regional working-class tones appeared to ground New Labour in worthy Northern grit. Indeed, Fairclough indicates a number of features of Blair's voice, which, while remaining firmly middle class, included the judicious use of Northern pronunciation and colloquial vocabulary.[18] By 2005, opposition leader David Cameron on the other hand was thought to be 'hiding' his public school accent by the *Telegraph* in order to downplay his privilege.[19] In contrast to previous eras then, where an upper-class accent could be assured of respect, a more favourable response was elicited from voices that were perceived to be normal, straightforward or colloquial in style.

It was not only the way voices sounded that was symptomatic of the ideologies behind the new national voicescape. Their delivery changed too. In the vocal climate created by New Labour, an interactive rather than authoritative style gave the impression of the speakers' approachability, honesty and accessibility. Rather than the rousing political rhetoric of war leaders Winston Churchill and Thatcher, politicians' suitability for leadership was validated by a more informal style and tone that seemed more in keeping with the more peaceful times that characterised the beginning of Blair's office.[20] The mixture of embarrassment and humility with which Blair managed to claim that the 'hand of history' was upon his shoulder at the 1998 Good Friday agreement press conference seemed to signal his role as facilitator of change rather than leader of men. Citizens of an interactive democracy did not require their elected representatives to speak from a position of institutionalised authority, but as one individual to another, sincerely, rationally and truthfully. Most significantly, these shifts appeared to locate the validation of the voice in the values of those by whom it was heard, rather than in the assumed and invested authority of the speaker – a development which seems linked to the 'echoing of language' and convergence of parties that began to occur in the 1990s, according to Turner.[21] The more 'ordinary' or 'normal' a level to which the voice was pitched, the wider the range of people it seemed to appeal.

In terms of delivery, perhaps the most characteristic medium for the voices of politicians during the Blair years was television. Cultural theorist Paddy Scannell's work on the amplification of the voice notes how sincerity in vocal delivery seems to challenge the privileges implied by

the refined vocal qualities acquired by aesthetic training or educational background.[22] Sincerity is not a quality that seems to require these kinds of investment. Of course, access to mediatised space and the paraphernalia of technology is a form of privilege too (especially before the era of digital cameras and YouTube), yet television's intimate style was well suited to deliver Giddens' 'promise of democracy'. The apparently 'natural' way of speaking it makes possible seems to give millions of individuals intimate access to an untheatricalised inner self, speaking sincerely and honestly as if to a partner or lover. Unsurprisingly, television became the preferred medium, for politicians, princesses, celebrities and finally even the Queen during this period. As early as 1995 Princess Diana had 'revealed all' in an intimate TV interview with Martin Bashir, gaining considerable public sympathy. Not until the Queen appeared on television after her daughter-in-law's death did the public seem satisfied by her response. Meanwhile, the combative delivery required by other forms of exchange in public space seemed to some to be anachronistic or less authentic. According to cultural theorist Bob Franklin, Prime Minister's Questions was a 'shop window' for politicians 'to present their leadership qualities', its space corrupted by a sense of theatricality.[23] Early in his period as Leader of the Opposition, David Cameron distanced himself from the event, disapproving of its unruly, unempathetic style.[24]

Not only was Blair a consummate TV performer, he displayed mastery of vocal delivery in different spaces and for different audiences. One of the first politicians to emerge from behind the podium, and famously able to speak without a script, Blair's oratorical ability seemed to enable him to deliver the spontaneous, natural, interactive and unscripted speech that suggested the moral virtue of the speaker. In fact, these qualities of spontaneity and freshness were identified as part of Blair's appeal by Phillip Gould as a welcome relief from the discredited and supposedly sleaze-ridden Tory voices of the 1990s.[25] The apparently extempore nature of Blair's voice on the occasion of Diana's death, with its actorly pauses inserted for emotional impact, as sociolinguist Martin Montgomery argues, enabled him to give the impression that his words emerged spontaneously from his inner self.[26] As I will show, although this belief in Blair's sincerity would not last, the public's demand for this quality in the political process was on going.

The instrumental voice

As discussed, much of New Labour's ideological architecture derived from the work of social philosopher Anthony Giddens. In *The Transformation*

of Intimacy (1992), Giddens claims that a democratic society must give 'equal ranking' to each voice, ensure 'participation', and provide means 'for individuals to make their voices heard'.[27] In his later book, *The Third Way* (1998), Giddens emphasised the reinvigoration of an 'active civil society' achieved through the 'democratisation of democracy' and the 'downward devolution' of power to a participating citizenship.[28] This emphasis on vocal participation relied on the acceptance of the principle of inclusive pluralism and of the equally valid expression of each individually empowered voice. In fact, under New Labour cultural participation was a political strategy.

During this period of relative economic prosperity, levels of public spending on the Arts were relatively high, and the National Policy for Theatre in England (2000) resulted in £25 million of new public money being made available to theatre.[29] In spite of Tessa Jowell's description of the Arts as a 'stockaded' space however, and the long established tradition of 'arms-length' funding of the Arts, public funding of creative activity and means of access to cultural space were devolved through highly managed and ideologically saturated means. At grassroots level, to receive a grant of up to £10,000, it was necessary that a project met criteria such as 'championing cultural diversity'.[30] New Labour's Third Way approach, seeking to reconcile the principles of social justice with economic growth, also aimed to serve the public better through the application of market ideology. At the end of Blair's office in 2007 ACE was arguing that a 'more entrepreneurial and innovative culture' would ensure that theatre was 'valued by and in tune with the communities it serves'.[31] Its 'Public Value' document implied greater institutional flexibility and interactivity through a pledge to engage in 'talking with and listening to a wide range of people'.[32] Yet, as an incipient 'impact' agenda took hold, the 'value' of theatre was increasingly located in its economic contribution. In 2004, Dominic Shellard's *Economic Impact Study of UK Theatre* found that theatre contributed £2.6 billion pounds annually to the economy overall and produced significant benefits in terms of local employment and economy.[33] 'The Creative Economy' became a priority of both ACE and the British Council, encouraging an entrepreneurial spirit and self-supporting creativity alongside subsidisation.

As the Introduction to this book argues, voices rarely speak entirely 'freely', and in articulating subjectivity must negotiate ideological and economic structures. Under New Labour, state management of cultural space was highly instrumentalist, and seamed with liberal thinking. Indeed, David Edgar, writing in the honeymoon period after the party's

accession, argued for the 'fundamental, practical and urgent' role the Arts might play in the government's 'redefinition of citizenship'.[34] Under New Labour, such citizenship would be endowed through the management of both education and the arts. In state schools, the rights and responsibilities of democratic participation were fostered through the introduction of Citizenship classes from 2002.[35] The new subject taught 'the importance of playing an active role in the democratic and electoral processes' as well as a 'mutual respect, tolerance and understanding for everyone'.[36] Similarly, in the cultural sphere, self-expression seemed to provide opportunity for the empowerment and 'self-actualisation' of previously marginalised or unassimilated groups. Four of the six priorities for Arts Council England (namely 'Taking Part in the Arts'; 'Children and Young People'; 'Vibrant Communities'; and 'Celebrating Diversity') encouraged the active participation of a more diverse citizenry in community activity.[37] In London, the young people's theatre project *Zoop Zoop Hackney* (2007) was part of Local Democracy Week. The Young People's Participatory Theatre Project initiative aimed to introduce 'hard to reach' and 'at risk' young people. Similarly, the Arts Council report *Paving the Way* of 2007 was concerned with the 'engagement and retention' of 'at risk' young people, and stressed that theatre would provide them with 'opportunities to express themselves and make their views known'.[38] In subsidised theatre, specific awards for ethnic minority writers, including the Alfred Fagon Award for playwrights of Caribbean or African descent gave opportunities to previously under represented voices to enter the theatrical establishment. The Royal Court's Unheard Voices scheme was specifically open to 'non-British writers, and theatre practitioners'. As the scheme evolved, it was made specifically for young Muslim writers.[39]

So, on the one hand, New Labour's support for and inclusion of marginalised voices in theatre implied a more inclusive and representative, and less elitist and institutionalised sector. On the other, its policies could be seen as a means to assimilate all voices to mainstream ideological values and practice (as in Bourdieu's view of participation as a means of ensuring assent), as well as to secure 'civil' behaviour. Giddens argues, for example, the importance to civility of 'feeling secure in encounters in public places with individuals we may never see more than once'.[40] Youth theatre, in particular, as the *Social Impact Study of UK Theatre* (2006) comments, 'helps funding agencies achieve their social objectives, such as reductions in youth offending'.[41] As my subsequent chapter on young voices discusses, New Labour's aspiration to empower young voices democratically through self-expression (while failing to

give them the vote) could be seen as the rhetoric of adult concern, and was accompanied by measures to restrict and control young people's access to public space. For ethnic minorities, as I discuss in Chapter 4, the articulation of identities in prestigious mainstream space exerted pressure to conform to the values of mainstream cultural structures which in more general society continued to assume the inferiority or subversive aspects of non-standard – or 'non-white' – voices.

Non-standard voices

The Giddensian ideology of participation, with its ethos of tolerance, diversity and inclusion, by no means swept away residual and culturally engrained ways of ordering or suppressing 'alien', 'inferior' or 'unacceptable' voices. In the education system within which young voices were formed, there may have been greater 'dialect tolerance' on behalf of teachers, but the National Curriculum continued to perpetuate the idea that non-standard English and dialects were deficient.[42] Speaking was marked according to criteria that favoured children who could use standard English when speaking in formal situations.[43] In 1999 Home Secretary David Blunkett allied himself with persistently popular prescriptive attitudes towards language, issuing revised orders for English in the National Curriculum.[44] The orders identified features of non-standard English such as 'they was' and 'ain't' alongside the edict: 'Pupils should be introduced to some of the main features of standard English and be taught to use them'.[45] A new booklet swept aside the contributions of descriptive ideology that had contributed to the original development of the English Orders. The booklet *Not Whether but How* was issued to all schools instructing teachers how to teach 'correct' grammar.[46] The continued suppression of dialect through the enforcement of standard English suggests, as Renate Barsch had argued in the late 1980s, how easily working-class speech or dialect becomes a 'label' or 'burden'. To Barsch, the stigma that speakers of non-standard English suffered provided justification for the enforcement of the 'blessing' of 'neutral' standard English, enabling speakers to be treated as 'what they are and what they want to be as a person'.[47] It is a view that conflicts with more recent sociolinguistic approaches discussed in relation to young people's speech that recognise the inventive and potentially transformative practice of code switching often practiced by non-standard speakers. A quite different approach was taken in Scotland, as I will discuss, where the teaching of Scots dialect through literature encouraged a sense of pride in deviance from English norms.

In spite of the apparent advent of the polycentricism of English in sociolinguistics, and New Labour's emphasis on pluralism, attitudes continued to exist that suggested a privileging of some voices over others. At the same time, new globalised structures were emerging that further complicated attitudes towards regional forms of English. In an article that addressed the international intersections of class, mobility and language, linguist J. K. Chambers predicted in 2000 that within seventy-five years 'national standard languages' would be 'mere abstractions'. 'Global English', he claimed, would become 'a supranational standard' and be 'used by upper-middle-class people everywhere'. By contrast, voices marked by regional forms would remain economically disadvantaged: 'urban localisms will have proliferated to the point where citizens in the lower socioeconomic strata will be instantly identifiable by their accents'.[48] At the same time, the regionalisms of the British voice would become, in Chambers' description, 'homely allegiances – ancient blood ties', acting as a response analogous to the protective measures taken by those voices that perceive themselves as threatened or inferior.[49] Sue Clifford and Angela King's 2006 book *England in Particular: A Celebration of the Commonplace, the Local, the Vernacular and the Distinctive*, seemed to provide evidence to support him. Describing itself as 'a counterblast against loss and uniformity, and a celebration of just some of the distinctive details that cumulatively make England', the 'coffee-table' volume suggests that the nature of Englishness lay in the local specificity of place and language.[50] The authors' clearly marketable approach is in some senses reactionary, locating national pride in regional dialect, and suggesting a sense in which a fixed and essential sense of national identity can be located in vocal sound. Chapter 3 will return to these issues with regard to the Scottish voice where I explore the implications of its specific nature in terms of devolution and Scottish identity, globalisation and commodification.

As the Blair period progressed, and particularly following the bombing of London in 2005, the liberal principles that lay behind the New Labour vision of an equal and inclusive voicescape were increasingly assaulted. As I described near the beginning of this chapter, a major thrust of New Labour's policy was to implement measures that protected and supported the rights and status of groups such as second and third generation immigrants and people of minority sexual orientation. In line with European law, major legislation had been introduced to curb the voices of those inciting religious and race hatred.[51] An ETHNOS report, *The Decline of Britishness* (2005), reflected widespread dissatisfaction with the dominant pluralistic liberal ideologies.[52] Fuelled by fears

of the incursion of foreign terrorists, the public expressed its discontent with increased levels of immigration and moral pluralism, and with policies that were perceived as being biased towards ethnic minorities. A narrative of what Paul Gilroy termed 'endangered whiteness' took hold and was propagated in the press.[53] In 2004, Broadcaster Robert Kilroy-Silk resigned from the BBC after calling Arabs 'suicide bombers' and 'limb amputators'. In the following year a Hull City football fan was convicted for 'indecent' homophobic taunting.[54] In debates over these events and other controversies, the term 'political correctness' came to be widely used to refer to restrictions being placed on freedom of expression. Very often, these debates centred around sensitive issues of multiculturalism and race.[55] The increasingly popular and active British National Party exploited this increased sensitivity, calling on notions of freedom and nationalism in its claim that the abolishment of multi-culturalism would restore 'true freedom of speech to Britain' and hence help to 'rebuild British Democracy'.[56]

In the wake of the July bombings in 2005, a deeply shocking event that had also evoked the spectre of 9/11, public belief in the principles of equality, diversity and pluralism was severely threatened. A shift in the public mood and opinion occurred that was reflected in government policy and discourse. New controls of foreign voices were deemed neces-sary to protect Britishness. The 'Life in the UK' test for all immigrants introduced in 2005 tested language and knowledge of British history and values. The Home Office also moved to impose English language tests on religious leaders.[57] In education, a Review of Citizenship rec-ommended less emphasis on pluralism and more on 'British values'.[58] Moreover, a new preference for terms such as 'cohesion' and 'integra-tion' rather than 'multiculturalism' was reflected in the denouncement of the latter term by Trevor Phillips, chairman of the Commission for Racial Equality.[59] This change of political climate also affected the regu-lation of cultural space. In 2007, a government report *Our Shared Future* had recommended that the Arts Council should include a requirement for 'cohesion and integration' for funding applications.[60] Rather than being celebrated within a climate of diversity, it seemed that the voices of ethnic minorities were to be subsumed into a standard and strictly 'policed' notion of Britishness.[61] As I explore in Chapter 4, it would became necessary for ethnic minority voices to negotiate not only the patronage of theatre's liberal establishment, but also the hostility caused by the perception of the privileging of non-white voices.

In spite of these increasing pressures for a narrower and more regu-lated voicescape, the ideology of liberal diversity largely persisted in the

Arts. Yet even in its largely tolerant spheres, during the 'crisis in liberalism' diagnosed by theatre scholar Helen Freshwater in this period, issues concerning race and religion provoked sensitivities around the increasingly contested notion of free speech. Many voices of various political persuasions united behind comedian Rowan Atkinson's 2004 campaign to preserve artists' freedom from restrictions proposed in a new law to outlaw religious hatred. In 2005, the Arts Council failed to fund a tour of Richard Thomas and Stewart Lee's *Jerry Springer: the Opera* (2003–6) following its controversial broadcast on BBC 2 and a series of protests by offended Christian groups. In 2004, violent protests from sectors of the Sikh community led to the closure of Gurpreet Kaur Bhatti's play *Behzti*. The affair, Freshwater states, seemed to suggest that within liberal society 'mere tolerance of difference is not enough'.[62] Certainly, both the virtue of tolerance and the principle of freedom of speech now seemed problematic, leading to fractiousness and clashes rather than a tolerance and plurality of voices and opinions.

Vocal dystopia

Towards the end of the Blair period, public discourse seemed to present a somewhat dysfunctional version of the rational, consensual 'dialogic democracy' of the kind envisioned by Habermas and endorsed by Giddens. In the Habermasian ideal, democracy should be rational and consensual, free of class interest, basing itself on universal conditions of human understanding discovered through shared knowledge, human trust and accord.[63] Political processes proceed through discourse and the free expression of views rather than violence and the imposition of authority. The philosopher's thinking recalls a series of visions of orally based societies, including Jean-Jacques Rousseau's eighteenth century Romantic vision of a sincere, simple oral society, all of which have raised the relationships between public space and the degree to which it includes all voices.[64] It is unsurprising, given the equally compelling history of corruption and self-interest in political power, that by such measures democracy seems to fall so far short. In spite of New Labour's 'fresh' start, its inclusion of a wider range of voices, and its initiatives to consult, it was the perception of its failure to listen, particularly to public opinion over the second Iraq war, that most seemed to discredit the government. In the Chomskyan tradition of political scepticism, Fairclough contended that New Labour's claim to use dialogue was a matter of presentation, its real behaviour 'univocal' and 'monological'.[65] The presence of political spin came to be regularly interpreted

as a sign of fundamental untrustworthiness and lack of decency. As a climate of distrust set in, the voices of the Labour party were no longer heard as fresh, natural or truthful. Rather, the voices of politicians were perceived by the public as trained, artful and artificial.

As is now abundantly clear the Iraq War was not only Saddam Hussein's nemesis but Tony Blair's. In 2003 it was estimated that a million people participated in a mass demonstration against the war in Iraq in a revival of the kind of mass public protests that had taken place in Britain over the poll tax in the late 1980s.[66] With the 2004 publication of the Hutton report on the government's so-called 'sexing-up' of the September Dossier on Weapons of Mass Destruction in Iraq, the public's scepticism became acute. A sense of betrayal and of anger was focused on the Prime Minister's voice, and a sense, in particular, of its 'performance'.[67] The sincerity previously perceived in Blair's voice became prey to the 'performative paradox' that has been noted by a variety of commentators, including Jonas Barish in his book *The Anti-theatrical Prejudice* (1981).[68] As Scannell explains, once perceived as performed, the conviction of a speaker's sincerity evaporates.[69] As with Goffman's idea of the gap between the speaker's words and her 'true' self, once the voice is perceived as a mere presentation of words distant rather than fused to the self, it appears to disguise the true identity of the speaker.[70] Indeed, once Blair's sincerity was doubted, the Prime Minister's acting abilities, which at the beginning of the period had been seen as an asset, now associated his voice with dishonesty. For theatre scholar Joe Kelleher, Blair's ability to 'perform' in the manner of the 'straightforward guy' amounted to no more than a convenient vote-winning 'impression'. Kelleher argued that Blair's 'internalised' focus and 'struggles with self-examination' were part of New Labour's posture, a con act that was 'all spin and no substance'.[71]

A spate of portrayals of Blair in theatre and TV confirmed the impression that the politician's outward manner masked his malign intent. *New York Times* critic Ben Brantley described Nicholas Farrell's depiction of Blair in David Hare's *Stuff Happens* (2004) 'as a ludicrously lyrical emblem of self-interest'.[72] In 2006, producers Marks and Gran staged the satirical *New Statesman Episode 26: The Blair B'stard Project*, with comedian Rik Mayall as a New Labour Blairite central character defected from the Tories. In the popular imagination, Blair had become 'Bliar'.[73] Highly validated by its public in 1997, by 2007, the Prime Minister's emotive style no longer evoked empathy, nor a belief in its purity of motive. On the occasion of Blair's departure, *The Times* inserted stage directions into his speech and described, with no trace of empathy, but with oodles of irony, how his voice 'trembled' with emotion.[74]

Clearly these matters, to which I return in the following chapter, are crucial not only for politicians but also for actors, for whom the quality of transparency can also be a key means to a convincing performance. Like politicians, many theatre makers are heavily invested in the perception of their processes and spaces as Habermasian, where voices participate freely and openly. Politically, the public's sense of betrayal had grave consequences for the democratic process. As Franklin suggests in *Packaging Politics* (2004), a citizen's own willingness to make their voice heard is a function of the respect they have for the voices of politicians: 'electoral participation [. . .] may falter as respect for political talk diminishes'.[75] By the end of the period the public conviction had grown that the voices of the general public were going unheard. As Blair stole from power in 2007, Gordon Brown made the now perennial promise of a 'listening' government, and a state in which the 'citizen' was in control – a promise that would be made once again in 2010 by the liberal conservative Coalition as the new government struggled to cope with the fall out of the latest expenses scandal.[76] Transparency was confirmed as a precondition of representative democracy, and in spite of the Prime Minister's disgrace, the public continued to expect politicians to uphold it.

2
Giddensian Mediation: Voices in Writing, Representation and Actor Training

In the year of New Labour's victory, 1997, Royal Academy of Dramatic Arts (RADA) trained actor Michael Sheen played Henry V for the Royal Shakespeare Company in Stratford and at the Barbican. His performance was praised by critic Roger Foss for the way the Welshman appeared 'born to speak in iambic pentameters', as well as the way he made Henry appear slightly 'nervous' in taking on his political responsibilities. Rather as Blair's delivery of the news of the Good Friday agreement in 1998 appeared to suggest humility, Sheen gave a performance that sounded like an effortlessly 'natural' rendition of text, but also eschewed the vocal performance of theatricality or privilege.[1] The actor was not the only one to be praised for an apparently unaffected vocal style. In 2004, critic Alan Bird noted the 'simple openhearted honesty' of Ben Whishaw's portrayal of Hamlet at the Old Vic. According to Bird, there were 'no histrionics', the performance realised with 'simple unpretentious ease'.[2]

This cultural preference for an untheatricalised vocal performance of Shakespeare, rather than the declamatory style, for example, used by Laurence Olivier or John Gielgud in the mid to late twentieth century, had equivalences in a favouring of new writing that seemed to be unmediated, whether it be, for example, by writerly excess or by 'dogmatic' authorial intrusion. In 2007, Artistic Directors of aspiring fringe venue Theatre 503, Tim Roseman and Paul Robinson believed that new writing should not be 'dogmatic, preachy or worthy'.[3] For Chris Cooper of Theatre Company Big Brum, 'The age of telling people what to think is dead.'[4] Where the Agitprop characters of the 1970s and 1980s seemed puppet-like mouthpieces of a bolshie, un-cooperative writer, the moral integrity of writing now seemed to depend on the truthful articulation of thought and feeling by characters apparently unmediated through the authorial voice. As in performance, there was an urge to

'transparency', a quality that according to Stephen Lacey is conveyed in social realism, a form that influences many of the writers in the case studies contained in this volume, and which often places emphasis on the accurate reproduction of the outward forms of the voice as well as on the articulation of the experience of voices associated with relatively little cultural privilege.[5]

In theatre practice during the Giddensian period, there was a tendency to think of the representative spaces of theatre and its voices as democratically free spaces of political debate. Such sentiments became particularly acute in the latter stages of the Blair period, and in spite of the instrumentalism practised through the arts as the previous chapter discussed, government rhetoric characterised itself as voice-less, following the arms-length principle of support for the arts. A great deal of theatre rhetoric also devoted itself to the idea of political challenge and democratic debate. At the Bush, according to its Chairman John Shakeshaft, under Josie Rourke's new tenureship as Artistic Director, the theatre would nurture 'the most visceral and potent voices of our era'.[6] At the West Yorkshire Playhouse, literary director Alex Chisholm insisted on theatre's 'present tense', and that theatre is about 'a big question that is ongoing'.[7] Robinson and Roseman called for scripts that were 'fearless', 'searching', 'questioning, 'irreverent', and Lisa Goldman, her own background in political activism, emphasised new work at Soho Theatre as 'exhilarating and dissenting'.[8] This rhetoric – though it somewhat suggests Foucault's insight that in a system of authorship a sense of transgression may be used to restore literature's dangerous and therefore morally attractive qualities – asserts the 'voices' of new writing as making powerful, important and independent contributions to democracy.[9] It is a notion of theatre's role that resonates through the discourse of a range of practitioners, particularly when it comes to the voice. Highly respected voice teacher Cicely Berry emphasises such traditions most powerfully in *Text in Action* (2001), where she insists that the performer's voice is not to be made 'beautiful', but must 'energize the audience', and 'awaken the desire to talk'.[10] Her invocation of a democratic sphere underlines her belief that voices in theatre can awaken attention, engage with the contemporary, and in their relationship with the audience can conjure and stimulate the kind of dialogue important to a democracy, empathetic or otherwise.

By exploring the construction of voice in writing and its training for performance in the context of ideological and industrial concerns this chapter examines in more detail the pressures exerted on individuals to 'have' or 'find' their own voice, and to represent the voices of others.

Practices were subject to an aspiration to make mainstream subsidised theatre representative of a diverse culture in which the voices of the people were apparently unmediated by an authorcentric or excessively literary representative process – a context that seemed to give ground for the inclusion of previously unheard or marginalised voices, and to enable characters to speak in their 'own' voices. Drawing on interviews and workshops with writers and dramaturges, and the writing guides that emerged in the period, the first part of this chapter explores aspects of the writer's voice, surveying procedure and practice of new writing venues the Royal Court, the Soho Theatre and the National Theatre, before addressing aspects of voice training that were shifting according at least partly to Giddensian ideologies.[11] It argues that, a 'listening' practice concerned with the sounds and rhythms of real speech and marginalised voices evolved, demoting the voice of the writer as a literary authority, while the idea of its 'unique' qualities continued to be convenient to the industrial and commercial aspects of theatre production. The chapter turns to the practice and discourse of prominent voice teachers such as Berry, Patsy Rodenburg and Kristin Linklater, whose work with actors was often devoted to the production of transparency in vocal delivery, and to enable actors to articulate truthfully an inner self fully engaged with text or character provided by exterior sources. It explores the extent to which practice was adjusted in the Blair era away from the 'voice beautiful' and RP, in order to accommodate the diverse sounds and experience of an inclusive theatrical voicescape.

The writer's 'voice'

A discussion of the 'writer's voice' must recognise that it is dealing with a highly textured and apparently contradictory concept, resonating both with the qualities of body and speech, with notions of writing and language, and with political and ideological implications. Challenging the notorious binary divide of speech and writing, Barthes' essay, 'From Speech to Writing', describes what he calls the 'voyage of the body (of the subject) through language'. Writing twists and modulates, organises and structures the body – but this body returns, 'indirect, measured, musical' through pleasure.[12] Barthes' emphasis on writing as rhythm and music, a temporal, responsive process that resists the fixing tendencies of image and sign, points to the 'spontaneous', 'transparent' and 'direct' properties often associated with oral communication, rather than its supposed 'deathly' linguistic aspects identified by a great many

cultural and linguistic theorists.[13] In a wider social and cultural context, the apparently 'crystalline' communication of oral communication, as Derrida puts it, of 'a unanimous people united in the self-presence of speech' seems to endow direct, unmediated oral exchange with moral integrity. Such a model lies behind the emphasis on transparency in a political system that relies on the promise of having a 'voice' – an aspiration as this chapter hopes to show that can also exert influence over the types of writing that are programmed in theatre's spaces and how they are made.

The idea that the body is present in and through language also contributes to the difficulty of fully separating a text from the human person who is considered its origin. Somewhat counter to the tendencies in critical thought in the latter part of the twentieth century to de-privilege the biography of the author, the idea of the unique timbre of the writer's voice has remained stubbornly present in the responsive discourse that dramatic text incites. It remains the effort of certain types of critical discourse to become intimate with the writer's person, through close description and analysis, and sensitivity to tonal and rhythmic qualities. It seems commonplace to speak, for example, of the 'wit' of Wilde, the 'furious energy' of Berkoff, the 'cynicism' of Middleton. These qualities of energy and tone are arguably physical aspects of the ways the writer negotiates her identity through the structures of language, questioning, queering and kicking against them as much as being caught in the norms and structures of society. In *The Full Room* (2002), director Dominic Dromgoole identifies not only the form and style of writers, but also their 'human' characteristics such as the 'magnanimity and vigour' of April de Angelis, or the 'compassion' of Jim Cartwright.[14] Although Dromgoole's familiar approach would perhaps be avoided in academic critical practice discouraged by the 'death of the author', his appreciation can be seen as restorative, an individual response that refuses to separate the unique voice of the writer and the tone and style of their work from the particular ways in which these qualities are embodied through literary technique, form or character.

Such interpretative discourse often itself becomes an aspect of the writer's 'voice', setting up an expectation that is based upon the idea of coherence of an individual and the 'body' of work she produces. In this process, the writer's voice can begin to feel separate from the writer's physical person, and as a concept points to a series of lacunae that open between origin and text, presenting both ambiguities and opportunities. The 'writer's voice' becomes an object of discourse or interpretation, or an artistic product that journeys away into the spaces

and spheres of public and privatised exchange. As an object, now tenuously connected to its physical origin, the 'writer's voice' becomes a kind of persona that both is the writer and is also something apart from her, a separate entity that requires an effort to maintain or resist. Whole groups of writers have come to be classified according to aspects of their 'voices', such as the 'Angry Young Men' of the 1950s, or the 'In-Yer-Face' group identified by Sierz. Such designations may of course be taken as evidence of what Barthes calls the 'facile and trivial' use of the 'epithet', with which the artistic subject is constituted, or a means through which writers can be conveniently classified and packaged.[15] Lucy Prebble, who completed the Advanced Playwriting Course at The Royal Court in 2003, describes the idea of 'The Voice' itself as a 'huge weight around the neck of a writer starting out', and 'a concept created by and useful to literary and marketing managers'.[16] Joel Horwood, who was selected as one of the Court's 50 living writers during its 50th anniversary season in 2006, described the 'crippling' effects of 'having a voice', favouring the anonymous basis on which some fringe theatres ran scratch and shorts nights.[17]

'Finding' the voice

Several scholars have discussed the significant increase and professionalisation of the structures and services of literary management in the subsidised sector in the years of the new writing boom in the 1990s and 2000s.[18] Mary Luckhurst, for example, links the contemporary demand for new plays with the breakdown of the idea of a homogenous national identity and the inclusion of 'different (often minority) dramatic voices'.[19] By contrast, Jacqueline Bolton insightfully argues that dramaturgical practice tended to privilege the development of script at the expense of other theatrical vocabularies.[20] Bolton identifies, particularly in relation to the Royal Court under the leadership of Stephen Daldry, a certain convergence in the roles of literary management, selection, programming and marketing.[21] Attending to the production of new writing as cultural and commercial process, this scholarship has established the importance of dramaturgical practice in 'finding' voices, and the subsidising and supportive structures through which writers have often been inducted.

Less discussed are the assumptions made by the ideology and practice of 'finding the voice', a very commonly used and rarely examined phrase that raises questions regarding the relation of the artistic and political individual subject within the demos. In 2005, US academic

and creative writing teacher Peter Elbow pointed to the growing prefer-ence for the term 'voice' in contrast to 'style' in the literature of creative writing and across academic fields.[22] According to Elbow, whose think-ing resonates with Barthes' emphasis on the physical materiality of writing, the writer's voice is found through accessing the unconscious, providing the 'presence' and 'resonance' of the writer's body.[23] The title of Elbow's book, *Everyone Can Write* (2000), links ideologically to the 'democratization of creativity' of the 1960s and 1970s described by Paul Dawson in *Creative Writing and the New Humanities* (2005). Within this progressive pedagogy, which somewhat counters an emphasis in the teaching of humanities on the study of great works by great men (and women), writing is an active and creative means of 'personal growth' and self-knowledge.[24] It is thus an expressive and empowering art aligned to the idea of the 'self-actualising' individual used by Giddens amongst others, and resonates with New Labour's interest in widening access and participation in cultural activity – that is, in order to 'have' a voice, it must first be 'found' through expressive means.

The process of 'finding the voice' was emphasised both in dramaturgi-cal practice, as well as being commonly recommended in many of the self-help writing guides that appeared in the 2000s. At the Soho Theatre, senior reader Dale Heinan's advice to aspiring writers was to strive to write in 'your own' 'original' voice.[25] Often, the similarities in the writing process with the ways (described later in this chapter) that actors have been encouraged to go inside themselves to discover and expel their emotional centre were striking. In *Awaken the Writer Within: Discover How to Release Your Creativity and Find Your True Writer's Voice* (2001), Cathy Birch advised writers that they could 'explore the treasures' of their normally hidden self or 'subconscious' by taking their 'awareness inwards'.[26] Experienced and respected British dramaturge, Noël Greig, who had facilitated the careers of many 'new voices', told writers in his book *Playwriting: A Practical Guide* (2005) that the task of 'finding your own voice' would be fulfilled by delving inside oneself, and by allowing the mind to 'operate intuitively'.[27] Tim Fountain, literary manager of the Bush 1997–2001, encouraged a similar approach in his pragmatic book aimed at aspiring writers, *So You Want to be a Playwright?* (2007): 'An audience wants to hear *your voice*' (original emphasis). A writer must 'look inside' him or herself, Fountain advises, and listen to his or her 'inner voice'.[28] In some of this literature an equation of sincerity with a broad appeal is apparent. Elbow claims that the access of the voice to the inner self would make it more likely to appear truthful, sincere and relevant, that is, to 'fit' its listeners.[29] For Greig, the articulation of

thoughts and feelings are both 'unique' and 'personal' as well as being 'universal'.[30] The writer, says Fountain, who could negotiate a 'truthful' and 'accurate' examination of the inner self would demonstrate a 'universal truth' and have 'universal appeal'.[31]

Amongst those that advocated 'finding the voice', not only did it appear that a reconnaissance of the inner self ethically validates writing, but also that accessing its universal quality would give writing its social pertinence. For writer David Greig, letting 'your unconscious speak' and accessing 'inner truth' enables you to 'speak the unconscious of the society you are writing within' – a view that surely reformulates Bourdieu's ideas on the subject, sedimented with the norms and structures of society.[32] Heinan's workshops showed aspiring writers how to make characters from 'unanswerable questions' that proceeded from painful, complex or insoluble personal or public issues, such as 'Why can't I move on?' or, 'Will the world survive as we know it?' The political relevance of the writer's voice, and its power, according to Heinen, to 'challenge' reality by the dropping of 'ideological bombs' on 'the way we view the world' was located in its depth and honest exploration of the inner life of the writer.[33] At Theatre 503 Roseman and Robinson's idea of political writing was achieved through 'stretching the self'.[34] Their description of the writing process suggested elasticated boundaries to inner and outer space, and the scrutinising of society through the conflation of the private inner self with society. Such ideology of 'finding the voice' through writing thus seems to accord with theories of subjectivity that regard an individual's capacity for agency to lie in her self-articulation rather than oppression through language. In addition, the positioning of individual subjectivity at the centre of experience confers a moral integrity associated with vocal freedom and empowerment (yet which also sits well within an industry within which the writer's voice is a highly marketable product).

Whatever the pressures exerted on writers through marketisation or reputational factors, the democratic ideology of 'finding the voice' helps to contest the idea that political radicalism can be located in the writer's literary virtuosity. This equally powerful tradition, both Romantic and elitist, contrasts to the ideology of 'everyone can write', by suggesting the superior qualities of linguistic expression possessed by the writer, and perpetuated by artists such as Howard Barker who in the 1980s claimed that theatre should be a 'vehicle of complex articulation', and whose highly crafted poetic style fell from favour in the more colloquial sounding 1990s and 2000s, where there was a concern to represent the voices of 'real' people (as I describe below).[35] Nevertheless

its ideology differs from that implied in the position taken by writer David Hare, for whom theatre fulfils its democratic function through an 'in depth, complex way of speaking'. Hare's extolment of the virtues of lecture-like uninterrupted speech in *Obedience, Struggle and Revolt* (2005) seems concerned with the articulation of a writerly authority, rather than with the potential vocal and physical embodiment of the demos.[36] Similarly, for David Edgar, theatre's radicalism lies in its in-depth, subtle and extended discussion of complex ideas.[37] His 'state-of-the nation' play, *Playing with Fire*, which premiered at the National in 2005, makes little attempt to represent the demotic speech of marginalised speakers in spite of its West Yorkshire setting and multicultural themes.[38] For all the undoubted merits of these approaches, the notions of the writer's superior capacities of articulation upon which they rest are poorly attuned with Giddensian principles of inclusion and equality – as with the view expressed in this book that the representation and sounds of diverse and non-standard voices in theatre space can challenge and scrutinise society.[39]

Voice and representation

In some ways, the Habermasian model of dialogic democracy, which lies under the rhetoric of theatre makers in the 2000s, affirms the role of the writer as an instrument and facilitator of debate. Yet it also assumes that a small number of individuals with access to a dialogic sphere legitimately represent the voices of others. In political terms, representative democracy is something of a contradiction in terms, substituting an active participating demos with a class of potentially self-interested professionals.[40] Here there is a point of comparison with the subsidised theatre sector, whose institutionalised circle can seem elitist and hierarchical to those it excludes – and its public funding in particular a justification for such charges.[41] Its system of competitions and awards as well as a 'rhetoric of talent' suggests not only a desire to reward deserts, but also an acquisitive marketplace, absorbing 'new voices' into a structured system of prestige and status.[42] As the 'voice of a generation', Simon Stephens told the elite group of emerging writers at the Royal Court, they were 'gold dust'.[43] For Young Vic Artistic Director David Lan, it was the 'distinct voices' of award winners Fin Kennedy and Neil Duffield that represented the 'value' of their writing.[44] Such praise of writers' voices perhaps detracts attention from their labour, as well as obscuring the economic vicissitudes suffered by 'struggling' artists at grassroots level.[45]

For an individual theatre, new writing and the voices of the writers to which it gives audibility contribute both to the idea of providing a sphere of public debate, but also to the construction of a coherent 'voice' for the theatre as an artistic persona with a distinct creative identity.[46] Artistic Director of the Coventry Belgrade, Hamish Glen, claimed that 'bold, radical and startling' new work would help him 'find a voice for the Belgrade', that was 'distinct and exciting', and above all 'unique'.[47] Similarly, at the Royal Court, literary manager Ruth Little described each individual theatre as having a 'voice' expressing its 'temperament' or 'persona' and connected to 'who it is and what it wants'. For Little, this sense of the theatre's 'voice' is determined by the aims and methods of the Artistic Director as well as the terms of the theatre's public remit and subsidy. The inclusion of new voices fulfilled the theatre's national responsibility to 'amplify certain voices' that 'press the culture forward into new territories'.[48] Like many others, The Royal Court's Artistic Director from 1998 to 2006, Ian Rickson, emphasised challenge and change, telling Sierz, 'Our work has to be radical, progressive and forward-looking'.[49] Yet a 'branding meeting' in 1998 reported by Little and McLaughlin confirmed that inaccessibility, elitism and exclusivity had been perceived as the theatre's negative attributes.[50] Again, a certain tension is suggested here, between the role of democratic challenge and scrutiny, and the perception of theatre's exclusivity, raising the perennial debate around whether theatres succeed in representing a wide cross section of the demos.

Thinking of writers as voices raises further questions of representation beyond the idea of 'finding the voice' as a methodological approach that empowers truthful expression, or the extent to which voices are selected to represent new writing theatres and their ideologies. 'In-Yer-Face' writing seemed to have 'spoken for' a generation – yet it had voiced democratic disengagement, and can perhaps be seen as part of a wider shift in both politics and theatre that anticipated a movement away from representation and towards more interactive and participatory forms. Scholarship has noted not only the burgeoning of new writing from the mid to late 1990s and into the 2000s, but also a diversification of form, an interest in space and sites, and the programming of more devised and digital work.[51] These developments partly derive from the Boyden Report of 2000, which identified a need to 'move beyond' Britain's traditional classical heritage to create a 'dynamic contemporary theatre'.[52] Boyden was concerned to make British theatre more representative, recommending that a new national policy promoted 'cultural diversity in a socially inclusive theatrical culture' and that the 'social base' and 'age

group' of audiences were broadened.[53] Although endorsing the importance of new writing to the health of the sector, the report also noted the narrowing relevance of traditional text-based theatre, and an overall decline in audience numbers.

Boyden's emphases on inclusion and diversity, as in any guidance attached to the provision of public subsidy, raised important questions regarding artistic freedom. There was strong resistance to 'interference', as Andrew Haydon's account of practitioners' hostile response to the Arts Council's 'box-ticking' approach to extending cultural diversity suggests. His view is typical of a tendency in the discourse of both scholars and practitioners to argue that the institutionalisation of dramaturgy from the mid 1990s has been restrictive of writers' creative freedoms and of dramatic experimentation. Haydon ironically capitalises New Writing, describing its development as a 'genre all of its own', which 'marginalized' plays not 'naturalistic, contemporary and set in a very specific (usually underprivileged and urban) social milieu'.[54] His assessment illustrates tensions over who or what new writing should represent and how, as well as the assumption that writing that is realist in approach or that represents the lives of marginalised people is politically conservative. An element of dismissiveness here feeds into certain types of elitism described above that insists on the literary qualities of dramatic dialogue, or the superiority of formal experimentation, underestimating how new realist work can extend and diversify theatre's representative sphere.

As Raymond Williams points out, realism is not a mimetic practice (though it depends on convincing its audiences through accurate representative strategies), but in its extension of the reality represented on stage to a wider and more 'ordinary' class of people is actually 'dynamic'.[55] The production of work that supports the audibility of voices whose sensibilities and consciousnesses are under normal circumstances repressed or sidelined, suggests a change and challenge to the allocation of time, space and resources in the representative sphere itself. In terms of style, it also implies a certain downgrading of the audibility of the writer's unique voice in favour of the apparently transparent representation of the voices of the characters represented. Tracing the strong traditions of realist drama through the new writing of the twentieth century by John Osborne, Harold Pinter, Edward Bond and Jez Butterworth, amongst others, Stephen Lacey makes a powerful argument for the disturbing and challenging effect realism can have on audiences due in part to the *absence* (my emphasis) of the authorial voice – the writer's apparent refusal to interpret or judge her play's action and characters.[56] Rather,

realist writing implies a dialogic practice of engagement with the outside world and the sounds of voices in negotiation with each other.

Michelene Wandor's *The Art of Writing Drama* (2008) is an exception to most of the writing guides in this period in its inclusion of a short section on dialogue. Her reference to Bakhtinian theory in acknowledging what she calls the 'shifting between speech in every day life and its contexts, and speech as represented in writing' implies not that the writer is looking inside herself for inspiration, but that she is shaping characters' voices and their relationships from material heard in external contexts.[57] Such an approach implies writers' processes that suggest not so much the closed off body or isolated psyche of 'finding the voice', but a Bakhtinian intersubjectivity that strongly qualifies an individualistic methodology. Writing conceived as an active and dynamic process can also be discerned in Little's view that the best plays find their 'tension, energy and complexity' in 'complex and chafing relationships' between the self and the wider world.[58] As with the processes of realising the voice for performance that I turn to in the latter part of this chapter, I argue that it is often the practice of 'listening' to others, and to the wider world, rather than the process of introspection through which this is achieved (as well as according politically with the extension of cultural representation that is affectuated through socially realistic dialogue). Another emerging writer Hannah Davies, as well as both Horwood and Prebble, reported that their writing courses emphasised *listening* to 'real' people, and transcribing 'real' dialogue. In addition, an ethical onus that accorded with the egalitarian political spirit of the times was implied by the way Davies was taught that characters would be 'betrayed' by an overbalancing of characters' voices by her own.[59]

In Chapter 1, I discussed how the accession of New Labour brought about a climate in which public voices could be easily invalidated by what were considered the evils of excessive and ostentatious privilege, self-interest or self-display. So in theatre, naturalistic and socially realistic styles that avoided elaborately poetic or literary qualities implied the democratic rights of 'ordinary' citizens, and seemed to allow 'normal' and more diverse voices to be represented and heard. Polemical, or markedly poetic or literary styles were disfavoured. A consciously literary quality was conceived of as theatrical, and therefore held to be specious or pretentious.[60] Such preferences could also be seen in the ways in which 'emerging' writers were encouraged to construct the voices of characters. According to Horwood, a 'poetic' register was unlikely to be validated by an audience, and a 'dialectically authentic' style preferred.[61]

Prebble referred to a desire 'to strip theatre of its literary pretensions' and an abhorrence for the 'affectation' of a consciously constructed 'writerly' voice. Instead, she felt she was encouraged to write in a 'colloquial, or at least truthful and naturalistic' style.[62] Indeed, according to playwright and academic Steve Waters, an 'anti-theatricality' developed, a 'disgust with the rhetoric of fiction', and a desire for 'undressed, unplugged theatre'.[63] Such emphases place an onus of responsibility on the 'authentic' representation of character's voices, whatever the writers' personal backgrounds and experience.

This emphasis on representing the voices of the people implies a responsibility to and negotiation on behalf of the playwright of the way people really speak. It implies a demotion of what might be termed the exterior linguistic and literary features of the writer's voice that is highly problematic to more elitist ideologies of theatre practice. In the 2000s, rather than serving a provocative function through the unique literary voice of the writer, theatre's political role was apparently located within its ability to represent 'normal' voices. This was most apparent in the verbatim movement, which provided practitioners with plentiful opportunities to 'give' voices to real people who enjoyed little cultural audibility, and in so doing scrutinise institutionalised practice of the state and society. In fact, the verbatim movement, with its patchwork techniques of transcripts and interviews, seemed to represent the apex of theatre's claim to be the nation's most inclusive and democratic forum.[64] Acclaimed and successful plays such as *The Colour of Justice* (1999) and *Bloody Sunday* (2005) (both edited by Richard Norton-Taylor), *Guantanamo* (2003) (by Victoria Brittain and Gillian Slovo), and *Talking to Terrorists* (2005) (by Robin Soans) were symptomatic of the engagement of theatre and its audiences in common political dissent and collective moral outrage. For Soans, a chief practitioner in the verbatim movement, the genre allowed the people 'to speak for themselves', and as a direct result of disillusionment with the voices of government became 'the conscience of the nation'.[65]

The claim that verbatim was a response to the lack of transparency in the Blair regime was widely made. To Michael Billington the genre presented 'raw information' rather than 'spin'.[66] Similarly, to Edgar, verbatim 'emerged in a period in which people have no trust'.[67] The discourse surrounding this genre is permeated with the kinds of Giddensian values that the government itself perpetuated, but seemed to fail to live up to. The voices of theatre, in contrast to those of the government, were assumed to speak truly and freely, out of personal sincerity rather than self-interest, and unlike those spun by politics or mediated by the press,

seemed possessed of honesty and integrity. Victoria Brittain, co-'writer' of *Guantanamo*, claimed in fact to have 'no agenda', to absent herself from a process which allowed the 'unmediated' voices of the people to be heard.[68] This apparent transparency was as important as the meticulous care with which practitioners claimed to represent accurately the original voices from which they drew their material. This book argues that feelings of betrayal by the democratic process affected the way theatre makers approached their own representative processes, and by the end of this period, verbatim had become a target for practitioners' politically motivated frustrations. Just as there was a reaction against the values of inclusion and the realistic styles that seemed to best convey diverse voices, there was a backlash, which I return to in the final chapter of this book, against verbatim and its assumptions of a 'true' representative process and ethical transparency.

Reasserting vocal freedoms

Towards the end of the Blair decade, as the narrative of betrayal began to take hold, the impulse to reassert a sense of freedom and independence for theatre's voices became strong. A shift in thinking was occurring, which reflected an anxiety with practices that had come to be associated with government policy and the administration of Blairite ideology. In 2004, the year after Blair took the country into Iraq, Waters described new play development as a 'new cultural interventionism', complaining of the lack of transparency and accountability in the processes of literary management.[69] In the next few years his views were echoed by many practitioners who feared that if theatre appeared too easily to tick the government's 'boxes' the integrity and independence of writers' voices would be compromised. The rhetoric of theatre's freedom and challenge became strong, countering what journalist Paul Taylor saw as 'goody-goody' programming, and a tokenistic and spurious policy of inclusivity.[70] To practitioners, an overly liberal and left wing theatre sector was ultimately oppressive, preventing the proper range of political views from being articulated.

Feelings of discomfort and suspicion grew that the structures of literary management were part of a process of institutionalisation and commodification. At the Writers Guild, Edgar was critical of an overemphasis on dramaturgy and script development.[71] Indeed, Harry Derbyshire's conference paper in Portsmouth in 2007 argued that theatres' writing programmes were a form of closed shop or clique rather than a means of widening access or empowering a range of voices. Theatrical

'breakthroughs', on the other hand, according to Derbyshire, were associated with the 'new, unmediated' and 'unique voice' of the artist.[72] On the same occasion, Michael Bhim claimed that the effect of writing programmes on new writing was to perpetuate a 'comfort zone' and encourage novelty only within certain boundaries. The programmes, Bhim claimed, were overly 'respectful', 'prescriptive', and merely a means for writers to make progress within the industry.[73] His points imply that inclusion produced writing that conformed to a preconceived template, rather than the scrutiny of society that McGrath had envisaged. If Bhim was right, efforts to include new writers through literary management thus curtailed the freedoms of voices by grooming them towards institutionalised forms of articulation. The point is moot. Davies, a graduate of the Royal Court Invitation group, claims she 'never felt groomed', and reports that emerging writers were 'challenged' to disregard 'rules' of 'well-made' plays.[74] Yet her assertion is qualified by National Theatre Senior Reader Ben Jancovich's observation that a writer and/or a theatre may slip into a relationship based on outmoded expectations of each other even without knowing that they were doing so.[75]

Theatre makers were anxious to demonstrate their independence from liberal ideology. Speaking on Radio Four in 2007, Hytner lamented the lack of a 'mischievous right-wing play', an act that according to Jancovich caused the National to be 'deluged' with scripts claiming to fit this description.[76] A series of Platform events staged short new works by writers such as Richard Bean and Prebble, which were designed to pose dissenting right wing ideologies. The plays were followed by audience debates asking 'Is a Multi-faith Society Desirable?' and 'Should Further Immigration be Allowed?' These events engineered theatre as a Habermasian space of democratic citizenry freer, more liberal, and apparently more 'offensive' than the allegedly prescriptive or 'politically correct' values that regulated voicescapes outside theatre, and which comedian Rowan Atkinson's 2004 campaign to exempt artistic voices from legislation outlawing religious hatred had tried to protect. When Gurpeet Kaur Bhatti's *Behzti* (2004) was closed after protests by members of the local Sikh community at Birmingham Repertory prominent members of the liberal arts establishment rushed to condemn the decision. Their emphasis was a defence of the freedoms of writers and of theatre, rather perhaps than a concern with the potential of nonstandard and little heard voices to provide democratic scrutiny and extend the representational sphere.[77]

Broadly, as with verbatim, towards the end of the period there was a reaction against the naturalistic and 'normal' styles that are so often

associated with the voices of the marginalised. Indeed, Mark Ravenhill suggested that the preference in subsidised theatre for socially realistic plays was explained by a desire to demonstrate it was 'earning the keep it gets from our taxes'.[78] At the 2007 'Between Fact and Fiction' conference, discussion largely favoured the imaginative and metaphorical 'truth' to which some delegates believed the writer's voice had access over the documentary 'truth' scripted by the verbatim theatre of the 1990s and 2000s.[79] There was a chorus of calls for the return of practice that reinstated the centrality and importance of the writer's voice, and these were echoed elsewhere in discourses around writing and the writer's role. Billington's *Sate of the Nation* (2007), for example, asserted that it was the 'individual dramatist' in his or her 'truculent solitude' – rather than people speaking for themselves – who helped us to understand ourselves and the world.[80]

In fact, new kinds of collaborative practice were emerging, which implied further shifts in the role of the writer and her voice, and a new Bakhtinian polyvocality that included not only dramaturges, but a host of theatre practitioners. While they did not necessarily aim to be socially realistic, such forms could blend the 'ordinary' voices of a range of characters with a wide variety of theatrical techniques. Anthony Neilson's *The Wonderful World of Dissocia* (2004) included sophisticated sound, music and light design by Nick Powell and Chahine Yavroyan, texturing its protagonist's down-to-earth Northern vocal delivery with suggestions of her disturbed mental state. The National developed *War Horse* (2007), the story of a Devonshire teenage boy and his horse, in which the writer produced script in conjunction with a large creative team of puppeteers, choreographers and other types of practitioners. Gregory Burke's *Black Watch* (2007), to whose voices I attend in the following chapter, blended the 'authentic' tones of Scottish working-class soldiers with the choreography of Stephen Hoggett and music of Davey Anderson under the banner of the National Theatre of Scotland (NTS). These developments suggest the merging of voices and theatrical languages, verbal and non-verbal, and a shifting in theatre space of the 'sensible' in which 'voices' of practitioners are mutually mediated as part of the collaborative process.

The actor's voice

As Berry's investment in stimulating discussion in the audience through the voice implies, voice teachers, every bit as much as other practitioners, share an interest in protecting theatre as a vibrant space of

political freedom and dialogue. They too adjusted practice in the Giddensian period, and in the shifting voicescapes of the late 1990s and early 2000s work in theatre reflected cultural change through adjustments in traditional practices that already negotiated complex terrain. Practice had developed over the twentieth century that balanced the creative interpretation of the performer, a duty to the text, and the needs of the audience. The surge in new writing called upon actors to embody and mediate the experiences and identities of previously marginalised or stigmatised groups and individuals, a development that de-emphasised the role of fine articulation and tone, and in particular disturbed the role of RP as the industry norm. Adjusting their practice to ensure the audibility and accurate representation of the sounds and dialects of these diverse voices would throw up new ideological contradictions and practical difficulties for actors and their teachers.

Articulating ideology

Elsie Fogerty's founding of the Royal Central School of Speech and Drama (Central) in 1906, had established a focus in training the actor's voice on articulation, diction and elocution, the apparently external and mechanical features of the voice.[81] Early definitions of 'articulation', which the *OED* traces back to the fifteenth century, are to do with distinct movement, segmented joints, the separation of one part from another. This aspect of voice training is physical, mechanistic, concerned with tongue, teeth and the control of airflow. It is about getting the distinct parts of the vocal and respirational apparatus to move with precision and intent. Such work is likely to cause changes in the way voices sound, modifying vowels and defining consonants, rather than respecting 'original' sounds of individual voices. One of the most important applications of voice work, especially before the widespread use of sound amplification, was to enable it to be heard clearly in large public spaces. According to Berry, voices need to use more fricative consonants in larger spaces (Figure 2.1). This exerts great pressure towards vocal homogeneity, (and suggests that studios or sound amplification give better opportunities for non standard voices to be audible). Where certain accents might blend or blur vowel sounds, or de-emphasise certain consonants, work on articulation for the purpose of clarity will tend to encourage the precise enunciation of individual sounds according to standardised or agreed norms.

During the mid twentieth century, the now apparently obsolescent 'voice beautiful', as practised by actors such as Laurence Olivier or John Gielgud, dominated acting spaces. This was a highly articulated

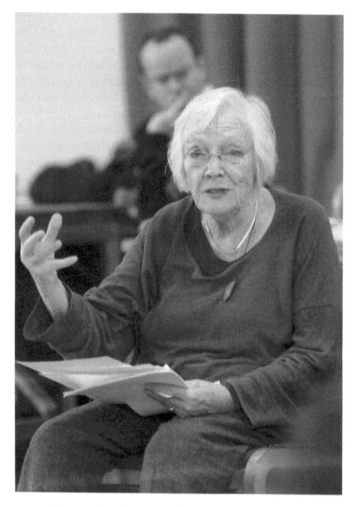

Figure 2.1 Cicely Berry in rehearsal at the Royal Shakespeare Company

and resonant performance voice that made use of a heightened and aestheticised version of RP; in recent times it has been associated with a pretentious and mannered acting tradition that dovetails the training of the actor's voice with notions of the superior cultural status of literary language. Its most well known proponent, Clifford Turner, was famous for the inculcation in generations of actors of the 'RADA voice'. Turner worked at RADA in the 1940s and 1950s, training regional accents out of such actors as Peter O'Toole and Derek Smith.[82] Unsurprisingly,

Turner focused on the enunciation of classic literature, using Tennyson, Whitman, Masefield and Congreve, teaching actors to speak these texts musically. It was a predilection shared with other influential voice teachers throughout the twentieth century, including Berry (although her later twentieth-century teaching texts included extracts from writers such as Caryl Churchill, Sarah Kane and David Mamet).[83] Such practice, to director Peter Gill in 2007, associated the 'voice beautiful' with 'textual supremacy' and with 'class', 'style' and 'artificiality'.[84] Yet the longevity and persistence of the practices it developed, particularly in training the actor in clarity and resonance, are implied by the six reprints of Turner's *Voice and Speech in the Theatre* from 1950, the last of which took place as late as 2007.[85]

By the later decades of the twentieth century, not only had the 'voice beautiful' started to signal an actor's delusions of grandeur, an acute anxiety developed in the industry around the use of RP, an accent previously regarded by many as 'neutral'. On the one hand, the clarity with which RP was associated justified its use as an industry norm for enhancing vocal audibility. Yet, as the values that regulated voicescapes shifted under New Labour towards polycentricity and the levelling of class distinction, the historical associations of the RP accent with the English court, public school, English literature and with homogenised speech, seemed to contradict the dominant political values of equality, diversity and tolerance.[86] Voice teacher Sally Grace, a student at Central in the 1950s, and speaking there in 2000, lamented a world of 'reverse standards' where RP had 'lost its identity', yet she also pointed out the continued 'rife' perception of a non-RP speaker's social inferiority. Grace recalled a time when the disallowance of regional or non-standard accents from the speaking of Shakespeare was in some sense a refusal of the 'right' to speak.[87] Her claim supports the idea of theatre as a space of vocal privilege from which the majority were made to feel, like practitioner Steven Berkoff, that theatre was 'not reaaahlly' for the likes of him.[88] In her 2001 book, *Text in Action*, Berry disapproved of the tendency for the use of RP as a 'universal' accent. In drama schools, 'speech', according to Grace, had come to be seen as synonymous with 'phonetics', and with its associations with RP, a 'dirty word'.[89] An ethical ambiguity developed around the teaching of RP, which came to be seen as an interference with the speaker's 'natural' or 'original' voice. Rodenburg claimed that the imposition of RP was 'systematically to attack' the speaker's 'natural' pattern of sound. The practice, she wrote, was leading actors to sound 'disconnected and false', was 'morally wrong' and 'artistically unsound'.[90]

In fact, a highly mannered delivery was not only associated with an unfashionable sense of cultural privilege, it also seemed to conflict with the importance placed on transparency in vocal delivery in this period. In 1997 Canadian voice coach Kate Lynch referred to a 'fear of the "voice beautiful", the big phony "actor" voice'.[91] Similarly, Gill objected to the 'bombast' and 'phoniness' of the same tradition.[92] These moral reactions to what is perceived as vocal theatricality are part of a bigger tradition that has often been the focus of critical and cultural thought. Joseph R. Roach's book, *The Player's Passion* (1985) demonstrates at length the immense and longstanding anxiety concerning the perception by audiences of technique, training and rehearsal.[93] Similarly, Barish traces a demand for spontaneity and transparency back to Plato's hostility to impersonation. Barish describes the modern pressure to realise a 'true' version of the self through the appearance of continuity between 'inner impulse and outer action'.[94] As with politicians, this continuity was essential for the preservation of an actor's vocal credibility around the turn of the twenty-first century. According to influential director of the period Declan Donnellan, in his book, *The Actor and the Target* (2002), 'visible' evidence of an actor's vocal adeptness in the theatre would work against its credibility. Research and rehearsal, he wrote, must be 'invisible'.[95] Claiming that 'the greatest performances are seldom noticed', David Mamet counselled the actor to leave 'crocodile tears' to politicians, avoid emotional 'manipulation', and not to 'exhort' a reaction from the audience in *True and False* (1998).[96] Ironically, Mamet's advice accords precisely with the performance of intimate or 'natural' speech that was manipulated, as illustrated in Chapter 1, by the most prominent politician of the period.

Sounding 'natural'

If the literary heightening of the actor's voice seems to suggest vocal training that reinforces pre-existing cultural privileging, there is a quite different and very long tradition in voice training that emphasises individual freedom. As with the idea in writing that 'finds' the voice in the inner self or unconscious, a combination of respiratory and imaginative training can take an actor inside herself to the source of her creative bodily energies. Influential director Peter Brook had stated in his foreword to Berry's highly regarded book *Voice and the Actor* (1973), that an actor's 'natural instinct' is 'crippled', 'conditioned' and 'warped' by society.[97] Invoking the rhetoric of the civil rights movement, Brook claimed that voice teaching should be concerned with 'how to permit' the individual to assert their freedom by rejecting and jettisoning the

blockages imposed by society. Similarly, the psychophysical practice of voice teacher Linklater developed in the 1970s and subsequently influential in the 1990s and 2000s, was concerned primarily with 'freeing the voice'. Linklater claimed the natural voice is 'transparent' and reveals 'inner impulses of emotion and thought, directly and spontaneously'.[98] Linklater's methods allow the actors to 'delve' into the unconscious, 'connecting' with the physically and psychologically 'centred' expression of the actor's emotions and experiences.[99]

An emphasis on the inner resources of the performer's mind and body as the source of vocal expression accords with the idea that the voice expresses an individual subjectivity whose source is the body. When an actor is called upon to speak the words of another however, the perplexing issue of the plurality of theatre's voices is raised. The traditionally hierarchical relationship between performance and text implies a problematic intervention into the actor's subjectivity by the language of the writer. This was a conflict that had been recognised back in the 1930s by Roman Jakobson and other members of the Prague school who had stressed that the performer's duty, over and above the 'design' she constructed, was to the writer's words.[100] Voice teachers in the later twentieth century developed practice that implied greater equality between writer and performer (in fact some critics argued that overturned the hierarchy), and allowed the source of the actor's words to appear to spring from her own body.[101] This involved a process of physical and psychological merging. The 'connection' takes place, says Grace in 2000, 'deep, deep, deep, somewhere in, in here (She places her hand in her abdomen)'.[102] For Linklater, such processes ensure that textual interpretation is not 'imposed from the outside', but 'released from within'.[103] In her psychophysical techniques, sounds and words are transferred into emotions by the use of images or movements, by means of the actor's imagination, experience and senses. Indeed, the subtitle of the 2006 new edition of Linklater's *Freeing the Natural Voice* is 'Imagery and Art in the Practice of Voice and Language'.[104]

Such processes were designed to enable actors to realise text with reference to their own bodies and imagination, in so doing permitting their own experiences, expressed through their voices, equal or perhaps superior importance to the writer's words. Above, I suggested the difficulties with assuming that the writer's self can expand to represent the experience of identities that are very 'other' from her own. These objections apply to the processes of voice training too, which assume that actors will be able to imagine the identity of a character that has either apparently emerged from the writer's unconscious, or whose

voice has been heard in real dialogue. As Elin Diamond has pointed out, such processes are essentially interpretative.[105] The absorption of text by actors may subject the text itself to a further fixed and limited interpretation of a single individual, potentially simplifying the voices of both writer and character. The process of internalising and centralising text also raises the issue of the 'naturalisation' of assumptions regarding social relations. Writing in *New Theatre Quarterly* in 1996 Sarah Werner claimed that the practices of voice teaching result in the subjection of actors to ideas fixed in culturally venerated texts.[106] This was countered in a joint article by Berry, Rodenberg and Linklater the following year with arguments that the text can enter, expand, unlock and unleash the dormant potentialities of the inner self, and that it can be freeing, nurturing and challenging in its action. As such, text can be perceived as neither intruder nor oppressor, but as a 'natural' or 'organic' substance, creating a culturally empowering and life enhancing experience.[107]

Admittedly, these are assumptions that have been influenced by Reithian attitudes about the value of literary text. Yet perhaps the 'naturalisation' process also encourages Bakhtinian and dialogic relationships between voices of performers and writers, bypassing the opposition emphasised in performance and cultural theory between the authority of the text and the authenticity of the actor's personal experiences and creativity. It is also as well to remember the insights of Butler and others into the ways that an individual negotiates between social norms that may be carried through language and a new context that allows her to assert independence and transform identity. The idea that text is not constricting but liberating, that it opens up and presents new worlds of experience, and that its articulation allows the intense expression of feelings not permitted elsewhere by society, suggests that the speaking of literary and dramatic text makes possible the representation of otherwise illegitimate experience. Contemporary writing in particular, rather than the literary classics with their associations of cultural superiority, especially where it aims to articulate the speaker's own ways of speaking, allows dramatic dialogue to become an agent of political resistance or challenge, and a key means for stigmatised voices to become audible.[108]

A further potentially problematic issue however comes from the tendency to authenticate the voice of a character through its 'exterior' sounds. This encourages actors to construct vocal performance according to presumptions that relate vocal sound to 'natural' aspects of a character's identity such as region, age, race or gender (links that are discussed in specific cases in the subsequent case studies). This can be a particularly sticky issue with social realism, or with dialogue that represents non-standard

voices. Many practising voice coaches of the late twentieth and early twenty-first century were themselves taught by Joan Washington who was widely employed in the theatre and film industry in the 1990s and 2000s. Washington believed in the links between voice and features of the social and physical environment, including landscape. Her approach suggests the voice is a personal record, a historical and physiological palimpsest that reveals a character's physical journey through life. It is an approach followed, for example, by Rodenburg, in the much-used *The Actor Speaks* (1997), where Rodenburg advocates linking accent, class and physical posture. The approach demands meticulous research by actors into the context from which the voices of their characters emerge, and the embodiment of these exterior and social conditions into the voice and body of the actor. The idea is articulated in David Greig's play, *Pyrenees* (2005), where the main female character, Anna, an ex-actress, has been told by a voice coach in accents that 'people carry a landscape in their voice'. In Glasgow, she says, people speak with their 'heads down', and from 'the back of their throat' as it is 'always raining'.[109] Anna's remarks appear to give biological grounds for the sociolinguistic link between regional origin and vocal characteristics. The danger of this, to recall Bourdieu's linkage of a speaker's linguistic resources with their cultural capital, is that accent and dialect are made to correspond to a fixed class or regional station that might impede or enhance the speaker's social mobility. Assumptions that link identity to class and region through the voice are problematic, implying that 'neutral' accents somehow express an identity freer than those attached to local conditions. Processes that compound the vocal with the local, while motivated by respect for the 'authentic' features of a socially real voice, can fulfil preconceived or fixed expectations of sounds of voices within social and cultural spaces.

Thinking of the 'real' rather than the 'represented' world for a moment however makes it possible to hear the voice as a dynamic technology of self-articulation, certainly in socioeconomic terms. Whether we think of the voice as physically connecting an individual to a regional or racial environment or origin, or negotiating more abstract social and economic structures, there is little doubt that vocal ability, be it in the 'gift of the gab' or in a 'good ear' for the society and people around them, can be culturally advantageous. The extraordinary ability to code-switch displayed by second and third generation immigrants, or the actor's skill in mastering a variety of voices is a lubricant of social mobility. For many actors, the voice is both tool and ware of commercially oriented work such as voiceovers and commercials, providing a

welcome stream of income to many performers. At the upper end of the career structure such work can bring huge professional fees. For all the importance placed by voice teachers on the ethical aspects of representing non-standard voices authentically, the pragmatics of the industry and such commercial considerations are evident. In *The Actor Speaks*, Rodenburg advises actors to master as many accents as possible. Of course, the pressures exerted by such commercial work, and the short amount of time available to master accents well, potentially compromises the meticulous and careful techniques she advises. Accent work can become a broad brush, as accents are linked to broad cultural perceptions of the speaker's characteristics that help casting directors to match actor's vocal features to the product for which voices are required.[110] Such casting can play into crude and stereotyped perceptions that an actor may be concerned to combat during the privileged time and space of extended theatre performance.

Sounding dynamic

As with an over concern with the 'finding' the voice in writing, practices that turn the performer inwards may impose a dangerously limiting set of personal experiences and attitudes on the representation of a voice and identity that is other. Indeed, in the context of both voice and actor training, processes that focus on finding the voice are supplemented and modified by other approaches that counter such introspective activities and suggest a dynamic self engaged in social action. Rehearsals in drama schools and within the theatre industry, which usually succeed the general work on strengthening and training of the voice, shift the focus of voice construction towards motivation, action and social interaction. For Donnellan, the voice is 'a tool for doing things', and through vocal action, 'state' becomes 'direction'. His guide to acting, *The Actor and the Target* (2002) encourages the actor to construct the voice dynamically and transitively.[111] Similarly, 'You don't need portrayal, you need *action*', says Mamet, an emphasis that expresses his desire to avoid the conditions of stasis: 'A person with an objective' is '*alive*'.[112] Such formulae emphasise the dynamic possibilities of the voice and are suggestive of the speech act theories of J. L. Austin and John Searle, and of the performative identities that were suggested in critical thought in the latter parts of the twentieth century. Berry's *Text in Action* is bursting with ideas that physicalise text, allowing actors to play intentions and motivations that spring from the imagined desires or will of the character.[113] As Eastern influenced practitioner Phillip B. Zarrilli was aware, the 'recessive' tendencies of self-reflexive or internalised approach to respiration,

the mind, the feelings and the body that have been commonly used in conservatoire training require countering. Zarrilli encourages the use of martial arts to provide an outward direction and 'encounter' between the inner self and the outer world.[114]

Further issues concerning the degree of agency and dynamism in the relationship between individual and society come out of a consideration of the physical and phenomenological nature of vocal interaction. As a penetrative phenomenon the voice is a physical *intra* – vention into the body of another, helping to form, as Dolar puts it, 'the texture of the social.'[115] Not only can we hear our own voice as it passes outside our bodies, its sounds and rhythms pass in and out of other bodies. For Ong, the phenomenology of orality is essentially inclusive: 'sound incorporates', uniting human beings in 'close-knit groups'.[116] He omits discussion that oral society may construct and impose its own rigid internal rules, or exclude voices that sound 'other'. As with language the sonic qualities of the voice have potential to subjugate the listener through the imposition of authoritarian, conventional or coercive social structures.[117] Yet it is not a passive nor naive listening that voice teaching claims to encourage. In the opening paragraph of *Text in Action*, Berry speaks of the necessity of 'being open' to 'sound and sense'.[118] She advises that an actor must 'hear' the words as they are spoken so that they are 'discovered' afresh, an approach that seems to allow meaningful and live interaction between the performer's vocal and aural senses and the language he or she speaks.[119] In many of Berry's exercises, actors are urged to speak aloud, and to listen to the sound that passes to the exterior as a form of discovery. A conscious practice of attentiveness encourages a sharpened sensibility to sound and difference in both actors and audiences. Text, as voice teacher Joe Windley also suggests, becomes an 'experience', or 'encounter'.[120] This attentiveness is not only a creative and active process in the performer, but extends to the audience, who become co-creators, making possible the conditions to apprehend the physical beings of others.[121] The listening practice of voice teaching, in accordance with a model of theatre space that is dialogic and democratic, claims to make possible an encounter with something other, an experience that is both shared and that can be new, even within a potentially homogenising oral community.

Performing voices in the shifting voicescape

I do not wish to deny however the utopic strains in the practice of voice teaching. In *Freeing Shakespeare's Voice* (1992), for example Linklater

attributes the populace near psychic communicative competence in their ability to receive 'sensorially' the 'thought content' of others: 'We can picture the speaker's body as all mouth and the listener's body as all ear'.[122] Cultural historian Eric Havelock describes oral society similarly: 'a performance of the person's mouth, addressing another person's ear and hearing with his own personal ear the spontaneous personal reply'.[123] These models not only remove the possibility of what Bakhtin calls the 'reaccentuation' of meaning in the process of listening – the gap between what a speaker tries to say and what is heard or interpreted – they also embody a completely transparent and intensely intimate public sphere where meaning is conveyed immediately and directly between interlocutors.[124] In political terms a society based on ethically transparent oral communication is a historically recurrent ideal that appears to sidestep the flaws of a representative system. As this book demonstrates, it is a model that relies on the transparency that both actors and politicians rehearsed during New Labour's Giddensian period. At the time of Sheen's performance of Henry V, described in the opening of this chapter, the RSC voice coach was Berry, whose work with actors aimed to unite the expression of inner instinct and emotion with the exterior textures of dramatic and literary dialogue. Whishaw, another acclaimed actor of 2004 graduated from RADA, where the voice teaching was led by Ellen Newman. Close colleague of Rodenburg, Newman had in 2002 delivered RADA's commercial workshops for elected members and council officers, teaching their participants to achieve 'honesty of voice' through respirational control and expressing a sense of emotional conviction.[125] The training of both actors' and politicians' voices fostered the 'transparency' that won public validation in both theatrical spaces and political spheres.

Such 'naturalistic' or 'transparent' styles also tended to be financially lucrative. Many actors expected to become economically dependent on screen acting, and in the 2000s, modules dealing with television and film, often designed in conjunction with the industries associated with these media, became important components of the curriculum in drama colleges.[126] Such courses taught a much 'smaller' type of vocal delivery, and compounded the growing conviction that the 'truth' of the inner self must be delivered in an intimate style. Voice teacher Joanna Weir Ouston wrote in 2007 that the growing tendency for many students to remain in 'a zone of their own sound' derived from the desire from casting directors for actors to sound 'natural'.[127] Such was the strength of belief in the link between such 'natural' delivery and the authenticity of the voice that at the plenary discussion at the 2007

William Poel verse speaking workshop at the National Theatre, young actors expressed concern that the structure of the verse and the size of the space had an adverse effect on the 'truthfulness' of vocal delivery.[128] In the same period the dominance of the untheatricalised 'natural' voice was furthered by the increasingly common use of technological enhancement in mainstream commercial and subsidised theatre. In 1997, at the National, Trevor Nunn installed a system of microphones in the Olivier to improve audibility. In spite of the 'dismay' that the *Telegraph*'s Oliver Pritchett reported this caused amongst 'theatrical circles', during the subsequent decade the use of individual radio microphones became widespread.[129] As I discuss further in Chapter 3, during the National Theatre of Scotland's 2007–8 production of *Black Watch*, individual microphones enabled the actors to project their characters' colloquial and heavily accented Scottish voices into large auditoria.[130] While it is possible to argue with Paddy Scannell that the use of sound amplification gives access to non-standard or 'normal' voices to public space, the practice seems somewhat to undermine the part believed to be played by heightened breathing and vocal resonance in conveying embodied feeling and the powers of the transformative imagination.[131] Ironically, company voice teacher on *Black Watch* was Ros Steen, whose work, which I discuss further below, aimed to vibrate the text through the body of the performer, connecting it with the 'creative energies and impulses of the actor', and, through these vibrations to the bodies of the listener.[132] The use of microphones suggests rather the diminishment of the degree of physical effort in producing such bodily vibrations, certainly changing and arguably lessening the nature of physical communion between actors and audience.[133]

Regardless of these developments in the industry, many theatre practitioners continued to be concerned with the delivery of text to a live audience. In 2007, National Theatre voice teacher Jeanette Nelson continued to emphasise 'throwing' the voice to every seat in the auditorium of the Olivier, in spite of the microphones embedded in its boards.[134] Persistent complaints were made by teachers of voice, often targeted at the young, that the ability to deliver speech in large public spaces was on the decline.[135] To start its proceedings, the 2000 conference on voice for industry professionals at Central chose Berry's claim that the 'understated' way in which actors who had done 'a good deal of television and film' tended to deliver their lines could work against them when speaking 'heightened or poetic text'.[136] Her concerns echo through a variety of comments made about public speech in the period and beyond.[137] In 2008, Royal Shakespeare Company founder Sir Peter

Hall, bemoaning the influence of careers in TV and film, and the con-temporary belief that a 'quiet' delivery is 'realistic', called for an end to 'mumbling' by actors under the age of forty.[138] From the 1990s however, RP's position as an industry norm was significantly challenged. There was in practice, in spite of the above complaints, more willingness to tolerate and indeed engage with newer, and quickly evolving accents that in previous eras were seen as unfit for theatrical purpose. Such developments were in line with the Giddensian ethos that linked toler-ance and diversity. They implied a giving or softening of standards of what was considered to be clearly articulated speech. Yet such shifts also elicited anxieties regarding the relative cultural audibility of young and adult voices, as my discussion of voice teachers' attitudes towards young people's use of the 'urban voice' in Chapter 5 will argue.

It is easy to dismiss preoccupations with articulation as the peren-nial concerns of theatre practitioners protective of their own interests. It seems more generous to refer to the phenomenological frameworks that allow us to think of the transformative properties of voice in a theatre auditorium. Regardless of the dangers of homogeneity or the semiotic readings that may be generated by elocutionary practice, the heightened act of articulation is also a part of the physical effort exerted by actors in training the voice to speak in public. Actors' voices must of necessity be articulated to be audible, and it is in these acts of breaking up and putting back together, that transformation occurs – especially when an actor creates a character whose voice, in terms of its sounds and rhythms, is markedly different from their own. Using the voice to create accent, as the mapping of neural activity of voice artists testifies, is not just a technical but also an imaginative procedure.[139] Perhaps this is partly what Rodenburg alludes to in her advocacy of vocal projection in *The Actor Speaks*, where she claims the 'imaginative vocal transforma-tion' of the actor delivers a performance 'beyond' the text to a place where the 'truth' is 'large and extreme'.[140] The challenge to actors and their voice teachers in this period was in balancing the demands of cre-ating diverse authentic-sounding voices that used non-standard accents and dialects with a performance style that also achieved the heightened imaginative transformation deemed necessary to embody the identities of their speakers.

Broadly speaking, in the late 1990s and 2000s there were conflict-ing tendencies in theatre's voicescapes, which can be discerned in the discourse surrounding production and programming. Playwright Bean, in the light of the failure of his play, *Under the Whaleback* (2003), to transfer to the West End, pointed to the assumptions of theatre

producers that audiences prefer 'witty lines delivered by Ralph Fiennes' to hearing 'five tattooed Hull trawler-men dying'.[141] Programming decisions elsewhere suggested that voicescapes were becoming more diverse and tolerant of difference. Tanika Gupta's reworking of Harold Brighouse's *Hobson's Choice* (2003) at the Young Vic, allowed Asian accents to inhabit and modify the play's Salford dialogue, tingeing the familiar sounds of a 'white' British form with contemporary regional Asian voices. Tim Supple's extraordinarily successful 2006–8 touring production of A *Midsummer's Night Dream* went further: actors were not expected to conform to a standardised or literary style of speaking Shakespeare, but used a variety of Indian and Sri Lankan accents and languages.

In conservatoire training, there were clear signs that new skills required by vocal diversity were being seriously addressed. At Central, for example, a component on International and British accents other than RP was added to its MA Voice Studies.[142] Such new courses addressed the need for actors to approach sensitively the diverse ways of speaking English and the new skills and sounds that were needed to embody authentically the range of characters produced in new writing. As theatre became what Marvin Carlson has called 'a newly interdependent world that speaks with many different voices' however, it became more difficult to assume that the assumptions made by an actor regarding the style and delivery of a character's voice would be received by audience members according to the values intended in its construction.[143] At the same time, the very fact that voices might sound increasingly different, and speak from ever more diverse places, exerted a pressure to ensure that voices were empathetic or accessible to all audience members. Arguably, this threw more emphasis on 'universal' aspects of the voice that were neither linguistic nor phonetic.[144]

In voice practice, heightening 'universal' emotion through sound can be a way of combating the potential alienation that non-standard or foreign voices might encounter. In the Traverse production of Greig's *Damascus* (2007), a play that itself addresses the limitations and possibilities of communication (as I explore further in Chapter 3), several British trained actors were required to play a mixture of Arab, Scottish and Eastern European characters. Company voice teacher Ros Steen aimed for a powerful emission of the performer's energies within a set of universal categories to describe vocal sound, such as 'high male' or 'deep female'.[145] It may be that Steen's categories, while appearing to be tolerant of vocal diversity, implied a set of conventional notions in particular regarding gender and race. It is hard to judge whether the

pride and arrogance in actor Alex Elliott's portrayal of Arab professor Wasim was a product of the actor's own notions of Arab men, or the result of his compelling imaginative engagement with the character.[146] The play, as Greig stated, had not aimed to achieve social realism: his Arabian characters were of the 'imagination'.[147] His comment points to the ethical tensions between artistic licence and convincing and accurate portrayal in the articulation of identities that are 'other'.

In the socially realistic vocal styles that many writers often chose in this period to present the experience of marginalised characters, actors often received validation for their performances according to their capacity to sound both authentic and emotionally engaged. The voice of Guildhall graduate Lennie James, for example, in Roy Williams' *Fallout* (2003), skilfully articulated the very specific dialect and language with which Williams chose to reflect his character's origins in a South London council estate, while also giving a sense of emotional interpretation through the 'righteous anger' with which he performed the part of the struggling black policeman.[148] James' performance thus balanced an act of imaginative transformation with expectations of authenticity and social reality. Despite the caveats I have outlined above, I believe that the interpretative and transformative processes of emotional embodiment are a means through which a performer can intervene in the contract of reality and empathy that imply conservative or fixed versions of realistically represented voices. As the following case studies will show, skilful negotiation in vocal construction and delivery contribute to an artistic palate of techniques that can be used to articulate political and social challenge and scrutiny as practitioners embody and express the marginalised identities of the demos. Such negotiations, as the following chapter discusses, would be particularly complex for Scottish writers and performers given the defining moment of the nation's history that devolution implied.

3
Migration and Materialism: David Greig, Gregory Burke and Sounding Scottish in Post-devolutionary Voicescapes

The opening of a new Scottish Parliament following devolution in 1998 focused a re-articulation of Scotland's place and position with regard to the United Kingdom and beyond. An already existing inclination to use the poetry of eighteenth-century Ayrshire poet Robert Burns to voice a uniquely Scottish sounding identity served for this critical moment of national self-interpellation. To some, the tendency had caricatured Scottish rustic life with 'pathos, whimsicality, sentimentality, nostalgia or dialect humour', but in 1999 the singing of the poet's 'A Man's A Man for a' That' at the opening of Parliament seemed to condense, unite and channel a disparate national identity performed through an act of vocal solidarity.[1] The act resonated with the Scottish oral tradition, calling to mind post-colonial writer Edward Braithwaite's claim that the oral exchange of 'nation language', being of the 'breath', creates a live continuum of meaning between speaker and audience.[2] Donald Dewar's address, with its references to the 'shout of the welder', 'the discourse of the Enlightenment', 'the speak of the Mearns', and 'the wild cry of the Great Pipes' carefully selected the sounds and strains of distinctly Scottish voices and traditions, that have resonated within Scotland's borders and beyond. In so doing, Scotland's first First Minister suppressed the nation's internal histories of dialogic tensions that have centred around the use of Scots, Gaelic and standard English, and the sense of fracture in Scottish identity well documented in historical and cultural scholarship.[3] Attempting to endow the nation with both pluralism and unity, Dewar conjured a new public sphere, celebrating the emergence of 'a new voice in the land, the voice of a democratic Parliament', – a nation capable of speaking with 'one voice . . . to shape Scotland, a voice for the future'.[4] Although Dewar did little to predict the coming splits over Scotland's independence, his speech heralds

a new national public sphere, to which the voices of Scottish theatre would both contribute and critique.

In both performance and literary contexts, the sounds of Scottish voices had often been used to articulate a strong socialist political tradition. In the late 1920s, Jo Corrie's *In Time O' Strife,* which was produced by the Fife Miner Players and toured the Fife mining communities, used realistic dialogue to depict the effect on Scottish workers of the General Strike. The Glasgow Unity Theatre, formed in 1941, with its strong links to the British Communist Party, also toured Scotland, with plays such as Robert McLeish's *The Gorbals Story* (1946), and Ena Lamont Stewart's *Men Should Weep* (1947). Scots dialect was used to portray the concerns and strains of contemporary urban life, particularly those of ordinary labourers and their families. In the 1970s, Roddy McMillan's *The Bevellers* (1973), and John Byrne's *Slab Boys* trilogy (1978–82), also used Scots to represent the working lives of Scottish working lads. In the more traditional popular and communal forms of Scotland, such as the folk music revival in the 1950s in the Edinburgh People's Festival, dialect was also a vital element, bringing together performers and audiences in shared popular forms of entertainment. Ceileidh dance and singing seemed to suggest inclusive, communal and open political values and spaces, with little sense of the nation's political divisions, clan rivalries or class hierarchies.[5] For Cairns Craig and Randall Stevenson, conscious of the history of its oppression by standard English, the 'live and direct' qualities of the Scottish voice associated it with a sense of national liberation and cohesion.[6]

In the field of new contemporary Scottish drama, the orientation of Scotland according to a global rather than insular context would, it was hoped, avoid the retrospective and inward looking mentality that Englishman John Tiffany, appointed literary director of the National Theatre of Scotland in 2006, referred to as 'bogging'.[7] Indeed, the Scottish Executive aimed to make Scotland the 'most globally connected small nation on Europe'.[8] As in England, where the Arts had been used to help create the sense of a more diverse and inclusive national voicescape, so in Scotland, cultural produce would play its part in creating a new confident national identity.[9] Specifically in post-devolution Scotland, new theatre writing would help to define Scotland's continuing relationship with a wider world. As theatre scholar Robert Crawford had put it in 1993, it was 'those writers who look abroad' who were 'often its 'most valuable territorial voices'.[10] Claiming that theatre had 'first put distinctively Scottish voices on the cultural map', the Scottish Arts Council Drama Strategy 2002–7 predicted that Scottish cultural strategy would aim to

make an 'export' of 'our dramatists' work', creating a 'higher profile' and 'reputation' of which 'the Scottish people can be justly proud' of. Scottish writing, according to the Council, 'liberated' from England, would serve as an 'ambassador for Scotland' in a globalised cultural market.[11] Philip Howard, Artistic Director of Edinburgh new writing theatre The Traverse, noted the determination of much new Scottish writing 'to avoid being seen as insular or inward-looking'. Howard urged Scottish writers 'to investigate what the country means to a wider world'.[12] The title of the play anthology in which he wrote, *Made in Scotland,* suggested that making plays was not only an artistic and cultural pursuit, but a form of internationally marketable cultural production.

Devolution renewed issues regarding the types of language chosen by practitioners to express Scottish identity and culture.[13] In contrast to the retrospective self-examination that seemed to have gripped a sense of Scottish identity, literary scholar Cairns Craig argued that both the nation and the Scottish self were spaces of 'dialogue' and 'dissonant voices' that implied an evolving and diversifying sense of identity and nationhood.[14] In the new context of devolution, the use of 'authentic' Scots, for all its local tones and textures and with its suggestion of oppositional versions of Scottish identity could be construed as anachronistic, or even to the cosmopolitan-minded, distastefully nationalistic and/or embarrassingly parochial. Yet, the avoidance of Scots dialect might suggest a betrayal of the issues raised by the freedom and rights given to the Scottish people to speak in their own voices – an evasion of the opportunity to embrace a sense of national distinctness. In this chapter I explore how the post-devolutionary work of David Greig and Gregory Burke articulates complex relationships between localised individual identities, globalisation and Scottish territorialisation at home and abroad. Using the tensions and complexities in the Scottish voice as 'cultural evidence' of a rapidly shifting voicescape, I argue that the voices created by Greig and Burke scrutinise and trouble the sense of self-determination and autonomy encouraged by the official discourse of the period at a time in Scotland when efforts to build a sense of national identity centred around a rhetoric and practice of confidence. In the wake of devolution and through the deliverance of the National Theatre of Scotland the voices of Burke and Greig's characters scrutinise conventional notions of the links between vocal sound, national character and place. The performance and production of their work in global contexts illustrates and cautions of the allegiances between Scottish socio-economic cosmopolitanism and the seductive yet long stigmatised power of the Scottish demotic.

Migrancy and the materiality of the voice

David Greig's plays have reflected a deep interest in the link between voice and language, identity and nation. In fact, his work explicitly engages with the idea that the sounds of voices and the language they use carry the speaker's historical, national, and present and past material circumstances. Many of Greig's characters use a standard English whose apparent neutrality seems highly appropriate to the 'transnational space' and 'transnational subjectivity' that scholars have identified in his plays, where a migrant condition is the norm.[15] Such is the indeterminate relationship of place and voice in *The Cosmonaut's Last Message to the Woman he Once Loved in the Soviet Union* (1999), which was produced by Paines Plough at the Lyric Hammersmith in the year of Scottish devolution, revived at Glasgow's Tron in 2000, and returned to London to be produced at the Donmar Warehouse in 2005. Travelling across borders, the play has been translated into German, French, Japanese, Bulgarian, Portuguese and Italian, and articulates a vocal oscillation between local and material, global and spiritual space. Dissolving rather than devolving identity, its voices resist national frameworks of identification, and are deeply ambivalent even to the idea of a distinct individual self.

In *Cosmonaut*, the use of crude Scottish demotic is symptomatic of a profoundly reactionary and kneejerk territorialism, the Proprietor telling the play's mildly spoken protagonist Keith, 'Don't speak Gaelic in here [. . .] It's my language you cunt'.[16] The play's other characters, many of whom appear in several locations, tend to resist or elude the rootedness and fixedness of a distinct national or regional accent. It is a point that challenges commonly held expectations of the voice discussed in the Introduction to this book, according to which vocal sound is frequently heard as a marker of individual identity. Journalist Paul Taylor, for example, claims that the 1999 production's refusal to use accent as a means to draw distinctions between its multiple and overlapping characters caused 'confusion'.[17] Parts were doubled and were undistinguished through voice, suggesting the dissolution of boundaries and differences between individuals. At the 2005 Donmar production the choice also troubled Gerard Berkowitz, who caustically commented on Michael Pennington's failure to differentiate French and Scottish characters.[18] Yet in *Cosmonaut*, language is, like the characters, deracinated and migrant, enigmatically signalling the connections of a fragmented universe rather than the stability of the individual subject.

While *Cosmonaut* denies the conflation of personal and national identity by permitting the voice and language passage through traditional borders and boundaries, its sister play, *Pyrenees* (2005), produced by

Paines Plough at the Menier Chocolate Factory in London, cautiously acknowledges the continuity of individual and national identity through vocal materiality. The play is set, appropriately, on an outside terrace in the Pyrenean borderland. At its beginning, Anna, an ex-actress who works for the British Embassy, is interviewing an amnesiac man, who has been lost in the show. Like the voice coaches that were discussed in the previous chapter, Anna assumes that 'people carry a landscape in their voice'.[19] Re-routing *Cosmonaut's* movement away from specific locale, Anna works backwards, determining identity from the historical and material evidence of a person's physiology contained in their voice and language. Eventually, it is the Man's use of the word 'clamjamfree', a word utterly distinctive in its contours of vowels and consonants, along with his wife Vivienne's confirmation that his accent is 'posh Edinburgh', tempered by a few years in Africa, but still bearing 'a tiny amount of residual Aberdeenshire', that appears to confirm the Man's identity (p. 83). In a sense his voice betrays him, signifying the return of his regional identity, his internalised vocal landscape. Slowly, it becomes clear that the Man is Keith, the disappeared protagonist of *Cosmonaut.*

Pyrenees explores and troubles the relationships between the broad and superficial markers of national identity, and the individual trajectories that are plotted by the voice in the body, and in the people we know. The shift suggests a greater willingness on the part of Greig to consider the relationship of Scots dialect with identity, yet as part of Paines Plough provocatively titled series This Other England, Greig seems to be denying the sense of Scottish distinctiveness.[20] In *Pyrenees*, Anna's Welsh and Keith's Scottish accents are very nearly unidentifiable: Anna complains 'I'm Welsh but I'm so bloody English' (p. 35), and the Man himself is mistaken by everyone, including himself, for an Englishman. Ironically, in fact, the thought of being Scots elicits from the Man a popular but reductive stereotype of the national character far from the confident figure implied in the rhetoric of devolution: 'A mean-spirited, depressed, dour, violent, Jock', the Man complains, 'No wonder I went mad' (p. 37). The disappearance of characters' accents into a standard and hegemonic tongue implies the dissolution of distinct identity into a larger whole, both resisting and recognising the notion of the devolution and difference of Scottish identity.

Not migrant, but marginalised

As I suggest in this chapter's opening paragraphs, the use of Scots in Scotland itself can be divisive and problematic. Historically, as Neal Ascherson's *Stone Voices* (2002) describes, Scots, or Lallans, originating

geographically in the lowland area of Scotland, enjoyed only a brief period as national language from the fourteenth century before the Reformation.[21] Over time, Scots has become more confined to working-class industrial areas, and has suffered from a stigmatisation that is at least partly to do with attitudes to class as much as to region. In 1971, lexicographer David Murison claimed for example that the 'debased industrial variety' of Scottish speech was far from the historical literary dialect 'guid Scottish' of Robbie Burns, and could 'hardly be described as Scots'.[22] In the wake of devolution Burke's *Gagarin Way* (2001) constructed heavily accented voices, and a violent foul-mouthed protagonist, 'talking pish to some cunt I hardly ken'.[23] The play's realistic representation of working-class urban voices rooted Burke's characters very firmly in the industrialised working-class Fifian lowlands. Alienated and marginalised, the sensibility that their voices expressed proved extraordinarily resonant but also elicited anxieties regarding the suppressed and potentially violent powers of the stigmatised voice.

Gagarin Way portrays the botched kidnap attempt of a 'Jap' by warehouse workers Gary and Eddie. Gary's voice in particular is imbued with the Socialist dogma of his regional past and the 'bogging' mentality lamented by the play's director, Tiffany. 'We got a bit ay a communist tradition round here you ken' (p. 64). His violent partner in crime Eddie shows no interest in the delights of cosmopolitanism. 'Travel', he says, is 'bollocks', deriding the 'fucking cunts' who spend their summers 'fucking off up some hill tay purify their fucking spirit' (p. 22). Exploiting the strategies identified by Bourdieu of speakers considered low in linguistic capital, the demotic qualities of Gary and Eddie's voices are statements of resistance to hegemonic and insidious corporate standardisation.[24] In their coarse working-class Scottish idiom the men articulate their belief that they sit, at the bottom of a 'pecking order' that has become global (p. 28). The more Anglicised voice and accent of their young accomplice Tom by contrast, is merely a sign of the extent to which he has been groomed for a life of corporate exploitation. In for five jobs, and with a useless degree in politics, Tom wants to 'get on' (p. 13).

Eddie's kidnap victim is Frank, a fellow Scot who has had a successful career as a manager in the global conglomerate that employs them all. Frank speaks the 'supranational' standard that J. K. Chambers has identified as the language of the cosmopolitan elite.[25] Now living in Surrey, his Scottish accent has disappeared, and his origins are no longer recognisable even to his fellow Fifians: 'What fucking accent is that?' [. . .] You dinnay sound like you're fay Leven' (p. 53). Rather than Gary's

impassioned but anachronistic Scottish socialist rhetoric, Frank speaks an apparently innocuous and standardised 'corporate pish' (p. 58). Indeed, he is the mouthpiece for the corporation, and as such admits that he has 'exploited and robbed honest, working people' (p. 86). In an extraordinary and climatic moment however, Burke's script allows the regional features of his voice to resurface. In a speech, played by Maurice Roeves in its original production with intense and defiant emotion, the return of Frank's native voice is a typically and traditionally Scottish articulation of resistance to globalism, 'I've had enough ay this fucking shite' (p. 89).[26] At the same time, it signals a capitulation to greater and more powerful forces: tragically, this eruption of human feeling is also the moment that Eddie loses his. Frank is shot dead, making a mockery of Tom's plaintive question, 'Do you, you no . . . think that devolution's been a success?' (p. 67).

Through Eddie, Burke constructs a sharp but uninstitutionalised and amoral voice that challenges a social order that marginalises the working class through its low expectations, an attitude that the values of some theatre's voicescapes can sometimes enforce. At the same time, he is a psychotic, drug-addled and violent presence, and poses a challenge to the social order, as a series of shell-shocked responses by theatre reviewers suggest: Eddie was called 'a terrifyingly articulate psychopath' in *What's On*, 'a terrifyingly articulate thug' by the *Telegraph*, and a 'frighteningly verbose criminal' in *Theatre Journal*.[27] Both character's and writer's voice were thus undermined on the grounds that working-class characters could not be articulate. Benedict Nightingale claimed that although the Scottish education system is 'famously good', its 'less successful products can't often speak with such wit, verve and savvy.' Steve Cramer found it 'implausible' that 'businessmen and working-class folk' have knowledge of 'such arcane areas'. Philip Fisher claimed that the working-class voices were 'used' by the writer to voice 'heavy' themes.[28] Such responses deflect attention from the way that Eddie's empathy resistant voice, deracinated from local values, carries the lethal threat of an alienated and deracinated identity striking back at the very structures that have encouraged his amorality. As he points out, with typical sardonic humour, 'It's amazing what you can do way a library ticket' (p. 10).

Mouthing and mobilising Scotland

As commentators have suggested, given the criticism of *Gagarin Way* of globalised economics, the play's own enormous international success

seems somewhat ironic.[29] Its contemporary urban Scots, also used by the popular working-class characters of Irvine Welsh, seems a typically distinguishing feature of Scottish cultural produce – the unique selling point and 'malleable' asset of 'Scotland the Brand'.[30] A consciousness of the marketability of the Scottish voice sticks in some Scottish throats, suggesting a collision of class and national identity, and another of the historic fractures in the Scottish voice. Historically, as Tom Nairn argues in *the Break-Up of Britain* (1977) as part of his assessment of the emigration of Scotland's intelligentsia after the Enlightenment, there was no association of 'vulgar Scottishism or tartanry' of popular culture with 'higher' forms of nationalism.[31] Subsequently, the development in the Edwardian period of a 'tartanised caricature' of a 'Bonnie Highland Laddie . . . mouthing comic songs, couthy sayings and jokes' marks a stereotyping of Scottish identity that appears to have found and fed its market niche in the twentieth century and beyond (and humorously embraced in certain contexts such as football World Cup).[32] Certainly, the association of stereotyped markers of Scottish identity have added to the sensitivities around the use of the Scottish voice in 'serious' drama. David Pattie, for example, includes accent in his discussion of devalued iconographic markers of Scottish identity.[33] Burke's portrayal of Scottish voices of the working-class soldiers in his next play, *Black Watch* (2006) has also been heard as part of this context. Eclipsing the reputation of *Home* (2006) as a flagship National Theatre of Scotland project that recalled the localised traditions of Scottish theatre, the production has more than any other been seen as its foreign delegate, its style, imagery, politics and production values rich fodder for semiotic and cultural analysis.

In addition to bagging a large clutch of awards, the play has generated a great deal of enthusiastic commentary amongst journalists and theatre aficionados in establishing the NTS as a very significant world-class touring producer.[34] Scholarly criticism has been less enthusiastic, raising reservations regarding the production's willingness to present Scotland clichés, and also towards what has been perceived as the reactionary values of its politically incorrect Scottish male protagonists.[35] Citing Burke's own reference in his Author's Note to the tendency to homogeneity in soldiering, Reid finds that the play 'fails to interrogate' an idealised history of the Scottish regiment, and offers an 'essential and exclusive conception of identity'.[36] Yet this is to downplay the critical strengths of Burke's otherwise stigmatised voices. His soldiers provide a critique of the processes of representation and the role they are asked to play in overseas warfare that relates to the wider disillusionment in

Britain regarding the perceived dishonesty of politicians over the war in Iraq in the dog days of the Blair period. The production's rich blend of aesthetic and documentary approaches combine to authenticate the validity of the soldiers' Scottish voices and experience while articulating a critique of representation through a self-referential meta-theatricality.

As with *Gagarin Way*, in *Black Watch* Burke was concerned to represent the experience of ordinary Scottish men, whose voices are rarely heard directly in mainstream cultural space. Partly based on the author's interviews with working-class Scottish soldiers, its voices were constructed with concern for authenticity and accuracy, and presented the audience with competing and contested narratives and narrators of national history, while being mediated by ethical, pragmatic and artistic values and factors. Before the play began, a microphone announcement, rich in the hyperbole of commercialism, promised the 'thrilling', 'unforgettable' and 'unique' spectacle of the Military Tattoo. It wasn't until the straight-talking Cammy stepped out in civvies to speak to the audience simply and directly that the action proper began, 'A'right', he says, 'Welcome to this story of the Black Watch'.[37] The soldier's straightforward style and the bathos of his entrance immediately suggested a lack of artifice that contrasted with the theatricality of the play's prelude, and a direct and apparently interactive channel of communication with the audience. Arguably, there is a tendency here of documentary theatre to the 'emotional enlistment' identified by Lib Taylor in seeking the audience's sympathies.[38] The men's down-to-earth register is well attuned to the acute preference for the voices of the ordinary and the sincere in this period in the British theatrical context, and in the years following the invasion of Iraq in particular to the cynicism regarding the motives of politicians and what were perceived as their dark arts of spin in the public sphere. Nevertheless, the Scottish soldiers refused to conform completely to either traditional or renewed versions of Scottish patriotism. They were not there to romanticise what the Sergeant calls the 'three hundred years ay being in the shite' of the regiment's history. In fact, mythologised and romanticised aspects of Scottish military history were humorously and brutally debunked, 'Bollocks. Fuck all that Cullodenshite. The Highlands were fucked' (p. 30).

Rather than setting up Scotland's opposition to England, the play traced the history of the exploitation of Scottish working-class men by the British ruling classes. At first, the pompous English Lord Elgin co-opts an archaic Scottish accent in his call to arms, 'Wha'll follow a Bruce'. As the play's portrayal of recruitment strategies through history reached the present, Elgin's voice became familiar, colloquial, and, as if to suggest the

complicity of Scotland with British colonialism, thoroughly Scottish: 'you dinnay want tay join the army?' (p. 27). As the play progressed, a projection of the *Today* programme replayed the speeches of leader of the Scottish Nationalists, Alex Salmond and British Defence Secretary, Geoff Hoon. The deliberate lack of synchronicity between their voices and the pictures suggested the hollow and deceitful nature of both MP's politicised rhetoric. In contrast, radio microphones amplified the soldier's live voices, allowing the naturalistic delivery style that the period associated with honesty and authenticity to fill the huge spaces within which the play was performed. The play's original performance in Edinburgh's Drill Hall allowed the private and off-duty voices of the men, and their ambivalence towards the war for which they risked their lives, to be heard within a space that echoed with a past vocal history of the instruction of military discipline.

An acute awareness of the potentially exploitative practices of artistic representation in *Black Watch* is used to critique the structures of a representative political system in which certain subjects lack a voice. Well aware of their exclusion from access to the public sphere through the media, on arriving at Camp Incoming, soldier Fraz jokes they should watch the TV news to 'find out why the fuck we're here' (p. 9). Even though half of Cammy's book, *The Seven Pillars ay Wisdom*, is missing, it gives the men an opportunity to reflect on the way that soldiering is glamorised and misrepresented, as they joke about their own war being filmed 'on Kinghorn Beach. Who'll fucking know?' (p. 15). The men's suspicion and savvy regarding their relatively impotent position as subjects extends to the way they are represented in *Black Watch* (Figure 3.1) itself, many of whose scenes present a version of the Writer's pub meetings with them while researching for the play. Sceptical of the idea of telling their stories for 'the fucking theatre', the men agreed to meet the writer, to whom they variously refer as 'fucking cunt' or 'poof' (p. 4). While this kind of language perhaps panders to prejudices regarding the coarseness of working-class speech, as an anti-language it can be interpreted as a knowingly provocative class statement of the soldiers' resistance to the values they assumed to inhabit theatre's spaces themselves.[39] Many of the scenes depicting the writer's interviews with the off-duty soldiers blocked them at opposite ends of the traverse formation, their voices thrown across a no-man's land of distrust, suspicion and ignorance. The Writer, according to Stewarty, had come 'tay make a name for himself' (p. 60). In fact the men also questioned the potential of theatre to represent their experiences at all, frequently dismissing the Writer's attempts to hear their tales, 'Go tay fucking Baghdad if you want tay ken what

Figure 3.1 Michael Nardone in *Black Watch* (2006)

it is like' (p. 7). Such scenes drew attention to the ethical issues and voyeuristic tendencies in theatre's desire to give voice to the voiceless, as well as to the potential vulnerability to manipulation of rarely heard voices. It is perhaps not surprising that the men articulated loyalty not to 'Britain', and 'no even for Scotland', but were fighting ultimately for the tight male unit, 'my regiment' and 'my mates' (p. 72).

Black Watch also acknowledged vocal taciturnity as a form of cultural resistance linked to the tradition of Scottish working-class masculinity. The regiment's class and military background had created a world in which the vocalisation of emotions such as tenderness or vulnerability was prohibited, and ultimately self-destructive. All steps were taken to avoid being seen as a 'poof', and relationships between the men were expressed by competitive banter. Indeed, rather than speak of their pain, the soldiers preferred to self-mutilate. In spite of this sensitivity to the men's vocal culture, the soldiers' relative inarticulacy was partly conceived of as a deficit by the play's director. According to Tiffany, the men's habits of articulation limited its speakers' range of expression. The 'dark' Fife palate, Tiffany claimed, located the voice towards the back of the mouth, working against its projection, and physically restricted the men's capacity to express themselves.[40] Faced with voices that were apparently physically unable or culturally resistant in terms of

self-articulation, the production found non-discursive and theatricalised means to tell the soldiers' stories. Amongst these was the use of musical interludes in which the men would perform highly choreographed movements designed by the play's Movement Director Steven Hoggett, who according to Tiffany, had found 'a beautiful way of expressing what Gregory's characters couldn't'.[41] Nowhere was this clearer than when the men received letters from loved ones. Whereas the Officer's highly articulate letters home described the operations of military combat, the content of the men's letters were never heard. Instead, each soldier created individually 'a subconscious sign language' for the content of the letter, a repetitive action, performed to music (p. 39). Similarly, emotion was also released in the singing of traditional military songs, such as in 'The Gallant Forty-Twa', 'it's yinced I was a weaver' (p. 21). The archaic Scots dialect and the deeply elegiac tone of these newly arranged traditional songs seemed to open for the soldiers a wider range of vocal and linguistic expression, if to some extent indulging the sentiment that the men's voices in general resisted. In the play's final physicalised sequence the military tune 'The Black Bear' was played on bagpipe and drum, while the men paraded, stumbled and fell, continually helping each other to their feet, and so expressing physically an intense and infinite love for each other. The play's final wordless but highly moving sound was that of the panting of the actors' breaths, its specifically Scottish aspects now melded into universal physical, epic and emotional frameworks.[42]

The global voicescape

The making of *Black Watch* reflected the increasing tendencies of this period for new writing to be to developed within a holistic and collaborative theatre practice that drew on the expertise of a talented group of practitioners. In the case of *Black Watch*, this group was distinctly British rather than specifically Scottish, and included Tiffany himself as director, his fellow Huddersfield born choreographer Hoggett, Glaswegian musician Davey Anderson, and Welsh sound designer Gareth Fry. The play helped to establish the 'voice' of the NTS, receiving unprecedented critical acclaim, including Oliviers for Best New Play, Director, Sound and Choreography. The play was packaged as *The National Theatre of Scotland's 'Black Watch'*, associating the theatre with the authorship of the production just as much as its writer.[43] As its first Artistic Director, Vicky Featherstone's voice was highly audible in the way that the new national theatre began to define its role and

relation to the public sphere and to the people. Her determination to be 'forward looking' and reject 'old ideas' about nationalism in some ways converged with the thrust of the Scottish Executive's cultural policy to forge Scotland's path abroad, and indeed with the progressive and cosmopolitan values of her appointment, as an Englishwoman, to the most powerful job in Scottish theatre. Around its first production, *Home*, there had been a rhetoric of connection, where Featherstone had claimed the project was for local people, 'giving them a voice'.[44] Yet, in her foreword to *Black Watch*, Featherstone privileges the mediating 'voices' of artists, pointing to the need 'for us to trust' artists' abilities to help us 'see our complex world in a different way'.[45] A desire to give the people a voice through theatre is not necessarily incompatible with the valuing of artistically mediated experience, but an emphasis on both suggests the tensions of the representative processes.

Further tensions are present in Featherstone's claim that 'by being national you automatically become international', a remark that reignites uncomfortable issues regarding the contested nature of Scottish identity, and the legitimacy of its purchase on the global market.[46] It is worth considering the practical ways in which the changes in the production's treatment of the soldiers' voices suggested a diminishing concern with the 'authenticity' of their Scottish sounds. On tour in Aberdeen, the men's accents were, according to Billington's English sensibilities, 'impenetrable'.[47] Yet as Tiffany confessed, on the tour's more far-flung destinations, accents were adjusted in the interests of 'communication'.[48] Such adjustments raise the question of the relationship between the tonal, rhythmic and accentual qualities of the voice, and the meanings, experiences and identities conveyed in dialect. In contrast to the uncompromising stance of Tom Leonard's defiant speaker of 'Good Style' (1969): – 'if yi canni unnirstan thim jiss clear aff', 'get tay fuck ootma road' – the makers of *Black Watch* prioritised comprehensibility.[49] The compromises made for the *Black Watch* tour could therefore be construed as pointing to global structures an indeed artistic practice in which the values of universal communication and accessibility are privileged over an authenticity based on local embodiment.

The loss of local specificity and degradation of language in translation were to a large extent the themes of Greig's *Damascus* (2007), a play that presented an anaemic Scottish identity articulated through a Scottish voice almost entirely subsumed into a standard English as a global product. More than *Cosmonaut* and *Pyrenees*, *Damascus* – first performed at the Edinburgh Traverse – suggests the political consequences of the individual's capitulation to standardising and materialistic global

values. Set in a hotel lobby that recalled the earlier plays' indeterminate environments, the Scottish identity of the play's central protagonist Paul, a sales rep for English language textbooks, is at times so weak it is almost placeless.[50] His country of origin is portrayed in the play as insignificant: young Syrian hotel receptionist Zakaria has never even heard of Scotland. His research results in references to a highly packaged and inauthentic commodity, 'Mel Gibson. Braveheart [. . .] Freedom!' (p. 22). Elena, the play's transsexual Ukrainian Christian Marxist cocktail pianist, informs the audience directly, 'Scottish, English, it's the same thing'.

As with *Black Watch,* events in Iraq are behind the deep distrust of the representative processes that are conveyed in *Damascus*. For the Arab intellectuals of the play, all British voices are complicit in a 'democracy' made 'ridiculous' by the complacency of its people in the face of their government's undemocratic action (p. 49). Commodification is also a factor in the degradation of language. As Syrian professor Muna's discussion with Paul points out, the real function of his English language textbooks books is to teach Syria's young people 'to communicate as widely as possible' in the 'globalised marketplace' (p. 25). In *Damascus*, the Scottish voice exists in an environment in which all language is degraded by political, personal and commercial interest. Accordingly, Muna's translation of Wasim's Arabic speech for Paul hardly comes close to paraphrase. Wasim's Arabic poetry is itself pretentious and spurious, the sophisticated intellectual choosing the 'language of the street' to try to make love to Muna (p. 26). 'Representation is always a failure', Greig writes in his tour diary for his own play; writing can hope to 'conjure', but it can 'never capture'.[51] It is perhaps not surprising then when the play, according to Greig, was 'given' a 'naturalistic' production style it should elicit the controversy when performed in the Middle East. His tour diary describes how he faced the fury of audience members who considered the suicide of Zakaria, the play's most marginalised character, un-Arabic.[52] Greig's subsequent defence of his entitlement through the artistic imagination to 'write' characters of any age, race, or gender points to the political dimensions of creating a character whose identity is considered other, and the ethical minefield that practitioners cross in attempting it.[53]

An overlapping series of writers' voices in *Damascus* each to a greater or lesser extent are empowered through local and international linguistic contexts. All construct cultural produce from a different position within the global economy. Paul as a writer of English textbooks for an international market; Dean Wasim as a proudly Arabic poet; bell boy Zakaria, as a wannabe Hollywood script writer. In writing *Damascus,*

Greig makes an implicit comparison of the latter, a natural poet whose talents are not recognised, with his own output and career as an established playwright in the cosmopolitan touring context. It was a comparison that became acute when the British Council took this play about Syria to Damascus itself, where it elicited a kind of anger directed at Greig himself for being able to 'swan about writing plays' when the creativity of others was stifled.[54] Not only does the creation of socially realistic voices for cosmopolitan contexts risk the dilution of vocal specificity, it seems to undermine the right of a political subject to use her own voice to represent herself. As noted of *Gagarin Way*, the theatre industry is part of the exploitative and homogenising system of the very system of global capitalism it often attempts to critique.[55] While *Damascus* scrutinises the effects of globalised voicescapes on individuals, its use of standard English as the lingua franca of the liberal and leisured international theatre going elite inevitably imagined its Middle Eastern characters in a language that was inadequate and from a cultural position that was outside, apparently contributing to the silencing of local voices marginalised through globalised structures.

The native voice returns

While the Scottish identity of Greig's more middle-class voices are sometimes diluted to the point of placelessness, in his reworking of Euripides' *The Bacchae* (2007) a deracinated Scottish demotic returned through the voice of globally successful Glaswegian actor Alan Cumming. In some ways, as the first classic play to be produced by the National Theatre of Scotland, *The Bacchae*, in Tiffany's capable and busy hands, appeared to assert further the dramaturgical confidence of the nation.[56] Yet, nearly a decade after the event the production emphasised through its casting choices and vocal styles the diminutive status and archaic outlook of the Scottish authorities in relation to the larger and more powerful frameworks within which the country sought to articulate itself. Unlike Lochhead's exotic and demonised standard English speaking Medea of 2000, Dionysos/Cumming was Scottish, working class, and globally famous. Returning to his home country after 'revealing' himself in 'foreign places', the rumours that he was not regarded as a 'real god' and his mother called a 'simple slut' had angered him.[57] Like Dionysos, as Cumming revealed in pre-publicity for the production, the actor regarded accepting the part as 'coming home from exile' to his country where he was 'supposed to be recognised'.[58] Vengeful, Glaswegian and dangerous, the illegitimate and scorned voice of Cumming/Dionysos

returned to his native land with powers unrecognised and unwisely repressed by the institutionalised and already anachronistic domestic authorities of Scotland.

Like other reworkings of classic texts of the period, Greig's translation implied the close links of identity and locality.[59] *The Bacchae's* dynamic redistribution of voices was based on class as much as region, and commented on the way residual domestic hierarchies had been overwhelmed in broader global and popular structures. Cumming's accompaniment by other newly liberated and highly seductive voices, a roving black American female Chorus, suggested new post-historic allegiances. Tiffany's casting of Tony Curran as King Pentheus, and Paola Dionisotti as Pentheus's mother, both actors with classically trained and well-articulated voices, suggested the traditional authority and propriety of Scottish power. Curran's first words in particular, 'What the hell is going on?' (p. 15) came across as the attempt of an insecure man to wield an oppressive and humourless authority. Curran's highly educated tones were constructed not as a version of English colonialism, but were inflected with the nasal tones and narrow attitudes suggestive of the Calvinist Scottish bourgeoisie. It was this repressive tradition that Cumming's voice was out to subvert. Highly sexualised, entertaining, playful, unabashed, and camp, he teased and flattered the audience, telling them he had returned 'Like you. Fleshy./Man? Woman?' Employing the characteristically intimate tones of the period, Cummings not only directly addressed the audience, but interacted flirtatiously with individual members: 'What do you think?' he asked them directly (p. 7). Whereas Pentheus attempted to assert himself by invoking an outmoded form of authority, 'I'm in charge. I'm writing/ The script' (p. 29), Dionysos/Cumming seduced the audience, who cooed and called in response, with his daring, defiant and apparently transparent ad-libbing style.[60]

As the production proceeded, it became clear that the voice of Dionysos was not only powerful but also dangerous. Though born inside it, and for all its down-to-earth working-class origins, the celebrity-god derived his power from outside the state, its powers unloosed from the national context. As a highly theatricalised and performative entity, the voice of Dionysos, like the stage lights that burned the town, was not only alluring but also much brighter than the state's domestic powers. Invoking the 'anti-theatrical prejudice', Pentheus attempted to discredit Dionysos by drawing attention to his thespian nature: he is a 'Bakkhic actor from abroad'. For Pentheus, Dionysos is a 'stranger' who can 'twist words cleverly'. For Dionysos/Cumming, and his adoring audience on

the other hand, this verbal dexterity was a creative art to 'mock' and 'spin words playfully' (pp. 29–31). Once he had seduced them, Dionysos used his arts to make the women believe that Agave's son was a mountain lion and tear his head from his shoulders. In the awful moment of realisation, Dionisotti's voice, wracked with grief, drew on the vocal techniques associated in Greek drama with the intense expression of emotion. Her cries, rent, it seemed, from her inner being, made clear the suffering to individuals caused by Scotland's deafness to the voice of one it had 'denied'. The voice of the celebrity-god had asserted its much greater powers, to exert a 'human' vengeance for his country's prejudice and distrust (p. 85).

In spite, or perhaps because of the narrative of confidence, through its use of the contemporary demotic in *The Bacchae*, Scottish theatre mocked the fear of the popular working-class voice, dressing Pentheus and his old fashioned male authority as a woman. While traditionally resistant immobile working-class regional Scottish speakers had been in reality the victims of the commodifying and exploitative tendencies of global capitalism, Greig's adaptation implied how representations of working-class Scottish voices, empowered by commercial forces that had superseded national structures of order, were themselves to be feared by inward and backward domestic authorities. The production itself illustrated the NTS' assertion of its own status through its annexation of the classical canon and celebrity casting, decisions that were likely to result in the play's commercial appeal. NTS Executive Director Welshman Neil Murray had previously bemoaned the expectation to use 'some Scottish actor having made it in Hollywood'.[61] The values that informed the production of *The Bacchae* were not so much a capitulation to such expectations, but a return to the Scottish demotic itself in the tradition of Scottish theatrical popularism. The play both articulated a powerful version of Scottish identity, and further established the voice of the NTS itself as a producer with global appeal.

While the direct address and cabaret style of *The Bacchae* may in some respects have recalled the open and direct modes of performance traditionally associated with the Scottish voice in performance, the growing prominence of new writing through the Traverse, and the collaborations between British artists that grew under the emergence of the National Theatre of Scotland, opened contexts and markets beyond Scottish borders.[62] In contrast to this growing strength and success in terms of reputation and status, the voices of Burke and Greig's Scottish characters tended to trouble the sense of Scottish confidence encouraged by the new Scottish authorities, expressing ambivalence and

apprehension regarding the articulation of a specifically Scottish iden-
tity in globalised voicescapes. While Burke's socially realistic local voices
became subsumed into tragic, epic and global frameworks, the voices
of many of Greig's migrant characters seemed to evade a specifically
national identity, although the playwright's work articulated an increas-
ing willingness to use the voice as a means to articulate the specific
conditions of a devolved and deracinating Scotland. Tensions around
the apparently culturally specific 'exterior' features of the voice and
its relationship with personal identity can also be heard in the sounds
and language of voices articulated by black practitioners to which the
following chapter turns, as they made work for culturally prestigious
'white' mainstream spaces in Britain from the late 1990s.

4
Vocalising Allegiance: Kwame Kwei-Armah, Roy Williams and debbie tucker green

As the New Labour government began its office, with its multicultural-ist emphasis on diversity and tolerance, the Minister in charge of the new Department of Culture, Media and Sport, Chris Smith claimed that some cultures had become so 'absorbed' that 'we' no longer thought of 'them' as 'foreign'. A South African sitar, according to Smith, was 'music, not foreign music'.[1] Smith's claims call to mind the aspiration to '*legitimate* diversity' (my emphasis) of New Labour ideologue Anthony Giddens, and the grooming of identity according to a contract of empa-thy.[2] Kwame Kwei-Armah himself in fact graciously described his pres-ence in the mainstream as a symptom of liberalism, explicitly aligning himself with the 'new wave of empathy' that seemed to coincide with the Party's accession.[3] Given the history of black voices and speech in Britain since the waves of immigration following the Second World War, for Kwei-Armah, Roy Williams and debbie tucker green – black playwrights who emerged during New Labour's empathetic regime – the sounds and styles of the voices they constructed would inevitably raise problematic issues of inclusion, assimilation and representation.

As with Scottish voices, in black writing and performance certain sounds seem inflected with culturally specific contexts. Historically, there had been intolerant and oppressive responses to the sounds of black voices from British institutions. A series of reports made in the 1970s, 1980s and 1990s on education pointed to the stigmatisation of immigrants' native dialects, the 'cruel' and institutionally racist nature of the British education system, and its historical exclusion of 'planta-tion English'.[4] Journalist Yasmin Alibai-Brown describes how the British education system treated West Indian immigrants as 'trainee whites', and equated their non-standard speech with anti-social and deviant behaviour.[5] Under such circumstances, it is not surprising that language

became for some black speakers what Rachael Gilmour calls 'a privileged locus of resistance', with second and third generation young black people adopting creole as a means of self-identification.[6] For black artists, according to writer David Dabydeen, the 'poetic napkin' of English literary language – in contrast to the 'barbaric', 'snarling', 'angry' nature of Creole – acted as an excluding norm.[7] Similarly, Indian director Jatinder Verma, who came to Britain from Kenya in 1968, claimed that the literary norms of 'English English', such as he had learnt of in school in Nairobi, acted as a silent means of exclusion.[8]

For much of the latter half of the twentieth century, black voices were relatively excluded from culturally privileged spaces (although the Black Plays Archive opened at the National Theatre in 2013 testifies to their mainstream producing and programming in theatres such as the Royal Court and the National).[9] Highly active after its founding in 1985 and funded by the Greater London Authority, the Black Theatre Forum supported the work of African Caribbean and Asian theatre companies, but its productions were produced largely as Black Theatre Seasons in the West End rather than integrated into mainstream programming.[10] Within this context, the choice of a 'standard' (but 'assimilated') or 'authentic' (but 'ethnic' and 'inferior') voice was crucial. For Trinidadian Mustapha Matura, who came to England in 1962, and whose plays were produced from the 1970s in the Royal Court, 'writing in dialect was an important political act', and related to the silencing of black voices in the media and through oppressive police tactics including the Sus laws.[11] Such 'authentic' sounds have often been interpreted as a political challenge to the norms of what Dimple Godiwala calls 'rigid white space', and similarly heard by Lynette Goddard as an articulation of 'political resistance to the dominant conventions of the English stage'.[12] They are also, of course, sounds that extend mainstream theatre's representative sphere and make audible the experience of otherwise marginalised black speakers: even by the late 1990s, playwright Roy Williams recounts his surprise to find that *Class Enemy* (1978) by Nigel Williams, which used the dialect of young black and white boys, was about 'the likes of him'.[13]

In the 1990s, a series of ACE reports after the cut in funds to the Black Theatre Forum in 1985 had recognised the importance of black arts to the diversification of British culture, and paved the way for New Labour's introduction of a range of measures to increase and support the representation of black voices in the mainstream.[14] This culture of inclusion and diversity and a new climate of empathy, intimacy and democracy seemed to grant indigenous black writers and performers

the right to speak for themselves, avoiding the 'inauthenticity' of a '"chocolate-covered" kind of black talk' that Kwei-Armah discerned in common representations of black voices in the mainstream.[15] It also raised a number of questions. Would inclusion jeopardise the capacity of black voices for auditory 'provocation' of white norms? Would it tokenise practitioners and what would be the terms of their selection? Would it lead to the loss of the cultural specificity of black voices? This chapter explores the representative strategies used by Kwei-Armah, Williams and tucker green, as well as the challenge and scrutiny they practised, as they articulated the negotiations of black identity within the climate of empathy prevailing in theatre's voices-capes in the 2000s.

Vocal allegiances

Kwei-Armah's trilogy of plays, produced in the Cottesloe at the National Theatre, *Elmina's Kitchen* (2003), *Fix Up* (2004), and *Statement of Regret* (2007), made use of Jamaican, African, London and hybrid accents and dialects to illustrate the geographical and cultural origin of a character's identity, as well as the allegiances they had made as first, second and third generation British citizens. A vital part of Kwei-Armah's strategy to achieve 'cultural equality' was the use of a black 'cultural lens'. Although his metaphor is visual, a component of his strategy is the use of 'the language of his father and the language of his peers'.[16] The first of the trilogy, *Elmina's Kitchen,* deals with the lives of the working-class black community in Hackney, and created the complex voicescapes of three generations of black voices that expressed the tensions between the pressures to integrate into British society and the attraction of marginalised and illegitimate sub-cultures. The play cafe-owning Deli's second-generation hybrid identity is reflected in his blended working-class British and West Indian accent. His response to Grenadian immigrant turned gangster Digger's expletive, 'You mudder arse!' is the admonishment, 'How many times I got to tell you about language like that in here, Digger?' This is followed by the broad Jamaican, 'Ah you me ah talk too yuh na!'[17] Near the beginning of the play, Deli reacts to Digger's production of a gun with, 'Don't fuck about Digger [. . .] what happen if a customer walk in now?' A moment later he answers the phone in the pleasant friendly tone and standard English of sales: 'Elmina's Kitchen, takeaway and delivery, how can I help you?' (p. 6). His switch portrays his culturally complex identity, and a pragmatic, economically driven use of standard English.

For Deli's son Ashley, his father's use of self-help manuals makes of him a 'blasted white man' (p. 62). Taking his cues from Digger, his father's attitudes are a form of emasculation, and a dilution of black identity. Ashley makes his more rebellious allegiances clear by mastering the gangster talk used by Digger: 'So, yes my don, what a gwan?' (p. 12). The youth has tried to prove his readiness for Digger's style of manhood by the adoption of black urban dialects influenced by American 'gangsta' rap, much of it a copy of the 'chat' he sees on the garage videos he watches on the VH1 channel. 'Hold the mic while I flex, I'm a lyrical architect with the number one set' (p. 29). Digger's accent, as Kwei-Armah specifies in his stage directions, 'swings from his native Grenadian to hard-core Jamaican to authentic black London' (p. 4). These are deliberate expressions of political and racial allegiance. His frequent use of the West Indian expletive 'bloodclaat' aligns him with a history of black exploitation, and his hardcore Jamaican gangster chat is most pronounced when dealing with his gangster cronies: 'Tricky wha you say, rude bwoy?' (p. 8).[18] When told to 'fuck off' by Deli, he admonishes him for using a 'Viking' swear word while disapproving of the 'language of our heritage' (p. 8). Similarly, for Digger, Deli's insistence on the use of 'Please' is a symptom of the 'British blacks' weakness in accepting assimilation into British culture (p. 5). To Deli, the audience's touchstone, this is Digger's 'eighties shit': a linguistic dogma that leads to an extreme and dangerous form of self-marginalisation (p. 25).

Deli's vocal allegiances, like those of his creator, whose ability to express a 'tri-cultural' identity through different dialects, reflect an attitude that black vocal adaptability is survival, mobility and marketability in contemporary British society. The work of sociolinguists suggests that such code switching is an empowering process that allows speakers to construct their identities according to different social and cultural contexts.[19] In the case of Kwei-Armah the ability to code switch between different dialects gave him a freedom of identity that allowed him to 'be whatever I need to be at any one point in time'.[20] For Williams, who told aspiring young black state school writers that success would depend on their ability to 'mingle with people out of your world', it was a practice borne of artistic and social necessity.[21] Yet in spite of its potential advantages to practitioners, the code switching practised by black characters in these writers' plays involves highly problematic politicised choices that can undermine a stable sense of identity. Often it is a sign of inauthenticity or a 'false personality' rather than a pragmatic or artistic skill, suggesting identities painfully distanced from or no longer grounded in the 'inner self'.[22] Ashley's vocal theatricality is

evidence not of code switching versatility, but of a false identity that will endanger the youth's happiness and future. In the end it is gangster Digger himself, whose restricted social options are reflected in his difficulty in pronouncing the word 'expletive', who tells Ashley: 'Go back to school, youth, and learn' (p. 4).

In the second play of his trilogy, Kwei-Armah goes further in his exploration of black identity through vocal expression. *Fix Up* portrayed the uncompromising but ultimately destructive political determination of fifty-five year old bookshop manager Brother Kiyi to construct his identity according to an admirable but anachronistic black power movement. Like Digger, Kiyi expresses his allegiance with a code switching that suggests a false identity.[23] To the illiterate and stuttering Carl who delivers his books, Kiyi speaks with a 'refined but noticeable West Indian accent', using Swahili terms when advertising his cultural heritage, and reverting to 'hardcore West Indian' when vexed (p. 39). Like his creator, Kwei-Armah, who jettisoned his slave-owning family name, Kiyi has changed his name from Peter Allan, choosing to signal his ancestors' journey to the Caribbean from Africa. Inhabited by the recordings of the voices of past black political leaders, Kiyi is 'fed from above' with the evangelical fervour and 'vibrations' of the voices of past political leaders and influential black artists such as Maya Angelou, James Baldwin, Claude McKay and Marcus Garvey (p. 55). As Kwei-Armah's stage direction indicates however, Marcus Garvey's Jamaican accent is 'Truemanesque' and 'overarticulated', suggesting a falseness in its allegiance to a white rhetorical tradition (p. 3).

As the play unfolds, Kiyi is found not only to have falsified the slave narratives he has been transcribing, but denied the existence of his daughter Alice, the mixed race issue of his life in contemporary Britain. In a final agonised sequence a montage of live voices, recordings and mythologies express Kiyi's tortured psyche.[24] The character's singing of the blues slave chant that followed, as specified in the stage directions, is slow, and 'void of emotion' – unlike the scene in Steve McQueen's more recent Oscar winning film *Twelve Years a Slave* (2013), where a nineteenth-century black slave formulates and releases his passion during the singing of a negro spiritual.[25] In *Fix Up* the black voice is drained, the play a dire warning of the consequences for black identity of the refusal to negotiate with contemporary circumstances.

In addition to language and dialect, *Fix Up* raises the issue of the allegiance of voice with emotional aspects of racial identity. A tradition of black anger has in many ways been legitimised and exploited in mainstream culture, Kiyi's emotion failed to find a satisfactory outlet,

but instead a chain of vocal strategies illustrated the difficulties caused to black migrant identity through transplantation and slavery. For David Sutcliffe a 'clash of values' in the British context brought about by immigration resulted in the silencing and submergence of African and Caribbean identity, and caused a 'desperate, untenable' position for some individuals. 'They feel dispossessed of themselves'.[26] Similarly, Samuel Kasule has found a 'psychosis' in the character of Kiyi, and documented cases of black immigrants as they struggled to reconcile a conflicted identity.[27] Such evidence suggests that the uncomfortable allegiances forced by life in Britain have necessitated heart-breaking dilemmas, or made an individual seem somehow 'untrue' to themselves, their class, or to their ethnic origins. Granted equality, but on white terms, and subject to insidious forms of prejudice and historical burdens, the anger and frustration of the black voice becomes anguished, stifled and ultimately self-destructive.

The difficulties of second and third generation black citizens are compounded by the potential compromises of integration into mainstream and prestigious institutions and careers, where there are expectations of conformity to explicit and implicit ideological and economic norms. A brief reference to the backgrounds of many black artists demonstrates an apparent mismatch between the outward success that some black artists achieved in the period and the conflicted identities they often articulated in their work. Kwei-Armah's working-class Deli in *Elmina's Kitchen* was played by LAMDA trained Paterson Joseph. Successful playwright and film star actor Lennie James, for whom the ability to code switch was integral to his artistic process, played the offensive and racist Joe in Williams' *Fallout* (2003).[28] Fierce defendant of West Indian culture, Kwaku of Kwei-Armah's *Statement of Regret,* was played by repertory actor and TV star Don Warrington, whose childhood Geordie accent had been superseded by the sophisticated repertoire demanded by his TV voiceover work. Colin McFarlane, who played African Michael Akinbola in the same play, was a second-generation Britain of Jamaican stock, whose RAF father sent him to public school and then on to university. McFarlane's website advertised him as *'a familiar face, a familiar voice'*, and included clips from his voiceover Cd, 'The Art of the Voice', which demonstrated the commercial possibilities of American, West Indian, African and Cartoon voices.[29] In fact, the *Daily Mail*'s reference to the actor as 'Colin McFarlane (beautiful voice)', evoked the very British norms that had previously excluded many of his race.[30]

Both the final play of Kwei-Armah's Cottosloe trilogy, *Statement of Regret*, and *Joe Guy* (2007), by Roy Williams, performed at the Soho

Theatre, deal with the difficulties of integration into institutions of the British establishment. Both plays explore the nature of success for the black British citizen during the decade described by critic John Peter as 'the years of vainglorious ambition', and as a response to the homogenising of the 'black community' by an indiscriminate multiculturalism, deal with the fractious politics of African and Caribbean immigrants.[31] *Statement of Regret* is set in a political think-tank, inhabited by a large ensemble of middle-class, educated black people, and reveals the personal and political difficulties of a highly articulate and divided black intelligentsia of mixed national origin. In *Statement of Regret* characters represent themselves with confidence, fluency, and articulacy. Kwei-Armah makes this very explicit indeed in his lengthy vocal instruction to the actors:

> Ideas and arguments are second nature to all of the characters. Dialogue should fall out of their mouths with ease, comfort and pace, and with constant overlapping by the others who have often got the argument before the sentence has been completed.[32]

The characters demonstrate the vocal fluency and discursive powers of highly educated and skilled users of English, scotching any residual notions of the inherent racial limitations to their linguistic capabilities.[33] In *Joe Guy*, which deals with the opportunity for young black talent in less refined surroundings, Williams' shy African hero becomes a football superstar, ditching his strong Ghanaian accent, having been bullied at school, in favour of an overblown 'Jamo' vocal style, 'Yer boomba! [. . .] (*putting on a bad Spanish accent*) GETTT DOWWWWN TO THE NIIIITY GRIIIITY!'.[34]

In both plays, inauthenticities abound, and choices made during the passage to success enforce and betray disguise of characters' origins. Kwei-Armah's think-tank founder, Kwaku Mackenzie, his real name Toks, makes use of his 'authentic West Indian accent when he wants', but 'his straight English accent defies his working-class roots'. Kwaku's best friend Michael's English is 'cut-glass', his Nigerian accent never used in the office (p. 4). These are some of the most insidious manifestations of code switching, as success leads not to the defiance of the gangster, but to secretiveness, shame and snobbishness about cultural, racial and class origin. Similarly, in *Joe Guy*, Joe's vocal costume is an arrogant, overblown preposterous baroque, a sign of the inauthenticity of his identity. Through a lengthy monologue Williams dramatises Joseph's adoption of a new identity through heightened vocal theatricality.

In performance, the softly spoken Ghanaian, played by Abdul Salis, wrenched his voice and body into another shape as he took on the persona of a loud-mouthed swaggering show-off.[35] The result was an absurd caricature of Jamaican slang and attitude, 'you pussy hole, rass clart, boomba hole, batty bwoi' (p. 33). A sense of falseness was further emphasised by the use of reverb, signalling the warping of the voice and distancing from the 'true' and 'good' inner self of the man.

Although it is often caricatured as such, the persistent presumption in wider society that black voices are resistant or counter-cultural in many cases is reductive and inaccurate. An OFCOM report revealed in 2005 that many second and third generation British black parents were norm enforcers, more sensitive, for example, to the use of illegitimate language than their white peers (a sensitivity that Kwei-Armah confessed obliged him to correct his own son's language).[36] His work troubles the assumption that the black voice is oppositional or alternative, providing a strong condemnation of black separatism through his critique of an obsolescent and destructive response to the contemporary indigenous black situation by misguided adherence to alternative or separatist linguistic markets. The success of writers and performers in culturally prestigious spaces and institutions is itself evidence of ability and aspiration within European traditions in which many second and third generation black voices have been immersed. In contrast to the rejection practised of the kind of 'foreign Method shit' by the Caribbean characters of Derek Walcott's play *A Branch of the Blue Nile* (1986), Kwei-Armah has stressed the need to ensure that 'authentic' and 'valid' black experience is represented in a manner 'acceptable' to mixed mainstream audiences.[37] The writer implies some strategic use of techniques and ideologies with which traditionally white audiences are familiar. Of *Fix Up* he argues that the passion expressed by James Baldwin, 'a most brilliant articulator of black artistic rage', is 'universal' – a term that recalls the assumptions made in the voice teaching practices regarding the emotional trth of the inner self.[38]

Skilfully blending the specific cultural circumstances that seem to be carried in vocal sound, with the 'universal' emotion that apparently proceeds from the inner self, performers of both Kwei-Armah's and Williams' plays articulated black identity in ways that gained empathy and admiration. In *Statement of Regret* (Figure 4.1), West Indian Kwaku 'screams from the heart' to his African friend, 'If you were so great, why didn't you come and get us?' This was a highly cathected moment, focusing the accumulated feeling of a long episode of racial history.[39] It generated much acclaim for Warrington, whose performance was

Figure 4.1 Don Warrington in *Statement of Regret* (2007)

described as 'tremendous' in the *Telegraph*, his 'ruined grandeur' (a phrase
with *Lear*-esque connotations) praised in the *Guardian*.[40] In *Elmina's
Kitchen*, during Digger's haunting warning to Ashley of the need to learn
the 'whole science' of 'dis bad man t'ing', as his gangsta persona receded,
his accent became more standard and his words more literary: 'you need
to have thought about, have played wid and have learnt all of the possible
terrible and torturous ways that death could arrive' (p. 30). Shaun Parkes'

voice, skilled in its manipulation of script, tone, pitch and intention, slowed and lowered to create a performance that signalled the terrible finality of death. The effect on the audience of this speech was evident in their hushed, intent response, as the actor revealed the depth of the character's dreadful contemplation.[41] In Williams' *Joe Guy*, Joe's monologue made the audience empathise with a very young man, deeply hurt by gross racial bullying, 'what do I sound like, some booboo big rubber-lips monkey-faced African bin-bag?' (p. 33). Salis' performance was an extraordinary feat of vocal creativity, dexterity and psychological depth, expelling the suffering of the inner self and transforming it into a language commonly caricatured and illegitimised by mainstream society. Aggressively breaching the fourth wall Salis directed lines to individual members of the audience: 'Is who you looking at?' (p. 33). Yet audience members who had physically flinched in response to its most aggressive phrases, were assertive in their curtain call appreciation of the young actor's performance.[42]

Multiculturalism and patronage

For successful black artists, further issues regarding integration and assimilation were raised by the uncomfortable position in which they were placed by the liberal policies designed to address society's inequalities. Both Kwei-Armah and Williams were recipients of a number of awards, particularly in the early stages of their careers, some aimed at ethnic minority writers exclusively. By the time *Sing Yer Heart Out for the Lads* (2004) went on tour in 2006 Williams had received at least six.[43] For some black artists, the acceptance of state support suggested collusion with an oppressive, hegemonic and specifically white regime. In 2003 writer Benjamin Zephaniah publicly refused the very high honour of an OBE, commenting that such awards appease 'blacks who would be militant' in order to give the impression of an 'inclusive' establishment.[44] His poem, 'Bought and Sold', criticised other black people for accepting honours and in so doing joining the 'oppressors' club'.[45] Given the scepticism of the director of the Institute of Race Relations, Ambalavaner Sivanandan, who noted that New Labour could afford to be 'nice' on the basis of race relations, enhancing the status of middle-class Blacks while having 'very little for ordinary black people except palliatives', it is tempting to suggest that the liberal and inclusive principles of theatre's voicescapes did not extend to the real world speakers and contexts that playwrights sought to represent.[46] Williams himself was deeply conscious that his work might be seen as a hostage

to tokenism and political correctness. He countered such charges with an aspiration to the equality borne not of patronage but of merit: 'black writers', he insisted, 'have got to be good. There shouldn't be any tokenism.'[47] His plays offered a critique of the empathetic society that New Labour sought to construct, resisting the liberal platitudes that suggested the unproblematic and successful cultural absorption of black voices.

Sing was Williams' attempt to write a 'head-on play about the state of the nation that looked at multiculturalism'.[48] Graduating from the temporary Loft to the Cottesloe, and then touring nationally, its working-class characters' voices, both white and black, temporarily reconfigured the structures and sounds of the theatres' spaces. The play portrays events in a London pub the afternoon of the 2000 England Germany football game. Its characters voice racist attitudes that directly challenge the discourse of liberal multiculturalism. Offensive language is a matter of course, creating the sense of 'authenticity' expected of popular portrayals of the contemporary working class.[49] Even before the arrival of the group of football playing lads, publicans' Gina and Jimmy's language has the high frequency of swearing that was frequently associated with the lower classes.[50] Of their 61 utterances in the short opening sequence before the entrance of Gina's son Glen, there are 18 examples of offensive language, including 'fuckin', 'pissin' 'piece of shit', 'tosser', 'bollocks' and 'my arse'.[51] On the surface it seems that Williams could be accused of tapping into a frequently evoked stereotype of the white working class. With the entrance of Glen, Gina's son, the racial and ethnic complexities of Britain's multicultural society begin to emerge. As in other Williams plays, allegiances have become mixed, young characters in particular using the sounds and rhythms that imply the political values associated with a race other than their own.[52] Glen's mother's foul-mouthed reproof is laced with Williams' satire, 'You taking the piss? Glen, I swear to fucking Christ! [. . .] English Glen, we speak English in here' (pp. 131–5). More aware of linguistic politics than his characters, Williams is demonstrating the implicit correlation made in ordinary society of whiteness with British English, even of this 'inferior' and vulgar variety, but also articulating the subcultural territory in which identity is claimed through cross-racial vocal allegiance.

The arrival of the pub football team makes the racism of language explicit. Williams draws on traditional fears of working-class hooliganism and the long association between football and extreme forms of British Nationalism. Extremely offensive language, vocalised loudly and aggressively, is used to express the team's xenophobia, 'Fuck off Voller,

you German cunt!' and 'YER DIRTY GERMAN BASTARD' (p. 171). This was the sort of racist working-class language and discourse highly disapproved of by the football authorities themselves, and delegitimised by the controversial Race and Religious hatred laws of the period.[53] Rather than silence its voices however, Williams' play amplifies them, bringing them out of the football grounds and into theatre space apparently dominated by the liberal virtues of tolerance and empathy. In an audience review of the play, Wendy Barton-O'Neill confesses that the play's 'coarse and vulgar' language left her 'squirming in her seat' and 'choking on her ice-cream'.[54] During Pilot Theatre's staging of the play the vocal volume and emotional pitch of the young men were intense. The imaginary TV, at which the actors directed their chants and hurled abuse was positioned in the audience, to whom was presented a large, fluid, angry and intimidating mob of emotional working-class males.[55]

By far the most sophisticated form of discourse in *Sing* belongs to Alan, an articulate white man who uses specious and insidious racist arguments that enforce British identity as white. His is a reactionary voice whose subtle racism has been intensified by hatred of the new equality, and the government's 'soppy immigration laws' (p. 82). It is Alan's voice that eggs the violence on, stirring up racial conflict in a manner that recalls the alleged involvement of the BNP in the Barnsley and Oldham riots.[56] Williams' tactics are complex, however. Within Alan's racist discourse he embeds a critique of the white liberal elite. It is the politically correct liberal agenda of the ruling middle-class 'smart arses', Alan claims, that has repressed the working classes of all races in order to keep itself in power (p. 66). These arguments are not easily dismissed. Asian academic Dimple Godiwala identifies 'a certain kind of liberal from the dominant classes' who uses tokenism to 'reassure himself of his multicultural inclusiveness while continuing to exclude his racial/economic others'.[57] To Yasmin Alibai-Brown, critical of the liberal ethos of civilising the 'Other', efforts to include the culture of ethnic minorities easily turns into 'image-making of the most hollow and wishful kind'.[58] Like Alan's, these claims imply that the same liberal ideology that appears to support the black voice ensures the continuation of the cultural domination of the white elite. Without condoning Alan's racist discourse, Williams uses a racist white voice to damn the patronising and self-serving nature of the white liberal sector of society. Of course, this is the very sector that often runs theatre as well as other public and cultural space, and is frequently responsible for the implementation of its inclusive regime.

In spite of its simplistic co-option to the values of liberalism, *Sing* exposed the shallowness of ideological reconstruction that had been

achieved under New Labour. In *Fallout* (2003), at the Royal Court, Williams continued his indictment of the inefficacy of the Party's multiculturalist policy.[59] Loosely based on the real life case of the black on black murder of schoolboy Damilola Taylor, Williams' play portrayed the murder of an African boy by a group of West Indian youths from a ghettoised London council estate. Where *Sing* immersed the audience in a white working-class idiom, the linguistic environment of *Fallout* was that of black working-class youth. Their modus operandi is that of insult. Emile's greeting of Ronnie is 'Troll', her riposte, 'Kiss my arse'.[60] The young speakers are sharp, but their language is sparse, sentences always simple in structure and rarely more than a few words in length. As in *Sing*, a sense of physical threat accompanies the characters' ill-contained energies, the play's first line of dialogue as the black youths make a vicious attack, 'Kick him in the head, kick him!' (p. 1). This physical energy and violence, staged with the audience in close proximity, elicited the adjectives 'terrifying' from critic Phillip Fisher, 'scary' from Benedict Nightingale, and 'alarming' from Charles Spencer.[61]

This is a violence that is linked to society. Four years after the Macpherson report had found the British police institutionally racist, *Fallout*'s young black policeman delivered the play's most shocking black on black assault. Despising the '*Guardian*-reading shit' and 'wishy-washy liberal crap' which ultimately patronises, tokenises and excludes the indigenous black population, Joe's frustration and anger culminates in his violent interrogation of 'facety little nigger' Emile (p. 72). Forced to return to the tactics of the ghetto, his language and behaviour become recidivist: 'See Emile, dis is getting vex!' Joe expels the frustrations and disillusionments of his riven self, 'Cocksucker. Pig. Bastard', 'white man's bitch' (p. 109). Rather than providing a shining example of the 'success' of multicultural policies, Joe voiced an ultimately self-destructive black rage focused through a hatred of deprived and marginalised black youths, and their savage struggle at the margins of multicultural society.

Rather than pandering to the stereotyping that fixes and ghettoises black identity as inferior or barbaric however, Williams' black voices asked questions of the audience's habitual ways of hearing them. While their offensive qualities seemed to confirm the worst and most prejudiced expectations, these black voices wielded a discomforting humour. Shanice enlightens Ronnie who believes that 'white bwois' don't have PhDs: 'Aint juss bruddas who have dem' (p. 27). It was a humour that elicited uncertainty from the play's white critics: Nightingale, for example, found the play 'disconcertingly funny'.[62] On the other hand,

Williams' dialogue was a major means through which he ensured belief in the reality of the ghettoised world of the play. To *Time Out's* Jane Edwardes, the dialogue of *Elmina's Kitchen* provided the play's grounding in the 'front line' of a grim social reality that 'seems cut off from the wider London culture'.[63] Similarly, Williams' use of a 'street lingo' to Fisher seemed 'realistic', and to *Independent* journalist Roda Koening, the dialogue gave the play an 'up-to-the minute authenticity'.[64] In fact, this perception of authenticity makes the voices and experiences of Williams' characters more powerful. Rather than neutralising the political intent of his voices by allowing them to become less pointed or aesthetically sugared, Williams constructed a harsh, ill-resourced, offensive and illegitimate verbal anti-language.[65] To the aesthetic sensibility of critic and poet Tom Paulin, Williams used an 'ugly, ugly, ugly basic language' far from 'the great music of the black vernacular'.[66] The resistant and offensive qualities of these voices reflected a refusal to adapt either to literary expectations or to the empathetic grooming offered by the institutionalisation of liberalism.

Renegotiating the contract

In common with Kwei-Armah and Williams, the presence of tucker green in the theatrical mainstream could be associated with New Labour's inclusive and diversifying project. *trade* (2006), for example, was developed through the Royal Shakespeare's new writing programme, where an Equality Action Plan was 'widening the Company's commitment to diversity'.[67] Yet, like much of the work I explore in this volume, the voices tucker green constructs offer a critique of the empathetic terms of theatre's voicescapes. Further, aspects of her work invoke traditions that challenge dominant modes of articulation. Notably, the deliberate spelling of her name and the titles of her works with lower case letters suggests the iconoclasm associated with black feminist writers such as bell hooks, and a resistance to the assertion of dominant ideologies through linguistic practice.[68] Without eschewing entirely the realist and transparent modes that can articulate the complex nature of experience from a specific perspective, tucker green's hypnotic but alienating blend of the real and the poetic reformulates the 'contract of empathy' made with marginalised voices through its realignments of racially and regionally inflected norms of subjectivity. Her work not only provides an acute political critique of 'natural' expectations regarding black voices, but positions audience members in ethical frameworks that extend beyond a narrowly defined 'British' voicescape. Amongst other things, her work

is concerned with the infliction of pain, including the violence that is associated with naming, othering and categorisation, and its role in the interpellation of the individual within society and in her relationships with others.

In *born bad* (2003) and *stoning mary* (2005), produced at the Hampstead Theatre and the Royal Court downstairs respectively, tucker green explores the dynamics of personal and familial relationships, positioning the audience as witnesses of the most painfully inflicted interpersonal cruelty. In these plays we see characters use verbal and vocal abuse (rather than action or narrative) as a strategy to expel, displace and inflict pain of the most extreme kinds within their most intimate relationships. *born bad* deals with Dawta's determination to confront her parents and siblings with her Dad's abuse of herself and her brother as children. The voice is used as a form of musical artillery, Dawta's speech pounding and battering her 'bitch bitch' Mum, 'And I'll call it like iss nuthin, and I'll say it like iss nuthin like the nuthin you are like the nuthin you are like the nuthin you try to mek me.' Dawta's verbal assault affirms the impossibility of negating her voice, and is used to mirror back Mum's collusion in her abuse as a child, 'watchu spectin on reflectin yu back' (p. 4). In some ways this is a metonymic use of language, re-embodying the violence of the abuse practised upon the speaker. Its displacement is also perlocutionary, physically shocking the audience with its sheer venom, and negating the empathy that might otherwise extend itself to a victim of abuse such as Dawta. This effect has been noted by audiences and critics, and was discussed at a Royal Court post-show talk, where Ruth Little observed the dialogue's refusal to solicit compassion.[69] In others plays, tucker green's voices practice this displacement of cruelty to suggest a shared responsibility. In *stoning mary*, a white Dad and Mum blame each other for the disappearance of their Child Soldier son. The Dad's memory of his son's smell and the emotion it carries, the 'after-bath aroma . . . the smell – lovin that the smell of lovin that – lovin smellin', fixates and mutates to an embittered dehumanising insistence on the mother's 'contamination' of the boy, with her 'spray-it-as -you-feel-it-full-on artificial/stink'.[70] Older Sister cruelly taunts her Young Sister, even though she is facing death by stoning, because someone has cared enough to give her glasses, '*Thick. Thick.* I could be an no one would give a fuck – I could be goin blind and no one wouldn't know no one wouldn't want wanna know – know to not give a fuck know to do that . . . ' (p. 45). Overhearing these tortuous and circling verbal barrages inflicted within their most familiar relationships, the audience also suffers the raw and relentless pain of

these damaged and necessarily selfish individuals who are in situations ultimately caused by the much larger geopolitical context to which the play obliquely alludes.

tucker green both uses and resists cultural specificity as a political strategy, disorientating the assumptions that tend to control responses to racialised – or otherwise categorised – voices in order to refer to widely applicable ethical structures. *trade* concerns the sexual tourism of white women in the Caribbean, and explores its alienating and damaging consequences. Three black actresses play a variety of roles, beginning and ending with three LOCALS, two of whom become the white females 'NOVICE', and 'REGULAR'. In many ways the play uses the women's voices to perform and unpack the practices of objectification that occur in the 'here' to 'there', and the 'we' and 'them' of the globalised sexual tourism industry.[71] While none of the characters have proper names, the audience witnesses their *naming*. Speaking chorally at first, as an interconnected group rather than as a collection of individuals, the actresses begin the play as three local women. A patterning of pronouns of place and person suggest themes of subject and object, and the politics of place. The women's accents perform a modulation, for example, from 'Me' to 'Meh', and subtly draw attention to grammatical dialectical differences, 'from who they are. From who they is' (p. 5). After a short opening sequence, one of the three black LOCALS becomes:

> 'The old/ "older"/ white woman.
> *"The Regular Tourist."'*

And another:

> *'"The Younger White Woman."*
> The first-time-over-'there' – tourist. *"The Novice."'*
> (pp. 6–7)

In this act of transformation the women are thus labelled, and in the following sequences each character is forced to confront, to defend or deny her self-deceptions, vanities or hypocrisies. REGULAR repeatedly emphasises that she is different from NOVICE. Forced to admit she is 'older', she can at least cling to the knowledge 'that at least I'm not . . . *her*' (p. 7). Her self-differentiation is also an effort to remain superior and apart, a familiar tactic of othering, whether on racial, sexual or as here, on the grounds of class and snobbery. At the end of the play, the process of naming circles round, confirming and re-fixing the white women's

names, again drawing attention to this othering device. Here, a chink of awareness surfaces, as NOVICE concedes to LOCAL, 'I didn't know about you', and REGULAR asks 'How does it feel?' (p. 61). With that the three LOCAL women re-emerge, reminding the audience of the changes of their own attitudes during the course of the play towards seeing three black local women, who 'juss', then 'just' live 'here' (p. 61). These shifts in accent and dialect draw attention to the othering process that can be practised through a language that articulates a culturally determined other. Their recognition invites the audience to acknowledge its own racially determined subject position, contributing to what Mireira Aragay and Enric Monforte term her 'ethico-political resubjectivisation' as she is encouraged to reflect on her own position as witness.[72]

tucker green's casting specifications contradict 'normal' – and potentially damaging – expectations of 'black' and 'white' speakers. Her retention of elements of representational dialogue is a strategy, enabling her to make strange the familiar norms of vocal representation. The script of *trade*, for example, requires actors to embody multiple roles, suggesting both familiarly individual, but also interlocking identities. The three black actresses play not only the locals and the tourists, but also a chorus that includes the native Jamaican hoteliers, the local woman's partner Bumster, whose services the white women buy, Bumster's friend, an American tourist, and others. Reversing and disorienting the norms of representation, *trade* makes us hear a multitude of voices through individual bodies, troubling the reductive processes through which we may make assumptions regarding the experience and identity of a person on the grounds of race, gender or class. In *stoning mary* too, the voice and its language are important means through which tucker green disrupts the norms which might blunt our engagement with others who are gravely affected by ethical issues that occur 'elsewhere'. A white HIV infected couple discuss who should have the single medical prescription they can afford. These voices have not been given the 'universal' language of standard English, and neither do they speak a distinctly 'black' dialect; instead the Estuary accents used in performance at the Royal Court suggest a specifically English location, although they deal with issues that might be presumed to occur in Africa. The technique not only severs the connection of the voice with race, but deliberately attaches the identities of the characters to a more place and context familiar to British audiences. The hypnotic cruelty of the dialogue, inflicted by people suffering upon each other, seems to originate not from the 'elsewhere' but from England itself. tucker green thus implies a transpersonal morality and political interdependence on a global scale

through both invoking and disturbing the norms of locale, proximity and vocal subjectivity. The polyvalence and intersubjectivity of her dialogue suggests ethical connections across distance, time and through bodies, regardless of aspects of personal identity that might elsewhere lead to a sense of a disconnected and compartmentalised society.

Critiquing the critique

Whatever the pitfalls of tokenism, the inclusion of Kwei-Armah, tucker green and Williams in the programmes of theatres such as the National and the RSC not only greatly improved such institutions' claims to cultural diversity, it gave these writers' voices much cultural prestige (a prestige that tucker green undermines by refusing media interviews).[73] Responses to their presence and the voices that they represented reveal much about the 'white tribalism' of the critics, as well as illustrating the rather narrow norms and expectations that their work negotiated as they entered these culturally prestigious spaces.[74] As I have discussed, appreciation of Williams' authentic dialogue was apparent, and just as many critics enjoyed Kwei-Armah's 'terrific ear for vibrant street-talk', or his 'pithy and potent' language.[75] Others were confounded by West Indian and urban dialect: Nicholas de Jongh was forced to call for a programme glossary.[76] The latter had in fact been provided 'to explain the words or phrases to the overwhelming majority of the audience members'.[77] Reviews of *Elmina's Kitchen* contained a very high frequency of comments on the challenge the voices of the play posed to auditory expectations of 'white' space.[78] These were typified by Spencer's comment, 'the West Indian street-talk means that for whities like me it is sometimes hard to follow'.[79] More recently, Roy Williams has stated his aim in *Kingston 14* (2014) at Stratford Theatre Royal to resist the 'tendency to dilute' a culturally specific dialogue so that 'everyone understands'.[80]

The old chestnut of quality as a shibbolethic standard of the British cultural establishment was also frequently rolled out. Whereas productions of both Williams' and Kwei-Armah's work were frequently praised for their realisation of Europeanised performance traditions, the plays themselves received mixed and indifferent reviews. Michael Coveney of *The Daily Mail* claimed he did not want to sound 'patronising' yet found *Elmina's Kitchen* 'not a very good play'.[81] Spencer found *stoning mary* 'thin'.[82] To Dominic Cavendish, reviewing *born bad,* the characters' 'stylised patois' of 'limited vocabulary and primary school-level grammar' is a 'homogenising device', yet he felt able to praise 'Kathy Burke's

production' that rips like a 'dynamite-blast through the Hampstead Theatre'.[83] David Benedict commented that the staging of *Sing* in its Loft space was a symptom of the National 'aspiring to the condition of pub theatre'.[84]

In the case of tucker green, though she seemed of all these writers to most fully possess the apparently prized qualities of a 'distinctive voice', admiration for the 'beautiful and jagged' qualities of her writing and respect for her craft were tempered by a dislike of a style that was perceived both as Spartan or austere, and as overly ornate and crafted.[85] What is more, its ultrarealistic qualities such as the sounds and dialect of colloquial speech and the overlapping, fragmented dialogue seemed to play against its equally apparent poetic and crafted aspects – qualities that were associated, often pejoratively in this period, with the literary 'voice' of the writer. Spencer, confessing to a 'jolt' in hearing the play's political point made through the play's use of Estuary English, pulled no punches in his condemnation of what he called the show's 'showy stylistic flourishes' and 'superficially vernacular dialect'.[86]

If some critics could not reconcile the complexities of tucker green's style and register, others were guilty of an inability or refusal to read the subtleties of the writers' political positions. Williams' voice was bluntly aligned with a culture of political correctness in Alastair Macaulay's review of *Sing*, which criticised the play's overly simplistic moral frame-work, putting its programming down to the 'bossy' government's fund-ing agenda and Arts Council pressure to 'deliver a young, working-class, ethnically diverse audience.'[87] *Daily Mail* reviewer Quentin Letts com-pared *Joe Guy* to: 'an episode of *Footballers' Wives*'. His quip that it must have been 'written by one of those earnest souls from the commission for Racial Equality' was precisely the kind of charge that both tokenised and denigrated its black writer.[88] (Coincidentally, *Sing* was indeed used to propagate values of diversity and tolerance in lessons in Citizenship, a theme to which I return in the following chapter.)[89] In other cases, Williams and Kwei-Armah were both faulted for not being politically cor-rect enough. Ex-Black Panther immigrant Darcus Howe's review of *Fall Out* condemned Williams' negative portrayal of the black community: 'This was not a slice of real life but of low life sketched for the delectation of whites.' Howe used the standards lever to attack the play: 'Somewhere in the Royal Court, the liberal dynasty abjures all the rules that make for good drama when it comes to plays about blacks.'[90] It was on the con-trary Williams' refusal to be beholden to the 'liberal dynasty' that led him to challenge it. He wished neither to regurgitate a set of 'wishy-washy liberal platitudes' nor be a 'spokesman for a whole culture'.[91]

Perhaps the most telling responses to the inclusion of black voices in culturally privileged space were aired on BBC Two's liberally minded Newsnight Review:

> He [Williams] has a great ear for contemporary speech. It feels very raw, juddering. It jumps out at you. Then again, it is very artful. The speech is beautifully patterned and the whole play has this great pattern of tragic inextricability as you drive forward to the conclusion, which has this real weight of tragedy.[92]

Somewhere in Natasha Walter's shift of focus from Williams' dialogue and the auditory and physical impact of its voices to the literary tradition of tragedy is the loss of her sense of its 'juddering' impact. On the same programme, Mark Lawson admits to being 'terrified' of meeting the actors from *Sing* outside the 'safety of the theatre'. He comments, 'If it gets to the West End, you would want to exclude certain people because of the wrong people coming in . . . '.[93] Lawson's prejudices (of class rather than race) reveal a desire to preserve certain kinds of theatre space for a certain privileged elite.

If the dynamics of acceptance and resistance to the voices of black writers and their characters were illustrated in the critical response of the period, the programming of these plays by black writers attracted black audience members, whose presence contributed to temporary changes to the vocal composition of mainstream spaces. Black audience members, according to Edwardes 'lapped up' the West Indian dialect that was 'hard for me to follow'. Suddenly, Edwardes was in the minority, struggling not only with an alien dialect, but with culturally alternative norms of response and behaviour.[94] Groomed within different practices these audiences brought shifts, provocative to some, to the oral and aural dynamics and textures of theatres' spaces. Their presence suggested further theatre's capacity to extend at least temporarily the sphere of representation by including a wider range of voices, as well as the very close relationship between the programming of a diverse range of artistic voices and the role of theatre as a representative artistic and political sphere with the ability and legitimacy to articulate and scrutinise the demos.

5
Sending Up Citizenship: Young Voices in Tanika Gupta, Mark Ravenhill and Enda Walsh

The responses of white critics to black voices articulated in mainstream theatre space reveal some of the culturally inflected structures of voicescapes that marginalised identities negotiate in becoming audible. Similarly, young voices mediated, represented and heard largely through adult practices, often reflect 'adult concerns', even when represented in theatre or other cultural forms that seem to give them a voice or represent their experience. In the 2000s, an increasing number of mainstream theatres chose to represent the voices of young people by commissioning work through adult writers. Often their subjects sounded deeply unhappy, causing many adult critics to feel, like Georgina Brown 'very glad I am not a teenager', or to reflect, like Patrick Marmion on the 'trials and tribulations' of teenage years.[1] 'Being a teenager in Britain today is like being in mid-air with a bust parachute', concluded Benedict Nightingale after seeing the Connections plays for young people at the National Theatre in 2006.[2]

Outside the empathetic spaces of theatre in the wider media, the representation of the young can often reflect fears regarding the degeneration and disintegration of society. In 2006, pictures of widespread rioting in France had dominated television news, and in 2007, an article in the *New York Times* noted the tabloid depiction of young people in Britain itself as '"hoodies" or "chavs", feral youths bent on binge-drinking and delinquency'.[3] A wide variety of academic discourse has linked the cultural marginalisation of the young with this crude type of representation and 'moral panic' discourse. To Charles R. Acland, young people's voices have been treated by adults as an 'empty significant', made to represent adult concerns particularly regarding the dangers of the young to society.[4] In a British context, according to Peter Trudgill, young people's voices are the most stigmatised of society.[5]

This stigmatisation obscures the behaviour and identities of the young, and is often exercised through judgements regarding the way young people choose to speak and how their voices sound. In this tradition, deviances and deficiencies from 'proper' English become signs and symptoms of moral and behavioural deterioration, rising crime and slipping standards – fears that according to linguist David Crystal were particularly strong in the 1980s.[6] Such judgements pose a challenge to those who believe that in order to bring about a socially cohesive and functional integration of the young, their voices must be heard and heeded by adults, regardless of the value to individuals or to society of a training in 'proper' or standard English. Leo Butler's isolated and alienated heroine of his 2001 play *Redundant* puts it succinctly: 'Shit bein' seventeen int it? Never take us serious.'[7]

In liberal adult discourse in the 2000s, the role played by the demonisation of the young in their social exclusion was increasingly recognised, and the solution of inclusion and representation proposed. Martin Narey, Chief Executive of Barnardos charity noted a causal link between the view of youth as 'feral', and their social marginalisation.[8] Sociologists such as Christie L. Barron noted that the 'reality' of young people as a group 'has been excluded from the dominant discourse'.[9] Similarly, Kathryn Herr lamented that adolescents were not considered 'viable partners or creative collaborators in the social fabric of the country'.[10] International research and policy, during this broad period of empathy in Western Europe, emphasised the importance of extending to the young the period's values of self-articulation, inclusion and audibility. In 1991 the UK had signed the *United Nations Convention on the Rights of the Child* that had established that children should have the right to express views freely through writing, speech or art, as well as being given a role in their own governance.[11] Such principles appeared to inform New Labour's approach to citizenship, education and the arts, where young people could learn to express themselves and participate in a democratic forum. Yet at the same time, measures introduced by the party, such as its 'respect agenda', ASBOS and Dispersal Zones, which gave the police the right to move the young on from designated areas, as well as the growing use of CCTV cameras, seemed to be symptomatic of rather more coercive tactics to promote and secure appropriate behaviour.[12]

The idea of giving young people a voice has long been established, for example through movements such as theatre in education and youth theatre, and tend to work through participatory principles. Jeremy Weller's applied theatre project *The Foolish Young Man* (2006),

for example, sought to give young people the opportunity to represent their own experience directly.[13] Produced in what Richard Ings calls 'middle-class space' at the Roundhouse in Camden, the work aimed to reverse the dynamic of a traditional theatre process in which an actor *constructs* a role, allowing a marginalised young person to *drop* the role that society has given them (a view that recalls the idea of the false personality that I discussed in relation to black voices in the previous chapter). According to Ings, direct contact of a theatre audience with such voices challenges the 'danger' posed by the marginalised and which can in traditional representative theatre be diffused through the safety of conventional process and empathetic reception.[14] This outcome would seem to align well with liberal impulses to include rather than demonise the young, and to allow young voices to use their own voices to negotiate mainstream process and spaces. Such work however is often 'ghettoised', and is rarely heard in culturally privileged space.[15] Instead, young voices and their experiences have been more likely to be represented in the tradition whereby adult writers 'authentically' construct their voices.

From the 1990s and 2000s, television dramas in which young people dominated or had equal status to adults, such as *Hollyoaks* (Channel 4, 1995), *Shameless* (Channel 4, 2004), and *Skins* (E4, 2007), became highly popular, repositioning young people's voices in cultural, not to mention economic terms. In 2001, following Boyden, there was a 15 per cent injection of funds to youth theatre, and as part of the burgeoning new writing sector, adult writers increasingly chose young people as their subjects, empathetically representing young characters' anxieties, isolation and pain. Simon Bent's *Bottle Universe* of 2005 depicted the unlikely friendship of suicidal 'posh' girl Lauren and foul-mouthed bully Cock Dave.[16] David Greig's *Yellow Moon* (2007) told the story of teenage runaways self-harming Muslim girl Silent Leila and small town no hoper Stag Lee.[17] Similarly, the plays that form the focus of the present study present teenage protagonists largely marooned from wider or adult society. Tanika Gupta's *White Boy* (2007), commissioned by the National Youth Theatre and produced at the Soho Theatre, depicted the racially hybrid voices of the urban young, and a crisis of identity for young whites in particular. Mark Ravenhill's *Citizenship*, produced as part of the National Theatre's 2005 Connections series, portrayed the painful and lonely transition of a confused young man to adult life. Enda Walsh's *Chatroom*, produced in the same series, followed the path of a traumatised child through parental abandonment and cyber bullying. These productions arose from large participatory

projects by the National Theatre and National Youth Theatre, and as such occupy an ambivalent territory, apparently initiated through the desire to empower young people's voices, but also conforming in part to the commercial and hierarchical values that dictate the operations of showcase events in the economies of prestigious mainstream theatre space. I explore how the presence of young voices altered the tone and texture of these spaces, while also being modulated and mediated via adult practice and response. I argue that the productions not only point to a tendency on the part of adults to focus their own concerns through the deviances of young voices, but also illustrate the assumption that the inclusion of youth in adult society is a cure rather than the cause of youthful woe.

White boy, adult voice

In 2007 Tanika Gupta was commissioned by the National Youth Theatre as part of its Generation ID Season at the Soho Theatre to write a 'relevant current play' about 'what it means to be young and British today'.[18] *White Boy* portrayed the fatal stabbing of a talented black school hero by a desperate Sudanese immigrant, and was based on the real life event of the murder of promising young black footballer Kiyan Prince. Central to the portrayal of Gupta's young characters, and the opportunity they seemed to have been given to speak for themselves, was their use of the urban voice, a style of speech heavily influenced by black street dialect, and also used to lend 'authenticity' to the voices of young characters by other playwrights of the period, such as Roy Williams and Bola Agbaje.[19] This was a contemporary 'colour deaf' way of speaking, and contrasts to the 'oldee worldee lingo' that the characters claimed they were forced to use in school.[20] In *White Boy*, Gupta captures its punchy tempo, sharp wit, sass and cynicism. Contemporary colloquialisms abound, characters self-styling their illegitimate activities, fighting and kissing, as 'mashing up', and 'lipsin' (pp. 10–13).

Yet Gupta's young characters inhabit a frightening, poverty-stricken and lawless environment, barbaric and remote from adulthood. The action of the play takes place in a peripheral, graffiti covered and semi-criminalised space outside the school gates, and is constantly under CCTV surveillance. A 'high wire-mesh fence' creates 'prison-like' school gates (p. 9). The play begins with the arena's behooded and bloodied inhabitants engaging in a 'vicious' fight, in which support is shouted for Flips, a 'rough' sixteen year-old white 'school bully'. His opponent, Mohammed, is 'mashed' as his girlfriend is rumoured to have given Flips

a 'blow-job' (p. 7). Perhaps unsurprisingly, Alison Roberts' article on the play in the *Evening Standard* was sensationally entitled 'London's Teenage Crisis', framing the play in the tradition of 'moral panic' discourse associated with youth.[21] Sixteen year-old Shaz's complaint suggests the source of the problem – 'We don't have the vote anyway – not for two fucking years' (p. 39) – and echoes the well-intentioned concerns of adults regarding youthful alienation from adult cultural and political life.

This violent and largely amoral world appears in many ways to confirm adults' worst fears of the link between urban teenagers and the deterioration of society. At the time of the play's production, this was not being blamed so much on the lack of self-discipline amongst the free loading and feckless underclass, as on a sense of social deterioration linked to a narrative of endangered whiteness identified by Paul Gilroy in the wake of 9/11 and the wave of discontent with New Labour's multiculturalist emphasis.[22] Within this climate the use of an urban voice by youths of all races became associated with fears of racial miscegenation and of an increasingly influential black culture at the expense of white.[23] White boy 'wigger' Ricky's laments his feelings of racial inadequacy, 'so many kids in our class got history, countries, stories and different languages [. . .] mek me feel . . . dunno . . . I only speak English [. . .] Ain't cool to be white no more' (p. 25). This speech, performed by white actor Luke Norris with a West Indian accent described by Nicholas de Jongh as 'impeccable', suggested a young person whose choices of language were masking and perhaps causing a sense of alienation from his 'true' self.[24] The use of the urban voice in *White Boy* as a symptom of a false identity, and the linking of a particular and 'proper' way of speaking with racial provenance, suggest that both individual anxiety and social dysfunction can be diagnosed through young people's choices to ally themselves through their vocal and linguistic choices to the 'wrong' race.

Gupta's comments in a newspaper interview confirm her belief that the way the young speak shows that they have 'lost their identity'. As she puts it, 'the way they speak is not actually who they are'.[25] This once more invokes the notion of speech as a form of self-alienation as used by Kwei-Armah in the construction of black voices, and recalls Goffman's idea of the performative self discussed in the Introduction to this book. To Gupta, the choices that young people make about the way they speak not only discredit them, but somehow obscure or mask a 'real' or 'lost' identity (a view also shared by Weller and Ings, as I discussed above).[26] Such thinking implies that the self-disclosure offered in theatre offers a version of Giddensian intimacy, a chance to reveal one's

genuine self to another who will support and accept the 'real' version. While the use of the voice as a means of creating a usable identity does seem particularly apposite to the needs of young people, whose management of the changes from child, to adolescent to adult, necessitates experimentation with new and transitional identities, to believe that young people can 'be themselves' more easily in theatre space than in the outside world is perhaps to overlook the ways in which young people might use their voices in creative and positive ways to manage these periods of change and to build a sense of individual and group identity.

Looking at the work of sociolinguists reveals alternative and positive ways of hearing young people's voices (as well as the multivalent black voices of the previous chapter). For example, for Stacey Duncan, the code switching at which many urban youths are so adept, and which allows white youths to use black forms, is far from signifying a loss of identity. Rather, it is an act of 'interactional social accomplishment'.[27] Similarly, for Ben Rampton, the urban voice is evidence of young people's inter-ethnic solidarity, social skill in 'language crossing', and their negotiation of fluid identities in a changing and heterogeneous world.[28] Such thinking implies that the urban voice, in its meshing of sounds and language, can be heard not only as a virtuous act of multicultural citizenship, but also as a challenge to attitudes that fix the identity of a young speaker to stereotyped assumptions regarding the sounds of their voices. In spite of her own writer's skill in capturing the dialects of voices other than her own, Gupta's suspicions of 'wigger talk' disallow such potentially positive articulations of youthful identity and young communities. There are perhaps some parallels here between her own resistance to pigeon-holing as an 'Asian writer' and the way young people's exuberant and transgressive speech slips away from fixed and conservative social expectations that link standard ways of speaking with conformity to white adult standards.[29]

In the absence in *White Boy* of the vocal means to structure the positive identity of young people, Gupta's characters were left, in terms of verbal articulation, with nothing more than a 'bust parachute'. Rikki's anguished cry, 'I try and fit, I try and bend to mek myself a part of you', is expressive of an identity neither comfortably stable, nor excitingly fluid, but desperately agonised and lacking in the resources (p. 61). These naturalistic teenage voices, intended to represent authentically the world outside of theatre, spoke of the helplessness and dysfunction of those portrayed. The reception the actors received however points to an inconsistency in the responses young people's voices elicit from adults: a young actor's ability to use an accent that is perceived credibly

is highly prized as a sign of a promising talent. Yet it is an ability that adult discourse often reviles when used by the young on the street. In *White Boy*'s notices, praise and validation were meted out to the young actors' performance skills. De Jongh admired the young performers' 'emotional truth, spontaneity and naturalness'.[30] Sam Marlowe admired their 'insight and authenticity', and their performance of 'passion and intensity'.[31] These are not responses to voices that are 'raw', but to voices that have been mediated by writing and rehearsal, by directors, voice specialists and producers, by theatre spaces themselves, which are permeated with adult expectations, values and practice.

Although this play gave teenagers a rare chance to perform in a mainstream space, its production raised ethical issues concerning the theatre industry's representation of apparently inarticulate but 'authentic' voices. Writing about the middle-class theatre industry more generally, Aleks Sierz notes the dubious morality of its attempts to portray 'gritty naturalistic plays' whose 'authenticity' is based on the depiction of 'working-class or underclass characters'.[32] The effect of *White Boy* was to disqualify the urban voice as a means for young people to articulate individual or social identity. By contrast, the play incorporated acculturated and privileged forms of articulation of which adult society tends to approve in the young, enabling the actors to 'showcase' their 'talent' according to middle-class adult norms.[33] The failure of Gupta's characters to use representative speech to articulate their identities positively and confidently, as well as the Soho Theatre production's endowment of opportunity to only a limited group of young voices, suggests that in spite of the way the National Youth Theatre's ID project had engaged a very wide range of young people in schools and communities, mainstream theatre in some ways replicates the structures in society that enable a few to enter an elite circle, while excluding many from its most prestigious cultural spaces.

Citizenship and the induction of young voices

If Gupta's portrayal of excluded and segregated young voices seemed to disqualify their ability to express their identities positively, the young voices of Ravenhill's *Citizenship* (Figure 5.1) suggested a complex relationship between young people and what Ravenhill described as the valueless 'liberal, postmodern consensus' of the adult world.[34] Ravenhill's play contains a direct response to New Labour's attempts to use the education system as a means to instil its ideologies into the young. In schools, from 2002, the introduction of Citizenship classes

Figure 5.1 Claire-Louise Cordwell and Sid Mitchell in *Citizenship* (2005)

had been an attempt to combat the 'worrying levels of apathy, igno-
rance and cynicism' about social participation amongst young people.
As a 'preparation for adult life', the subject was intended to educate the
young in the values of democracy, and encourage them to behave in
morally virtuous ways within the community.[35]

Ravenhill's play suggests that in practice the teaching of Citizenship
was a species of irrelevant rhetoric, with little to offer the young. The
play's young protagonist, Tom, literally and symbolically bleeding over
his Citizenship essay, 'What does a Multicultural Society Mean to Me?',
is told by his ironically named Citizenship teacher De Clerk to write
it out again.[36] Under pressure from school inspectors, De Clerk's adult
voice is a veneer of platitudes: 'You know the school policy: we celebrate
difference. You report bullies. Everything's okay. You're okay.' The ver-
bal interactions of Tom and Amy by contrast, both highly confused and
unhappy adolescents, are highly volatile and emotional. Amy's voice is
particularly fragile, her admission that she cuts herself, ''Cos I am totally
useless', a bald statement of the lack of self-esteem caused by poor and
unloving parenting (p. 219). The young characters' attempts to com-
municate quickly give way to the physical, hugs and fighting, leading

eventually to sex. The result is yet another of the teenage pregnancies of such great cause of concern to adults in the period, and one that results in a giant baby (played by a member of the cast of young people). Similarly, amongst the boys, communication is on the most basic of levels. Stephen and Ray's young voices are monosyllabically brutal as they bully Tom into punching his 'wigger' friend Gary, 'Fight fight fight'. When Gary tells them they 'chat shit', they retort that he is 'chatting gay' (p. 222). As in *White Boy*, this urban street lingo is associated with the feral, bigoted and pre-civilised habitat of youth. Segregated and abandoned by adults, the young enforce a barbarous regime of intolerance, homophobia and cruelty, far from the 'very supportive, very liberal, very friendly' behaviour of which Ravenhill approves and of which he also shows they are capable.[37]

Ravenhill's portrayal of such uncivilised behaviour on the part of the young raises similar concerns to those of *White Boy*. Rather than use issues of race and ethnicity as the main focus of adult anxiety however, *Citizenship* uses Tom's confusion over his sexual identity as a conduit of cultural anxiety. According to Sarah Jane Dickenson, Tom becomes a 'metonymic boy figure' that unites 'vulnerability' with the 'persistent cultural sense of threat' perceived by society in homosexuality.[38] Dickenson's point is astute, perhaps given the introduction of civil partnerships in 2004 only four years after the repeal of Section 28 which had banned the promotion of homosexuality. Yet, an analysis of how Tom's voice was constructed by the actor and received by audiences reveals how theatre processes deflect or assimilate any such cultural anxiety. Actor Sid Mitchell performed Tom's voice with the 'transparency' associated by voice therapists with children's voices, and a quality, as I have suggested, that is highly validated in theatre space.[39] In the case of Tom, this transparency seemed to evoke the unself-interested blamelessness associated with childish speech: 'I have this dream,' he revealed, honestly, openly and straightforwardly, 'And in this dream I'm kissing someone. Real kissing. Tongues and that. But I can't see who I'm kissing' (p. 232). Such confessions invoked largely positive judgements from the play's adult critics. In fact Spencer found Tom a 'likeable' teenager, and Kate Kellaway that he was 'disarmingly played' by Mitchell.[40] If anything, it was younger members of the audience who were more offended. When I saw the production, some sections of its young audience were exuberantly vocal in their surprise and disgust when Tom kissed his gay lover.[41] Such responses are not only revealing of the play's complex identity politics, but also of the kinds of behaviour and values that liberal adult society is prepared to tolerate.

Ironically, its staging seemed to reveal a greater conservatism amongst the younger members of its audience, confronted with a representation of a stigmatised sexual behaviour otherwise excluded from their education in citizenship.

This is not to suggest that Ravenhill portrays the values of adult society as wholly desirable, as Tom's induction into an ethically suspect adult world suggests. His lover, Martin, is a professional adult with a boyfriend, a job, and is looking for 'money', 'fun' and 'sex' (p. 262). Tom, new to gay sex, and uneasy with the idea of promiscuity, is now more guarded. Having lost the disarming openness of the schoolboy, Mitchell's presentation of Tom's voice betrayed the character's anxieties through the performance of inner uncertainties. The subtext of his claim, 'I'm fine, I'm just fine', implied that he was feeling quite the opposite (p. 262). Tom's entry to the adult world was therefore signalled by the divergence between his feelings and his speech, and the construction of a complex vocal identity that protected, disguised or masked his inner self. The change implied that this divergence of language and voice was a necessary response to the dangers of the adult world, rather than, as in *White Boy*, symptomatic of the false expression of youthful identity.

In spite of the tendency of adult reviewers to neutralise the complexities and potential dangers of the characters' passage into the adult world, the introduction of young voices into the National Theatre seemed to result in some changes to the adult values predominant in its auditorium. Responses from adults identified a certain youthful sensibility expressed in the tone of the play and the attitudes of the speakers. Rachel Halliburton, commenting on the Connections productions generally, thought that in the plays' scripting writers had been able to release 'a more honest register of emotions' and 'greater playfulness'. Similarly, Sheridan Morley commented that the writers had 'plugged themselves into the complex rhythms of colloquial teenage speech and attitude'.[42] Anthony Banks, who as head of the Connections project had been closely involved in the development of *Citizenship*, identified its special youthful quality as 'flippancy', a style and tone that made the play 'immediately accessible' to its young audiences.[43] Indeed, on the theatre's *Citizenship* microsite (albeit part of the play's marketing) enthusiastic responses by members of its young audiences testified to its success in its attempt to 'represent us'.[44] Its flavour of youthful flippancy is seen in Tom's description of De Clerk's appearance through a wall as 'a bit gay' (p. 251). This is not only the type of politically incorrect phrase used by young people to undermine the worthiness of adult

treatment of matters concerning sexual identity, but elicited laughter from the play's young audiences which was a vital part of its disruption to the earnest norms of adult space. Its flippancy indeed, suggested a throwaway treatment of the extreme tribulations of teenagehood, and was shockingly different from the tone of adult discourse that surrounded these issues. The teenagers' unhappiness was kept 'light', their emotion if anything underplayed, difficult moments for its protagonists quickly evolving into something funny, strange or facetious. All of these tactics both evoked and resisted the dominant perception of youth by adults as unhappy as a result of their alienation. A playfully subversive and markedly youthful set of values had entered adult space, countering the ways in which it propagated adult concerns. The construction and performance of these specifically young voices both flattered and temporarily replaced the dominant, and in this case, adult conditions of theatre's voicescapes.

In the broad context of the greater inclusion of young in mainstream theatre, some reactions revealed its spaces as highly territorialised. Amongst adult critics, for example, Rachel Sheridan observed that White Boy was not 'geared' to her.[45] A sense of territory was also present amongst some practitioners – for example, amongst those responsible for the ways in which young voices are nurtured for theatre space. At The Contemporary Voice conference for Voice Teachers in 2006 held at Central, one delegate confessed to fearing that the acceptance of the use of the 'urban voice' represented the 'displacement' of adults from the 'cultural centre'. Another felt that the prevalence of the urban voice led adults to feel 'excluded'. Some delegates were quick to associate this way of speaking with perennial adult fears of the deviant and criminal behaviour of youth, their use of 'drugs' and access to 'too much money'.[46] On the other hand, and in spite of these adult strategies to stigmatise young voices, there was evidence of a willingness amongst other practitioners to tolerate the kind of 'linguistic relativity' that Duncan argues is necessary to allow young people to define themselves creatively, as well as to adjust practice according to the ways in which young people chose to speak.[47] Citing the high rates of self-harming amongst the young, a tolerant, supportive and sympathetic 'voice community' was urged by keynote speaker Ros Steen.[48] As the Conference recognised, Steen's remarks implied adjustments to teaching practice with regard to pronunciation and articulation, particularly with regard to RP as an industry norm.

Given these ambivalent and in some respects contradictory adult responses to youthful inclusion, it is worth pausing to reflect more on

the assumptions made by adult society on the worth and function of participation as a cure all for youthful woes. In 2007, a report on 'child well being' by UNICEF put Britain last in terms of its claim that the 'true measure of a nation's standing was how far its children felt loved, valued and included'. The report included a section expressing the 'views and voices' of 11–15 year olds themselves, placing the feelings of 'social exclusion' and of being an 'outsider' in its scale of well being.[49] There are parallels here not only with the work of applied theatres, where a belief in the value of participation as a stimulus to an empowering life experience for marginalised groups has been all important, not to say with the participatory politics that New Labour aspired to, with its emphasis on the democratic participation of all voices. As I have discussed, the ideology of its key philosopher, Anthony Giddens, suggests vocal participation was at the heart of its vision of democracy. Throughout the New Labour period (although the age of suffrage remained at eighteen), young people were encouraged to participate in the Arts, and urged to express their voices as part of the political process.[50] A rhetoric of the empowerment of young people adorned the party's public discourse, expressing concern with the self-confidence and well being of the young. Boyden, for example, claimed that participation in youth theatre would enable young people to develop their 'creativity and self-confidence'.[51]

Cynically speaking, New Labour's efforts to construct a safe civic society by encouraging the participation of young people in the Arts can be seen as a way of combating young people's affiliation to the alternative, and sometimes criminal, 'markets' described by Bourdieu in his critique of the 'game' of participation.[52] The increased tendency of youth to become the subject of theatre could therefore be seen as a means of social protection from those that might be otherwise alienated (and dangerous). In the light of the present discussion, the party's efforts can be seen as a liberal response to the perennial adult anxieties regarding the ways in which young people relate to adult society. John Deeney's article on the National Theatre's New Connections plays makes this case, discussing the mechanisms by which mainstream theatre practice might conjure young citizens according to state sanctioned economic and philosophical models.[53] In fact, for the previously and in some senses voluntarily marginalised voices of the young, entering theatre space creates a fundamental tension. On the one hand, inclusion provides opportunities for greater audibility and self-definition. On the other, participation suggests compliance with the adult solution to the problem of youthful discontentment, and thus with the other adult values that permeate and regulate theatre space.

During the period the National Youth Agency reported considerable 'public anxiety' around young people's refusal to participate.[54] Yet at the Writernet conference in 2008, Peter Rumney of the youth company Dragonbreath gave his view that young people's lack of participation could be seen as a self-defining choice.[55] This was a rare and controversial admission, acknowledging the potential irrelevance to young people of adult provided participatory projects for the young. Unsurprisingly, young people were generally much less convinced than adults of the value of participation in the Arts.[56] As Joel Horwood pointed out, young people's 'failure' to participate in youth theatre was quite often a result of ambitions that exceeded the parochial remit of participatory theatre. Indeed, Horwood reported most enthusiasm amongst Hackney's young people for the use of their voices and language in films rather than theatre.[57] Adults' efforts to enforce youthful participation sometimes failed to see the ambition or logic of young people's decisions not to subscribe to the principles of much youth and participatory theatre, or the attraction of young people to the less acknowledged selective or commercial values that regulated adult frameworks.

In the case of the Connections programme, which resulted in the production of both *Citizenship* and Walsh's *Chatroom*, young people's decision to participate was made for them or in conjunction with the teachers in the schools that joined the project. In spite of its openness at its base, in some ways, the structures of this programme can be seen as indicative of an industry whose structural principles were unapologetically based on notions of 'quality' and hierarchy. Open to hundreds of schools throughout the country, the scheme undeniably included many young people, producing new work specifically written for young voices.[58] However, the principle of quality was used to disbar the young from producing their own scripts. Instead, established adult writers 'secure in their own voice', were selected and commissioned by the theatre management.[59] According to Suzy Graham-Adriani's introduction to the 2005 volume of the plays, the scheme aspired to use 'the best scripts by the best writers'.[60]

Similarly, in terms of performance, the project allowed a very small group of companies access to the National Theatre's space. Rather than the participating schools, the prestigious and highly selective National Youth Theatre were given first choice of the plays for production.[61] Most tellingly perhaps, the schoolchildren who performed the plays selected in 2005 were replaced by drama school graduates for the plays' revival in 2006 (a decision that according to Banks was made mainly for pragmatic and legal rules governing the use of minors for performance).

Nicholas Hytner's decision to replace the schoolchildren, according to reviewer, Fiona Mountford, had 'sprinkled' the productions with 'stardust'. Such gushing responses to the evening's showcase of 'talent', of which Mountford's is one of many, heralded the imminent assimilation of new young voices into the heavily commercialised entertainment industry.[62] Once included in the National's space of privilege, these 'artists of the future' gained access to the industry.[63] His phrase is revealing of the way this privately sponsored scheme can be seen as a means of selecting those individuals deemed worthy of future industrial success. In spite of its inclusiveness at the lower levels, the scheme's pyramid structure of selection and privilege encouraged an assimilation to an industry which functions at its own most prestigious end according to principles of selection and competitive individualism rather than equality. Again, the project draws attention to the way theatre's most exclusive spaces often represented the young as unhappily excluded. Such exclusion means that the idea of participation becomes a rhetorical strategy or pipe dream: a privilege for the few rather than a principle that includes many.

Chatroom and the means of representation

The production of *Citizenship* and *White Boy* both reveal the complexities and relative narrowness of the terms under which young voices were invited to express themselves. Walsh's *Chatroom* addressed explicitly some of the ethical issues raised by the inclusion and representation of young people in adult cultural space. Portraying another contemporary version of Golding's island, unpoliced and apparently isolated from the adult world, this production used the encounters of six middle-class teenagers in chatrooms to express young people's attitudes to their status as clients of adult consumer society, their attempts to take control of their own representation, and the apparent impossibility of an unproblematic and happy transition into the adult world.

From the play's outset some of the teenagers take issue with the abuses to which they felt the young had been subjected to by adult representation. According to the highly cynical William, children are patronised, deceived and victimised by literature for children that fails to represent the 'real' world. Guilty, according to William, of wanting to 'keep us young' and stopping us 'thinking for ourselves', JK Rowling is the 'enemy' and needs to be 'taken out'.[64] Eva and Emily's discussion, about some 'pervert record producer' trying to sexualise all eight-year old girls, pointed to another adult strategy to exploit children (pp. 159–61). For

William, it was the draining influence of adult run media and literature that had resulted in teenagers being alienated and excluded. Deprived of full humanity as a result of being represented as a 'sub-person', a teenager, according to William, is reduced to a 'hormonal mess [. . .] a bad experiment'. Feeling manipulated, exploited, and deprived, William is motivated by a mistaken and dangerous need to reclaim the 'embarrassing joke' that adults have made of the 'voice' of youth (p. 186).

In many ways, given the host of comic caricatures of hormonal teenagers that the period spawned, William makes valid arguments about adults' representation of young voices.[65] His own means of articulation by contrast, are far from inferior or inadequate. Ignoring the tendency to construct young voices naturalistically, and in contrast to the way he had created young voices linked specifically to place in *Disco Pigs* (1996), Walsh gave William a teenage voice that was highly articulate, persuasive and sophisticated. This enabled the writer to imbue William's young voice with adult powers, challenging common perceptions that tend to delegitimise or limit young people's powers of expression. Adult interviewer Jim Mulligan for example believed the 'stylised and artificial' nature of William's language rendered it incredible from a 'fifteen year-old'.[66] Rather, its sophistication attacked the narrative of innocence that according to Barron is associated with young voices and deprives them of the right to be 'competent articulators of their own experience'.[67] William rails against such patronisation, and representations of adolescence by adults that are ridiculous, awkward and laughable. Styling himself an 'angry cynic', and frustrated at the other teenagers' complacency, William wants to reclaim the teenage right to 'stand for something' or to do 'something important' (p. 168).

Chatroom explores the consequences of the segregation and exclusion of the young. Rather than disengaged or apathetic, William's voice, without a positive outlet, becomes twisted, convoluted and deceptive, demonstrating the most distrusted features of the voice, and skilled in the arts of manipulation that its speaker has himself condemned in the adult world. Unsurprisingly, when the lonely and depressed Jim enters the chatroom, the younger boy becomes William's 'project' (p. 187). Like Tom's voice in *Citizenship*, Jim's voice is simple, colloquial and transparent, avoiding features that might alienate it to adults. 'Maybe I shouldn't even be in this place' he tells suicide chatroom host Laura, with an honesty, simplicity, and unaffected quality (p. 161). Abandoned by his father and distant from his mother, Jim's story speaks of a vulnerable and isolated young person. Under William's tutelage, the other teenagers make him prey to the exploitative representative strategies

they have learned from a cynical adult culture. They set about spinning Jim's life, effectively packaging the perfect teenage suicide statement. Reading their notes back to him they produce a crude and cruel version of his sad personal history, 'One momentous day, your father leaves you in the zoo leaving the family in the shit' (p. 179). Jim's teenage story, with its 'This-is-Your Life' tone and film-pitch reductionism, makes a mockery of the misery that Jim has suffered, and demonstrates the vulnerability of his voice to exploitative and false representation by others.

It is in fact Jim's inability to act, to perform an identity, or to take on a role, that makes him so vulnerable. During his account of his role as 'gay icon' St John in the local church Passion play, he explains how he was totally unable to separate his performance as John from his very real and desperate conviction that his mother 'hates' him (p. 163). As in *Citizenship*, this incident was related with a humorous irony, which evoked the audience's empathy, but resisted the elicitation of sentiment.[68] As the play progressed, Jim was able to overcome the passivity of his victim status, by attempting his own act of representation. Rather than complain that no one was listening, Jim surprised the other young characters as well as the audience, making and performing in his own film, thereby seizing the means to represent himself. Jim's choice of cowboy costume for his film was nostalgic, recalling his lost childhood, and expressing a yearning for a simpler time. The Raw Hide soundtrack, with its strong and simple heroic vocal style evoked a lost world of 'Good vittles, love and kissin'' where identity could be established through the making of straightforward and simple statements. The film's location by contrast was a white and shiny McDonalds, in which all the teenagers were present looking happy and fulfilled. It was a vision that recalled and potentially revised the fantasy McDonald's heaven they had discussed earlier, when they had concluded their childhood belief that 'God created everything is six days' was 'shit' (p. 166). Through this film, Walsh evoked a world in which the values of heroism, fantasy and mythology were mixed with commerce and commodification. Yet the result was a joyous, ironic and individualised act of identity construction that spoke of both the potential and the impossibilities of self-definition for contemporary teenagers.

After the film, Jim and Laura found themselves outside the chatroom. Here they communicated directly, and were clearly free of distorting or harmful adult discourses. In response to Jim's question, 'Will we talk about something?' 'What will we talk about?' they decide to talk of 'bunny rabbits' (p. 195). This conclusion suggested that Jim's film, in spite of the fantastic act of self-transformation it represented,

had revealed a representational impasse for young people. Although the film was a triumph, it was a fantasy from which Jim's own voice had been notably absent. Unable to find a wholly satisfactory means of self-expression its author was deposited back into childhood. Yet this reversion was redemptive, appearing to offer the damaged but resilient young hero and his new friend a second chance, in spite of their emotional difficulties. While recognising the difficulties teenagers would face in establishing an individual and robust identity, Walsh's ambivalent ending expressed belief in their capacity for epic courage, self-reliance and mutual support.

If the escape of Jim and Laura did not safely integrate them vocally into the adult world, as with the other plays I have discussed here, its production did allow its young performers to succeed in terms of the validation of their voices in theatre space. Andrew Garfield's rendition of Jim's failed performance, for example, was delivered directly to the audience, rather than through the conventions of a theatricalised chatroom, allowing the character to reveal his unhappiness with straightforward sincerity. Using the 'transparent' delivery I have described, Garfield played this account as both a gently humorous and unmanipulative act of bravery. As with Mitchell's performance of Ravenhill's Tom, the apparent simplicity of this vocal performance gave Jim's young voice enormous power within the auditorium. His articulacy was overwhelmingly praised by adult critics. Garfield's performance was, according to Billington, 'unforgettable', to 'Paul Taylor, 'indelible', and to both Halliburton and Marmion, 'impressive'.[69] Four years later, Garfield was cast in *The Social Network* (2010), a highly successful film about the founding of the kind of social networking site of which chatrooms had been precursors. As with Citizenship, and to a certain extent *White Boy*, the production of *Chatroom* had enabled some of its young actors to elicit an empathetic reaction from audiences and critics, and begin to establish their careers in the performance industry.

In *White Boy, Citizenship* and *Chatroom,* all mid 2000s plays of a time in which young people's voices were becoming more audible in prestigious cultural space, acts of vocal bravery, honesty and intimacy between young actors and audiences established empathy for individual performers, although young people on the whole were cast at worst as feral, at best as inadequate, unhappy, or dysfunctional. Often vocally 'transparent' qualities elicited adult approval, while language that young people used to differentiate themselves from adults, as in the case of *White Boy*, was presented as false, inadequate or incomplete, achieving only a qualified legitimacy as a means for young people to

express and explore their identities in their own voices and language. On the other hand, *Citizenship* brought new tones and vocal textures to the National Theatre, and served to expose some of the shortcomings of the adult world, while *Chatroom* scrutinised the exploitation and commodification of young people, articulating the pain caused to them by their awareness of it. Generally, the representation of the young in the new plays of the period exposed the flaw in the adult liberal assumption that increased opportunities to be included and to participate would lead to greater well being of young citizens. Rather, the increased representation of the young in theatre dovetailed conveniently with theatre's efforts to widen and rejuvenate its audiences. In this light, and as Walsh's play implies, the pain expressed by young voices might be linked not so much to their exclusion, but to young people's awareness of their status as potential clients of an adult society which increasingly in this period monitored, restricted and regulated their voices and movements through both physical restrictions and through its assimilative tactics.

6
Women Who Kill Children: Mistrusting Mothers in the Work of Deborah Warner and Fiona Shaw, Beatrix Campbell and Judith Jones, and Dennis Kelly

Having explored the sounds of Scottish voices in the wake of devolution, the negotiation of norms by black voices as they were included in mainstream space, and the pressures on young voices to participate under New Labour's empathetic regime, this final chapter turns to the theme of betrayal, a climate that began to pervade public discourse in the latter years of Tony Blair's period as Prime Minster. It does so by attending to the representation in theatre of women who have killed children – or been accused of this – and thus violated what society perceives as a fundamental human relationship based on intimacy and trust. I argue that in the construction of the voice of the female child killer in the voicescapes of theatre in this period we can hear 'cultural evidence' for the shift from an empathic inclusive context for otherwise stigmatised individuals to a climate of betrayal in response to the perceived lack of transparency in the political representative process. This betrayal was articulated in the deceitful voice of the murdering mother, whose seductive or transparent language traditionally disguises evil intent.

While feminist thinkers such as Hélène Cixous and Peggy Phelan have cast the voice of motherhood in a central psychosomatic role in the development of human subjectivity, the voice of the female killer of children violently transgresses this principle of female nurturing.[1] Her voice is highly stigmatised or silenced, and when represented, like a rarer and more extreme individual version of the voices of the feral young, it represents a deathly and insidious threat to society's most precious and vulnerable beings. Her voice is rarely directly heard, and if the mother is an 'absent present', as Ann E. Kaplan suggests in her study of *Motherhood and Representation*, the woman who kills children

is the etiolated negative even of this dubious formula.[2] Characterised as 'unnatural', the 'monstrous' or the 'masculine' female, she is constructed against a stereotype of motherhood that is itself a symbolic manufacture.[3] Outside the realm of culture and psychoanalysis, in the many real cases of women accused of murdering children, the voice of the transgressive and violent female delinquent is subsumed by legal processes, distorted by the media, and drowned out by the din of public discourse. If we hear her voice, in courtrooms, public statements, in newspapers or theatres, we are most often hearing its mediated version, laden with gender inflected assumptions and judgements. Occupying, to use Cixous' term, 'the place reserved for the guilty', she is subject of disapproval, slander and gross misrepresentation.[4] Where the woman is found guilty, and especially in cases where remorse is not expressed, her voice is silenced altogether by incarceration.

Criminologist Annie Worrall has argued that the female delinquent in the legal system (however much in pursuit of 'nothing but the truth') is subject to an institutionalised 'technology of muting' that reinforces the idea that women are evasive, manipulative and deceitful.[5] Given the difficulties of speaking of an act that is perceived as so heinous, it is tempting to presume that many women accused or guilty of murdering children might choose to remain silent because they will not be believed.[6] Theatre space, by contrast, ostensibly provides a voicescape where experience can be articulated and be safe from judicial sentencing. It seems to offer a 'technology of voicing' outside and apart from judicial process, and the opportunity to fill the void left open by a stigmatised or silenced identity. In theatre, one presumes, an actor might articulate the negotiation of such social expectation as are particularly intensely enforced around the female maternal identity, and which as the intensely censorious response they tend to elicit confirms, are difficult to challenge. Such subjects make sensational subjects for drama, and may attract the same voyeuristic impulses on which some sections of the press rely. Yet theatre is also a self-reflexive medium and can raise awareness of the flaws in representative acts, whether legal, political or dramatic. In so doing, it draws attention to the ethics of representative space, the operations of its othering mechanisms, and to the potentially deleterious presences or influences that may inhabit its processes.

There is of course a long tradition of plays that has allowed female killers of children, some mythological, some based on real women, to speak. Most notorious of these is the much revived and adapted Euripides' *Medea* (431 BC), the voice of whose eponymous heroine resonates through this chapter. Of the many plays of this period that

represented women who killed children I have selected three, pro-
duced within a seven year period in the 2000s, that illustrate the ways
that theatre attempts to voice her experience authentically.[7] In 2001,
Director Deborah Warner and actress Fiona Shaw offered a new voice
for the fictional mythological female protagonist of Euripides' ancient
text in their version of *Medea*. Beatrix Campbell and Judith Jones' *And
All the Children Cried* (2002) voiced real accounts of women who had
killed their own children, as well as including a fictional embodiment
of Myra Hindley, one of the most notorious real life female murderers
of children of the twentieth century. Dennis Kelly's *Taking Care of Baby*
(2007) used techniques associated with verbatim theatre apparently to
construct the real case of a young woman accused of the murder of her
two children, only to scrutinise and expose the means of representation
themselves. Each of these productions grapple with the difficulties of
giving voice to the otherwise unspeakable betrayal of women's nurtur-
ing role, and with negotiating the suspicions with which such voices
are inevitably heard. Each of them uses strategies to defuse this degree
of distrust, and each confers or suggests different types of responses
or responsibilities for their audiences. Ultimately they illustrate the
'evacuation of identity' that takes place around the representation of
the female subject, and which lies behind the stigmatisation and silenc-
ing of her voice.[8]

Revoicing *Medea*

Euripides' *Medea* (431 BC) unleashes a deeply wronged female voice
that challenges patriarchal structures and refuses confinement to
domestic space. Her first appearance in public suggests a schism in her
identity, and has a wider relevance with regard to the way distrusted
and stigmatised voices are included in theatrical space. At the start of
the play, the audience has heard Medea's voice wracked with uncon-
trollable private emotion, lamenting the loss of Jason, the father of
their two children, to the king's daughter Glauce. Her first verbalisa-
tions are broken and disjointed: 'Yoh!', 'A-ee' and 'Fe-oo', giving them
the 'elemental' or 'natural' resonance associated by cultural theorists
with the non-verbal aspects of the voice.[9] Once she emerges into pub-
lic space, Medea's voice is highly rational and articulate, appearing,
according to the Kenneth McLeish and Frederic Raphael version used
by Shaw and Warner, 'Against expectation . . . calm and self-possessed:
no sign of hysteria or grief'.[10] The switch has often led scholars to com-
ment on this apparent deviance from the norms of female speech. To

John Dillon the switch is evidence of her 'intellectual' powers, revealing her as 'a woman with a thoroughly male sense of honour and self-respect'. Peter Arnott claims that the practice of having men play women leads to the construction of 'highly masculine' female characters who 'organise', 'dominate', 'are strong themselves and impact their strength on others'.[11]

While they seem to represent Medea's voice favourably, these interpretations of Medea's public language as manly and virtuous imply the opposite of female voices. They easily seem to lead to the idea that Medea's public voice reveals an unnatural or unfeminine nature. For Simon Goldhill, Medea voices a 'wild and disturbed feminine force' within doors, but 'tricks, deceives and argues' in public space. Dolores O'Higgins puts this down to the play's historical context, claiming that as marginalised citizens in Ancient Greece all women were outsiders and were commonly characterised as deceptive liars.[12] Clearly, the issue of trusting women's voices is one that has been remarkably persistent. Warner and Shaw's new version of *Medea* was explicitly concerned to challenge the ways in which its protagonist's voice had been unfairly represented as a 'warped' and 'screeching vengeful creature'.[13] McLeish and Raphael's translation draws attention to this, their Chorus indicating the link between the 'injustice' of men's stories of women's 'faithlessness', the fact that women have 'no voice', and the effect of this on Medea, its chief victim: 'It crowds on me,/ This reputation: the witch, the witch!'[14] Warner's production aimed to promote, according to the production's pre-publicity, 'Sympathy for the Devil'.[15] Such an aim would challenge the visceral antipathy the character has often received, and which is apparent in scholarly response. To Robin Mitchell-Boyask she is 'indefinable and incomprehensible'.[16] To John Banville, she is 'barely comprehensible to us as a human being'. Baffled and horrified, he asks, 'how can we feel anything but revulsion for this appalling woman?'[17]

I wish to suggest that the production's tactics to render Medea's character empathetic resulted in the replacement of one set of presumptions regarding transgressive females with another. Its construction of Medea's voice according to literary norms as well as in accordance with a familiar contemporary social role downplayed the degree to which Medea's actions are presented as a rational course of action, and led to an avoidance of its powerful transcendence of cultural stigmatisation, represented by her final escape in the God of the Sun's chariot. By defusing the degree of distrust to which the voice of a woman who murders children is prone, and in the interest of normalising the voice of its

vilified protagonist, Shaw and Warner suppressed what Elin Diamond has called, in the context of female hysteria, an example of the 'unrepresentable' aspects of female experience.[18]

In terms of both script and performance, the voice of Medea was constructed to accord with many of the familiar and highly validated norms of theatrical speech. McLeish and Raphael's translation heightened Medea's voice through the use of highly stylised literary language, 'Die, children. Damned. Destroyed'.[19] This gave her voice the dignity associated with a poetic register, and was at its most intense at the most acute moments of the protagonist's shocking deeds, 'weep, wretch, weep / Who killed to prove your love' (42). Such stylisation gives Medea's voice a lyricism that seems to express the intimate and nurturing role of motherhood, but which also evokes a literary quality associated with the familiar rhythmic movement of Shakespearean English. Medea, affirming her love for her children while at the very point of killing them, characterises herself as a woman that loved not wisely but too well, rather than the vengeful witch of popular mythology. The poignancy did not escape the critics, who tended to respond favourably to its fusion of intense emotion and literary technique in the classic adaptation.[20] In addition to its literary heightening, Shaw and Warner had linked the expulsion of Medea's feelings to the Stanislavskian idea to the moral integrity of the inner self. In rehearsal, Shaw stated, much energy was devoted to making Medea's emotional journey 'truthful'.[21] What emerged, was a sympathetic interpretation of Medea as a 'normal' housewife. It was a reading that made the inconsistency in Medea's voice seem familiar and understandable, providing a logical continuity between the turmoil of her inner self and her public poise. Both theatre columnists Tim Teeman and Kate Bassett described Shaw's Medea in familiar and empathetic terms: 'a housewife on the verge of an extreme breakdown', and, 'a highly educated, crushed woman undergoing a mental breakdown'.[22] Such responses suggest that the retention of trust for Medea's voice rested on the perception and understanding of an emotionally tortured inner self nobly held in check rather than villainously disguised by public performance. In Shaw and Warner's version, Medea is not really 'unnatural', but rather 'understandable'. She is not 'foreign', but 'familiar'.

As Shaw herself emphasised, the end of her 'truthful' individual performance was to make Medea's 'terrible' actions seem 'justifiable'. Similarly, the production aimed to manifest through Medea's voice her 'human psyche', and for the audience to 'identify' with its 'universality'.[23] As in other contemporary versions of the story, this humanising

strategy necessitated the ditching of the 'deus ex machina' ending to suit what Shaw described, perhaps prematurely in 2000, as a 'post-theistic' society.[24] Distrusted and derided by commentators, Medea's victorious transcendence and escape in the Sun God's chariot was ditched.[25] In Shaw and Warner's version, in spite of the horrific murder of her own children, Medea ends up forever stuck with Jason in the hell of a failed marriage. As Aoife Monks puts it, the change ensured that 'the spectator recognised Medea once more as human and made room for her in their world'.[26] Such a destigmatising strategy may have encouraged the idea that 'normal' women might murder their children. On the other hand, it encouraged the audience to pity Medea as victim of her own bad marriage rather than be shocked by the elevation and empowerment of a transcendent and vindictive female voice with its reminder of 'truths' above and beyond the familiar. The assimilation of Medea's voice to what is familiar risks squeezing out the possibilities of the representation in theatre space of experience and identity that is more normally Other. The makeover it gave to the powerful myth of the murdering mother no doubt helped to bring this large touring production popular and commercial success, yet its particular blend of representative strategies, literary and performative, arguably prioritised the pleasure and comfort of the audience.[27] As the latest adaptation of the story of a fictional protagonist, its responsibilities to 'truthful' representation were tenuous.

Hearing Myra

Campbell and Jones's portrayal of two female child killers in *And All the Children Cried* at the West Yorkshire Playhouse in 2002 used real life transcripts of interviews with mothers who had abused and killed their children. In one sense this was an attempt to draw attention to the issues surrounding the stigmatisation of female offenders and the relative lack of direct testimony being used to inform the legal and penal treatment of such women. As I discussed above, gender criminologists have pointed out that women themselves have often evaded speaking about their own illegal behaviour, not wishing themselves to admit to criminality, perhaps because of their responsibilities to other family members or partners, and the fear of the consequences.[28] In the case of a mother's abuse and murder of her children, the abhorrence caused by such deeds, and the extreme vilification of women who are suspected or guilty of them, strongly intensifies this stigmatisation. By giving such potentially shocking material a public hearing, the writers sought

to make an urgent 'intervention' into public discourse, ultimately, Campbell claimed, so that children could be saved.[29]

As with Warner and Shaw's Medea, several strategies were used to make hearable the voice of their main protagonist, a young working-class mother, Gail, undergoing a prison sentence for the murder of her own children. These included a highly emotive performance style, the placing of the murders within the context of a cycle of abuse, a confessional and redemptive narrative framework, and the ring of truth with which much documentary and verbatim theatre is validated (an issue to which I will return). The play's construction of the voice of the notorious criminal Myra Hindley was arguably even more problematic. As with the case of mothers who murder, the case of this 'female icon of evil' provoked outrage, bafflement and repulsion.[30] Lesley M. McLaughlin notes how Hindley's actions have been 'unfathomable' and 'incomprehensible' to the public, impenetrable to criminologists, yet relentlessly fascinating to the press, to whom she has become a 'symbol of evil', a 'monster', a 'dangerous deviant', a 'lesbian and feminist'.[31] At the time the play was performed, Hindley was still in prison for her involvement in the torture and murder of other women's children in the Yorkshire Moors in the early 1960s, and about which she had for decades refused to speak. Although she was sometimes thought to have been under the influence of her male accomplice, Ian Brady, and in spite of her compliance and remorse in her later years, successive Home Secretaries refused to respond to her requests for parole, extending her original twenty-five year sentence to thirty-six years until her death in prison. As Jones acknowledged, the construction of Hindley's voice would necessarily challenge the public's 'expectations' and 'preconceptions' of one of the most notorious female criminals in British history.[32]

In the cases of women who kill children, I have argued that such preconceptions often revolve around the issue of trust. The association of Hindley's voice with deceit is clear in journalist Duncan Staff's book *The Lost Boy* (2007), which claims to be the 'definitive' version of the Moors murders. Staff states that Hindley was 'lying' when she claimed to be uninvolved in the murder of Lesley Ann Downs, portraying her 'flat emotionless voice' as a symptom of her untrustworthiness.[33] Her confession led Hindley's one time champion Janie Jones, who had been in prison with Hindley, to locate the source of her evil in her voice, 'she's brilliant with words, brilliant at manipulating people', and to conclude that 'she should never be released'.[34] This is an understandable response, given the presumption that Hindley used her voice to lure several children to their deaths. Even the idea of it seems to abuse the associations

of nurture and safety associated with the powerful female nurturing role. This presumed deceitfulness of her voice, masking its capacity for the morally abhorrent betrayal of its 'natural' role, is used to justify its utter and eternal silencing.

Perhaps wisely, given the weight of public feeling about her, the perception of Hindley as deceitful was not one that Campbell and Jones sought to undo. In contrast to the voice of Gail many features of Hindley's voice confirmed society's impression of her deceitfulness. From the outset, Hindley's calculated rather than spontaneous nature was emphasised, as she was first seen rehearsing her speech to the parole board. Her voice was educated and articulate, commanding the rhetorical strategies of a public address, and far from the colloquial, confessional manner of Gail. Indeed, according to Gail, hearing Myra speak was 'like listening to one of those documentaries on the BBC'.[35] The real Hindley was the daughter of a builder and had left school at fifteen, the voice of the fictional Hindley measured, socially mobile and civilised. 'When we meet', Hindley tells us of the parole board, 'I try to talk to them as though we were at a dinner party' (p. 20). Yet Campbell and Jones' tactics were designed to provoke reflection and awareness of the manufacture of Hindley's 'reputation', and the role of this in her subsequent years of incarceration. The voice that Campbell and Jones constructed was that of a deeply repressed woman mediating her own story through documentation and rhetoric and now haunted by the truly dreadful memories of her misdeeds.

If anything, the horrors of Hindley's deeds were intensified, and scenes depicting the abuse of Gail were dovetailed with the abuse perpetrated by Hindley upon her real life victims. At the moment the audience heard the crack of Gail's parents' whip, another child's voice, this time off-stage was heard crying: 'I want to see Mummy . . . I want to see Mummy . . . I cannot breathe . . . What are you going to do with me . . . '. This voice recalled the real recordings of Hindley and Brady torturing Lesley Ann Downey, one of the children she procured, terrorised and murdered. Carrying a recurring embodied echo of the child's life, however, the tape was also a recurring nightmare for the now repentant Hindley. At its most intense moment the tape was overwhelmed by the voice of opera singer Maria Callas, an ironic reminder of the aesthetic beauties with which Hindley drowned the memories of her horrific deeds (pp. 31–2).

By depicting these acts of repression, the authors suggested that the silencing of the voice of a woman who kills children deletes the hearing and therefore the possibility of understanding her acts, potentially

contributing to a cycle of further abuses and deaths. The play not only invoked the matrix of horror, repulsion and attraction to the acts committed by Hindley, but also suggested that the 'truth' of her experience must be heard for the good of society. Like Gail's, it was suggested that Hindley's acts were part of a cycle of abuse, 'Recently I have remembered' she says 'those tears' she shed as a child when her father abused her mother, 'and the unbearable wrenching feeling of panic in my guts when I heard him shouting' (p. 41). The confession momentarily held out the possibility that Hindley herself was a victim, a frightened woman alienated from her true self, clutching a bundle of press cuttings and watching endless and meaningless pictures of her younger self on video.

Response and responsibility

Near the end of the play, Campbell and Jones used further strategies to provoke audience responses to the women portrayed. Gail was made to walk out through the auditorium to stage her release back into society, encouraging the audience to think of her case as potentially real, rather than a fictional representation. An appeal to the audience was made through a largely discursive address by Hindley that explicitly threw her case open to the public. No longer witness to a harrowing emotional catharsis, the audience became individual citizens involved in an act of social intercourse with the notorious child murderer: 'Some of you might argue that we shouldn't even be in this conversation: that hanging would have been too good for me' (p. 48). This direct address, with its explicit references to the real people such as the parents of Hindley's victims, helped to prepare the ground for an open discussion described in the play's programme: 'THE DISCUSSIONS THAT FOLLOW THE PERFORMANCE PROVIDE YOU WITH THE SPACE TO ASK QUESTIONS AND VOICE YOUR OPINIONS'.[36] The audience it seemed, was to share in the responsibility of deciding whether the space of hearing that the production provided should alter the treatment of female offenders and contribute to the destigmatisation of their voices.

This switch in responsibility reflects the premise of documentary pieces that theatre can be a type of speech act (in spite of J. L. Austin's exclusion of literary forms from this capacity).[37] According to Janelle Reinelt in an article on British documentary theatre in 2006, the genre can 'embody a kind of analogical critique' of the way we live our 'national or local lives'. Reinelt attempts to demonstrate how 'the interpenetration of performance codes and practices with what is considered "real life"' generates the 'potential explanatory power of performance

to shape ideas, question truth claims' and 'sway public opinion'.[38] In terms of the response to *And All the Children Cried*, however, much of the commentary that the play generated demonstrated considerable discomfort with just this type of attempt to blend performance codes and 'real life'. For Germaine Greer, the play's attempts to make a 'general statement about female sex offenders' were 'misguided'. For her Radio Four colleague Mark Lawson, its factional texture resulted in a 'messy structure'.[39] Mark Tyler was troubled by the 'hamstrung' nature of docudrama: 'it can not be seen to be straying too far from the truth without losing credibility, while fictional aspects appear as true'. The result for Tyler, is 'polemic that lacks the courage of its convictions'.[40] Lynne Walker agreed that the blurring of fact and fiction, and its 'knitting together of case histories and academic discourse' left the play 'unsatisfactory as an investigative drama and limited as a social documentary'.[41]

Such responses suggest, through their objections to the mixture of aesthetic and documentary criteria of validation, a discomfort regarding the claims of theatre to a moral and political role with regard to wider society. On the other hand, the play was much admired for its avoidance of the kind of sensational treatment Hindley had received in the tabloid press. According to Lyn Gardner's very favourable review in the *Guardian*, the tendency for this type of drama to degenerate into 'salacious entertainment' was completely avoided.[42] To Gardner, the 'dramatic form' conferred 'dignity' on both the protagonists and the audience, by observing the 'restraint' of Greek drama. Similarly, for Greer, the play was 'austere' and 'dignified', not 'cheap and sensational', and its merit lying in 'credible' expression of both characters and the 'amazing performance' of Gillian Wright.[43] In summary, Campbell and Jones' attempts to make the 'unspeakable' deeds of its protagonists a 'thing of beauty' both 'elegant and eloquent' were validated in terms of aesthetics and taste, but not as a political statement.[44] The failures of critical response to accept the validity of their strategies partly expresses a discomfort with Campbell and Jones' interpellation of theatre's active role in public debate, and arguably a degree of resistance to surrendering the passivity with which theatre might invite its audiences to listen. Ultimately it was not suspicions of Hindley's voice that the play's responses suggested, but of the authors' themselves.

This returns me to the issue of Campbell and Jones' acknowledged choice to represent Hindley to draw attention 'boldly' to the problem of mothers killing their children.[45] Put bluntly by Greer, 'we wouldn't have noticed the play if Myra hadn't been in it'.[46] Writing in the *Guardian's* News Section, Angelique Chrisafis linked the play to the portrait of

Hindley in *Myra* by Marcus Harvey at the *Sensation* exhibition in 1997, pointing to the fascination of artists with the notorious criminal and their insensitivity to the families of the victims.[47]

Theatre can be as guilty as any other medium in its choice of sensational subjects, and discomfort has been expressed with the intimacy that confessional genres seems to offer. As we have seen, the voice of the woman who murders her children is an object of considerable tabloid fascination, and certainly as the reviews of *And All the Children Cried* suggested, is perceived by some cultural commentators to be best presented in the dignified medium of theatre with restraint. Intimacy with deviants, their responses suggest, is distasteful and potentially dangerous.[48] Such concerns tend to express fears that theatre's provision of empathy for its more transgressive subjects is distasteful and corrupting. Yet there is also the issue of whether the providers of empathy are the ultimate profiteers. The voice of the accused female, while apparently present in theatre space, is in fact absent, and a subject not represented by herself, but by others. Whatever her crimes, this leads her as open to as much *mis*representation as that which might occur in court, press or any form of public discourse. Where the subject is innocent, or not proven guilty, these issues become particularly acute. For all the well-intentioned debate generated in the theatre, the extra press coverage Campbell and Jones received for their inclusion of Hindley pointed not just to the power but also to the vulnerability of such excluded voices to exploitation.

The degradation of empathy

Both Shaw and Warner, and Campbell and Jones assume and rely on an inclusive and empathetic theatre space in their representation of the voices of mothers who murder their children. Kelly, by contrast, uses the voice of a mother accused of the murder of her children to expose the ethical degradation of public space, its falsely empathetic values, and to point to a climate of betrayal in a wider cultural context. His mock verbatim play *Taking Care of Baby* was produced in 2007 at Hampstead Theatre, and drew on the public fascination with the real cases of Angela Canning and Sally Clarke, women who had been imprisoned for murdering their own children, and later released when the expert evidence that had helped to convict them was found to be flawed.

It is a common claim of documentary and verbatim theatre practitioners that these forms offer opportunities for the 'voicing' of the experience of otherwise silenced or marginalised groups or individuals.

It is presumed that the 'truth' and 'authenticity' of 'lost voices' are somehow carried in the reproduction of their exact words and sounds.[49] In *Verbatim, Verbatim* (2008), for example, practitioner Alecky Blythe describes the lengths she goes to in order to retain the exact speech rhythms of her subjects.[50] Yet both she and her fellow practitioner, Robin Soans, acknowledge the negotiation between entertainment and truth that occurs as a crucial part of their practice. As I suggested in Chapter 2, in the latter part of the Blair office, there was a disillusionment around acts of representation in public space. Similarly, suspicions grew regarding the acts of editing, structuring and splicing that qualify these forms of theatre's claims to be a wholly transparent medium. The ability of documentary and verbatim forms to represent subjects truthfully seemed discredited by the interference of the writer or editor in the presentation or spin of its subject's words. Stephen Bottoms' article 'Putting the Document into Documentary' (2006), for example, cast aspersions on documentary forms as the apex of theatrical integrity.[51] In 2007 Dan Rebellato was deriding verbatim's 'deep voyeurism'.[52] By 2009 it was apparent to Stuart Young that the 'transparency' of the genre and its claims to record 'truth' disguised its 'dubious practices and exploitative practices'.[53] Soans is clearly aware of these accusations in the interview he gives for *Verbatim Verbatim*. 'I do not exploit or titillate the audience . . . I can be trusted', he protests, as if he were, himself, in the dock.[54]

In *Taking Care of Baby*, it is the conventions of verbatim that Kelly uses to make his critique of transparency in the public sphere. The voice of Donna, in spite of the case against her of killing her own child, is presented from the very beginning of the play as truthful, unmediated speech. As the play started, Donna, performed by Abigail Davies, was speaking aloud, out into the auditorium as if directly to the audience, relating her fourteen months in prison:

> DONNA I was too scared to move really, so I just stood there, I mean, and the door's, erm, closed, just behind me and I'm erm, you know, in this cell with this girl and she's not – do you want all this?[55]

Donna's faltering and spontaneous speaking style established her as a 'normal' young woman recalling her frightening experience in prison. According to the conventions of much verbatim theatre her voice was performed as 'natural', 'sincere' and 'truthful'. Full of hesitations, false starts, incomplete sentences, its style was colloquial, avoiding any specialised diction or syntactical complexity, but apparently determined

to give an accurate representation of her own experience. According to Kelly, the character's obsession with detail is part of her need to correct the impression of the misrepresentations of which she had been victim: 'She's had so much written about her that's fake'.[56] At the same time however, her question to the unseen interviewer, 'Do you want all this?' signalled to the audience the potential mediation and manipulation of her experience by a writer. Immediately, the selective processes and personal dynamics of constructing vocal testimony were suggested.

Donna's voice was performed in this apparently 'neutral' and therefore morally virtuous 'unspun' manner. Its virtue was ironically counterpointed with the self-interest of the voices that surrounded her, including that of the unseen interviewer, Mr Kelly, and the constant reminders of the apparatus of representation both inside and outside the theatre. Kelly's satirical portrait of The Reporter, a generic, brash and shallow sexist, points to the gendered and lurid ways that accused women have been represented in the press. Over coffee with the interviewer, The Reporter boasted of the evolution of Donna's portrayal from 'grieving mother', to the sensational cliché, 'Mother Murders Babies for Love', through to the comically alliterative grotesque, 'Double Death Donna in Affair Claim'. Naturally, in turn, the Reporter was aware of the interviewer's power, 'You're not gonna make me look like a cunt, are you?' (pp. 42–57). In fact this was precisely the effect of Kelly's play: unable to concentrate on the interview because of his 'permanent fucking hard fucking cock' brought about by the 'heat' and the waitress' 'tits', an implicit comparison was drawn between the Reporter's determination to 'have a bit of fun', and his attitude to women such as Donna as legitimate objects of exploitation or gratification (pp. 41–44). Not surprisingly, in performance, the character drew much laughter from the audience, a response that contrasted discomfortingly with the fake applause that accompanied the speeches of Lynn, Donna's politician mother.

Of all the characters, it was Lynn, the 'Love Mother' of the Reporter's stories, who is most adept in the arts of representation. As with traditional depictions of the treacherous female, Lynn's voice tricked, manipulated and deceived all around her, including, at first, the audience. Lynn's interviews with the writer, who at this point does not intrude, adopt an intimate, confessional tone, as she tells us of her son's death. 'I'm on this train . . . You think, "I'm living with the tragedy of having lost my boy . . . "' (p. 16). Her voice is constructed to seem accessible, down-to-earth and consummately 'normal'. Gradually, and as it is revealed that Lynn's son died of a drugs overdose, it becomes

clear that it is Lynn rather than Donna who is the real Medea of the piece. It becomes apparent that Lynn has invited a TV crew into her home to make a documentary as part of her political campaign. When an emotional and disturbed Donna screams, 'I'll cut your fucking head off, you fucking bitch, you fucking cunt', Lynn issues the order, 'don't record this', plunging the stage into 'sudden darkness filled with white noise' (p. 70). As she explains of her use of the media: 'you're playing, not with the truth, but with the public perception of the truth' (p. 87).

Lynn's crime is not in the murder of her children but in their exploitation for her own ends. Kelly's displacement of vocal untrustworthiness from Donna to Lynn expresses his condemnation of those who exploit the voices of the accused, and of the spin in public political life that was perceived as endemic under a Blair government which was at this point widely discredited after their unpopular involvement in the Iraq war. Unlike Campbell and Jones, whose Hindley eluded utter damnation as she emerged as a victim of her own repression, and in contrast to Shaw and Warner, who staged Medea's voice within the bounds of society's empathy, Kelly offers no mitigation for Lynn's crimes. This writer perpetuates the mythologies of deviance from women's virtuous role as a caring mother in order to get at his main target, the manipulativeness and lack of transparency that he discerned in public space.

Transferring responsibility

This brings me to the ethical issues raised by Kelly's play concerning the audience and its responses to a voice not only deeply stigmatised, but also highly vulnerable. Kelly's foregrounding of the processes of writing and performance not only encouraged audiences to consider the values that might lie behind an act of representation, it asked them to become aware of the possibility of their own collusion with its degraded processes. In a sense it foresaw the recent tendency on behalf of some theatre makers to make work that explicitly addresses this issue. The work of Tim Crouch, for example, has been framed within a philosophical tendency to 'democratise' cultural exchange – a development that assumes a shared responsibility for what happens in cultural space, and an acknowledgement that the behaviour of the audience contributes to the process and practices of representation.[57] In a wider sense, such developments in theatre were part of a movement that increasingly thought of those that control the means of representation as monsters, rather than those that they depict, and looked forward to the Leveson Inquiry in 2011, which examined the relationship of politicians with the press,

the dubious ethical practices and mutual interests that blighted public trust in representative processes.[58] Going further perhaps than Leveson, *Taking Care of Baby* attempted to illustrate the pleasurable collusion of the audience with the strategies of representation, and in so doing the ways in which the voice of the stigmatised individual, even if ultimately unknowable, becomes the victim and responsibility of us all.

Rather than reflect on the nature of response and their own role in it, many critics chose to acclaim Davies' performance as Donna. Kelly has described how in audition Davies 'tried not to let you know what she was feeling'. He compares her performance with the kind of manipulative 'fake' emotion that people use in real life for effect.[59] Certainly the actor's restraint also worked on many of the play's critics, given the almost unanimous praise she received. For an empathetic Nicholas de Jongh, Donna was a 'victim' of spin, a 'sweet withdrawn girl', 'subsumed and exploited in a media blitz.'[60] Perspicaciously, Sam Marlowe of *The Times* saw similarities between Kelly's play and real life cases such as that of the disappearance of Madeleine McCann, claiming that the 'outpourings of concern and sympathy mask an ugly desire for titillation'.[61] Davies' voice had managed to suggest innocence, and sincerely delivered truthfulness, her emotions kept within the parameters of taste and decency. Other responses were more circumspect, and commented on the ultimately evasive and uncertain nature of Donna's testament. According to Bassett, 'Abigail Davies's "shaky-voiced" performance managed to seem "dead ordinary" and "heart-rending", but also 'scary'.[62] For Paul Taylor, Davies' 'stunning performance' was based on her ability to be 'heart-breakingly direct' yet 'elusive'.[63] This trembling between the perception of elusiveness and truthfulness expresses society's willingness and desire to trust and accept, but also its tendency to suspect the voice of the unknown and potentially dangerous female voice. Ironically, and as in the case of *And All the Children Cried,* the writer's own voice was greeted with ambivalence. For many critics it was invalidated by what was seen as over cleverness. Many critics expressed distrust of the play, the writer and the lack of certainty with which it ultimately concludes: Claire Alfree calls the play 'deceptive and very clever', Spencer accusing it of a 'self-advertising cleverness', de Jongh of a 'chronic evasiveness', and Jane Edwardes that it is 'a little too clever for its own good'.[64] In spite of Kelly's care to signal an examination of the writer's responsibilities, Spencer commented 'the dramatist seems as opportunistic as his characters'.[65]

Feminist literary critics have discussed how the representation of women as Other leads to the evacuation of their 'real' identity. In the

case of the transgressive female the vacuum created by the silence of her voice tends to be filled with that which is more familiar to society, or alternatively, with that which it most fears. Kelly's play neither provokes pleasure through intimacy with the subject, nor reassures with familiar condemnation. Rather, the comforts of intimacy and empathy are elicited only to be withdrawn, exposing the evils or uncertainties they may harbour. In a sense, the act of representation itself is exposed as a seductive deceit akin to the strategic manipulations apparently practised by the voice of a woman who lures children to their doom. For all its cynicism regarding the manipulations of the writer, *Taking Care of Baby* also raises the alarming question of what we are to do without him. At the end of the play, when Donna announces her pregnancy, the interviewer struggles for words. As he withdraws, he leaves the young woman alone on stage, to tell us of her suicide attempt in Lewisham car park. The audience is left with no mediator, and a suicidal and newly pregnant young woman already accused of murdering two of her own children. Across the lengthening silences in the Hampstead Theatre it seemed that a space was opened. An image of a baby floating within a womb of missiles against a background of stars opened out the little space of the theatre to suggest the link between Donna, our relationship with her, and a terrorising potential of global and cosmic significance. In the absence of a reassuring, and structuring presence, the audience is left with the voice of Donna alone, the question of whether to believe her, and the discomforting responsibility of 'taking care of baby'.

Conclusion: Betrayal and Beyond

By attending to how voices were scripted and trained, performed and perceived, this book has explored some of the ways in which playwrights and performers represented the voices of characters in theatre space. It has tried to hear in the voices of theatre practitioners and in the responses of audiences the values of theatre itself and, in a much broader sense, the values of wider society in the decade during the office of a Prime Minister whose own vocal delivery appeared to conjure the political aspirations and disappointments of the period. In so doing, it has used the voice as 'cultural evidence' of the shifting values of the voicescapes within which individuals identify themselves. It has found during the Blair period a climate of empathy, inclusion and support for those that had been previously marginalised, but also that flaws and misgivings regarding the representative process could be detected in the construction and delivery of characters' voices. The sounds of Scottish voices cast doubts on the narrative of confidence offered in the wake of devolution, while the non-standard sounds and sensibilities of black dialect and youthful flippancy offered challenges to the institutionalised expectations of culturally privileged theatre space in London theatres. These voices, often constructed to sound 'real' and to express themselves 'transparently', frequently resisted both expectations and empathy to articulate cultural discomfort with the well-intentioned liberal or adult terms of their inclusion or devolution. They thus at least partly fulfilled both McGrath's aspiration for them to perform a scrutinising function from within the demos, as well as theatre's own characterisation of itself as a sphere of political engagement, where newly included voices provide unique and challenging articulations of contemporary experience. At the same time, the casting of writers as 'voices' enabled theatres and their managers to present their role as

democratically important and empowering, while using 'new voices' as products that consolidated the creative identity of theatres in a competitive marketplace.

As I am writing this Conclusion in 2014, I am conscious that despite my interest in newly included voices I have been exploring a narrow range of developments that occurred in cultural voicescapes in the 1990s and 2000s. There are many groups of individuals, including for example the Northern Irish, the Welsh, the disabled, or religious groups, whose cultural audibility shifted, or for whom the terms of empathy appear to have changed. The cultural anxiety generated by the AIDS epidemic in the West has faded and greater civil equality created for gay people for example, but the cultural predominance of highly theatricalised male 'camp' voices seemed to suggest another version of the schismatic identities that have been performed in some black and young voices. A study of plays such as *Certain Young Men* (1999) by Peter Gill or Jonathan Harvey's *Hushabye Mountain* (1999) and *Out in the Open* (2001) may have helped to illuminate the shifting context within which male gay identity was articulated during the decade following New Labour's accession to power. Equally, the acute contradictions in the values of liberal society towards migrant or ethnic minority voices could have been focused by a study of the Northern British-Pakistani and Indian voices of *East is East* (Royal Court, 1997) and *Rafta Rafta* (Lyttleton, 2007) of Ayub Khan Dhin, the censored female voices of Gurpeet Kaur Bhatti's *Behzti* (2004), and those of Alio Bano, whose *Shades* (2009) emerged through the Royal Court's Unheard Voices scheme for young Moslem writers launched in 2007, and humorously depicted a young British Moslem woman's experiences of dating Moslem men in the UK.

This book has indirectly explored the significant and ongoing shifts in the cultural audibility of women's voices. In the Blair years in theatre some women, such as Vicky Featherstone and Jude Kelly were promoted to powerful positions, and the work of female directors such as Marianne Elliott, Katie Mitchell and Phyllida Lloyd was acclaimed in culturally prestigious venues. Although the Artistic Directorships of the National Theatre, and Royal Shakespeare Company still remain male preserves, and women remained unequally represented in theatre, the trend has continued to gain momentum with the appointment of Josie Rourke at the Donmar, Indhu Rubasingham at the Tricycle, and Featherstone at the Royal Court.[1] 2008 saw the first ever play by a female writer produced on the National Theatre's main stage in Rebecca Lenkiewicz's, *Her Naked Skin*. In 2007 the Royal Court produced twenty-year old Polly Stenham's play *That Face*, and two years later, teenager Anya Reiss's *Spur*

of the Moment (suggesting another evolution in theatre's voicescapes in terms of the empowerment of young writers). The Royal Court also produced Lucy Prebble's *Enron* (2009), and the National Theatre *The Effect* (2012). The Tricycle's *Women, Power and Politics* (2010) project, which staged the work of nine female contemporary writers, produced Moira Buffini's *Handbagged* (2013), a play portraying the relationship of Elizabeth II and Margaret Thatcher. It was a period in which Helen Mirren's numerous TV, film and stage portrayals of Elizabeths I and II appeared to supersede the vogue for Michael Sheen as Tony Blair, and suggested a new era in which historical versions of upper-class and hyper received versions of English regained respect and interest.[2]

In spite of this growing evidence of female cultural audibility, the voices of women continued to be patrolled. Much comment was provoked by David Cameron's infamous 'Calm Down Dear' line to Labour MP Angela Eagle in the House of Commons in 2011, an incident that reignited the tradition of feminist complaint of the control of female voices by patriarchal norms.[3] In theatre, the continued use of *Medea* mythology and the voices of 'hysterical' women to articulate cultural anxieties pointed to an ongoing suspicion of female power and its representation continued to articulate threats to social stability. Mike Bartlett's *Thirteen* (2012) at the National Theatre imagined a female prime minister's dilemma regarding the bombing of Iran and the violent murder by the wife of an American diplomat of her own precocious daughter. The play suggests that the voice of the woman that is perceived to break and betray its nurturing role retains its power to focus fears regarding the fabric and fragility of society.[4] Perhaps the most disturbing version of female deviance was Jack Thorne's *Let the Right One In* (2014), in which a wild vampire girl Eli, vulnerable and tortured through her exclusion from the human world, makes friends with a bullied and isolated teenage Oskar. The girl's strange voice, with its intonations and range outside the colloquial Scottish realist norms of the play, is a signal of her otherworldly nature and of the way she is othered in society.[5] After several sickening bloodfests, Oskar takes Eli in her coffin on a train, escaping unpunished like Medea in her chariot of the sun, but to a place where her presence will continue, no doubt, to bleed through into the 'normal' world.

Articulating coalition

As I have noted, the narrative of betrayal that is now used for Blair's ten years in power responds to the perception of his Party's hypocrisy,

but also the failure of its Third Way strategy to unite economic prosperity with social justice. A new 'out of touch' narrative is emerging regarding the Coalition government in which the extent to which the Conservative Liberal elite is representative of the country has been an ongoing theme. In 2010, the press reported that 23 of David Cameron and Nick Clegg's Cabinet members were millionaires, that they had a combined worth of £70 million, and that 67 per cent of them had gone to top private schools compared with 7 per cent of the population.[6] While tokens of diversity remained in the formidable Yorkshire tones of Baroness Warsi, William Hague and Eric Pickles, there was only one representative from an ethnic minority, and only four women were included (and after a reshuffle in April 2014 the number dropped to three).[7] In contrast to the Estuary speaking New Labour days, in which John Prescott had claimed that 'we're all middle class now', there was a return to an increased cultural sensitivity over class background and over accent as, to use Goffman's term, an 'identity peg'. If anything, politicians' voices became more intensely symptomatic of their electability. Patrick Wintour in the *Guardian* claimed 'research has shown the sound of a voice is worth more votes to politicians than the content of their speeches'.[8] Aware of this, the 'patrician-voiced' David Cameron attempted to defend his Etonian tones, 'I don't want to drop my accent or change my vowels. I am who I am.'[9] Meanwhile his Chancellor, George Osborne, was suspected of affecting a 'Mockney' accent, and his opponent, Labour leader Ed Miliband of a nose operation to improve his vocal delivery.[10] Ironically, while the voices of the elected government and the Westminster elite were used to discredit them, it was the third in line to the hereditary throne, the popular Prince William, who was adjudged to have a 'relaxed' modern RP accent and the professional competence to fulfil his symbolically representative role.[11]

Under the Coalition, limited resources and a climate of austerity has led to a more fractious and anxious political context. Measures such as cuts and reforms to welfare, the scrapping of the 50p tax rate for higher earners, the introduction of an unpopular 'bedroom tax', and failure to rein in the bonus culture in banks resulted in a perception that the government was reinforcing divisions between rich and poor. As concern for 'hard working families' became the main Parties' mantra, a re-emergence of the idea of the 'deserving' and 'undeserving' elements of society seemed to be growing, and there has been evidence of a more divided and divisive society. In England, the United Kingdom Independence Party (UKIP) leader Nigel Farage's apparently direct talking style appealed to voters, and his claim that the main parties 'don't

listen' has arguably enabled the Party to feed on fears regarding immigrants to the UK and appear to 'speak for' the alienated working-class voter.[12] In Scotland, a campaign for Independence has also re-focused discontent with the representative system – particularly with regard to the historical underrepresentation of ordinary Scottish voices at Westminster. While the Scottish Nationalist targeting of lower income groups promised a better future to the poor and marginalised, both Alex Salmond's use of Scottish slang, and George Galloway's 'Just Say Naw!' pro-Union campaign attempted to focus their sense of Scottish identity through the 'authentic' features of the Scottish voice.[13]

In British popular culture, representations of a hierarchically structured society have proliferated, with TV programmes portraying a plutocratic system with rigidly or specifically class bounded characters. From 2010 *Downton Abbey,* set in an Edwardian British country estate, became nationally and internationally popular, portraying its upper-class characters with contemporary RP and its servants with period Yorkshire (without local dialectical features). The 'scripted reality' TV series, *The Only Way Is Essex* (2010–) and *Made in Chelsea* (2011–), with their portrayals of contemporary Britain, seemed to use the 'real' speech of 'real' young men and women from specific class and regional areas. Like *Shameless* (2004–13), the popular TV soap depicting life on a Manchester council estate, and *Benefits Street* (2014), the Channel Four documentary of a real street in Birmingham, these shows caused controversy regarding the extent to which they represented or stereotyped working-class identity. The latter in particular seemed to suggest the feeding of a voyeuristic interest in 'poverty porn'.[14] While Owen Jones' book *Chavs* (2011) has challenged the 'conspiracy of silence' that had developed around working-class identity and its demonisation, the phenomenon of 'chav-speak', and the crude characterisation of 'common' speech in the media, reinforced the perennial narrative that links non standard speakers of English with behavioural deviance and moral inferiority.[15]

In theatre there was also a shift of attention to the sounds of a more excluding and hierarchically structured society. Dominic Cooke's decision in 2010 to programme plays at the Royal Court about the middle and upper classes suggested a determination to scrutinise 'what it means to have power, and what it means to have wealth' rather than challenge this through the representation of marginalised voices.[16] In *Posh* (2010), Laura Wade's depiction of Oxbridge undergraduates portrayed the covert and obnoxious strategies of the privileged to maintain their position. The early 2010s also brought a host of class inflected voices through a spate of revivals of the works of Terence Rattigan, the centenary of

whose birth fell in 2011. In 2010, the decade's most ubiquitous actor to date, old Harrovian Benedict Cumberbatch, led in *After the Dance* at the Lyttleton, a play which portrays a group of Mayfair hedonists on the eve of the war. In 2011 there were revivals of *The Deep Blue Sea* at the West Yorkshire Playhouse and Chichester Festival Theatre, *Flare Path* at the Theatre Royal Haymarket, and *Cause Célèbre* at The Old Vic. This was followed by *The Browning Version* and David Hare's *South Downs* in 2012 – making for an evening of 'clipped vowels, clever rejoinders and suppressed emotions' – and *The Winslow Boy* at the Old Vic in 2013.[17] Coinciding with the period of economic austerity introduced by the Coalition, the revival of Rattigan's characters' class-defined social positions suggested a vogue for retrospective type of English identity associated with the stiff upper lip, a sense of repression and a war time bracing for hard times. Cumberbatch's fears that his privileged background, could 'ostracize' him from the 'normal codes of conduct in society', and his 'posh' accent lead to 'class-typing', suggested the continued challenges to talented actors with regard to gaining a casting beyond their 'natural' vocal characteristics (a fear that is both corroborated and countered by Boltonian Maxine Peake's view that 'if you've got a regional accent you're not taken as seriously').[18] The rash of actors with private school backgrounds who achieved success in the period arguably suggests that the long established benefits of the British private school system could remain a helpful leg up.[19]

As I have argued, theatres have, and will presumably continue to provide voicescapes for the articulation of identities that are marginalised by wider society. It may be that few of the new generation of writers that emerged through the writing programmes of the Royal Court are specifically interested in the portrayal of the voices and experience of regionally based speakers. However, since the end of the Blair period, the spate of plays in which upper-class identities have been sympathetically articulated have been countered by revivals of socially realistic work from the past. These revivals have again brought 'ordinary' voices into theatre space, and speak of an interest in attending to the causes and contexts with which the voices of the poor, the working class and the marginalised negotiate. Revivals of *The Bevellers* (1973) in 2007 at Glasgow Citizens, and *Men Should Weep* at the National Theatre in 2010, portrayed Glaswegian labour and poverty. Arnold Wesker's West End kitchen workers came to The National in *The Kitchen* (1959) in 2011, and Shelagh Delaney's in *A Taste of Honey* (1958) revived at both the Sheffield Crucible in 2012 and the National Theatre in 2014 articulated the realities of working-class Salford experience. Wesker's

Chicken Soup with Barley (1958), portraying an East End family at the time of Moseley's Fascist march was revived at the Royal Court in 2011, and the Norfolk dialect of Wesker's domestic drama *Roots* (1959), with its portrayal of female enlightenment and empowerment, was revived at the Donmar Warehouse in 2013. Lee Hall's new play, *The Pitmen Painters* (2007), which transferred from Newcastle Live to the National, articulated the struggle between class solidarity and individual artistic expression through the Northumbrian voices of miners in the 1930s. Hall's stage adaptation of his 2000 film *Billy Elliott*, which similarly explored the creative potential of an artistic male in a Northern context, represented its young male protagonist succeeding as a ballet dancer. The play's popularity, and its transfer to Broadway in 2008, is perhaps telling of a lasting predilection for the articulation of unfixed and aspirational identities that defy their oppressive or austere circumstances. Both a 2013 revival of *The Pajama Game* (1954) and a musical version of *Made in Dagenham* (2014) suggested the West End appeal of the empowerment of the voices of ordinary working people in the context of an oppressive or anachronistic social order.

Within theatre, as the industry responds to its own series of funding cuts, the discourse of practitioners suggests both shifts and changes in its management and a fractious and painful narrowing of opportunity.[20] In an interview for *The Japan Times* in 2014, Vicky Featherstone commented – from her globe trotting perspective – that people who have been on the 'outside' were coming in to the 'center', replacing the Oxbridge old guard. Writer Jack Thorne by contrast warned of the danger of poor pay, and of industry circles becoming 'smaller and smaller', populated by 'the sons and daughters' of the already established.[21] A similar point has been made more controversially by the incoming minister for Culture, Media and Sport, Sajid Javid, who has emphasised the responsibility of the Arts to increase diversity and access for all classes and races, while urging the sector – which he perceives as serving the elite – to seek funding from philanthropists rather than taxpayers.[22] Javid has expressed support for the well-known black performer Lennie Henry's call for quotas of black actors in the creative industries (which incited a UKIP council candidate to goad the British actor to leave the country).[23] Roy Williams, who in the 2000s had fiercely rejected tokenism, also pits race against class in his preparedness to envisage quotas for black practitioners in a risk-averse theatre industry whose circle he sees contracting to cater for the 'white middle class'.[24] In 2014 the exploration in *Yellow Face* (National Theatre, 2014) of a Chinese immigrant's fantasy of playing Jimmy Stewart on the big screen took

its starting point as the casting of white actors in Asian roles in *Miss Saigon*. The play recycled the American dream, but its themes resonated with the British context where in 2012 controversy was caused by the Royal Shakespeare Company's failure to cast Asian actors in *The Orphan of Zhao*.[25] Aware that casting practices were still tending to tie character to race – a big issue for many ethnic minority actors born and raised in Britain – established black actor Paterson Joseph cautioned young black actors against using a 'black theatre voice'. More important, he claimed, was vocal versatility coupled with a sense of 'who you are in the world'.[26]

Young voices have been increasingly audible in theatre's voicescapes, and have continued to gain representation in cultural space and media. The hugely popular TV sixth form drama series *Skins*, which ran from 2007–2013, refreshed its young cast every two years, and consulted 'normal' teenagers for authentic expressions and dialect.[27] In mainstream theatre the integration of the young has led to more performances by children themselves, from E. V. Crowe's *Kin* (2010) at the Royal Court, where pre-teen actresses played foul-mouthed isolated ten year old girls at boarding school, to the Royal Shakespeare Company's redemptive version of childhood loneliness in *Matilda* (2012), whose open casting gave opportunities to some children to perform in Stratford, the West End and on Broadway. In general society, by contrast, hundreds of thousands of young adults faced unemployment, as well as more expensive housing and education costs.[28] As part of the government's programme of austerity, The National Association of Youth Theatres lost its regular funding, and there were also cuts to youth theatre groups across the country such as Croydon, Stamford and Burnley.[29] A deeply disturbing outbreak of civil unrest across Britain in the summer of 2011, depicted in Gillian Slovo's verbatim play *The Riots* (2011) at The Tricycle, renewed national debate on the disruptive behaviour of young people and its causes. Barnardo's again condemned descriptions of the young as 'feral', 'animal' and 'vermin', and the gross overestimation of the proportion of crime for which young people were responsible.[30] At the other end of the scale, in 2011, *The Daily Mail* reported that the 22 year-old Daniel Radcliffe, star of the Harry Potter film series, and who appeared in the West End in *Equus* in 2007, earned £51.7 million.[31]

Voicing representation

New Labour's political aspirations had implied a vision of a diverse and tolerant society where previously rigid and authoritarian structures and systems would be responsive and transparent, sensitive and answerable

to the collective will of the people. By the end of the Blair period, the perception of a major flaw of representative democracy – that the elected voice cannot always be trusted to respond to the will of the electorate – had resurfaced. During the Coalition government from 2010, a string of incidents and affairs have followed the MPs expenses scandal that had begun under Brown, casting aspersions on the conduct of MPs, the press, police and public broadcasting.[32] Worldwide, the Wikileaks and Edward Snowden affairs suggest intense preoccupations with trust and transparency, not only on behalf of publics in relation to the authorities, but of the authorities with regard to the potentially dissenting and disordering potential of e-space. More than ever, in an age of online petitions, live Twitter feeds and instantaneous interactive response, there seems justification for more direct forms of democracy to succeed in Western forms of representative systems.[33] Yet these forms are quickly becoming, like other forms of mediatisation, manipulated as a means of marketisation, surveillance and regulation. I have argued that the validation of the qualities of sincerity and transparency were linked under New Labour and beyond to the intimate relationship promised between politicians and the people who voted for them. A betrayal of a promise, like that of Nick Clegg's on not raising tuition fees, can undo all the 'plain-speaking' work that propels a politician to power.[34] Writing in 2014, politicians of all the major parties, are now perceived as monotone, as the electorate seems to crave voices that seem unspun, singular and above all responsive.[35] Noting the widely recognised disillusionment in the West with the representative system, political scholar and Green Party member Andrew Dobson's *Listening for Democracy* (2014) offers 'meaningful listening' on behalf of governments as the solution, 'listening, as a solvent power, works best when the powerful are obliged to listen – without interruption – to the voices of the powerless'.[36]

Within this rapidly shifting context, practitioners continue to use oral and aural means to attend to the voice, to deconstruct the discredited practices of representation, and to suggest alternatives. The final chapter of this book explored how the voice was used as a metaphor for the degraded processes of democracy. Plays such as *Chatroom, Taking Care of Baby* and *Black Watch* for example included valuable reminders of the duties and failings of representative processes in artistic spheres, drawing on and deconstructing the tradition of the 'author-creator' who, 'absent from afar . . . keeps watch over, assembles, regulates'.[37] The work of Tim Crouch is perhaps most typical of this tendency to use authorship, and its apparent 'death', as a means of ethical and political questioning.[38] Crouch challenges audience members to consider their

own potentially collusive role in the exploitative practices of representation in theatre performance. *Adler and Gibb* (2014), at the Royal Court, continued the practitioner's deconstructive mission, ruthlessly exposing and undermining the research and rehearsal strategies of the actor protagonist's 'acquisitive' pursuit of reality.[39] Many other practitioners and companies have taken further steps to remove the norms of time, space and authorship, preferring site specific or non theatre spaces to explore both intimate and communal interactions, and giving audiences opportunities to participate directly in making performance together. Individual artists such as Adrian Howells or Deborah Pearson, and the one-on-one festivals at the Battersea Arts Centre have used alternative, non-theatre spaces, alter egos and created experiences that demand of audiences reassessments of the clear lines that have delineated roles in representative processes. Rather than enforcing the privileging of representation as a cultural and political practice, these forms of performance perhaps mount a challenge to a Habermasian model, offering instead more direct, interactive and participatory means of communication.

Further major shifts are occurring in the relations of theatre, subjectivity and the demos due to the apparent expansion of time and space afforded to theatres by digital technologies and the internet. Audiences can now perform new versions of themselves through online gaming pieces, construct a 'voice' for themselves through DIY technology, or experience new intimacies with distant strangers through web chat and 'face-time' platforms. This digital space is a kind of new public sphere, which mediates and represents voices, and which produces new fields of cultural articulation and audibility. Its potentially infinite internet windows, to a greater or lesser extent public or privatised, imply challenge to traditional institutions, such as the 'dead white males' generation of press critics, and provide new spaces to challenge totalising versions of contemporary experience. Yet the internet has also been a medium in which the individual renders herself vulnerable by publicising her 'inner' self, where she may be encouraged to explore exploitative or even morally abhorrent fields of representation, and in which she subjects herself to unwanted approaches, oppressive ideologies and insidious marketing discourses. The net is another place and means of mediation, complex in its workings, which seems to emphasise the interconnectedness of subjects, but where voices and language are physically separated from individual bodies.

While it is tempting to argue that a heavily mediated web space reaffirms the particular values of live theatre, in the development of work for traditional mainstream spaces practitioners continue to negotiate

with powerful ideologically and economically driven agenda. The influence of new Arts Council priorities of digital media and theatre for family audiences can be discerned in many collaborative productions, as well as a growing corporatisation of theatre practice, in which individual artists are submerged within greater brands such as the National Theatre, and the National Theatre of Scotland. Yet in the 2010s writers and performers continue to use both voicing and listening practices to surprise, scrutinise, stretch and challenge the values of the demos. In 2014, Gurpeet Kaur Bhatti's *Khandan (Family)* articulated the experience of a Birmingham British Sikh family, reflecting the Royal Court's continued interest in amplifying new and marginalised voices through social realism. The same theatre's production of *Maidan: Voices From the Uprising* (2014), a verbatim piece based on the uprising in the Ukraine, suggests continued faith and investment in the vocal testimony of 'real' words. At the National, both Alecky Blythe's *London Road* (2011), about the serial killing of Ipswich prostitutes in 2006, and Nadia Fall's *Home* (2014), about young people from Britain and abroad in residential care, combined music and choreography with testimony of people whose voices are rarely heard or are drowned out by louder discourses. 1927's *The Animals and Children Took to the Streets* (2011–14) combined the ingenuity of digital technology with subversively androgynous female vocal dexterity to bring beauty and attention to urban squalor, alienation and isolation. Nick Payne and Carrie Cracknell's devised piece *Blurred Lines* (2014) made frequent use of microphones to stress the performed rather than natural qualities of female roles in tackling the potentially pernicious link between the representation of women in performance and wider, globalised structures of sexual oppression. The programming of such diverse and thought-provoking pieces demonstrates a commitment to extend the sphere of representation and to use the artistry of voices, in collaboration with a range of other media, to examine its terms. I hope this book has helped to demonstrate the ways that the inclusion of marginalised, diverse or rarely heard voices in theatre can articulate and scrutinise society, and more generally the value in attending to the voice as a tool of both creative and reflective practice.

Notes

Introduction: Articulating the Demos

1 Steven Connor, 'The Strains of the Voice', in *Voices and Emotion: Volume III*, edited by Krzystof Izdebski (San Diego, Oxford and Brisbane: Plural Publishing, 2009), pp. 298–305 (p. 298).

2 Raymond Williams, *Marxism and Literature* (Oxford: Oxford University Press, 1977), p. 29.

3 *Shorter Oxford English Dictionary* (Oxford: Oxford University Press, 2002), p. 3553.

4 There is a consensus of scholarly analysis on the influence of Giddens on New Labour, Simon Prideaux for example, citing discussions in the work of Kirk Mann, Paul Cammack, David Morrison and others. Simon Prideaux, *Not So New Labour: A Sociological Critique of New Labour's Policy and Practice* (Bristol: Polity Press, 2005).

5 *Shorter Oxford English Dictionary*, p. 3553.

6 Anthony Giddens, *The Transformation of Intimacy: Sexuality, Love and Eroticism in Modern Societies* (Cambridge: Polity Press, 1992), p. 186.

7 The linkage of participation and empathy can also be seen in the work of John Gray. John Gray, 'Liberalism and Living Together', in *The Moral Universe*, edited by Tom Bentley and Daniel Stedman Jones (London: Demos, 2001), pp. 1–8; Giddens, *The Transformation . . .* , p. 136.

8 Carol Johnson, 'Moving Citizenship: Exploring Worlds of Emotional Politics', paper given at the Autumn Colloquium, Birkbeck College, 24 October 2008.

9 Carol Martin, for example, refers to an 'epistemological crisis in knowing truth'. Carol Martin, *Theatre of the Real* (Basingstoke: Palgrave Macmillan, 2013), p. 14.

10 See Janine Hauthal Wuppertal, 'Realisms in British Drama since the 1990s: Anthony Neilson's *Realism* and Gregory Burke's *Black Watch*', in *Realisms in Contemporary Culture: Theories, Politics, and Medial Configurations*, eds Dorothee Birke and Stella Butter (Berlin: de Gruyter, 2013), pp. 146–77 (p. 173).

11 Liz Tomlin, 'Foreword', in Vicky Angelaki (ed.), *Contemporary British Theatre: Breaking New Ground* (Basingstoke: Palgrave Macmillan, 2013), pp. viii–xxvi (p. x).

12 G. A. Bryant and David Jary have described the influence of Habermas on Giddens. G. A. Bryant and David Jary, 'Anthony Giddens', in *The Blackwell Companion to Major Social Theorists*, edited by George Ritzer (Oxford: Blackwell, 2003), pp. 247–73; Jürgen Habermas, *Communication and Evolution of Society*, trans. by Thomas McCarthy (Cambridge: Polity Press, 1984), p. 59.

13 Ric Knowles, *Reading the Material Theatre* (Cambridge: Cambridge University Press, 2004), pp. 14–15.

14 Dan Rebellato, *1956 and All That: The Making of Modern British Drama* (London: Routledge, 1999).

15 Winsome Pinnock, 'Breaking Down the Door', in *Theatre in a Cool Climate*, edited by Vera Gottlieb and Colin Chambers (Oxford: Amber Lane Press, 1999), pp. 27–38 (p. 29).

16 Michael Boyd, conference panel contribution, at 'How Was it For Us: Theatre Under Blair', Writers' Guild, 9 December 2007.

17 John McGrath, *Naked Thoughts that Roam About*, edited by Nadine Holdsworth (London: Nick Hern, 2002), p. 236.

18 *Modern British Playwriting: The 1990s: Voices, Documents, New Interpretations*, edited by Aleks Sierz (London: Methuen, 2012), p. 54.

19 Voice teacher Flloyd Kennedy states that a voice performed in the theatre is 'the voice of the actor, the voice of the character, *and* the voice of the author'. Flloyd Kennedy, 'The Challenge of Theorising the Voice', *Modern Drama*, 52 (2009), 405–25 (p. 412). In *Reading Theatre* (1999) Anne Ubersfeld identifies a critical anxiety over the lack of certainty surrounding the central identity of a dramatic text. Anne Ubersfeld, *Reading Theatre*, edited by Frank Collins and Paul Perron, trans. by Frank Collins (Toronto: Toronto University Press, 1999), p. 167.

20 Mikhail Bakhtin, 'Discourse in the Novel', in *The Dialogic Imagination*, edited by Michael Holquist, trans. Caryl Emerson and Holquist (Austin and London: University of Texas Press, 1981), pp. 285–422.

21 Steven Connor, *Dumbstruck: A Cultural History of Ventriloquism* (Oxford: Oxford University Press, 2000), p. 4; Mladen Dolar, *A Voice and Nothing More* (Cambridge, MA: MIT Press, 2006), p. 112.

22 Roland Barthes, 'From Speech to Writing', *The Grain of the Voice: Interviews 1962–1980*, trans. by Linda Coverdale (Berkeley and Los Angeles: University of California Press, 1981), pp. 3–7 (p. 4).

23 Elsie Fogerty, *The Speaking of English Verse* (London and Toronto: J. M. Dent & Sons, 1923), p. vii.

24 Konstantin Stanislavski, *An Actor's Work*, translated and edited by Jean Benedetti (London: Routledge, 2008), pp. 54–5.

25 Erving Goffman's thought is highly influential to Giddens. Erving Goffman, *The Presentation of the Self in Every Day Life* (New York: Doubleday Anchor, 1959), p. 253.

26 See Philip Auslander, *From Acting to Performance* (London and New York: Routledge, 1997), pp. 29–30.

27 Pierre Bourdieu, *Language and Symbolic Power*, edited by John B. Thompson, trans. by Gino Raymond and Matthew Adamson (Cambridge: Polity Press, 1991), p. 86.

28 Judith Butler, *Excitable Speech: A Politics of the Performative* (New York and London: Routledge, 1997), p. 28.

29 See Enrique Pardo, 'Figuring Out the Voice: Object, Subject, Project', *Performance Research* 8 (2003), 41–50.

30 See for example, Petr Bogatryev, 'Semiotics in the Folk Theatre', trans. by Bruch Kochis, in Matejka and Titunik, eds, *Semiotics of Art: Prague School Contributions*, pp. 33–50 (p. 37).

31 Erving Goffman, *Stigma: Notes on the Management of Spoiled Identity* (New York: Simon and Schuster, 1963), p. 2.

32 Keir Elam, *The Semiotics of Theatre and Drama* (London and New York: Routledge, 1980), p. 72. Also see Ubersfeld, p. 173.

33 Laura K. Guerrero and Kory Floyd show how features such as tempo, pitch, pitch range, resonance, nasality and shrillness, as well as its level of articulation are used as indicators of a speaker's 'likeability, achievement and dominance'. Laura K. Guerrero and Kory Floyd, *Nonverbal Communication in Close Relationships* (Mahwah, NJ and London: Laurence Erlbaum Associates, 2006), p. 78.

34 Also see James Milroy and Lesley Milroy, *Authority in Language: Investigating Standard English* (London: Routledge, 1999), p. 15; Peter Trudgill, *Introducing Language and Society* (London: Penguin, 1992), p. 210; and Peter Trudgill, *Social and Geographical Perspectives* (Oxford: Blackwell, 1983), p. 205.

35 J. K. Chambers, *Sociolinguistic Theory* (Oxford: Blackwell, 1995), pp. 213–14; M. A. K. Halliday, *Language as Social Semiotic: the Social Interpretation of Language and Meaning* (London: Arnold, 1978), pp. 164–82; *Urban Voices: Accent Studies in the British Isles*, edited by Paul Foulkes and Gerard J. Docherty (London: Arnold, 1999).

36 William Labov, 'The Social Motivation of a Sound Change', in *Sociolinguistic Patterns* (Philadelphia: University of Pennsylvania Press, 1972), pp. 1–41.

37 For discussion of this, see Mireira Aragay and Enric Monforte, 'Racial Violence, Witnessing and Emancipated Spectatorship in *The Colour of Justice, Fallout and Random*, in Angelaki, pp. 96–120 (p. 104).

38 Barthes, p. 4; Walter Ong, *Orality and Literacy: The Technologizing of the Word* (London and New York: Methuen, 1984), p. 175.

39 Michel Foucault, *Technologies of the Self: A Seminar with Michel Foucault*, edited by Martin Gutman and Hutton (Amherst: University of Massachusetts Press, 1988), pp. 16–49 (p. 49).

40 Maslow's well-known paradigm had placed 'self-actualisation' at the top of his 'hierarchy of needs'. Abraham H. Maslow, *The Maslow Business Reader*, edited by Deborah C. Stephens (New York: John Wiley & Sons, 2000), p. 16. For Giddens' discussion of 'self-actualisation' see Anthony Giddens, *The Consequences of Modernity* (Stanford: Stanford University Press, 1990), p. 124.

41 Giddens, *Consequences*, pp. 92–3.

42 John Bull, *Stage Right: Crisis and Recovery in British Mainstream Theatre* (Basingstoke: Macmillan – now Palgrave Macmillan, 1994).

43 Graham Saunders, 'Introduction', in *Cool Britannia? British Political Drama in the 1990s*, edited by Rebecca D'Monté and Graham Saunders (London: Palgrave Macmillan, 2008), p. 13.

44 Jen Harvie, *Staging the UK* (Manchester: Manchester University Press, 2005).

45 Steve Blandford, *Film, Drama and the Break-Up of Britain* (Bristol: Intellect, 2007), p. 7, 151.

46 Sierz selects Philip Ridley, Sarah Kane, Anthony Neilson and Mark Ravenhill; Sierz, *Modern British Playwriting*.

47 John Deeney, 'National Causes/Moral Causes?: The National Theatre, Young People and Citizenship', *Research in Drama Education*, 12 (2007), 331–44.

48 *Alternatives within the Mainstream: British Black and Asian Theatres*, edited by Dimple Godiwala (Newcastle: Cambridge Schools Press, 2006).

49 Adrienne Scullion, 'Self and Nation: Issues of Identity in Modern Scottish Drama by Women', *New Theatre Quarterly*, 17 (2001), 373–90 (375); David

Pattie, '"Mapping the Territory": Modern Scottish Drama', in D'Monté and Saunders, pp. 143–57 (p. 147); David Pattie, 'Theatre Since 1968', in *A Companion to Modern British and Irish Drama, 1880–2005*, edited by Mary Luckhurst (Oxford: Blackwell, 2006).

50 Kate Dorney's *The Changing Language of Modern English Drama, 1945–2005* (London: Palgrave Macmillan, 2009) explores dramatic dialogue using linguistic and socio cultural frameworks, but largely ignores the paralinguistic and physiological aspects that actors bring to text in performance.

51 Andrew M. Kimbrough, *Dramatic Theories of Voice in the Twentieth Century* (New York: Cambria, 2011).

52 Alessandro Portelli, *The Text and the Voice* (New York: Columbia University Press, 1994), p. 15.

53 Flloyd Kennedy, 'The Challenge of Theorising the Voice', *Modern Drama*, 52 (2009), 405–25 (pp. 407–8).

54 Susan Melrose, *A Semiotics of the Dramatic Text* (London: Macmillan, 1994), p. 202.

55 The interpenetration of bodies in phenomenological perception can be traced to Merleau-Ponty. Maurice Merleau-Ponty, *Phenomenology of Perception*, trans. by Colin Smith (London and New York: Routledge, 2002), p. 216. See also Marin Jay, *Downcast Eyes: The Denigration of Vision in Twentieth-Century French Thought* (Berkeley: University of California Press, 1994); Adrienne Janus, 'Listening: Jean-Luc Nancy and the "Anti-Ocular" Turn in Continental Philosophy and Critical Theory', *Comparative Literature*, 63 (2011), 182–202. Jean-Luc Nancy, *Listening*, trans. by Charlotte Mandell (New York: Fordham, 2002).

56 Charles Bernstein, *Close Listening: Poetry and the Performed Word* (Oxford: Oxford University Press, 1998).

57 Adriana Cavarero, *For More Than One Voice: Toward a Philosophy of Vocal Expression* (Stanford: Stanford University Press, 2005), p. 8.

58 Nick Couldry, *Why Voice Matters: Culture and Politics after Neoliberalism* (London: Sage, 2010), pp. 2–3.

59 Williams, *Marxism and Literature*, pp. 132–5.

60 Arjun Appadurai uses the suffix 'scapes' to refer to dimensions of the 'social imaginary', but does not attend specifically to the voice. Arjun Appadurai, *Modernity at Large* (Minnesota: University of Minnesota Press, 1996). Hazel Smith and Roger T. Dean, who use the term to describe vocal and sonic blends created through digital technologies, argue that the multidimensional connotations of the suffix 'scapes' are highly appropriate given the multiple aspects of the voice. Hazel Smith and Roger T. Dean, 'Voicescapes and Sonic Structures in the Creation of Sound Technodrama', *Performance Research*, 8 (2003), 112–24 (p. 123).

61 Jacques Rancière, *The Politics of Aesthetics: The Distribution of the Sensible*, trans. by Gabriel Rockhill (London: Continuum, 2004), pp. 12–13.

62 Henri Lefebvre, *The Production of Space*, trans. by Donald Nicholson-Smith (Oxford: Blackwell, 1991), p. 27.

63 Jonas Barish, *The Anti-theatrical Prejudice* (Berkeley and LA: University of California Press, 1981).

64 Josie Ensor, '"Mockney" George Osborne Back the Briddish Who Wanna Work', *Telegraph*, 17 July 2013, http://www.telegraph.co.uk/news/politics/

georgeosborne/9966717/Mockney-George-Osborne-backs-the-Briddish-who-wanna-work.html [accessed 17 July 2013].

65 Norman Fairclough, *New Labour, New Language?* (London and New York: Routledge, 2000), pp. 98–103.

66 See, for example, Joe Kelleher, 'Our Radius of Trust: Community, War and the Scene of Rhetoric', in *Blairism and the War of Persuasion*, edited by Deborah Lynn Steinberg and Richard Johnson (London: Laurence and Wishart, 2004), pp. 173–85 (pp. 173–4); and Mark Lawson, 'The Next PM Will Be the One Who Can Best Fake Sincerity', *Guardian*, 5 October 2007, http://www.guardian.co.uk/comment/story/0,,2184031,00.html [accessed 12 October 2007].

67 According to an Ipsos MORI poll in June 2013, one in five people (21%) said they trusted MPs to tell the truth and 72% did not trust them. Ipsos MORI, Trust in MPs Poll, 13 June 2013, http://www.ipsos-mori.com/research publications/researcharchive/3184/Trust-in-MPs-poll.aspx [accessed 19 June 2013].

68 See, for example, D'Monté and Saunders, p. 10.

69 Stuart Hall, 'New Labour's Double-Shuffle', *Soundings* 24 (2003), 10–24 (p. 12).

70 Tony Blair, *The Third Way: New Politics for the New Century* (London: Fabian Society, 1998).

71 Flavio Romano, *Clinton and Blair: The Political Economy of the Third Way* (London: Routledge, 2006), pp. 4–8.

72 David Hare, *The Absence of War* (London: Faber & Faber, 1993).

73 Paul Cammack, 'Giddens' Way with Words', in *The Third Way: Criticisms, Futures, Alternatives*, edited by Sarat Hale, Will Leggett and Luke Martell (Manchester: Manchester University Press, 2004), pp. 151–66; Norman Fairclough, *New Labour, New Language?* (London and New York: Routledge, 2000).

74 Jack Straw, qtd in Alwyn W. Turner, *A Classless Society: Britain in the 1990s* (London: Aurum Press, 2013), p. 313.

75 'NT's Hytner Rounds on "Dead White Male" Critics"', 14 May 2007, http://www.whatsonstage.com/west-end-theatre/news/05-2007/nts-hytner-rounds-on-dead-white-male-critics_21073.html [accessed 30 May 2014].

76 Kwame Kwei-Armah, quoted in Barbara Ellen, 'Songs in the Key of Kwame', *Observer*, 23 November 2003, Review, p. 3.

77 Lynette Goddard sees her work as 'eminently different' from that of her male contemporaries. Lynette Goddard, 'Backpages', *Contemporary Theatre Review*, 15 (2005), 369–86 (p. 380).

1 New Labour, New Voicescapes 1997–2007

1 Yosser Hughes was a main character in Alan Bleasedale's BBC TV series, *Boys From the Blackstuff* (1982)

2 In 1983 during Prime Minister's Questions, Thatcher accused Dennis Healey of being 'frit' of a general election.

3 See Robert Busby, *Marketing the Populist Politician: The Democratic Democrat* (Basingstoke: Palgrave Macmillan, 2009), p. 82, and Graham Ball, 'Mr Major Has Found a More Macho Voice, Oh Yes', *Independent*, 3 November 1996, http://www.independent.co.uk/news/mr-major-has-found-a-more-macho-voice-oh-yes-1350436.html [accessed 15 July 2013].

4 See Richard Hefferman and Mike Marquese, *Defeat from the Jaws of Victory: Inside Kinnock's Labour Party* (London: Verso, 1992), p. 206.

5 One of Blair's chief advisors, marketing and advertising executive Philip Gould, had worked closely with Clinton's press strategy and polling team in the run up to the 1997 election. See Philip Gould, *Unfinished Revolution* (London: Abacus, 1999).

6 Labour Party, *New Labour: Because Britain Deserves Better* (London: Labour Party, 1997), p. 3.

7 Second generation Guyanese immigrant Trevor Phillips became head of the new Commission for Racial Equality. Baronness Amos, first black deputy head girl of Bexleyheath Technical High School for Girls, became the first black female member of the Cabinet and Leader of the House of Lords. Dewsbury council schoolgirl Betty Boothroyd became the first female speaker of the House of Commons.

8 The number of black and Asian MPs rose from 5 in 1992 to 9 in 1997. Richard Cracknell, 'Social Background of MPs', *House of Commons Library*, November 2005, http://www.parliament.uk/commons/lib/research/notes/snsg-01528.pdf [accessed 31 December 2006]; Bhikhu Parekh, *The Parekh Report* (London: Profile, 2000), p. 3.

9 In 2005 the People's Millions project gave the public a vote on the awarding of public subsidies. 'Blair Launches "Big Conversation"', 28 November 2003, http://news.bbc.co.uk/1/hi/uk_politics/3245620.stm [accessed 10 December 2009]; 'The People's 50 Million', http://www2.biglotteryfund.org.uk/prog_the_peoples_50_million [accessed 19 March 2010].

10 See, for example, Alwyn W. Turner, *A Classless Society: Britain in the 1990s* (London: Aurum, 2013), pp. 6–7.

11 *The Kumars at Number 42*, created by Sanjeev Bhaskar, Richard Pinto and Sharat Sardana (Hat Trick Productions, 2001).

12 *The Routes of English*, produced by Simon Elmes and Tony Phillips, presented by Melvyn Bragg, (BBC Radio 4), 1999; Simon Elmes, *Talking for Britain: A Journey Through the Nation's Dialects* (London: Penguin, 2006); 'Sounds Familiar', http://www.bl.uk/learning/langlit/sounds/index.html [accessed 23 February 2008]; 'Your Voice', http://www.bbc.co.uk/voices/ [accessed 23 February 2008].

13 Peter Trudgill and Richard Watts, *Introducing Language and Society* (London: Penguin, 1992) p. 71.

14 Peter Trudgill and Richard Watts, *Alternative Histories of English* (New York: Routledge, 2002), p. iv.

15 In 1999 Taavitsainen, Melchers, and Pahta saw 'linguistic variation as a complex continuum of language use from standard to nonstandard [. . .] covering several dimensions from one pole to another'. Irma Taavitsainen, Gunnel Melchers and Päivi Pahta, 'Introduction', in *Writing in Nonstandard English*, edited by Irma Taavitsainen, Gunnel Melchers and Päivi Pahta (Amsterdam: John Benjamins, 1999), p. 1.

16 Paul Foulkes and Gerard Docherty, 'Introduction', in *Urban Voices: Accent Studies in the British Isles*, edited by Paul Foulkes and Gerard Docherty (London: Arnold, 1999), pp. 3–17 (p. 13).

17 See James Mills, 'Queen's English Moves into the Realm of "Thames Estuary"', *Daily Mail*, 5 December 2006, http://www.dailymail.co.uk/pages/live/

articles/news/news.html?in_article_id=420246&in_page_id=1770 [accessed 15 October 15].

18 Norman Fairclough, *New Labour, New Language?* (London and New York: Routledge, 2000), p. 98.

19 Alice Thomson, 'The Toffs are Back – and Only David Cameron Can Stop Them', *Daily Telegraph*, 25 October 2005, http://www.telegraph.co.uk/opinion/main. jhtml?xml=/opinion/2005/10/25/do2501.xml&sSheet=/opinion/2005/10/25/ ixopinion.html [accessed 3 November 2007].

20 Michael Peace, 'Informalization in UK Party Election Broadcasts 1966–1997', *Language and Literature*, 14 (2005), 65–90.

21 Alwyn T. Turner, p. 8.

22 Paddy Scannell, *Radio, Television and Modern Life: A Phenomenological Approach* (Oxford: Blackwell, 1996), p. 74.

23 Bob Franklin, *Packaging Politics: Political Communications in Britain's Media Democracy* (London: Arnold, 2004), p. 10.

24 'Cameron Says PM Stuck in the Past', 7 December 2005, http://news.bbc. co.uk/1/hi/uk_politics/4505250.stm [accessed 24 January 2008].

25 *Unfinished Revolution*, p. 271.

26 Martin Montgomery, 'Speaking Sincerely: Public Reaction to the Death of Diana', *Language and Literature*, 8 (1999), 5–34 (p. 26).

27 Anthony Giddens, *The Transformation of Intimacy: Sexuality, Love and Eroticism in Modern Societies* (Cambridge: Polity, 1992), p. 186.

28 Anthony Giddens, *The Third Way: The Renewal of Social Democracy* (Oxford: Polity, 1998), p. 78.

29 An Arts Council England report issued in 1998 shows that the level of public funding in the UK in the 1990s stood at 0.14% of GDP, far below the average of comparable countries. Arts Council England, *International Data on Public Spending in the Arts in Eleven Countries* (Arts Council England, 1998). In 2002, the Treasury's Comprehensive Spending Review promised an annual increase in real terms of 3.5% to the Arts for three years. HM Treasury, *Spending Review 2002*, http://webarchive.nationalarchives.gov.uk/20071204130111/http:// hm-treasury.gov.uk/spending_review/spend_sr02/press/spend_sr02_press dcms.cfm [accessed 3 January 2015].

30 Arts Council England, *Grants for the Arts* (Arts Council England, 2005), p. 4.

31 Arts Council England, Theatre Policy 2007, http://www.hm-treasury.gov.uk/ Spending_Review/spend_sr02/report/spend_sr02_repchap17.cfm [accessed 21 October 2007].

32 Arts Council England, 'About Us: Planning for the Future – Public Value', http://www.artscouncil.org.uk/aboutus/planning.php [accessed 23 October 2007].

33 Dominic Shellard, *Economic Impact Study of UK Theatre* (Arts Council England, 2004), http://www.aandb.org.uk/render.aspx?siteID=1&navIDs=1,8,250 [accessed 6 January 2006].

34 David Edgar, *State of Play*, edited by David Edgar (London: Faber & Faber, 1999), p. 24.

35 Tony Blair, *The Third Way: New Politics for the New Century* (London: Fabian Society, 1998)

36 *Edexcel GCSE in Citizenship Studies – Short Course (3280)* (Mansfield: Edexcel, 2003), p. 6.

37 Arts Council England, *Our Agenda for the Arts 2006–8* (Arts Council England, 2006), p. 1.

38 Arts Council England, *Paving the Way: Mapping of Young People's Participatory Theatre* (Arts Council England, 2007), http://www.artscouncil.org.uk/publication_archive/paving-the-way-mapping-of-young-peoples-participatory-theatre/[accessed 30 January 2012]. See also Bill McDonnell and Dominic Shellard, *Social Impact Study of UK Theatre* (Arts Council England, 2006), p. 3.

39 Unheard Voices, http://www.royalcourttheatre.com/ywp_detail.asp?Article ID=93 [accessed 3 April 2010]

40 Giddens, *The Third Way*, p. 87.

41 Similarly, Helen Jermyn's ACE report states that the 'performance' of communities is aided by young people's involvement in arts and sports. Helen Jermyn, *Arts in England: Attendance, Participation and Attitudes in 2001* (Arts Council England, 2001), p. 86.

42 The ideology of the National Curriculum was derived from the theories of Basil Bernstein, who recognised that working-class speakers can be 'disvalued and humiliated' within institutions dominated by middle-class norms. Basil Bernstein, 'Social Class, Language and Socialisation', in *The Routledge Language and Cultural Theory Reader*, edited by Lucy Burke, Tony Crowley and Alan Girvin (London: Routledge, 2000), pp. 448–55.

43 National Curriculum English Level Descriptors, http://www.ncaction.org.uk/subjects/english/levels.htm [accessed 1 November 2007].

44 Lynn Truss's best-seller *Eats, Shoots & Leaves: The Zero Tolerance Approach to Punctuation* (London: Profile Books, 2003) testifies to the continued cultural importance placed on 'correct' English.

45 *English: The National Curriculum for England* (London: Department for Education and Employment and Qualifications and Curriculum Authority, 1999), p. 17, http://publications.teachernet.gov.uk/eOrderingDownload/QCA-99-459.pdf [accessed 14 December 2009].

46 *Not Whether but How: Teaching Grammar in English at Key Stages 3 and 4* (London: Qualifications and Curriculum Authority, 1999).

47 Renate Bartsch, *Norms of Language: Theoretical and Practical Aspects* (London and New York: Longman, 1987), p. 290–1.

48 J. K. Chambers, 'World Enough and Time: Global Enclaves of the Near Future', *American Speech*, 75 (2000), 285–7 (p. 287).

49 J. K. Chambers, 'World Enough . . . ', p. 287.

50 Sue Clifford and Angela King, *England in Particular: A Celebration of the Commonplace, the Local, the Vernacular and the Distinctive* (Oxford: Hodder and Stoughton, 2006).

51 The 1998 the Crime and Disorder Act criminalised racially aggravated offences. Subsequently, the Crown Prosecution Service, reported a 23% rise in prosecutions for racially motivated crimes in 2006–7. 'CPS Racist and Religious Crime Data Published', 20 February 2008, http://www.cps.gov.uk/news/press_releases/108_08/index.html [accessed 14 December 2009].

52 A BBC/Mori poll reported that while 62% of respondents believed Britain to be a better place because of multiculturalism, 32% thought it threatened the British way of life. 'Muslims "Want Sermons in English"', 11 August 2005, http://www.cps.gov.uk/news/press_releases/108_08/index.html [accessed 25

November 2007]; ETHNOS, *The Decline of Britishness: A Research Survey* (Commission for Racial Equality, 2005).

53 Paul Gilroy, *After Empire: Melancholia or Convivial Culture* (Abingdon: Routledge, 2004), p. 95; also see Michael Collins, 'Sinking . . . Poor White Boys Are the New Failing Class', *Sunday Times*, 19 November 2006, http://www.times online.co.uk/article/0,,2092-2459733,00.html [accessed 26 November 2006].

54 'BBC Halts Kilroy for Race "Rant"', 9 January 2004, http://news.bbc. co.uk/1/hi/uk/3383589.stm [accessed 5 February 2008]; Denis Campbell, 'Football to Boot out Homophobic Fans', *Observer*, 30 October 2005, http:// observer.guardian.co.uk/uk_news/story/0,6903,1604623,00.html [accessed 16 December 2006].

55 See The Fuse Group, *Language and Sexual Imagery in Broadcasting: A Contextual Investigation*, (Office of Communications, 2005), p. 10, http://www.ofcom. org.uk/research/radio/reports/bcr/language.pdf [accessed 25 November 2006].

56 See Paul Bagguley and Yasmin Hussain 'The Bradford Riot of 2001: A Preliminary Analysis', conference paper at the Ninth Alternative Futures and Popular Protest Conference, Manchester Metropolitan University, 2003, http://www.leeds.ac.uk/sociology/people/pbdocs/Bradfordriot.doc [accessed 25 November 2006]; British National Party, *Rebuilding British Democracy*, http://www.bnp.org.uk/candidates2005/manifesto/manf4.htm [accessed 25 November 2007].

57 Calls for a 'Britishness' test for foreign-born imams were dropped later in 2005.

58 'Schools "Must Teach Britishness"', 25 January 2007, http://news.bbc. co.uk/1/hi/uk/7459669.stm [accessed 16 December 2009].

59 Trevor Phillips, quoted in 'Race Body Snubs Un-British Work', 10 April 2004, http://news.bbc.co.uk/1/hi/uk/3615379.stm [accessed 2 January 2007].

60 Commission on Integration and Cohesion, *Our Shared Future* (Commission on Integration and Cohesion, 2007), p. 126, http://image.guardian.co.uk/ sys-files/Education/documents/2007/06/14/oursharedfuture.pdf [accessed December 16 2009].

61 Kwame Kwei-Armah, conference panel contribution, 'How Was it For Us', 2007.

62 Helen Freshwater, *Theatre Censorship in Britain: Silencing, Censure and Suppression* (London: Palgrave Macmillan, 2009), p. 148.

63 Jürgen Habermas, *The Theory of Communicative Action*, vol. 1 (Cambridge: Polity Press, 1991), p. 287.

64 Political sociologists Lewis, Inthorn and Wahl-Jorgenson note that Habermas' vision of ideal democracy is related to a series of predecessors. Sanna Inthorn, Justin Lewis and Karin Wahl-Jorgensen, *Citizens or Consumers: What the Media Tell us About Political Participation* (Maidenhead: Oxford University Press, 2005), p. 5. Also see Ruth Finnegan, *Literacy and Orality: Studies in the Technology of Communication* (Oxford: Basil Blackwell, 1988), p. 5.

65 For Noam Chomsky, the process of democracy is a 'sham' that seeks to suppress the public's 'voice'. Noam Chomsky, *Deterring Democracy* (London: Verso, 1991), p. 6, p. 352; Fairclough, p. 12.

66 '"Million" March Against Iraq War', 16 February 2003, http://news.bbc. co.uk/1/hi/uk/2765041.stm [accessed 24 November 24].

67 The perception of Blair's trustworthiness plummeted: 46% of people had considering him trustworthy in 2000, a mere 29% in 2006. Ipsos Mori,

Trustworthiness of Politicians – Trends, 12 October 2007, http://www.ipsos-mori. com/researchpublications/researcharchive/poll.aspx?oItemId=97&view=wide [accessed 6 December 2009];

68 Jonas Barish, *The Anti-theatrical Prejudice* (Berkeley and LA: University of California Press, 1981).

69 Scannell, p. 74.

70 Erving Goffman, *The Presentation of the Self in Everyday Life* (New York: Doubleday Anchor, 1959), p. 253.

71 Joe Kelleher, 'Our Radius of Trust: Community, War and the Scene of Rhetoric', in *Blairism and the War of Persuasion*, edited by Deborah Lynn Steinberg and Richard Johnson (London: Laurence and Wishart, 2004), pp. 173–85 (pp. 173–4).

72 Ben Brantley, 'Current-Event Cartoons as the Stuff of Theater', *New York Times*, 13 September 2004, http://www.nytimes.com/2004/09/13/theater/ reviews/13stuf.html?_r=0 [23 February 2014].

73 The Urban Dictionary website defined 'bliar' as a 'smug grinning war monger with a split personality and a preference for dictatorship and suppressing free speech'. 'bliar', http://www.urbandictionary.com/define. php?term=tony+bliar [accessed 17 December 2009].

74 *The Times* reported Blair's final speech to the Commons thus:

'I wish everyone, friend or foe, well.'
His voice trembled. 'And that is that.'
His voice broke. 'The End'.
'The Handover', *The Times*, 28 June 2007, p. 6.

75 Franklin, p. 13. Also, see Ipsos Mori, 'Where Have All the Voters Gone', paper given at the Political Marketing Conference, Bath Spa University College, 9 September 2004, http://www.ipsos-mori.com/newsevents/ca/ ca.aspx?oItemId=197 [accessed 16 December 2009].

76 Gordon Brown, quoted in 'Gordon Brown Press Conference', 11 May 2007, http://uk.reuters.com/article/topNews/idUKL1151125320070511?pageNum ber=2 [accessed 20 October 2007].

2 Giddensian Mediation: Voices in Writing, Representation and Actor Training

1 Roger Foss, 'Review of *Henry V*', *What's On*, 12 November 1997, in *Theatre Record*, 17 (1997), 1447.

2 Alan Bird, 'Review of *Hamlet*', 28 April 2004, http [accessed 24 December 2010].

3 Paul Robinson and Tim Roseman, 'Interview with Andrew Haydon', 19 January 2007, http://www.londontheatre.co.uk/londontheatre/reviews/hamlet04.htm [accessed 3 April 2010].

4 Chis Cooper, conference panel contribution, 'At the Sharp End', University of Portsmouth, 15 September 2007.

5 Stephen Lacey, 'Staging the Contemporary: Politics and Practice in Post-War Socialist Realist Theatre', in David Tucker, *British Social Realism in the Arts* (Basingstoke: Palgrave Macmillan, 2011), pp. 57–80, p. 57.

6 John Shakeshaft, quoted in 'Bush Theatre Announces New Artistic Director', 12 March 2007, http://www.bushtheatre.co.uk/bush_artistic_director_press_release.pdf [accessed 5 July 2007].

7 Alex Chisholm, conference panel contribution, at 'Between Fact and Fiction', Birmingham University, 13 September 2007.

8 Robinson and Roseman, 'Interview with Andrew Haydon', 2007; Lisa Goldman, in Aleks Sierz, 'Interview with Lisa Goldman', 30 March 2007, http://www.theatrevoice.com/listen_now/player/?audioID=469 [accessed 24 July 2008].

9 Michel Foucault, 'What is An Author', in *The Foucault Reader*, edited by Paul Rabinov, trans. by Josué V. Harari (London: Penguin, 1986), pp. 101–21 (p. 108).

10 Cicely Berry, *Text in Action* (London: Virgin Publishing, 2001), p. 27, p. 3.

11 Interviews were conducted with Hannah Davies and Joel Horwood, participants of the Royal Court Invitation group in 2005; Lucy Prebble, from the 2003 Advanced Playwriting group; Ruth Little, Literary Manager of the Royal Court; and Ben Jancovich, at the National Theatre.

12 Roland Barthes, 'From Speech to Writing', in *The Grain of the Voice: Interviews 1962—1980,* trans. by Linda Coverdale (Berkeley and Los Angeles: University of California Press, 1981), p. 7.

13 See Jacques Derrida, *Of Grammatology,* trans. by Gayatri Chakravorty Spivak (Baltimore: Johns Hopkins University Press, 1997), pp. 101–40; Mladen Dolar, *A Voice and Nothing More* (Cambridge, MA: MIT Press, 2006), pp. 112–13; Eric A. Havelock, *The Muse Learns to Write: Reflections in Orality and Literacy from Antiquity to the Present* (New Haven and London: Yale University Press, 1986), pp. 54–64; Walter Ong, *Orality and Literacy: The Technologizing of the Word* (London and New York: Methuen, 1982), p. 82; Ruth Finnegan, *Literacy and Orality: Studies in the Technology of Communication* (Oxford: Basil Blackwell, 1988), pp. 4—9.

14 Dominic Dromgoole, *The Full Room: An A–Z of Contemporary Playwriting* (London: Methuen, 2002), pp. 49, 69.

15 Roland Barthes, *Image Music Text*, ed. and trans. by Stephen Heath (London: Fontana, 1977), p. 179.

16 Lucy Prebble, interview with Maggie Inchley, London, 10 October 2008.

17 Joel Horwood, interview with Maggie Inchley, London, 20 October 2008.

18 See Andrew Haydon, 'Theatre in the 2000s', in *Modern British Playwriting: the 2000s: Voices, Documents, New Interpretations'*, edited by Dan Rebellato (London: Methuen, 2013), p. 66.

19 Mary Luckhurst, *Dramaturgy* (Cambridge: Cambridge University Press, 2006), p. 203.

20 Jacqueline Bolton, 'Capitalizing on New Writing: New Play Development in the 1990s', *Studies in Theatre and Performance*, 32 (2012), 219.

21 Bolton, pp. 209—25 (p. 220).

22 Peter Elbow, 'Foreword', in Lizbeth A Bryant, *Voice As Process* (Portsmouth: Heinemann, 2005), pp. x–xii.

23 Peter Elbow, *Everyone Can Write: Essays Towards a Hopeful Theory of Writing and Teaching Writing* (New York and Oxford: Oxford University Press, 2000), p. 207.

24 Paul Dawson describes the 'democratization of creativity' in *Creative Writing and the New Humanities* (Abingdon: Routledge, 2005), pp. 132–3.

25 Dale Heinan, workshop, 'Politics and New Writing', Soho Theatre, 20 September 2007.

26 Cathy Birch, *Awaken the Writer Within: Discover How to Release Your Creativity and Find Your True Writer's Voice* (Oxford: How to Books, 2001), pp. 28–9.

27 Noël Greig, *Playwriting: A Practical Guide* (London: Routledge, 2005), p. 155.

28 Tim Fountain, *So You Want to be a Playwright? How to Write a Play and Get it Produced* (London: Nick Hern, 2007).

29 Elbow, *Everyone Can Write . . .* , p. 210.

30 Noël Greig, p. 133.

31 Fountain, pp. 16–18, p. 33.

32 David Greig, in Peter Billingham, 'Interview with David Greig', *At the Sharp End: Uncovering the Work of Five Contemporary Dramatists* (London: Methuen, 2007), pp. 73–93 (pp. 83–5).

33 Heinan, workshop.

34 Robinson and Roseman, 'Interview with Andrew Haydon', 2007.

35 Barker's company The Wrestling School lost its Arts Council funding in 2007, but his work was staged by the National in 2012. Howard Barker, 'Radical Elitism in the Theatre', and 'Honouring the Audience', both in *Arguments for a Theatre* (Manchester: Manchester University Press, 1997), pp. 32–7, (p. 32), pp. 45–7 (p. 45).

36 David Hare, *Obedience, Struggle and Revolt* (London: Faber and Faber, 2005), pp. 2–5.

37 David Edgar, *State of Play* (London: Faber & Faber, 1999), p. 14.

38 David Edgar, *Playing With Fire* (London: Nick Hern, 2005).

39 Commenting on the new writing produced in the early 2000s, Cambridge academic and poet Drew Milne claimed that textual 'autonomy' was being replaced with a degrading 'sociality' as a result of audiences' demand for mimetic representation of reality. Drew Milne, 'The Anxiety of Print: Recent Fashions in British Drama', in *Crucible of Cultures: Anglophone Drama at the Dawn of a New Millennium*, edited by Marc Maufort and Franca Bellarsi (Brussels: PIE-Peter Lang, 2003), pp. 31–46 (p. 36).

40 Sonia Alonso, John Keane and Wolfgang Merkel (eds), *The Future of Representative Democracy* (Cambridge: Cambridge University Press, 2011), p. 4.

41 Amelia Howe Kritzer refers to 'a specialized and non-democratic elite' running theatre, in *Political Theatre in Post-Thatcher Britain. New Writing: 1995–2000* (Basingstoke and New York: Palgrave Macmillan, 2008), p. 4. In 1997, W. B. Worthen described the theatre industry as being composed of the 'institutionalised voices of university professors and newspaper critics, actors and directors'. W. B. Worthen, *Shakespeare and the Authority of Performance* (Cambridge University Press: Cambridge, 1997), p. 3.

42 After attending the Royal Court Invitation young writers group in 2007 for example Bola Agbaje and Alexandra Wood had plays produced in the theatre's associated festival, which won the Olivier Award and the George Devine Award respectively.

43 Hannah Davies, interview with Maggie Inchley, York Theatre Royal, 12 September 2008.

44 David Lan, quoted in 'ACE – Awarding Excellence in Theatre Writing', 27 February 2006, http://www.artscouncil.org.uk/pressnews/press_detail.php?rid=10&id=595 [accessed 17 September 2008].

45 Clare McAndrew, *Artists, Taxes and Benefits: An International Review* (Arts Council England, 2002), p. 63; Dominic Cooke, 'Why are the Arts so White?', *Time Out,* 17–23 October 2007, p. 24.

46 See Mary Luckhurst, *Dramaturgy* (Cambridge: Cambridge University Press, 2006), p. 203.

47 Hamish Glenn, quoted in Shaun Gardiner, 'The Belgrade: Regional Theatre in Bloom', htttp://www.aestheticamagazine.com/gfx/19belgrade.pdf [accessed 1 August 2008].

48 Ruth Little, interview with Maggie Inchley, Royal Court Theatre, 13 October 2008.

49 Ian Rickson, quoted in Aleks Sierz, 'Interview with Ian Rickson', http://www.inyerface-theatre.cm/archive10.html [accessed 17 September 2008].

50 Ruth Little and Emily McLaughlin, *The Royal Court Theatre: Inside Out* (London: Oberon, 2007), p. 371.

51 Sierz, Billington, Edgar and Lane all comment on the surge of new writing in the period. Michael Billington, *State of the Nation: British Theatre Since 1945* (London: Faber & Faber, 2007), p. 375; Edgar, *State of Play*, p. 3; Aleks Sierz, '"Art Flourishes in Times of Struggle": Creativity, Funding and New Writing', *Contemporary Theatre Review*, 13 (2003), 33–45 (p. 40); David Lane, *Contemporary British Drama* (Edinburgh: Edinburgh University Press, 2010), pp. 25–6.

52 Bolton details the increase in output and funding of new writing in the 1980s and 1990s, p. 210.

53 Arts Council England, *Roles and Functions of the English Regional Producing Theatres Fund Report* (Bristol: Peter Boyden Associates, 2000), pp. 36–7.

54 Andrew Haydon, 'Theatre in the 2000s', in *Modern British Playwriting: the 2000s: Voices, Documents, New Interpretations*, edited by Dan Rebellato (London: Methuen, 2013), p. 70.

55 Raymond Williams, 'A Lecture on Realism', London International Film School, 8–10 October 1976, http://www.afterall.org/journal/issue.5/lecture.realism [accessed 8 April 2014].

56 Lacey, p. 67.

57 Michelene Wandor, *The Art of Writing Drama: Theory and Practice* (London: A & C Black, 2008), pp. 130–1. Steve Waters' *The Secret Life of Plays* (London: Nick Hern, 2010) also acknowledges the mutual interests of playwriting and sociolinguistic knowledge study (p. 116).

58 Ruth Little, email to author, 28 July 2014.

59 Davies, interview with Maggie Inchley, York Theatre Royal, 12 September 2008.

60 Elbow for example warned against 'pretension and overwriting'. Elbow, *Everyone Can Write . . .* , p. 203.

61 Horwood, interview.

62 Prebble, interview.

63 Steve Waters, conference panel contribution, 'Between Fact and Fiction'.

64 According to academic Antoinette Moses, the genre provided 'a celebrated forum for uncelebrated voices'. Antoinette Moses, conference panel contribution, at 'At the Sharp End'. Also, see Hare's description of the genre in *Obedience, Struggle and Revolt*, p. 76.

65 Robin Soans, conference panel contribution, 'How Was it For Us'.

66 Michael Billington, *State of the Nation: British Theatre Since 1945* (London: Faber & Faber, 2007), p. 380.

67 David Edgar, conference speech, 'Between Fact and Fiction'.

68 Victoria Brittain, conference panel contribution, 'How Was it For Us'.

69 Waters in Luckhurst, pp. 213–14.

70 Paul Taylor, 'The Royal Court: Caught in the Spotlights', *Independent*, 13 January 2006, http://www.independent.co.uk/arts-entertainment/theatre-dance/features/the-royal-court-caught-in-the-spotlights-522696.html [accessed 21 June 2010]; also see Jay Rayner, 'Why is Nobody Doing the Right Thing?', *Observer*, Review, 11 November 2007, p. 6.

71 Anne Hogben, 'In Conversation with David Edgar', *UK Writer*, Autumn 2007, p. 33.

72 Harry Derbyshire, conference panel contribution, at 'At the Sharp End'.

73 Michael Bhim, conference panel discussion, 'At the Sharp End'.

74 Davies, interview.

75 Ben Jancovich, interview with Maggie Inchley, National Theatre, 10 October 2008.

76 Nicholas Hytner, quoted in Lalayn Baluch, 'Hytner Appeals for 'Offensive' Plays to Challenge National's Liberal Audience', *The Stage*, 14 November 2007, http://www.thestage.co.uk/news/newsstory/.php/18856/hytner-appeals-for-offensive-pays-to [accessed 26 July 2008].

77 Arts Council Chairman Sir Christopher Frayling, Writers' Guild General Secretary Bernie Corbett, playwright David Edgar, and Asian director Jatinder Verma all defended the young writer's right to speak freely. Nicholas Hytner defended theatre's right to offend. Nicholas Hytner, 'Theatre "Should Be Offensive"', 21 December 2004, http://news.bbc.co.uk/1/hi/entertainment/4112533.stm [accessed 30 August 2013]. Edgar feared the result of the affair would be writers' self-censorship. Anne Hogben, 'In Conversation with David Edgar', *UK Writer*, Autumn 2007, p. 33.

78 Mark Ravenhill, 'A Touch of Evil', *Guardian*, 22 March 2003.

79 Delegates, conference panel discussion, at 'Between Fact and Fiction'.

80 Billington, p. 401.

81 Lolly Susi, *The Central Book* (London: Oberon, 2006).

82 Kate White, 'Interview with Derek Smith', http://www.bl.uk/projects/theatrearchive/smithd4.html [accessed 5 May 2007].

83 Cicely Berry, *Voice And the Actor* (London: Harrap, 1973), p. 173.

84 Peter Gill, 'Speak to Me', in *Actors Speaking*, edited by Lyn Haill (London: Oberon, 2007), pp. 9–23 (p. 10).

85 J. Clifford Turner, *Voice and Speech in Theatre*, 6th edition (London: A & C Black, 2007).

86 Chapter 1 contains a fuller discussion of the use of RP in wider society.

87 Sally Grace, conference speech, in *Voice in British Actor Training: The Moment of Speech* (London: Central School of Speech and Drama, 2000), pp. 15–19 (p. 15).

88 Steven Berkoff, in Robert Cross, *The Theatre of Self-Performance* (Manchester: Manchester University Press, 2004), p. 69.

89 Grace, in *Voice in British Actor Training*, p. 16.

90 Patsy Rodenburg, *The Actor Speaks: Voice and the Performer* (London: Methuen, 1997), p. 123.

91 Kate Lynch, quoted in Alex Bulmer, 'Voice and Process: Instinct versus Skill [Includes Interview with Kate Lynch]', *Canadian Theatre Review*, 97 (1998), 36–40 (p. 39).

92 Gill, p. 11.

93 Joseph R. Roach, *The Player's Passion: Studies in the Science of Acting* (Newark: University of Delaware Press, 1985), p. 16.

94 Jonas Barish, *The Anti-Theatrical Prejudice* (Berkeley and Los Angeles: University of California Press, 1981), pp. 135, 459.

95 Declan Donnellan, *The Actor and the Target* (Nick Hern Books: London, 2002), pp. 88–90.

96 David Mamet, *True and False: Heresy and Common Sense for the Actor* (London: Faber & Faber, 1998), pp. 77–80.

97 Peter Brook, in Cicely Berry, *Voice and the Actor*, p. 3.

98 The work of LAMDA trained Kristin Linklater has been influential in Britain and the US since the 1970s, and is well known for its emphasis on liberating rather than training the voice. Kristin Linklater, *Freeing the Natural Voice* (New York: Drama Book Publishers, 1976), p. 57.

99 Such internal focus has also been strongly emphasised through the influential psychoanalytical and therapeutic approach of the Alfred Wolfsohn and Roy Hart tradition after the Second World War, as well as in Eastern influenced practices that became very common at the end of the twentieth century and beyond. The profiles of voice staff at the Central School of Speech and Drama emphasise their interest in dance, sensory approaches, and the integration of yoga and tai chi. See Noah Pike, *Dark Voices: The Genesis of Roy Hart Theatre* (Zurich: Spring Journal, 1999); Academic Staff, http://www.cssd.ac.uk/staff.php/8/full_time_academic.html [accessed 21 March 2009].

100 In Jakobson's influential essays 'Language in Operation' (1949) and 'Linguistics and Poetics' (1958) the actor's task is described as constructing a 'delivery design' for the text. Roman Jakobson, 'Closing Statement: Linguistics and Poetics' in *Style in Language*, edited by T. A. Sebeok (Cambridge, MA: MIT Press, 1960), pp. 350–83 (p. 377). See also Jiří Veltruský, 'Dramatic Text as Component of Theater', trans. by Jiří Veltruský, in *Semiotics of Art: Prague School Contributions*, edited by Ladislav Matejka and Irwin R. Titunik, (Cambridge, MA and London: MIT Press, 1976), pp. 94–118 (p. 109).

101 Jane Boston, Jacqueline Martin and Natalie Crohn Smith all discuss the subordination of text to actor's creative role in the later twentieth century. Boston in Clifford Turner, 6th edition, pp. vii–xv (p. xi). Jacqueline Martin, *The Voice in Modern Theatre* (London and New York: Routledge, 1991), p. 173. Natalie Crohn Smith, 'Stanislavski, Creativity and the Unconscious', *New Theatre Quarterly*, 2 (1986), 345–50 (p. 349).

102 Grace, p. 15.

103 Kristin Linklater, *Freeing the Natural Voice* (New York: Drama Book Specialists, 1976) p. 185.

104 Kristin Linklater, *Freeing the Natural Voice: Imagery and Art in the Practice of Voice and Language* (London: Nick Hern, 2006). See also David Zinder's exercises for actors in *Body Voice, Imagination*: A Training for the Actor (New York and London: Routledge, 2002), p. 15.

105 Elin Diamond (ed.), 'Realism's Hysteria. Disruption in the Theatre of Knowledge', in *Unmaking Mimesis: Essays in Feminism and Theatre* (London and New York: Routledge, 1997), pp. 4–38 (p. 30).

106 Sarah Werner, 'Performing Shakespeare: Voice Training and the Feminist Actor', *New Theatre Quarterly*, 47 (1996), 249–58 (p. 251).

107 Cicely Berry, Patsy Rodenburg and Kristin Linklater, 'Shakespeare, Feminism, and Voice: Responses to Sarah Werner', *New Theatre Quarterly*, 49 (1997), 48–52 (p. 49). Kristin Linklater, *Freeing Shakespeare's Voice: The Actor's Guide to Talking the Text* (New York: Theatre Communications Group, 1992), pp. 6–7.

108 These issues continue to be debated with regard to the new relationships made possible between 'performer' and text by digital authorship. See Jane Boston, 'Poetic Text in Contemporary Voice Training: A Repositioning', *Voice and Speech Review*, 8 (2014), 131–48.

109 David Greig, *Pyrenees* (London: Faber & Faber, 2005), p. 13.

110 The website of voice agent Sue Terry advertised the qualities of her clients' voices both in terms of accents, such as 'Scottish' or 'Northern', and their tonal qualities, 'smooth', 'husky' or 'reassuring'. 'Sue Terry Voices', http://www.sueterryvoices.com/ [accessed 7 November 2007].

111 Donnellan, p. 38, p. 79.

112 Mamet, p. 73.

113 See for example, *Text in Action*, p. 133; RADA voice tutor David Carey's physicalised exercises similarly aim to emphasise the 'vitality and muscularity' of text. David Carey, workshop, William Poel Speaking English Classic Drama Event, National Theatre, 31 October 2007;

114 Phillip B. Zarrilli, 'Senses and Silence in Actor Training and Performance', *The Senses in Performance*, edited by Sally Barnes and Andre Lepecki (New York: Routledge, 2007), pp. 47–70 (p. 56).

115 Dolar, p. 14.

116 Ong, pp. 71–2.

117 Jean-Luc Nancy discusses an extreme example of this in the context of Nazi Germany in *Listening*, trans. by Charlotte Mandell (New York: Fordham, 2002), pp. 49–59.

118 Berry, *Text in Action*, p. 9.

119 Cicely Berry, *Text in Action* (London: Virgin Publishing, 2001), p. 2, p. 18.

120 Joe Windley, in *Voice in British Actor Training*, pp. 20–4 (p. 23).

121 Patsy Rodenburg claims 'a receptive, listening audience is almost as creative as the actor'. Patsy Rodenburg, *The Actor Speaks: Voice and the Performer* (London: Methuen, 1997), pp. 344–50.

122 *Freeing Shakespeare's Voice*, pp. 6–7.

123 Havelock, p. 64.

124 Mikhail Bakhtin, *The Bakhtin Reader: Selected Writings of Bakhtin, Medvedev and Voloshinov*, edited by Pam Morris (New York: Routledge, 1994), p. 251.

125 Saba Salman, 'Up on Stage', *Guardian*, 15 May 2002, http://www.theguardian.com/society/2002/may/15/localgovernment.guardiansocietysupplement [accessed 28 November 2014].

126 Lise Olson of the Liverpool Institute for Performing Arts testifies that 'the acting program was devised with much industry consultation'. Lise Olson, conference speech, in *Voice in British Actor Training*, pp. 25–8 (p. 27).

127 Joanna Weir Ouston, quoted by Boston, in Clifford Turner, p. xiv.

128 Delegates' Plenary, William Poel Speaking English Classic Drama Event, National Theatre, 31 October 2007.
129 Oliver Pritchett, 'Can You Hear us At the Back', *Sunday Telegraph*, 4 April 1999, http://www.123people.co.uk/ext/frm?ti=person%20finder&search_term=ellen%2 [accessed 12 November 2010].
130 *Black Watch,* performance, Barbican, 29 June 2008.
131 Paddy Scannell, *Radio, Television and Modern Life: A Phenomenological Approach* (Oxford: Blackwell, 1996), pp. 73–4.
132 Ros Steen, 'Seein Oursels As Ithers See Us', http://www.rsamd.ac.uk/export/sites/default/common/documents/Academy/Seein_Oursels.pdf [accessed 23 December 2010].
133 See Dan Rebellato's discussion of amplified sound in theatre in Dan Rebellatto, *Theatre and Globalization* (Basingstoke: Palgrave Macmillan, 2009), pp. 42–3.
134 Jeanette Nelson, workshop, William Poel.
135 Windley, p. 22; Grace, p. 17.
136 *Voice in British Actor Training*, p. 9.
137 In the same year, voice trainer John Carey identified a lack of 'relish' that young people took in speaking in public. John Carey, conference speech, *Voice in British Actor Training*, pp. 11–14 (p. 11); in 2004, actress Fiona Shaw claimed that, 'good speaking in big places' was not being taught. Fiona Shaw, 'The Irony of Passionate Chaos: Modernity and Performing Medea', *New Theatre Quarterly,* 20 (2004), 237–44 (p. 244) [accessed 26 March 2010].
138 Peter Hall, quoted in Louise Jury, 'Stop Mumbling, Sir Peter Hall Tells Young Actors', *Evening Standard,* 22 January 2008, http://www.thisislondon.co.uk/theatre/article-23433564-stop-mumbling-peter-hall-tells-young-actors.do [accessed 11th November 2010].
139 Caroline McGettigan, presentation at The Voice Symposium, The Science Museum, 16 November 2012.
140 Rodenburg, *The Actor Speaks*, p. 233.
141 Richard Bean, qtd in Dominic Cavendish, 'Richard Bean: Blurred Boundaries', *Telegraph,* 10 May 2008, http://www.telegraph.co.uk/culture/theatre/drama/3673273/Richard-Bean-blurred-boundaries.html [accessed 12 November 2010].
142 The Specification continued to include a compulsory unit on Practical Phonetics with specific reference to RP. Central School of Speech and Drama, *MA Voice Studies Course Specification* (London: Central School of Speech and Drama, 2007), p. 5.
143 Carlson, *Speaking in Tongues*, p. 17.
144 Janelle Reinelt discusses a 'homogenisation' of productions 'touring' the international theatre circuit, with its 'multilingual audiences' in 'Performing Europe: Identity Formation for a New Europe', *Drama Review,* 53 (2001), 365–87 (p. 385).
145 Steen draws on the methods of Nadine George. Nadine George, 'My Life with the Voice', http://www.voicestudiointernational.com/sider/My_Life_with_the_Voice_article.pdf [accessed 12 November 2010].
146 Performance of *Damascus,* Traverse, 12 August 2007.
147 David Greig, qtd in 'Road to Damascus', Charlotte Higgins, *Guardian,* 16 February 2009, http://www.guardian.co.uk/stage/2009/feb/16/david-greig-playwright-damascus [accessed 12 November 2010].

148 Jasper Rees, 'Fallout: Damilola Was Just the Beginning', *Telegraph,* 23 June 2008, http://www.telegraph.co.uk/culture/tvandradio/3555016/Fallout-Damilola-was-just-the-beginning.html [accessed 8 November 2010].

3 Migration and Materialism: David Greig, Gregory Burke and Sounding Scottish in Post-devolutionary Voicescapes

1 See Hugh MacDiarmid, 'Robbie Burns: His Influence', *Selected Essays of Hugh MacDiarmid* (Oakland: University of California Press, 1970), pp. 177–82 (p. 180).
2 Edward Braithwaite, 'Nation Language', in *The Routledge Language and Cultural Theory Reader,* ed. Lucy Bourke, Tony Crowley and Alan Girvin (London and New York: Routledge, 2000) pp. 310–16 (p. 311).
3 John Macmurray, *Persons in Relation* (London: Faber & Faber, 1961), p. 15; Ian Brown (ed.), 'A Lively Tradition and Creative Amnesia', *The Edinburgh Companion to Scottish Drama* (Edinburgh: Edinburgh University Press, 2011), pp. 1–5; John McGrath, *Naked Thoughts That Roam About,* ed. by Nadine Holdsworth (London: Nick Hern, 2006), p. 210; Edwin Muir, *Scott and Scotland: The Predicament of the Scottish Writer* (London: Routledge, 1936), pp. 17–21; James Kelman, 'Vernacular', *Brick: A Literary Journal,* 51 (1995), pp. 68–9.
4 Donald Dewar, Speech at the Opening of the Scottish Parliament, 1 July 2014, http://www.scottish.parliament.uk/EducationandCommunityPartnerships resources/New_Parliament_Levels_A-F.pdf [accessed 11 May 2014].
5 These were traditions that John McGrath had also revived in his tour of local Scottish venues with *The Cheviot, The Stag, and the Black, Black Oil* (1973).
6 Cairns Craig and Randall Stevenson (eds), 'Introduction', in *Twentieth Century Scottish Drama* (Edinburgh: Canongate, 2001), pp. vii–xiii (p. vii).
7 John Tiffany, talk to Genesis Directors. David McCrone, Angela Morris and Richard Kiely describe Scotland's 'continuous questing for identity' in *Scotland the Brand: the Making of Scottish Heritage* (Edinburgh: Edinburgh University Press, 1995), p. 5; Ian Brown and Mark Fisher call Scotland a nation 'almost obsessively aware of itself' in *Made in Scotland: An Anthology of New Scottish Plays* (London: Methuen, 1995), p. vii.
8 Scottish Executive, *Creating Our Future . . . Minding Our Past: Scotland's National Cultural Strategy* (Edinburgh: Scottish Executive, 2000), http://www,scotland.gov.uk [accessed 30 January 2009].
9 See Carol Craig's diagnosis of negativity in the Scottish national psyche, *The Scots' Crisis of Confidence* (Glendaruel: Aygyll, 2011).
10 Robert Crawford, *Identifying Poets: Self and Territory in Twentieth Century Poetry* (Edinburgh: Edinburgh University Press, 1993), p. 13; Christopher Harvie explores the tensions between local and global tendencies in Scottish history in *Scotland and Nationalism: Scottish Society and Politics, 1707 to the Present* (London: Routledge, 2004) (1977), p. 5.
11 Scottish Arts Council, *Drama Strategy 2002–7* (Edinburgh: Scottish Arts Council, 2002), p. 3.
12 Philip Howard, in *Made in Scotland: An Anthology of New Scottish Plays* by Mike Cullen, Simon Donald and Sue Glover (London: Methuen, 1995), pp. xi, xiii.

13 See Trish Reid, '"From Scenes Like These Old Scotia's Grandeur Springs":
 The National Theatre of Scotland', *Contemporary Theatre Review*, 17 (2007),
 192–201 (p. 192).

14 Cairns Craig, *The Modern Scottish Novel: Narrative and the National Imagination*
 (Edinburgh: Edinburgh University Press, 1999), p. 77.

15 Anja Müller and Clare Wallace, 'Neutral Spaces and Transnational Encounters',
 Cosmotopia, pp. 1–13 (p. 2); Charlotte Thompson, 'Beyond Borders: David
 Greig's Transpersonal Dramaturgy', in *Cosmotopia*, pp. 103–17 (p. 106).

16 David Greig, *The Cosmonaut's Last Message to the Woman he Once Loved in the
 Former Soviet Union* in Plays 1 (London: Faber and Faber, 2002), pp. 209–301
 (p. 298). Subsequent references to the play are cited in text.

17 Paul Taylor, 'Independent,' 17 May 1999, *Theatre Record*, 19 (1999), 611.

18 Gerard Berkowitz, Theatre Guide London Review, Spring 2005, http://www.theat
 reguidelondon.co.uk/reviews/cosmonaut05.htm [accessed 14 May 2014].

19 David Greig, *Pyrenees* (London: Faber and Faber, 2005), p. 13. Subsequent
 references to the play are cited in text.

20 The season produced work by Greig, Philip Ridley, Enda Walsh and Douglas
 Maxwell.

21 See Neal Ascherson, *Stone Voices: The Search for Scotland* (London: Granta,
 2003), p. 137.

22 David Murison, 'The Future of Scots', *Whither Scotland*, edited by Duncan
 Glen (London: Gollancz, 1971), p. 178.

23 Gregory Burke, *Gagarin Way* (London: Faber & Faber, 2001), p. 11. Further
 references will be given in the text.

24 Pierre Bourdieu, *Language and Symbolic Power*, ed. by John B. Thompson, trans.
 by Gino Raymond and Matthew Adamson (Cambridge: Polity, 1991), p. 86.

25 J. K. Chambers, 'World Enough and Time: Global Enclaves of the Near Future',
 American Speech, 75 (2000), p. 287.

26 Production of *Gagarin Way*, Traverse Theatre, 11 August 2001.

27 Oliver Jones, 'Review of *Gagarin Way* (Cottesloe)', *What's On*, 10 October 2001;
 and Charles Spencer, 'Review of *Gagarin Way* (Cottesloe)', *Daily Telegraph*, 10
 August 2001, both in *Theatre Record*, 21 (2001), 1297–8 (p. 1297); Zachary A.
 Dorsey, '*Gagarin Way*', *Theatre Journal*, 54 (2002), 479–80 (p. 479).

28 Benedict Nightingale, 'Review of *Gagarin Way* (Cottesloe)', *The Times*,
 5 October 2001, in *Theatre Record*, 21 (2001), 1297–8 (p. 1297); Steve Cramer,
 'Review of *Gagarin Way* (Traverse), *List*, 9 August 2001, in *Theatre Record*,
 21 (2001), 1128–130 (p. 1129); Philip Fisher, '*Gagarin Way*', http://www.
 britishtheatreguide.info/reviews/gagarinway-rev.htm [accessed 21 January
 2009].

29 Following its first production at the Traverse in 2001, *Gagarin Way* trans-
 ferred to the National Theatre, followed by the West End in 2002. It has had
 twenty-two subsequent productions worldwide in seventeen languages. See
 Aaron Kelly and Dan Rebellato for discussion of the globalisation of Scottish
 literature and voices. Aaron Kelly, *Irvine Welsh* (Manchester: Manchester
 University Press, 2005), p. 30; Dan Rebellato, 'Playwriting and Globalisation:
 Towards a Site-unspecific Theatre', *Contemporary Theatre Review*, 16 (2006),
 97–113 (p. 97).

30 David McCrone, Angela Morris and Richard Kiely, *Scotland the Brand: the
 Making of Scottish Heritage* (Edinburgh: Edinburgh University Press, 1995), p. 5.

31 Tom Nairn, *The Break-Up of Britain* (London: Verso, 1981), p. 123.
32 Tom Devine, *The Scottish Nation*, 3rd edn (London: Penguin 2012), p. 360.
33 See Pattie, 'Scotland and Anywhere: The Theatre of David Greig', in *Cosmotopia*, pp. 50–65 (pp. 52–3).
34 Rebecca Robinson, 'The National Theatre of Scotland's *Black Watch*', *Contemporary Theatre Review*, 22 (2012), 392–9 (p. 393).
35 See Joanne Zerdy, 'Fashioning a Scottish Operative: Black Watch and Banal Theatrical Nationalism on Tour in the US', *Theatre Research International*, 38 (2013), 181–9 (p. 182).
36 Trish Reid, 'Post-Devolutionary Drama', in Brown, *Edinburgh Companion*, 188–99 (pp. 195–6).
37 Gregory Burke, *Black Watch* (London: Faber & Faber, 2007), p. 3. Further references will be given in the text.
38 Lib Taylor, 'The Experience of Immediacy: Emotion and Enlistment in Fact-based Theatre', *Studies in Theatre and Performance*, 31 (2011), 223–37.
39 Joyce MacMillan felt that audiences would need warning about the 'sheer squaddie obscenity of the language'. Keith Bruce reported that 'some of the audience' were 'unhappy' with Burke's 'faithful representation of the raw and explicit language of the soldiers'. Joyce MacMillan, 'Review of *Black Watch* (Pitlochry)', *Scotsman*, 23 March 2007; Keith Bruce, 'Review of *Black Watch* (Pitlochry)', *Herald*, 23 March 2007, both in *Theatre Record*, 27 (2007) 351 (p. 351).
40 John Tiffany, talk to Genesis Directors.
41 Tiffany, talk to Genesis Directors.
42 The play's invocation of local and universal frameworks is noted in several of the responses collated by Eva Aldea, and others in, 'Pipes and Drums: Responses to Black Watch', *Contemporary Theatre Review*, 18 (2008), 272–279 (p. 274, p. 277).
43 Cover of Burke, *Black Watch.*
44 Vicky Featherstone, quoted in Thom Dibdin, 'Home Work – National Theatre of Scotland and Vicky Featherstone', *The Stage*, 25 March 2006, http://www.thestage.co.uk/features/feature.php/11785 [accessed 26 February 2009].
45 Vicky Featherstone, 'Foreword', in Gregory Burke, *Black Watch* (London: Faber & Faber, 2007), p. xvi.
46 Vicky Featherstone, quoted in Thom Dibdin, 'Home Work – National Theatre of Scotland and Vicky Featherstone', *The Stage*, 25 March 2006, http://www.thestage.co.uk/features/feature.php/11785 [accessed 26 February 2009].
47 Michael Billington, 'Review of *Black Watch* (Aberdeen)', *Guardian*, 4 April 2007, in *Theatre Record*, 27 (2007), 418.
48 Tiffany, talk to Genesis Directors.
49 Tom Leonard, 'Introduction' in James Robertson (ed.), *A Tongue in Yer Heid. A Aelection of the Best Contemporary Short Stories in Scots* (Edinburgh: B & W Publishing, 1994), p. xiii.
50 David Greig, *Damascus* (London: Faber and Faber, 2007), p. 22. Further references are cited in text.
51 David Greig, 'Damascus Diary', in *Modern British Playwriting: 2000–2009*, pp. 274–83 (p. 280).
52 David Greig, 'Damascus Diary', p. 275.

53 David Greig quoted in Charlotte Higgins, 'Road to Damascus' *Guardian*, 16 February 2009, http://www.theguardian.com/stage/2009/feb/16/david-greig-playwright-damascus [accessed 17 May 2014].

54 Greig, 'Damascus Diary', p. 279.

55 See for instance, Jo Robinson, 'Becoming More Provincial? The Global and the Local in Theatre History,' *New Theatre Quarterly*, 23 (2007), 229–40; Dan Rebellato, 'Playwriting and Globalisation'; Janelle Reinelt, 'Performing Europe'.

56 Liz Lochhead conjectured that her decision to transpose the action of *Medea* (2000) to Scotland reflected an increased Scottish 'cultural confidence'. Liz Lochhead, Foreword, *Medea* (London: Nick Hern, 2000), p. iv.

57 David Greig, *The Bacchae* (London: Faber and Faber, 2007), pp. 8–9. Subsequent references are cited in text.

58 Alan Cumming qtd in Dominic Cavendish, 'Edinburgh Festival: Homecoming of the God of Parties', *Telegraph*, 14 August 2007, Web. 26 Feb 2009, http://www.telegraph.co.uk/culture/theatre/drama/3667097.

59 Irish writers Frank McGuinness, Seamus Heaney and Marina Carr as well as Scotland's Liz Lochhead had all used local dialect in their adaptations of Greek works in the period.

60 Performance of *The Bacchae*, Lyric Theatre, Hammersmith, 10 September 2007.

61 Neil Murray, qtd in Dan Rebellato, 'National Theatre of Scotland: The First Year', *Contemporary Theatre Review*, 17 (2007), 213–18 (p. 213).

62 See Steve Cramer, 'The Traverse, 1985–97: Arnott, Clifford, Hannan, Harrower, Greig and Greenhorn, in Ian Brown, *Edinburgh Companion*, pp. 165–76 (p. 171).

4 Vocalising Allegiance: Kwame Kwei-Armah, Roy Williams and debbie tucker green

1 Chris Smith, *Creative Britain* (London: Faber & Faber, 1998), p. 36.

2 Anthony Giddens, *The Transformation of Intimacy: Sexuality, Love and Eroticism in Modern Societies* (Cambridge: Polity, 1992), p. 132.

3 Kwame Kwei-Armah, 'How Was It . . . ?'.

4 In 1972, HMSO reported that the practices of schools to insist that black children reject the values of their parents was crueller than those imposed on the white working class. The 1986 Eggleston report emphasised how schools had expected black immigrants to leave behind their dialects, values and home lives. The Institute of Race Relations report, *Outcast England* (1994), concluded that the high exclusion rates of black children was caused not only by black children's extreme reactions to racism, but also by a societal stereotype that associates 'black' with 'problem'. A. H. Halsey, *Educational Priority* (HMSO, 1972), p. 3; John Egglestone, *Education for Some: The Educational and Vocational Experiences of 15-18 Year-old Members of Minority Ethnic Groups* (Stoke-on-Trent: Trentham, 1986); Jenny Bourne, Lee Bridges and Chris Searle, *Outcast England: How Schools Exclude Black Children* (Institute of Race Relations, 1994).

5 Yasmin Alibhai-Brown, *Who Do We Think We Are: Imagining the New Britain* (London: Penguin, 2001), pp. 160–2. Paul Gilroy also describes the

assessment of black British identity by white society as deviant and criminal. Paul Gilroy, *There Ain't No Black in the Union Jack: The Cultural Politics of Race and Nation* (Chicago: Chicago University Press, 1993).

6 Rachael Gilmour, 'Doing Voices: Reading Language as Craft in Black British Poetry', *Journal of Commonwealth Literature*, 2014, https://qmro.qmul.ac.uk/jspui/handle/123456789/5859 [accessed 28 June 2014]. David Sutcliffe draws on research carried out in the 1970s to show how 'patterns of Black British language choice run counter to the white pattern in the larger community'. David Sutcliffe, *Black British English* (Oxford: Basil Blackwell, 1982), p. 146.

7 Dabydeen, 'On Not Being Milton: Nigger Talk in England Today', in *The Routledge Language and Cultural Theory Reader*, ed. Lucy Bourke, Tony Crowley and Alan Girvin (London and New York: Routledge, 2000) pp. 302–9 (p. 307).

8 Jatinder Verma, 'The Challenge of Binglish: Analysing Multicultural Productions', in *Analysing Performance: A Critical Reader*, edited by Patrick Campbell (Manchester and New York: Manchester University Press, 1996), pp. 193–201 (pp. 195–8).

9 National Theatre Black Plays Archive, http://www.blackplaysarchive.org.uk [accessed 29 June 2014].

10 See Alda Terracciano, 'Mainstreaming African, Asian and Caribbean Culture: The Experiments of the Black Theatre Forum', in *Alternatives Within the Mainstream*, pp. 22–50; and Winsome Pinnock, 'Breaking Down the Door', in *Theatre in a Cool Climate*, ed. by Vera Gottlieb and Colin Chambers (Oxford: Amber Lane Press, 1999), p. 31.

11 Mustapha Maturo, 'Ter Speak in Yer Mudder Tongue', *Black British Culture and Society*, edited by Michael McMillan (London: Routledge, 2000), pp. 255–64 (p. 258).

12 Dimple Godiwala (ed.), in *Alternatives Within the Mainstream*, pp. 3–20 (p. 4); Lynette Goddard (ed.) 'Introduction', *The Methuen Drama Book of Plays by Black British Writers* (London: Methuen, 2011), pp. vii–xxv (p. viii).

13 Roy Williams, quoted in Aleks Sierz, 'What Kind of England Do We Want?', *New Theatre Quarterly*, 22 (2006), 113–21 (pp. 113–14); Kwame Kwei-Armah, 'Sixty Years of Forgotten Treasures', *Guardian*, 27 September 2009, http://www.guardian.co.uk/stage/2009/sep/27/black-theatre-archive-kwei-armah [accessed 29 May 2010].

14 *The Landscape of Fact: Towards a Policy of Cultural Diversity for the English Funding System* (1997) and *Cultural Diversity Action Plan* (1998). In 2006 the Sustained Theatre consultation produced a raft of initiatives, including Eclipse and the deciBel Awards, making available £250,000 in prize money to Black and Asian British Artists. Lola Young, *Whose Theatre? Report on the Sustained Theatre Consultation* (Arts Council England, 2006), http://www.artscouncil.org.uk/media/uploads/documents/publications/whosetheatre_phpB7dYie.pdf [accessed 20 March 2010].

15 Kwame Kwei-Armah, quoted in Deirdre Osborne, '"Know Whence You Came": Dramatic Art and British Identity', *New Theatre Quarterly*, 23 (2007), 253–63 (p. 259).

16 Kwei-Armah, in Ellen, p. 3

17 Kwame Kwei-Armah, *Elmina's Kitchen* (London: Methuen, 2003), p. 4. Further references are given in the text.

18 The term refers to the bloodied cloths used to clean the backs of slaves. *Elmina's Kitchen* Program, Cottesloe Theatre, May 2003.

19 See Stacey Duncan, 'Language and Identity in Youth Culture', in *Contemporary Youth Culture: An International Encyclopedia,* edited by Priya Parmar, Birgit Richard and Shirley Steinberg (West Port, CT and London: Greenwood Press, 2006), pp. 37–41 (p. 39).

20 Kwame Kwei-Armah, quoted in Maria Saugar, 'A Play For Today', http://www.ideasfactory.com/performance/features/perf_feature58.htm [accessed 22 December 2006].

21 Nathan A. Adams, 'An Interview with Roy Williams', http://www.black history4schools.com/articles/Raising%20Horizons%20booklet.doc [accessed 23 January 2007].

22 Kwei-Ahmah in Osborne, p. 258.

23 Kwame Kwei-Armah, *Fix Up* (London: Methuen, 2004), p. 4. Further references are given in the text.

24 Performance of *Fix Up,* Cottesloe Theatre, 18 December, 2004.

25 Steve McQueen (dir.), *Twelve Years a Slave* (Fox Searchlight Pictures, 2013).

26 Sutcliffe, p. 58.

27 Samuel Kasule, 'Aspects of Madness and Theatricality in Kwame Kwei-Armah's Drama', in *Alternatives Within the Mainstream,* pp. 314–28 (p. 316).

28 Lennie James, 'Face2Face with Tony Marchant and Lennie James', http://www.bbc.co.uk/writersroom/insight/tonylennie.pdf [accessed 29 January 2007].

29 'Colin McFarlane', http://www.colinmcfarlane.tv/main.html [accessed 20 December 2007].

30 Quentin Letts, 'First Night Review: *Statement of Regret', Daily Mail,* 21 November 2007, http://www.dailymail.co.uk/pages/live/articles/showbiz/reviews.html?in_article_id=494232&in_page_id=1924 [accessed 25 December 2007].

31 John Peter, 'Review of *Joe Guy', Sunday Times,* 11 November 2007, in *Theatre Record,* 27 (2007), 1301–3 (p. 1303).

32 Kwame Kwei-Armah, *Statement of Regret* (London: Methuen, 2007), p. 2.

33 See Bernstein, 'Social Class, Language and Socialisation', in Bourke, Crowley and Girvin, pp. 448–55.

34 Roy Williams, *Joe Guy* (London: Methuen, 2007), p. 5.

35 Performance of *Joe Guy,* Soho Theatre, 3 November 2007.

36 In the 1990s and 2000s black parents were more likely than whites to express offence at swearing on television and radio. The Fuse Group, p. 14. Kwei-Armah, *Elmina's Kitchen* Program.

37 Derek Walcott, *A Branch of the Blue Nile* in *Three Plays* (New York: Farrar, Strauss and Giroux, 1986), p. 218; Kwei-Armah, conference panel contribution, at 'How Was it For Us? . . . '.

38 Kwei-Armah, quoted in Osborne, 'Know Whence . . . ', p. 254.

39 Performance of *Statement of Regret,* National Theatre, 22 November 2007.

40 Charles Spencer, 'Statement of Regret: Race Triumph', 15 November 2007, http://www.telegraph.co.uk/culture/theatre/drama/3669283/Statement-of-Regret-Race-triumph.html [accessed 12 February 2010]; Michael Billington, 'Statement of Regret', 15 November 2007, http://www.guardian.co.uk/stage/2007/nov/15/theatre2 [accessed 12 February 2010].

41 Performance of *Elmina's Kitchen*, National Theatre, 15 June 2003.

42 Performance of *Joe Guy*.

43 Kwame Kwei-Armah won the Peggy Ramsay Award for *Bitter Herb* (1998) at Bristol Old Vic. *Elmina's Kitchen* won the Evening Standard's Charles Wintour Most Promising Playwright Award, and was the first play by a black British writer in the West End. Roy Williams won the Writers' Guild New Writer of the Year Award for the *No Boys Cricket Club* (1996). *Sing Yer Heart Out For the Lads* graduated from the National's temporary Loft studio in 2002 to the Cottesloe in 2004. In 2007, Williams' *Days of Significance* was produced at the RSC's Swan Theatre. At least two of the awards that Williams has benefited from – an EMMA (Ethnic Multicultural Media Awards) and an Alfred Fagon Award for writers of English with Caribbean connections – were specifically available to ethnic writers.

44 Benjamin Zephaniah quoted in Merope Mills, 'Rasta Poet Publicy Rejects OBE', *Guardian*, 27 November 2003, http://www.guardian.co.uk/uk_news/story/0,3604,1094118,00.html [accessed 23 October 2007].

45 Benjamin Zephaniah, 'Bought and Sold', http://www.benjaminzephaniah.com/content/rhyming.php [accessed 17 January 2008].

46 Ambalavaner Sivanandan, 'The Struggle for a Radical Black Political Culture', in *Black British Culture* (pp. 416–24), p. 424.

47 'Roy Williams', *Guardian*, 6 July 2002, http://arts.guardian.co.uk/britishtheatre/story/0,,749452,00.html [accessed 29 January 2007].

48 Roy Williams, quoted in Sierz, 'What Kind of England Do We Want?', p. 120.

49 The Fuse Group's *Language and Sexual Imagery* report alludes to the connection between the perception of 'authenticity' and the use of strong language. The Fuse Group, p. 25.

50 See McEnery and Xiao on public perception of a correlation between swearing and class. Anthony McEnery and Zhonghua Xiao, 'Swearing in Modern British English: the Case of *Fuck* in the BNC', *Language and Literature*, 3 (2004), 235–68.

51 Roy Williams, '*Sing Yer Heart Out For the Lads*', *Plays 2* (London: Methuen, 2004), pp. 129–235 (p. 132). Further references will be given in the text.

52 In Williams' *Lift Off* white youth Tone mimics the black street voice. In *Clubland* West Indian Kenny impersonates both white and African culture. In *Sing* black footballer Barry participates in racist white football discourse. Roy Williams, '*Lift Off*', in *Plays 1* (London: Methuen, 2004), pp. 161–240; Roy Williams, '*Clubland*', in *Plays 2* (London: Methuen, 2004), pp. 59–128 (p. 84).

53 The football authorities attempted to silence racist voices through the Taylor report in the aftermath of the 1989 Hillsborough disaster, and the 'Lets Kick Racism Out of Football' project in the 1990s and 2000s.

54 Wendy Barton O'Neill, 'Review', 29 September 2006, http://www.bbc.co.uk/northyorkshire/content/articles/2006/09/28/wendys_sing_yer_heart_out_review_feature.shtml [accessed 17 December 2006].

55 Performance of *Sing . . .* , West Yorkshire Playhouse, 16 February 2007.

56 Paul Bagguley and Yasmin Hussain 'The Bradford Riot of 2001: A Preliminary Analysis', conference paper at the Ninth Alternative Futures and Popular Protest Conference, Manchester Metropolitan University, 2003, http://www.leeds.ac.uk/sociology/people/pbdocs/Bradfordriot.doc [accessed 25 November 2006].

57 Godiwala, p. 5.
58 Alibhai-Brown, p. 120, p. 265.
59 See Harry Derbyshire, 'Roy Williams: Representing Multicultural Britain in *Fallout' Modern Drama*, 50 (2007), 414–34 (p. 414).
60 Roy Williams, *Fallout* (London: Methuen, 2003), p. 8. Further references will appear in the text.
61 Philip Fisher, *'Fallout'*, 2003, http://www.britishtheatreguide.info/reviews/fallout-rev.htm [accessed 25 December 2007]; Benedict Nightingale, 'Review of *Fallout'*, *The Times*, 18 June 2003; and Charles Spencer, 'Review of *Fallout'*, *Daily Telegraph*, 19 June 2007, both in *Theatre Record*, 23 (2003), 756–60 (p. 757).
62 Nightingale, 'Review of *Fallout'*.
63 Jane Edwardes, 'Review of *Elmina's Kitchen'*, *Time Out*, 25 June 2003, in *Theatre Record*, 23 (2003), pp. 701–6 (p. 704).
64 Fisher, *'Fallout'*; Roda Koening, 'Review: *Fallout'*, *Independent*, 23 June 2007, http://arts.independent.co.uk/theatre/reviews/article110027.ece [accessed 25 December 2007].
65 Parma suggests that the 'too controversial' black forms are 'the voice of social critique and criticism', and are 'marginalised' and 'virtually silenced'. Priya Parma, 'The Power of Rap as a Form of Literacy', in *Contemporary Youth Culture*, pp. 527–31 (p. 529).
66 Tom Paulin, *'Fallout'*, 30 July 2003, http://news.bbc.co.uk/1/hi/programs/newsnight/review/3013740.stm [accessed 25 December 2007].
67 Royal Shakespeare Company, Annual Report and Accounts, 2005–6, p. 19, http://www.rsc.org.uk/downloads/annualreport2006.pdf [accessed 29 May 2014].
68 See Lynette Goddard, 'debbie tucker green', in *Modern British Playwriting, 2000–2009*, (pp. 190–216), p. 206.
69 Marissia Fragkou and Lynette Goddard quote Little in 'Acting In / Action: Staging Human Rights in debbie tucker green's Royal Court Plays', in *Contemporary British Theatre*, 145–66, (p. 153) in their discussion of the refusal of empathy in tucker green's work.
70 debbie tucker green, *stoning mary* (London: Nick Hern, 2005), pp. 21–2.
71 debbie tucker green, *trade* (London: Nick Hern, 2005), p. 5. Further references appear in text.
72 Mireira Aragay and Enric Monforte, in *Contemporary British Theatre*, p. 110.
73 See Deirdre Osborne, 'The State of the Nation', in *Alternatives Within the Mainstream*, pp. 82–99 (p. 83). Before *Elmina's Kitchen*, journalist Mark Shenton claims that black voices and black audiences had been 'dismally served'. Mark Shenton, *'Elmina's Kitchen'*, http://www.bbc.co.uk/london/entertainment/theatre/elminaskitchen_300503.shtml [accessed 6 January 2007].
74 Kwei-Armah, 'How Was it For Us? . . . '.
75 Kate Bassett, 'Review of *Elmina's Kitchen'*, *Independent on Sunday*, 1 June 2003; and Georgina Brown, 'Review of *Elmina's Kitchen'*, *Mail on Sunday*, 1 June 2003, both in *Theatre Record*, 23 (2003), 701–6 (p. 701, p. 702).
76 Nicholas de Jongh, 'Review of *Elmina's Kitchen'*, *Evening Standard*, 30 May 2003, in *Theatre Record*, 23 (2003), 701–6 (p. 702).
77 Kwei-Armah, quoted in Osborne, 'Know Whence You Came', p. 259.

78 Also Georgina Brown commented that 'the thickness of the dialect often got the better of me'. Brown, 'Review of *Elmina's Kitchen'*.

79 Charles Spencer, 'Review of *Elmina's Kitchen'*, *Daily Telegraph*, 31 May 2003, in *Theatre Record*, 23 (2003), 701–6 (p. 703).

80 Roy Williams, in Natasha Tripney, 'Roy Williams', *The Stage*, 10 April 2014, p. 21.

81 Michael Coveney, 'Review of *Elmina's Kitchen'*, *Daily Mail*, 30 May 2003, in *Theatre Record*, 23 (2003), 701–6 (p. 702).

82 Charles Spencer, 'Thin Play Unworthy of its Punchy Production', *Telegraph*, 7 April 2005, http://www.telegraph.co.uk/culture/theatre/drama/3639955/Thin-play-unworthy-of-its-punchy-production.html [accessed 30 May 2014].

83 Dominic Cavendish, 'A Blast of Dramatic Dynamite', *Telegraph*, 13 May 2003, http://www.telegraph.co.uk/culture/theatre/drama/3594431/A-blast-of-dramatic-dynamite.html [accessed 28 November 2014].

84 David Benedict, 'Review of *Sing Yer Heart Out for the Lads'*, *Observer*, 5 May 2002, in *Theatre Record*, 22 (2002), 556–9 (p. 556).

85 Lyn Gardner, 'Trade', *Guardian*, 21 March 2006, http://www.theguardian.com/stage/2006/mar/21/theatre.

86 Spencer, 'Thin Play . . . '

87 Alastair Macaulay, 'Review of *Sing Yer Heart Out for the Lads'*, *Financial Times*, 11 May 2002, in *Theatre Record*, 22 (2002), 556–9 (p. 559).

88 Quentin Letts, 'Review of *Joe Guy'*, *Daily Mail*, 30 October 2007, in *Theatre Record*, 27 (2007), 1301–3 (p. 1301).

89 Helen Cadbury, '*Sing Yer Heart out For the Lads'*: *Education Pack* (Pilot Theatre, 2007), pp. 14–26.

90 Howe, 'Review of *Fallout'*.

91 Roy Williams, 'Foreword', in *Plays 2* (London: Methuen, 2004), pp. ix–xiii (p. x); Williams quoted in Sierz, 'What Kind of England Do We Want?', p. 121.

92 Natasha Walter, discussion of *Fallout*, on *Newsnight Review* (BBC Two), 9 May 2002, http://news.bbc.co.uk/1/hi/programs/newsnight/review/1976889.stm [accessed 25 January 2007].

93 Mark Lawson, discussion of *Fallout*, on *Newsnight Review* (BBC Two), 9 May 2002, http://news.bbc.co.uk/1/hi/programs/newsnight/review/1976889.stm [accessed 25 January 2007].

94 Edwardes, 'Review of *Elmina's Kitchen'*. For a discussion of the norms of audience behaviour, see Baz Kershaw, 'Oh for Unruly Audiences! Or, Patterns of Participation in Twentieth-Century Theatre', *Modern Drama*, 42 (2001), 133–55 (p. 150).

5 Sending Up Citizenship: Young Voices in Tanika Gupta, Mark Ravenhill and Enda Walsh

1 To Billington, the plays portrayed 'teenage angst and insecurity', to Charles Spencer the 'suffering, cruelty and depression' of teenage life. Patrick Marmion, 'Review of *Burn, Chatroom, Citizenship'*, *Daily Mail*, 17 March 2006; Charles Spencer, 'Review of *Burn, Chatroom, Citizenship'*, *Daily Telegraph*, 17 March 2006; Michael Billington, 'Review of *Burn, Chatroom, Citizenship'*, *Guardian*, 16 March 2006.

2 Benedict Nightingale, 'Review of *Burn, Chatroom, Citizenship'*, *The Times*, 17 March 2006.
3 Jill Lawless, 'Being A Youth In Britain isn't So Easy These Days', *The New York Times*, 20 March 2007, http://www.nytimes.com/2007/03/20/world/europe/20iht-london.4969936.html [accessed 13 February 2010].
4 Charles R. Acland, *Youth, Murder, Spectacle: the Cultural Politics of 'Youth in Crisis'* (Boulder and Oxford: Westview Press, 1995), p. 9.
5 Peter Trudgill, *Dialects of English* (Oxford: Blackwell, 1990), p. 126.
6 David Crystal, 'Plato's Problem, Linguistic, Split Infinitives', *Linguistics, Language Acquisition, and Language Variation: Current Trends and Future Prospects,* edited by James E. Alatis et al. (Washington: Georgetown University Press, 1996), pp. 5–29 (p. 8).
7 Leo Butler, *Redundant* (London: Methuen, 2001), p. 12.
8 Martin Narey, quoted in Sarah Bosely, 'Reaction: UN Report on Child Well-Being', *Guardian*, 14 February 2007, http://www.guardian.co.uk/society/2007/feb/14/childrensservices.comment [accessed 12 February 2010].
9 Christie L. Barron, *Giving Youth a Voice: A Basis for Rethinking Adolescent Violence* (Halifax: Fernwood Publishing, 2000), p. 10.
10 Kathryn Herr, 'Problematizing the "Problem" Teen: Reconceptualising Adolescent Development', in *Contemporary Youth Culture*, pp. 47–56, p. 47.
11 UN General Assembly, *Convention on the Rights of the Child 1989*, http://www2.ohchr.org/english/law/crc.htm [accessed 13 February 2010]; United Nations, *Report to the Convention of the Rights of the Child*, 25 February 2002, p. 126, http://www.everychildmatters.gov.uk/_files/88875ED12FE898A95524E6C34CB1AF8F0.doc [accessed 6 October 2008].
12 See Judi Atkins, 'Assessing the Impact of the Third Way', *British Party Politics and Ideology After New Labour,* edited by Simon Griffiths and Kevin Hickson (London: Palgrave Macmillan, 2010), pp. 39–68.
13 Also see Helen Nicholson, *Theatre, Education and Performance* (Basingstoke: Palgrave Macmillan, 2011), pp. 210–11.
14 Richard Ings, 'Meeting the Others; Jeremy Weller's Grassmarket Project', in *Performance and Community*, ed. Caoimhe MacAvinchey (London: Bloomsbury, 2014), pp. 115–40 (p. 134).
15 David Lane, *Contemporary British Drama* (Edinburgh: Edinburgh University Press, 2010), p. 137.
16 Simon Bent, *Bottle Universe* (London: The Bush Theatre, 2005), p. 79.
17 David Greig's *Yellow Moon* was produced at the Traverse in 2006 and toured nationally.
18 Paul Roseby, 'Introduction', in *White Boy*, Tanika Gupta (London: Oberon, 2008), p. 5.
19 For example, in Williams' *Clubland* (2001) and *Fallout* (2003), and Bola Agbaje's *Gone Too Far* (2007).
20 Tanika Gupta, *White Boy* (London: Oberon, 2008), p. 39. Further references will be given in the text.
21 Alison Roberts, 'London's Teenage Crisis', *Evening Standard*, 7 August 2007, http://www.thisislondon.co.uk/theatre/article-23407403-details/London's+teenage+crisis/article/do [accessed 29 October 2008].
22 Paul Gilroy coined this term in *After Empire: Melancholia or Convivial Culture* (Abingdon: Routledge, 2004), p. 95.

23 Barry and Boles noted that youth culture was now 'identified with black youth'. Elizabeth Barry and William Boles, 'Beyond Victimhood: Agency and Identity in the Theatre of Roy Williams', in *Alternatives Within the Mainstream: British Black and Asian Theatres*, edited by Dimple Godiwala (Newcastle: Cambridge Schools Press, 2006), pp. 297–313 (p. 299).

24 Nicholas de Jongh, 'NYT: Generation I.D: White Boy', *Evening Standard*, 14 August 2007. Performance of *White Boy*, Soho Theatre, 1 September 2007.

25 Gupta, in Roberts, 'London's Teenage Crisis'.

26 Jeremy Weller, 'A Play for Today', *Imagine* (BBC One), 31 October 2006.

27 Duncan, Stacey, 'Language and Identity in Youth Culture', in *Contemporary Youth Culture: An International Encyclopedia*, ed. Priya Parmar, Birgit Richard and Shirley Steinberg (West Port, CT and London: Greenwood Press, 2006), p. 39.

28 Also see Melanie E. Bush, 'Hip Hop, Wiggahs and Whiteness', in *Contemporary Youth Culture*, pp. 365–9 (p. 369). Ben Rampton, *Crossing: Language and Ethnicity Among Adolescents* (Manchester: St Jerome, 2005), pp. 2, 73.

29 Tanika Gupta in Peter Billingham, 'Interview with David Grieg', *At the Sharp End: Uncovering the Work of Five Contemporary Dramatists* (London: Methuen, 2007), p. 207.

30 De Jongh, 'NYT Generation'.

31 Sam Marlowe, '*White Boy*', *The Times*, 15 August 2007.

32 Aleks Sierz, 'Beyond Timidity: The State of British New Writing', *PAJ: A Journal of Performance and Art*, 27 (2005), 55–61 (p. 57).

33 To Rachel Sheridan the play was 'a showcase' for the 'abilities' of the young actors. Rachel Sheridan, 'Review of *White Boy*', 2008, http://britishtheatreguide. info/reviews/whiteboy-rev.htm [accessed 27 November 2008].

34 Mark Ravenhill, in Billingham, *At the Sharp End*, p. 126.

35 Qualifications and Curriculum Authority, *Education for Citizenship and the Teaching of Democracy in Schools: First Report of the Advisory Group on Citizenship* (QCA, 1998), p. 10.

36 Mark Ravenhill, '*Citizenship*', in *Shell Connections 2005: New Plays for Young People* (London: Faber & Faber, 2005), pp. 211–74 (p. 229). Further references are given in the text.

37 Mark Ravenhill, quoted in Jim Mulligan, 'A Zig-Zag Path Towards Some Idea of Who You Are', in *Shell Connections 2005: New Plays for Young People* (London: Faber & Faber, 2005), pp. 263–6 (p. 265).

38 Sarah Jane Dickenson, 'Fear of the Queer Citizen', in *Alternatives Within the Mainstream II*, edited by Dimple Godiwala (Newcastle: Cambridge Schools Publishing, 2007), pp. 124–41 (p. 137).

39 Voice therapists Moya L. Andrews and Anne C. Summers claim that the voices of children are more 'transparent' than adult voices, which have developed protecting strategies. Moya L. Andrews and Anne C. Summers, *Voice Treatment for Children and Adolescents* (San Diego: Singular, 2002), p. 8.

40 Kate Kellaway, 'Review of *Burn, Chatroom, Citizenship*', *Observer*, 19 March 2006; and Spencer, 'Review of *Burn, Chatroom, Citizenship*', both in *Theatre Record*, 26 (2006), 297–300 (p. 298).

41 Performance of *Citizenship*, National Theatre, 18 March 2006.

42 Rachel Halliburton, 'Review of *Burn, Chatroom, Citizenship*', *Time Out*, 22 March 2006; Sheridan Morley, 'Review of *Burn, Chatroom, Citizenship*', *Daily Express*,

16 March 2006; and Billington, 'Review of *Burn, Chatroom, Citizenship*', all in *Theatre Record,* 26 (2006) 297–300.

43 Anthony Banks, interview with the author, National Theatre (16 June 2008).

44 Chatroom Citizenship', http://www.nationaltheatre.org.uk/cc [accessed 3 January 2009].

45 Sheridan, 'Review of *White Boy*'.

46 Conference delegates, 'The Urban Voice', in *The Contemporary Voice: How we Teach Voice in the New Millenium*, edited by Bruce Wooding (London: International Centre for Voice, 2006), pp. 69–71 (p. 70).

47 Duncan, p. 39.

48 Ros Steen, 'Introduction to the Day', in Wooding, pp. 7–15 (p. 7).

49 UNICEF, *An Overview of Child Well-being in Rich Countries* (Florence: Innocenti Research Centre, 2007), p. 6, p. 37. Also see Les Black, Marjorie Mayo and Kalbir Shukra, *A Voice for Young People: An Evaluation of the Lewisham Youth Participation Project* (London: Centre for Urban and Community Research, 2000).

50 In 2002 the Electoral Commission a campaign called 'Votes Are Power' in schools. An 'independent' Commission reported in 2005 that 'non-voting and disengagement from the electoral politics are evident throughout society, particularly amongst younger age-groups'. The Electoral Commission, *Engaging the Public in Great Britain: An Analysis of Campaigns and Media Coverage*, http://www.electoralcommission.org.uk/document-summary?assetid=47281 [accessed 30 January 2012]; Sean Coughlan, 'Young People Vote Against Politics', 28 January 2003, http://news.bbc.co.uk/1/hi/education/2699275.stm [accessed 21 October 2008].

51 ACE, *Roles and Functions . . .* p. 38.

52 Pierre Bourdieu, *Language and Symbolic Power,* p. 58.

53 John Deeney, 'National Causes/Moral Causes?: The National Theatre, Young People and Citizenship', *Research in Drama Education,* 12 (2007), 331–44.

54 Karen Eden and Debi Roker, *Doing Something: Young People As Social Actors* (Leicester: National Youth Agency, 2002), p. 11.

55 Peter Rumney, discussion, 'It Isn't Fixed', Writernet Conference, Arcola Theatre, 7 December 2008.

56 43% of 18–24 year olds believed that something of value would be lost if their local area lost its cultural activities, compared with 71% of 55–64 year olds. Arts Council England. *Arts in England: Attendance, Participation and Attitudes in 2001* (Office of National Statistics, 2002), p. 48.

57 Horwood, interview, 2008.

58 The scheme has been sponsored by Shell, BT, and by Faber & Faber, who publish the plays' scripts and supply them to secondary schools. In 2006 for the first time three plays were selected for public performance in the Cottesloe: Mark Ravenhill's *Citizenship*, Deborah Gearing's *Burn*, and Enda Walsh's *Chatroom*.

59 Banks, interview with the author.

60 Suzy Graham-Adriani, 'Introduction', *Shell Connections 2005*, pp. vii–x (p. vii).

61 Suzy Graham-Adriani, quoted in Charlotte Cripps, 'Preview: NT Shell Connections', *The Independent*, 27 June 2005, http://www.independent.co.uk/arts-entertainment/theatre-dance/features/preview-nt-shell-connections-national-theatre-london-496720.html [accessed 19 February 2010].

62 Paul Taylor praised the 'ensemble of terrific young acting talent'; Sheridan Morley noted, 'There are enough star performances to provide a valuable evening for a talent scout'; and Benedict Nightingale commented, 'young British actors are in rich supply'. Paul Taylor, 'Review of *Burn, Chatroom, Citizenship*', *Independent*, 17 March 2006; Morley, 'Review of *Burn, Chatroom, Citizenship*'; and Nightingale, 'Review of *Burn, Chatroom, Citizenship*', all in *Theatre Record*, 297–300 (pp. 297–8).

63 Anthony Banks, quoted in Lindsey Turner, 'First-night Nerves', *Guardian*, 8 April 2008, http://www.guardian.co.uk/education/2008/apr/08/schools.artsinschools [accessed 21 June 2010].

64 Enda Walsh, '*Chatroom*', in *Shell Connections 2005: New Plays for Young People* (London: Faber & Faber, 2005), pp. 155–209 (p. 157). Further references will be given in the text.

65 Recalcitrant teenagers appeared in: *Harry Enfield's Television Program*, created by Harry Enfield (BBC Two, 1990); *The Catherine Tate Show*, created by Catherine Tate and Derren Litten (BBC Two, 2004); *Little Britain*, created by David Walliams and Matt Lucas (BBC One, 2004).

66 Jim Mulligan, '*Lord of the Flies* in a Chatroom', in *Shell Connections 2005: New Plays for Young People* (London: Faber & Faber, 2005), pp. 197–200 (p. 199).

67 Barron, *Giving Youth a Voice*, p. 31.

68 Performance of *Chatroom*, National Theatre, 18 March 2006.

69 Taylor, 'Review of *Burn, Chatroom, Citizenship*'; Marmion, 'Review of *Burn, Chatroom, Citizenship*'; Halliburton, 'Review of *Burn, Chatroom, Citizenship*'; and Billington, 'Review of *Burn, Chatroom, Citizenship*', all in *Theatre Record*, 26 (2006), pp. 297–300.

6 Women Who Kill Children: Mistrusting Mothers in the Work of Deborah Warner and Fiona Shaw, Beatrix Campbell and Judith Jones, and Dennis Kelly

1 Hélène Cixous privileges the voice of the mother, and its role, as the 'rhythm that laughs you', in the child's coming to language. Hélène Cixous, 'The Laugh of the Medusa', *Signs*, trans. by Keith Cohen and Paula Cohen, 1 (1976), pp. 875–93 (p. 882). Peggy Phelan has explored the 'living lyric of mothering' and the role of the voice as an interpenetrative agent of communication between mother and child. Peggy Phelan, lecture, 'Locating Voice', Queen Mary University London, 22 March 2012.

2 E. Ann Kaplan, *Motherhood and Representation: The Mother in Popular Culture and Melodrama* (London: Routledge, 1992), p. 3.

3 Jennifer Jones, *Medea's Daughters: Forming and Performing the Woman Who Kills* (Ohio: Ohio State University Press, 2003), pp. ix–xii; Kaplan, *Motherhood*, p. 109; Julia Kristeva, 'Stabat Mater', *The Kristeva Reader*, edited by Toril Moi (Oxford: Blackwell, 1986), pp. 160–86 (p. 161).

4 In 1999 and 2002 respectively, for example, Sally Clark and Angela Cannings
 were wrongfully committed of the murder of their baby sons. Clarke was
 presented in court as a career woman resentful of her children. In 2007, Kate
 McCann (and not her husband) was made a chief suspect by the Portuguese
 police after the disappearance of her daughter Madeleine. 'The Case of Sally
 Clark' 28 January 2003, http://news.bbc.co.uk/1/hi/england/2698425.stm
 [accessed 14 April 2012]; Cassandra Jardine, 'Kate McCann: Why Didn't
 They Believe Her?', *Telegraph*, 12 May 2010, http://www.telegraph.co.uk/
 news/newstopics/madeleinemccann/8503610/Kate-McCann-why-didnt-
 they-believe-her.html [accessed 14 April 2012].

5 Anne Worrall's *Offending Women: Female Lawbreakers and the Criminal Law
 System* (London: Routledge, 1990); See also Meda Chesney-Lind, 'Girls' Crime
 and Woman's Place: Toward a Feminist Model of Female Delinquency', *Crime
 and Delinquency* 35 (1989), 5–29.

6 From 1994, juries have had the right to 'draw inferences' from a suspect's
 silence, and as Janet Coterill states it is perhaps an 'inevitable consequence of
 human reasoning' that silence is interpreted as guilt. Janet Coterill, '"You Do
 Not Have the Right to Say Anything": Instructing the Jury on the Defendant's
 Right to Silence in the English Justice System', *Multilingua – Journal of Cross-
 Cultural and Interlanguage Communication*, 24 (2008), 7–24 (22).

7 Notable productions in this period that dealt with murdering mothers were:
 Marina Carr's *By The Bog of Cats . . .* , (1998); Theatre Babel's *Medea* by Liz
 Lochhead (2000); and Jack Thorne's *Fanny and Faggot* (2004).

8 Margaret R Higonnet, *The Representation of Women in Fiction*, edited by
 Carolyn G. Heilbrun and Margaret R. Higonnet (Baltimore: Johns Hopkins
 University Press, 1981) pp. ix–xxii (p. xx).

9 Performance of *Medea*, Queens Theatre London, 13 February 2001. In both
 James Morwood's and Diane Arnson Svarlian's translations, Medea's verbali-
 sation of her situation is accompanied by cries such as 'Aiai' and 'Aaaah!'.
 This is reduced to a 'primal cry' in Liz Lochhead's version. Euripides, *Medea:
 Hippolytus: Electra: Helen*, translated and edited by James Morwood (Oxford:
 Clarendon Press, 1997), p. 4; Euripides, *Euripides: Alcestis, Medea, Hippolytus*,
 trans. by Diane Arnson Svarlian (Indianopolis and Cambridge: Hackett
 Publishing Company, 2007), p. 66; Lochhead, Theatre Babel's *Medea*, p. 6.

10 Euripides, *Medea*, trans. by Kenneth McLeish and Frederic Raphael (London:
 Nick Hern, 1995), pp. 7–8.

11 Simon Goldhill, *How to Stage Greek Tragedy Today* (Chicago and London:
 University of Chicago Press, 2007), p. 21; John Dillon, 'Medea: From Witch
 to Intellectual', *Medea* Program, Abbey Theatre, 2000; Peter Arnott, *Public
 and Performance in the Greek Theatre* (London and New York: Routledge,
 1989), p. 87.

12 Dolores O'Higgins, 'Medea as Muse: Pindar's *Pythian*', in *Medea: Essays on
 Medea in Myth, Literature, Philosophy and Art*, edited by James J. Clauss and
 Sarah Iles Johnston (Princeton: Princeton University Press, 1997), pp. 103–26.

13 Fiona Shaw, in Fiona Shaw and Deborah Warner, 'Sympathy for the Devil',
 Guardian Unlimited, 30 January 2001, http://www.guardian.co.uk/Archive/
 Article/0,4273,4126863,00.html [accessed 2 April 2008].

14 McLeish and Raphael, *Medea*, pp. 10–14.

15 Shaw and Warner, 'Sympathy for the Devil'.

16 Robin Mitchell-Boyask, in Euripides, *Euripides*, pp. vii–xxxii (p. xxv).

17 John Banville, 'On Aristotle and Greek Tragedy', *Medea* Program, Abbey Theatre, 2000.

18 Elin Diamond, 'Realism's Hysteria: Disruption in the Theatre of Knowledge', in *Unmaking Mimesis: Essays in Feminism and Theatre*, ed. by Elin Diamond (London and New York: 1997), p. 27.

19 McLeish and Raphael, *Medea*, p. 4. Further references given in text.

20 Susannah Clapp, 'Mother Knows Best', *Observer Review*, 4 February 2001, http://www.guardian.co.uk/theobserver/2001/feb/04/features.review47 [accessed 29 December 2009]; Kate Bassett, 'Review of *Medea*', *Independent on Sunday*, 4 February 2001, p. 6.

21 Fiona Shaw, unpublished interview with Aoife Monks, London (15 February 2001).

22 Tim Teeman, 'A Modern Classic. Profile: Deborah Warner', *Play*, 27 January–2 February 2001, p. 23; Bassett, 'Review of *Medea*'.

23 Fiona Shaw, 'The Irony of Passionate Chaos: Modernity and Performing Medea', *New Theatre Quarterly*, 20 (2004), 237–44 (p. 242).

24 Shaw, interview with Aoife Monks.

25 Carr's *By the Bog of Cats . . .* , and Lochhead's *Medea* also omitted Medea's escape in the chariot.

26 Aoife Monks, '"The Souvenir From Foreign Parts": Foreign Femininity in Deborah Warner's *Medea*', *Australasian Drama Studies*, edited by Brian Singleton and Anna McMullan, 4 (2003), 32–45 (p. 40).

27 The production started at the National Theatre in Dublin in 2000, transferring to the Queens Theatre in London's West End in 2001, and subsequently touring in New York and Paris.

28 Merry Morash, *Understanding Gender, Crime and Justice* (London: Sage, 2006), p. 238.

29 Beatrix Campbell, *Woman's Hour* (BBC Radio Four), 22 April 2002.

30 'Myra Hindley: Child Killer', 15 November 2002, http://news.bbc.co.uk/1/hi/uk/2481911.stm [accessed 15 April 2012].

31 Lesley M. McLaughlin, *Media Representations of Myra Hindley* (Lesley M. McLaughlin, 2007), p. 9.

32 Judith Jones, discussion of *And All the Children Cried*, on *Woman's Hour* (BBC Radio Four), 22 April 2002.

33 Duncan Staff, *The Lost Boy: The Definitive Story of the Moors Murders and the Search for the Final Victim* (London: Bantam Press, 2007), p. 9.

34 Janie Jones, quoted in McLaughlin, *Media Representations*, p. 40.

35 Beatrix Campbell and Judith Jones, *And All the Children Cried* (London: Oberon, 2002), p. 41. Further references are in text.

36 Program, *And All the Children Cried* Program, West Yorkshire Playhouse, 19 April–11 May 2002.

37 J. L Austin, *How To Do Things With Words* (Oxford: Clarendon Press, 1962).

38 Janelle Reinelt, 'Toward a Poetics of Theatre and Public Events: In the Case of Stephen Lawrence', *The Drama Review*, 50 (2006), 69–87 (pp. 72–4).

39 Germaine Greer and Mark Lawson, *Front Row* (BBC Radio Four), 25 April 2002.

40 Mark Tyson, '*And All the Children Cried*', http://www.culturewars.org.uk/2004-01/cried.htm [accessed 23 March 2007].

41 Lynne Walker, '*And All the Children Cried*, West Yorkshire Playhouse, Leeds', *Independent*, 8 May 2002, http://www.independent.co.uk/arts-entertainment/theatre-dance/reviews/and-all-the-children-cried-west-yorkshire-playhouse-leeds-650596.html [accessed 29 December 2009].

42 Lyn Gardner, 'Review of *And All the Children Cried*', *Guardian*, 30 January 2003, http://www.guardian.co.uk/stage/2003/jan/30/theatre.artsfeatures2 [accessed 29 December 2009].

43 Greer, *Front Row*.

44 Campbell, *Women's Hour*.

45 Campbell and Jones, *And All the Children*, p. ii.

46 Greer, *Front Row*.

47 Angelique Chrisafis, *Guardian*, 20 April 2007, http://www.guardian.co.uk/uk_news/story/0,3604,687573,00.html [accessed 19 April 2007].

48 Terry Eagleton has discussed the ethical implications of the link that exists between 'pity' and 'intimacy'. Terry Eagleton, *Sweet Violence: A Study of the Tragic* (Oxford: Blackwell, 2003), p. 161.

49 Robin Soans, *Verbatim Verbatim: Contemporary Documentary Theatre*, edited by Will Hammond and Dan Steward (London: Oberon, 2008), p.32.

50 Alecky Blythe, in *Verbatim*, p. 81.

51 Stephen Bottoms, 'Putting the Document into Documentary: An Unwelcome Corrective', *The Drama Review*, 50 (2006), 56–68 (p. 58).

52 Dan Rebellato, 'New Theatre Writing: Dennis Kelly', *Contemporary Theatre Review*, 17 (2007), 603–8 (p. 604).

53 Stuart Young, 'Playing with Documentary Theatre: *Aalst* and *Taking Care of Baby*', *New Theatre Quarterly*, 25 (2009), 72–87 (p. 81).

54 Soans, *Verbatim*, pp. 36–42.

55 Dennis Kelly, *Taking Care of Baby* (London: Oberon, 2007), p. 15. Further references are given in the text.

56 Dennis Kelly, interview with Maggie Inchley, National Theatre, 12 May 2008.

57 A special issue of *Contemporary Theatre Review* is devoted to a discussion of the provocations of Crouch's work. Stephen Bottoms, 'Forum Introduction: Tim Crouch, *The Author*, and the Audience', *Contemporary Theatre Review*, 21 (2011), 390–3 (p. 391).

58 The Leveson enquiry was instigated in 2011 after it emerged that parts of the British press seemed to be using illegal phone hacking in order to obtain stories.

59 Kelly, interview with Maggie Inchley.

60 Nicholas de Jongh, 'Review of *Taking Care of Baby*', *Evening Standard*, 5 June 2007.

61 Sam Marlow, *The Times*, 6 June 2007, in 'Reviews of *Taking Care of Baby*', 680–2 (p. 681).

62 Kate Bassett, *Independent on Sunday*, 10 June 2007, in 'Reviews of *Taking Care of Baby*', 680–2 (p. 681).

63 Paul Taylor, 'Review of *Taking Care of Baby*', *Independent*, 7 June 2007, in *Theatre Record*, 27 (2007), 680–2 (p. 681).

64 De Jongh, 'Review of *Taking Care of Baby*'; Claire Alfree, 'Review of *Taking Care of Baby*', *Metro*, 6 June 2007; Jane Edwardes, 'Review of *Taking Care of Baby*', *Time Out*, 13 June 2007, all in *Theatre Record*, 27 (2007), 680–2 (pp. 681–2).

65 Charles Spencer, *Daily Telegraph*, 6 June 2007, in 'Reviews of *Taking Care of Baby*', 680–2 (p. 681).

Conclusion: Betrayal and Beyond

1 Elizabeth Freestone, *Guardian*, 'Women in Theatre: The Key Statistics – Interactive', 11 December 2012, http://www.theguardian.com/stage/interactive/2012/dec/11/women-theatre-key-statistics [accessed 11th June 2014].

2 Mirren's West End performance in *The Audience* (2103), produced with a private consortium in the West End, was broadcast to National Theatre Live digital audiences.

3 'David Cameron Tells MP Angela Eagle: 'Calm Down Dear', 27 April 2011, http://www.bbc.co.uk/news/uk-politics-13207256 [accessed 12th June 2014].

4 Between 2000–10 the female prison population rose by 27%, which according to the Women in Prison campaign group reflected more severe punishment of female offenders. 'Statistics', http://www.womeninprison.org.uk/statistics.php [accessed 12 April 2012].

5 Performance of *Let the Right One In*, Apollo Theatre, 13th June 2014.

6 Christopher Hope, 'Exclusive: Cabinet is Worth £70 million', *Telegraph*, 27 May 2012, http://www.telegraph.co.uk/news/politics/9290520/Exclusive-Cabinet-is-worth-70million.html [accessed 28 November 2014].

7 In the new government of 2010, the number of women elected reached a record 142, representing 22% of MPs. The number of women in the Cabinet represented 14% of its members. Research Paper 10/38, Section III, http://www.parliament.uk/briefingpapers/commons/lib/research/briefings/snsg-05548.pdf [accessed 2 June 2010]. In a further reshuffle in July 2014, apparently in an effort to make the party more representative, Cameron promoted 10 women, including 5 as Cabinet members.

8 Patrick Wintour, 'Ed Miliband Nose Operation Satisfies Surgeons and Labour Spin Doctors', 27 July 2011, http://www.theguardian.com/politics/2011/jul/27/ed-miliband-nose-operation-voice [28 November 2014].

9 'David Cameron, We Have A Few Questions For You', *Guardian*, 25 November 2011, http://www.theguardian.com/politics/2011/nov/25/david-cameron-answers-questions [accessed 28 November 2014].

10 Victoria Coren, 'George Osborne, Gawd Bless Yer', *Guardian*, 7 April 2013, http://www.theguardian.com/commentisfree/2013/apr/07/george-osborne-does-mockney-accent [accessed 17 June 2014]. Anne Karpf, 'Surgery Can't Fix Ed Miliband's Voice', *Guardian*, 29 July 2011, http://www.theguardian.com/commentisfree/2011/jul/29/ed-miliband-surgery-voice [accessed 16 June 2014].

11 Jasper Copping, 'Prince William's Cut-Glass Accent is Less Polished than Kate Middleton's', *Telegraph*, 4 November 2012, http://www.telegraph.co.uk/news/newstopics/howaboutthat/9653166/Prince-Williams-cut-glass-accent-is-a-little-less-polished-than-Kate-Middletons.html [accessed 17 June 2014].

12 Such fears were stoked by the government's 'Go-Home' advertising vans aimed at illegal immigrants in 2013.

13 Esther Webber and Vanessa Barford, 'Scottish Independence: A Layman's Glossary', 4 July 2014, http://www.bbc.co.uk/news/magazine-28088409 [accessed 7 July 2014].

14 Tara Conlan, 'Channel 4 Benefits Street Producers Struggle to Cast Second Series', *Guardian,* 16 April 2014, http://www.theguardian.com/media/2014/apr/16/channel-4-benefits-street-second-series-stockton-opposition [accessed 17 June 2014].

15 Owen Jones, *Chavs* (London: Verso, 2012), p. viii.

16 Dominic Cooke, 'Behind the Scenes at the Royal Court: Dominic Cooke's Year of Living Dangerously', *Observer,* 3 January 2010, http://www.guardian.co.uk/culture/2010/jan/03/dominic-cooke-royal-court-interview [accessed 4 June 2010].

17 Emma John, 'South Downs – The Browning Version – Review', 29 April 2014, http://www.theguardian.com/stage/2012/apr/29/south-downs-browning-version-review [accessed 9 July 2014].

18 Benedict Cumberbatch qtd in Anita Singh, 'Benedict Cumberbatch: Being Posh Can Ostracise You', *Telegraph,* 27 December 2011, http://www.telegraph.co.uk/culture/tvandradio/8978114/Benedict-Cumberbatch-being-posh-can-ostracise-you.html [accessed 11th June 2014]; Maxine Peake qtd in Singh, 'Maxine Peake: "Regional Accents Are Taken Less Seriously"', *Telegraph,* 12 June 2014, http://www.telegraph.co.uk/culture/theatre/10861268/Maxine-Peake-regional-accents-are-taken-less-seriously.html [accessed 9 July 2014].

19 Eton alumni such as Tom Hiddleston, Harry Redmayne, Damien Lewis and Dominic West proliferated.

20 'Spending Review: Culture Department Budget Cut by 7%', 26 June 2013, http://www.bbc.co.uk/news/entertainment-arts-23060049 [accessed 28 November 2014]. Tax breaks have been announced for producers, while unpaid artistic labour is common. UK Theatres Welcome Budget Tax Break', 20 March 2014, http://www.bbc.co.uk/news/entertainment-arts-23060049 [accessed 19 June 2014].

21 Matthew Hemley, 'Cuts Risk Smaller Talent Pool, Warns Let the Right One In Playwright', *The Stage,* 6 February 2014, p. 3. Jen Harvie assesses the economic pressures faced by many artists in *Fair Play; Art, Performance and Neoliberalism* (Basingstoke: Palgrave Macmillan, 2013), pp. 62–107.

22 'Sajid Javid's Culture for All Speech', Bristol, 6 June 2014, https://www.gov.uk/government/speeches/culture-for-all [accessed 6 August 2014].

23 'Lenny Henry Racism Row Candidate Quits UKIP', 29 April 2014, http://www.bbc.co.uk/news/uk-politics-27202753 [accessed 11th June 2014].

24 Roy Williams, in Natasha Tripney, 'Roy Williams', *The Stage,* 10 April 2014, p. 21.

25 Matt Trueman, 'East Asian Actors Seek RSC Apology Over *Orphan of Zhao* Casting', *Guardian,* 31 October 2012, http://www.theguardian.com/stage/2012/oct/31/east-asian-actors-rsc-apology [accessed 12th June 2014].

26 Paterson Joseph, National Theatre Platform, 17 October 2011.

27 Chris Green, 'Teen Writers Show Their Skins', *Independent,* 11 February 2008, http://www.independent.co.uk/news/media/teen-writers-show-their-skins-780666.html [accessed 12th June 2014].

28 Youth unemployment stood at 20.3% in 2011. Office for National Statistics, *Labour Market Statistics: October 2011,* 12 October 2011, http://www.ons.gov.uk/ons/dcp171778_237932.pdf [accessed 11 November 2011].

29 'Theatre Blog', http://www.theguardian.com/stage/theatreblog/2011/aug/31/save-national-association-youth-theatres [accessed 28 November 2014].

30 Barnado's, 'Scandal of Britons Who Have Given up on Children', 3 November 2011, http://www.barnardos.org.uk/news_and_events/media_centre/press_releases.htm?ref=74051 [accessed 11 November 2011].

31 Nadia Mendoza, 'A Magical Salary!', 30 November 2011, http://www.dailymail.co.uk/tvshowbiz/article-2067462/Daniel-Radcliffe-retains-spot-rich-list-UK-stars-30.html?ito=feeds-newsxml [accessed 30 November 2011].

32 Police failings with regard to the Stephen Lawrence in 1993 murder, and allegations of their falsification of accounts of the events at Hillsborough in 1989 have damaged confidence in the police. The BBC has been implicated in its failure to stop the activities of television presenter Jimmy Savile, about whom there have been a wide range of allegations of child abuse in 2014.

33 See David Judge, *Democratic Incongruities: Representative Democracy in Britain* (Basingstoke: Palgrave Macmillan, 2014), pp. 170–1.

34 See Mark Shepard and Robert Johns, 'A Face for Radio? How Viewers and Listeners Reacted Differently to the Third Leaders' Debate in 2010', *British Journal of Politics and International Relations*, 14.1 (2012), 1–18 (13).

35 See Alwyn W. Turner, *A Classless Society: Britain in the 1990s* (London: Aurum, 2013), p. 8.

36 Andrew Dobson, *Listening for Democracy: Recognition, Representation, Reconciliation* (Oxford: Oxford University Press, 2014), p. 10.

37 Jacques Derrida, *Writing and Difference*, trans. by Alan Bass (London: Routledge and Kegan Paul, 1978), p. 235.

38 See Dan Rebellato, 'Exit the Author' in *Contemporary British Theatre*, pp. 9–31 (p. 12).

39 Tim Crouch, 'The Theatre of Reality . . . and Avoiding the Stage's Kiss of Death', 18 June 2014, http://www.theguardian.com/stage/2014/jun/18/theatre-reality-adler-and-gibb-tim-crouch-playwright [accessed 7 August 2014].

Bibliography

Plays

Bent, Simon, *Bottle Universe* (London: The Bush Theatre, 2005)

Burke, Gregory, *Black Watch* (London: Faber & Faber, 2007)

——, *Gagarin Way* (London: Faber & Faber, 2001)

——, *The Straits* (London: Faber & Faber, 2003)

Butler, Leo, *Redundant* (London: Methuen, 2001)

Campbell, Beatrix, and Judith Jones, *And All the Children Cried* (London: Oberon, 2002)

Cullen, Mike, Simon Donald and Sue Glover, *Made in Scotland: An Anthology of New Scottish Plays* (London: Methuen, 1995)

Euripides, *Medea*, trans. by Kenneth McLeish and Frederic Raphael (London: Nick Hern, 1995)

Gifford, Anne, and Jane Robertson, *Contemporary Scottish Plays for Higher English and Drama* (London: Hodder and Stoughton, 2002)

Greig, David, *The Bacchae* (London: Faber & Faber, 2007)

——, 'The Cosmonaut's Last Message to the Woman he Once Loved in the Former Soviet Union', in *David Greig Plays:1* (London: Faber & Faber, 2002), pp. 209–301

——, *Damascus* (London: Faber & Faber, 2007)

——, *Pyrenees* (London: Faber & Faber, 2005)

Gupta, Tanika, *White Boy* (London: Oberon, 2008)

Kelly, Dennis, 'Osama the Hero', *Plays One* (London: Oberon, 2008), pp. 47–120

——, *Taking Care of Baby* (London: Oberon, 2007)

Kwame, Kwei-Armah, *Elmina's Kitchen* (London: Methuen, 2003)

——, *Fix Up* (London: Methuen, 2004)

——, *Statement of Regret* (London: Methuen, 2007)

Lochhead, Liz, *Medea* (after Euripides) (London: Nick Hern, 2000)

Made in Scotland: An Anthology of New Scottish Plays (London: Methuen Drama, 1995)

Shell Connections 2005: New Plays for Young People (London: Faber & Faber, 2005)

tucker green, debbie, *stoning mary* (London: Nick Hern, 2005)

——, *trade* (London: Nick Hern, 2005)

Walcott, Derek, *A Branch of the Blue Nile* in *Three Plays* (New York: Farrar, Strauss and Giroux, 1986)

Williams, Roy, *Fallout* (London: Methuen, 2003)

——, *Joe Guy* (London: Methuen, 2007)

——, *Plays 1* (London: Methuen, 2004)

——, *Plays 2* (London: Methuen, 2004)

Newspapers and periodicals

Evening Standard

Guardian

Herald
Independent
Independent on Sunday
The List
Mail on Sunday
Metro
Observer
Play
The Stage
Sunday Herald
Sunday Times
Theatre Record
The Times
Time Out
UK Writer

Other sources

Acland, Charles R., *Youth, Murder, Spectacle: The Cultural Politics of 'Youth in Crisis'* (Boulder and Oxford: Westview Press, 1995)

Adorno, Theodor, *The Culture Industry: Selected Essays on Mass Culture*, ed. by J. M. Bernstein (London and New York: Routledge, 1991)

——, 'On the Fetish Character in Music and the Regression of Listening' [1938], in *Modernism: An Anthology of Sources and Documents*, ed. Vassiliki Kolocotroni, Jane Goldman and Olga Taxidou (University of Chicago Press: Chicago, 1998), pp. 580–4

Aldea, Eve, et al. 'Pipes and Drums: Responses to Black Watch', *Contemporary Theatre Review*, 18 (2008), 272–9

Alibhai-Brown, Yasmin, *Who Do We Think We Are: Imagining the New Britain* (London: Penguin, 2001)

Anderson, Benedict, *Imagined Communities: Reflection on the Origin and Spread of Nationalism* (London: Verso 1991)

Andrews, Moya L., and Anne C. Summers, *Voice Treatment for Children and Adolescents* (San Diego: Singular, 2002)

Armand, Clara, 'Dialogism and the Theatre Event: Deborah Warner and Fiona Shaw's *Medea*, 2001', *New Theatre Quarterly*, 20 (2004), 225–36

Arnott, Peter, *Public and Performance in the Greek Theatre* (London and New York: Routledge, 1989)

Appadurai, Arjun, *Modernity at Large* (Minnesota: University of Minnesota Press, 1996)

Arts Council England, *Arts in England: Attendance, Participation and Attitudes in 2001* (Office of National Statistics, 2002)

——, *Arts in England 2003: Attendance, Participation and Attitudes* (Arts Council England, 2003)

——, *Grants for the Arts* (Arts Council England, 2005)

——, *International Data on Public Spending in the Arts in Eleven Countries* (Arts Council England, 1998)

——, *Our Agenda for the Arts 2006–8* (Arts Council England, 2006)

——, *Paving the Way: Mapping of Young People's Participatory Theatre* (Arts Council England, 2007)

——, *Roles and Functions of the English Regional Producing Theatres Fund Report* (Bristol: Peter Boyden Associates, 2000)

Ascherson, Neal, *Stone Voices: The Search for Scotland* (London: Granta, 2003)

Atkins, Judi, 'Assessing the Impact of the Third Way', *British Party Politics and Ideology After New Labour,* ed. by Simon Griffiths and Kevin Hickson (London: Palgrave Macmillan, 2010)

Auslander, Philip, *From Acting to Performance* (London and New York: Routledge, 1997)

——, *Liveness: Performance in a Mediatised Culture* (London and New York: Routledge, 1999)

——, *Theory for Performance Studies* (London and New York: Routledge, 2008)

Austin, J. L., *How To Do Things With Words* (Oxford: Clarendon Press, 1962)

Bagguley, Paul and Yasmin Hussain, 'The Bradford Riot of 2001: A Preliminary Analysis', conference paper at the Ninth Alternative Futures and Popular Protest Conference, Manchester Metropolitan University, 2003, http://www.leeds.ac.uk/sociology/people/pbdocs/Bradfordriot.doc [accessed 25 November 2006]

Bakhtin, Mikhail, *The Bakhtin Reader: Selected Writings of Bakhtin, Medvedev and Voloshinov,* ed. by Pam Morris (New York: Routledge, 1994)

——, *Problems of Dostoevsky's Poetics,* ed. and trans. by Caryl Emerson (Minneapolis: University of Minneapolis, 1984)

Banville, John, 'On Aristotle and Greek Tragedy', *Medea* Programme, Abbey Theatre, 2000

Barish, Jonas, *The Anti-theatrical Prejudice* (Berkeley and LA: University of California Press, 1981)

Barker, Howard, *Arguments for a Theatre* (Manchester: Manchester University Press, 1997)

Barron, Christie L., *Giving Youth a Voice: A Basis for Rethinking Adolescent Violence* (Halifax: Fernwood Publishing, 2000)

Barthes, Roland, 'The Death of the Author', in *Image – Music – Text* (London: Fontana, 1977), pp. 142–8

——, 'From Speech to Writing', in *The Grain of the Voice: Interviews 1962–1980,* trans. by Linda Coverdale (Berkeley and Los Angeles: University of California Press, 1981), pp. 3–7

——, *Mythologies,* trans. by Annette Lavers (St. Albans: Paladin, 1973)

Barton, Robert, 'Therapy and Actor Training', *Theatre Topics,* 4 (1994), 105–18

Bartsch, Renate, *Norms of Language: Theoretical and Practical Aspects* (London and New York: Longman, 1987)

Bennett, Susan, *Theatre Audiences: A Theory of Production and Reception* (London and New York: Routledge, 1997)

Berry, Cicely, *Text in Action* (London: Virgin Publishing, 2001)

——, *Voice and the Actor* (London: Harrap, 1973)

Berry, Cicely, Patsy Rodenburg and Kristin Linklater, 'Shakespeare, Feminism, and Voice: Responses to Sarah Werner', *New Theatre Quarterly,* 49 (1997) 48–52

Bhabha, Homi, *The Location of Culture* (London: Routledge, 1994)

Billington, Michael, *State of the Nation: British Theatre Since 1945* (London: Faber & Faber, 2007)

Billingham, Peter, 'Interview with David Greig', *At the Sharp End: Uncovering the Work of Five Contemporary Dramatists* (London: Methuen, 2007), pp. 73–93

Birch, Cathy, *Awaken the Writer Within: Discover How to Release Your Creativity and Find Your True Writer's Voice* (Oxford: How to Books, 2001)

Black British Culture and Society, ed. Michael McMillan (London: Routledge, 2000), pp. 255–64

Black, Les, Marjorie Mayo and Kalbir Shukra, *A Voice for Young People: An Evaluation of the Lewisham Youth Participation Project* (London: Centre for Urban and Community Research, 2000)

Blair, Tony, *The Third Way: New Politics for the New Century* (London: Fabian Society, 1998)

Blandford, Steve, *Film, Drama and the Break-Up of Britain* (Bristol: Intellect, 2007)

Boedecker, Deborah, 'Becoming Medea: Assimilation in Euripides', in *Medea: Essays on Medea in Myth, Literature, Philosophy and Art*, ed. by James J. Clauss and Sarah Iles Johnston (Princeton: Princeton University Press, 1997), pp. 127–48

Bogatryev, Petr, 'Semiotics in the Folk Theatre', in *Semiotics of Art: Prague School Contributions*, ed. Ladislav Matejka and Irwin R. Titunik, trans. Jiří Veltruský (Cambridge, MA and London: MIT Press, 1976), pp. 33–50

Bolton, Jacqueline, 'Capitalizing (on) new writing: New play development in the 1990s', *Studies in Theatre & Performance*, 32 (2012) pp. 209–25

Boston, Jane, 'Voice: The Practitioners, their Practices, and Their Critics', *New Theatre Quarterly*, 51 (1997), 248–54

Bottoms, Stephen, 'Forum Introduction: Tim Crouch, *The Author*, and the Audience', *Contemporary Theatre Review*, 21 (2011), 390–3

—— 'Putting the Document into Documentary: An Unwelcome Corrective', *The Drama Review*, 50 (2006), 56–68

Bourdieu, Pierre, *Language and Symbolic Power*, ed. John B. Thompson, trans. Gino Raymond and Matthew Adamson (Cambridge: Polity Press, 1991)

Bourne, Jenny, Lee Bridges and Chris Searle, *Outcast England: How Schools Exclude Black Children* (Institute of Race Relations, 1994)

Brown, Ian (ed.), 'A Lively Tradition and Creative Amnesia', *The Edinburgh Companion to Scottish Drama* (Edinburgh: Edinburgh University Press, 2011)

Bryant, Christopher G. A., and David Jary, 'Anthony Giddens', in *The Blackwell Companion to Major Social Theorists*, ed. George Ritzer (Oxford: Blackwell, 2003), pp. 247–73

Bulmer, Alex, 'Voice and Process: Instinct versus Skill [Includes Interview with Kate Lynch]', *Canadian Theatre Review*, 97 (1998), 36–40

Busby, Robert, *Marketing the Populist Politician: The Democratic Democrat* (Basingstoke: Palgrave Macmillan, 2009)

Butler, Judith, *Excitable Speech* (Routledge: New York and London, 1997)

——, 'Performative Arts and Gender Construction: An Essay on Phenomenology and Feminist Theory', in *Performing Feminisms: Feminist Critical Theory and Theatre*, ed. Sue-Ellen Case (Baltimore and London: Johns Hopkins University Press, 1990), pp. 270–82

Cadbury, Helen, '*Sing Yer Heart out For the Lads*': *Education Pack* (Pilot Theatre, 2007)

Callery, Dymphna, 'Writing for Stage', in *The Writer's Handbook*, ed. Jenny Newman, Edward Cusick and Aileen Tourette (London: Arnold, 2004), pp. 81–92

Cammack, Paul, 'Giddens' Way with Words', in *The Third Way: Criticisms, Futures, Alternatives*, ed. Sarat Hale, Will Leggett and Luke Martell (Manchester: Manchester University Press, 2004)

Carlson, Marvin, *A Historical and Critical Survey from the Greeks to the Present* (Ithaca and London: Cornell University Press, 1984)

——, *Speaking in Tongues: Languages at Play in the Theatre* (Michigan: University of Michigan, 2006)

——, 'Theater and Dialogism', in *Critical Theory and Performance*, ed. Janelle G. Reinelt and Joseph R. Roach (Ann Arbor: University of Michigan Press, 1992), pp. 313–23

——, 'Theatrical Performance: Illustration, Translation, Fulfilment, or Supplement?', in *Theatre Journal*, 37 (1985), 5–11

Cavarero, Adriana, *For More Than One Voice: Toward a Philosophy of Vocal Expression* (Stanford: Stanford University Press, 2005)

Central School of Speech and Drama, *BA (Hons) Acting Course Specification* (London: Central School of Speech and Drama, 2007)

——, *MA Voice Studies Course Specification* (London: Central School of Speech and Drama, 2007)

Chambers, J. K., *Sociolinguistic Theory* (Oxford: Blackwell, 1995)

——, 'World Enough and Time: Global Enclaves of the Near Future', *American Speech*, 75 (2000), 285–7

Chesney-Lind, Meda, 'Girls' Crime and Woman's Place: Toward a Feminist Model of Female Delinquency', *Crime and Delinquency* 35 (1989), 5–29

Ch'ien Nien-ming, Evelyn, *Weird English* (Cambridge, MA and London England: Harvard University Press, 2004)

Chomsky, Noam, *Deterring Democracy* (London: Verso, 1991)

Cixous, Hélène, 'The Laugh of the Medusa', *Signs*, trans. Keith Cohen and Paula Cohen, 1 (1976), 875–93

Clifford Turner, J., *Voice and Speech in Theatre*, 6th edn (London: A & C Black, 2007)

Commission on Integration and Cohesion, *Our Shared Future* (Commission on Integration and Cohesion, 2007)

A Companion to Modern British and Irish Drama, 1880–2005, ed. Mary Luckhurst (Oxford: Blackwell, 2006)

Connor, Steven, 'The Strains of the Voice', *Voices and Emotion: Volume III*, ed. Krzystof Izdebski (San Diego, Oxford and Brisbane: Plural Publishing, 2009), 298–305

Contemporary British Theatre: Breaking New Ground, ed. Vicky Angelaki (Basingstoke: Palgrave Macmillan, 2013)

Contemporary Youth Culture: An International Encyclopedia, ed. Priya Parmar, Birgit Richard and Shirley Steinberg, (West Port, CT and London: Greenwood Press, 2006), pp. 527–31

Cool Britannia? British Political Drama in the 1990s, ed. Rebecca D'Monté and Graham Saunders (London: Palgrave Macmillan, 2008)

Cosmotopia: Transnational Identities in David Greig's Theatre, ed. Anja Müller and Clare Wallace (Prague: Litteraria Pragensia, 2011)

Coterill, Jan, '"You Do Not Have the Right to Say Anything": Instructing the Jury on the Defendant's Right to Silence in the English Justice System', *Multilingua – Journal of Cross-Cultural and Interlanguage Communication*, 24 (2008), 7–24

——, *Dumbstruck: A Cultural History of Ventriloquism* (Oxford: Oxford University Press, 2000)

Couldry, Nick, *Why Voice Matters: Culture and Politics after Neoliberalism* (London: Sage, 2010)

Craig, Cairns, *The Modern Scottish Novel: Narrative and the National Imagination* (Edinburgh: Edinburgh University Press, 1999)

Craig, Cairns and Randall Stevenson (eds), *Twentieth Century Scottish Drama*, (Edinburgh: Canongate, 2001)

Crawford, Robert, *Identifying Poets: Self and Territory in Twentieth Century Poetry* (Edinburgh: Edinburgh University Press, 1993)

Crohn Smith, Natalie, 'Stanislavski, Creativity and the Unconscious', *New Theatre Quarterly*, 2 (1986), 345–50

Cross, Robert, *The Theatre of Self-Performance* (Manchester: Manchester University Press, 2004)

Crystal, David, 'Plato's Problem, Linguistic, Split Infinitives', *Linguistics, Language Acquisition, and Language Variation: Current Trends and Future Prospects*, ed. James E. Alatis and others (Washington: Georgetown University Press, 1996), pp. 5–29

Dawson, Paul, *Creative Writing and the New Humanities* (Abingdon: Routledge, 2005)

Dean, Roger T, and Hazel Smith, 'Voicescapes and Sonic Structures in the Creation of Sound Technodrama', *Performance Research* 8 (2003), 112–24

Deeney, John, 'National Causes/Moral Causes?: The National Theatre, Young People and Citizenship', *Research in Drama Education*, 12 (2007), 331–44

Derbyshire, Harry, 'Roy Williams: Representing Multicultural Britain in *Fallout*', *Modern Drama*, 50 (2007), 414–34

Derrida, Jacques, *Of Grammatology*, trans. by Gayatri Chakravorty Spivak (Baltimore: Johns Hopkins University Press, 1997)

——, *Writing and Difference*, trans. by Alan Bass (London: Routledge and Kegan Paul, 1978)

Devine, Tom, *The Scottish Nation*, 3rd edn (London: Penguin 2012)

Diamond, Elin, 'Realism's Hysteria. Disruption in the Theatre of Knowledge', in *Unmaking Mimesis: Essays in Feminism and Theatre*, ed. Elin Diamond (London and New York: Routledge, 1997), pp. 4–38

Dickenson, Sarah Jane, 'Fear of the Queer Citizen', in *Alternatives Within the Mainstream II*, ed. by Dimple Godiwala (Newcastle: Cambridge Schools Publishing, 2007), p. x

Dillon, John, 'Medea: From Witch to Intellectual', *Medea* Programme, Abbey Theatre, 2000

Directions in Sociolinguistics: The Ethnography of Communication, ed. John J. Gumperz .and Dell Hymes (Oxford: Blackwell, 1986), pp. vi–xii

Dobson, Andrew, *Listening for Democracy: Recognition, Representation, Reconciliation* (Oxford: Oxford University Press, 2014)

Dolar, Mladen, *A Voice and Nothing More* (Cambridge, MA: MIT Press, 2006)

Donnellan, Declan, *The Actor and the Target* (London: Nick Hern Books, 2002)

Dromgoole, Dominic, *The Full Room: An A–Z of Contemporary Playwriting* (London: Methuen, 2002)

Eagleton, Terry, *Literary Theory* (Minneapolis: University of Minneapolis Press, 1983)

——, *Sweet Violence: A Study of the Tragic* (Oxford: Blackwell, 2003)

Eden, Karen, and Debi Roker, *Doing Something: Young People as Social Actors* (Leicester: National Youth Agency, 2002)

Edgar, David, *State of Play* (London: Faber & Faber, 1999)

Egglestone, John, *Education for Some: The Educational and Vocational Experiences of 15–18 Year-old Members of Minority Ethnic Groups* (Stoke-on-Trent: Trentham, 1986)

Elam, Keir, *The Semiotics of Theatre and Drama* (London and New York: Routledge, 1980)

Elbow, Peter, *Everyone Can Write: Essays Towards a Hopeful Theory of Writing and Teaching Writing* (New York and Oxford: Oxford University Press, 2000)

——, 'Foreword', in *Voice As Process*, by Lizbeth A. Bryant (Portsmouth: Heinemann, 2005), pp. x–xii

English: The National Curriculum for England (London: Department for Education and Employment and Qualifications and Curriculum Authority, 1999)

ETHNOS, *The Decline of Britishness: A Research Survey* (Commission for Racial Equality, 2005)

Fairclough, Norman, *New Labour, New Language?* (London and New York: Routledge, 2000)

Fenn, Clare, et al., *Arts in England 2003: Attendance, Participation and Attitudes* (Arts Council England, 2004)

Finnegan, Ruth, *Literacy and Orality: Studies in the Technology of Communication* (Oxford: Basil Blackwell, 1988)

Fogerty, Elsie, *The Speaking of English Verse* (London and Toronto: J. M. Dent & Sons, 1923)

Foucault, Michel, 'What is an Author?', *Screen*, 20 (1979), 17–28

——, *Technologies of the Self: A Seminar with Michel Foucault*, ed. Luther H. Martin, Huck Gutman and Patrick H. Hutton (Amherst: University of Massachusetts Press, 1988)

Fountain, Tim, *So You Want to be a Playwright? How to Write a Play and Get it Produced* (London: Nick Hern, 2007)

Franklin, Bob, *Packaging Politics: Political Communications in Britain's Media Democracy* (London: Arnold, 2004), p. 14

Freshwater, Helen, *Theatre and Audience* (London: Palgrave Macmillan, 2009)

——, *Theatre Censorship in Britain: Silencing, Censure and Suppression* (London: Palgrave Macmillan, 2009)

The Fuse Group, *Language and Sexual Imagery in Broadcasting: A Contextual Investigation*, (Office of Communications, 2005)

Giddens, Anthony, *The Consequences of Modernity* (Stanford: Stanford University Press, 1990)

——, *The Third Way: The Renewal of Social Democracy* (Oxford: Polity, 1998)

——, *The Transformation of Intimacy: Sexuality, Love and Eroticism in Modern Societies* (Cambridge: Polity Press, 1992)

Gilbert, Helen, 'Describing Orality: Performance and Recuperation of the Voice', in *De-Scribing Empire: Post-colonialism and Textuality*, ed. Chris Tiffin and Alan Lawson (London and New York: Routledge, 1994), pp. 116–24

Gill, Peter, 'Speak to Me', in *Actors Speaking*, ed. Lyn Haill (London: Oberon, 2007), pp. 9–23

Gilmour, Rachael, 'Doing Voices: Reading Language as Craft in Black British Poetry', *Journal of Commonwealth Literature*, 2014, https://qmro.qmul.ac.uk/jspui/handle/123456789/5859

Gilroy, Paul, *After Empire: Melancholia or Convivial Culture* (Abingdon: Routledge, 2004)

——, *There Ain't No Black in the Union Jack: The Cultural Politics of Race and Nation* (Chicago: Chicago University Press, 1993)

Goddard, Lynette, 'Backpages', *Contemporary Theatre Review*, 15 (2005), 369–86

——, (ed.), 'Introduction', *The Methuen Drama Book of Plays by Black British Writers* (London: Methuen, 2011), pp. vii–xxv

Godiwala, Dimple (ed.) *Alternatives Within the Mainstream: British Black and Asian Theatres*, (Newcastle: Cambridge Schools Press, 2006).

Goffman, Erving, *The Presentation of the Self in Every Day Life* (New York: Doubleday Anchor, 1959)

——, *Stigma: Notes on the Management of Spoiled Identity* (New York: Simon and Schuster, 1963)

Goldhill, Simon, *How to Stage Greek Tragedy Today* (Chicago and London: University of Chicago Press, 2007)

Gould, Philip, *The Unfinished Revolution: How the Modernisers Saved the Labour Party* (London: Little and Brown, 1998)

Govan, Emma, Helen Nicholson and Katie Normington, *Devising Histories and Contemporary Practices* (London and New York: Routledge, 2007)

Gray, John, 'Liberalism and Living Together', in *The Moral Universe*, ed. Tom Bentley and Daniel Stedman Jones (London: Demos, 2001), pp. 1–8

Greig, Noël, *Playwriting: A Practical Guide* (London: Routledge, 2005)

Guerrero, Laura K., and Kory Floyd, *Nonverbal Communication in Close Relationships* (Mahwah, NJ and London: Laurence Erlbaum Associates, 2006)

Habermas, Jürgen, *Communication and Evolution of Society*, trans. Thomas McCarthy (Cambridge: Polity Press, 1984)

——, *The Structural Transformation of the Public Space: An Inquiry into a Category of Bourgeois Society*, trans. Thomas Burger and Frederick Lawrence (Oxford: Polity Press, 1989)

Hall, Stuart, 'New Labour's Double-Shuffle', *Soundings* 24 (2003), 10–24 (p. 12)

Halliday, M. A. K., *Language as Social Semiotic: the Social Interpretation of Language and Meaning* (London: Arnold, 1978)

Halsey, A. H., *Educational Priority* (HMSO, 1972)

Hare, David, *Obedience, Struggle and Revolt* (Faber & Faber: London, 2005)

Harvie, Christopher, *Scotland and Nationalism: Scottish Society and Politics, 1707 to the Present* (London: Routledge, 2004) [1977]

Harvie, Jen, *Fair Play: Art, Performance and Neoliberalism* (Basingstoke: Palgrave Macmillan, 2013).

——, *Staging the UK* (Manchester: Manchester University Press, 2005)

Hauthal Wuppertal, Janine, 'Realisms in British Drama since the 1990s: Anthony Neilson's *Realism* and Gregory Burke's *Black Watch*', in *Realisms in Contemporary Culture: Theories, Politics, and Medial Configurations*, ed. Dorothee Birke and Stella Butter (Berlin: de Gruyter, 2013), pp. 146–77

Havelock, Eric. A., *The Muse Learns to Write: Reflections in Orality and Literacy from Antiquity to the Present* (New Haven and London: Yale University Press, 1986)

Haydon, Andrew , 'Theatre in the 2000s', in *Modern British Playwriting: the 2000s: Voices, Documents, New Interpretations*, ed. Dan Rebellato (London: Methuen, 2013), pp. 40–96

Heddon, Deidre, and Jane Milling, *Devising Performance: A Critical History* (Basingstoke: Palgrave Macmillan, 2006)

Hefferman, Richard, and Mike Marquese, *Defeat from the Jaws of Victory: Inside Kinnock's Labour Party* (London: Verso, 1992)

Howard, Philip, *Made in Scotland: An Anthology of New Scottish Plays* by Mike Cullen, Simon Donald and Sue Glover (London: Methuen, 1995), pp. xi, xiii

Howe Kritzer, Amelia, *Political Theatre in Post-Thatcher Britain. New Writing: 1995–2000* (Basingstoke and New York: Palgrave Macmillan, 2008)

Ings, Richard, 'Meeting the Others; Jeremy Weller's Grassmarket Project', in *Performance and Community*, ed. Caoimhe MacAvinchey (London: Bloomsbury, 2014), pp. 115–40

Inthorn, Sanna, Justin Lewis and Karin Wahl-Jorgenson, *Citizens or Consumers: What the Media Tell us About Political Participation* (Maidenhead: Oxford University Press, 2005)

Iles Johnston, Sarah, 'Introduction', in *Medea: Essays on Medea in Myth, Literature, Philosophy and Art*, ed. James J. Clauss and Sarah Iles Johnston (Princeton: Princeton University Press, 1997), pp. 3–16

Jakobson, Roman, 'Closing Statement: Linguistics and Poetics' in *Style in Language*, ed. T. A. Sebok (Cambridge, MA: MIT Press, 1960), pp. 350–83

Jermyn, Helen, *Arts in England: Attendance, Participation and Attitudes in 2001* (Arts Council England, 2001)

Johns, Robert and Mark Shepard, 'A Face for Radio? How Viewers and Listeners Reacted Differently to the Third Leaders' Debate in 2010', *British Journal of Politics and International Relations*, 14.1 (2012), 1–18

Jones, Jennifer, *Medea's Daughters: Forming and Performing the Woman Who Kills* (Ohio: Ohio State University Press, 2003)

Jones, Owen, *Chavs* (London: Verso, 2012)

Judge, David, *Democratic Incongruities: Representative Democracy in Britain* (Basingstoke: Palgrave Macmillan, 2014)

Kaplan, Ann E., *Motherhood and Representation: The Mother in Popular Culture and Melodrama* (London: Routledge, 1992)

Kelleher, Joe, 'Our Radius of Trust: Community, War and the Science of Rhetoric', in *Blairism and the War of Persuasion*, ed. Deborah Lyn Steinberg and Richard Johnson (Laurence and Wishart: London, 2004), pp. 173–85

Kelly, Aaron, *Irvine Welsh* (Manchester: Manchester University Press, 2005)

Kelman, James, 'Vernacular', *Brick: A Literary Journal*, 51 (1995), 68–9

Kennedy, Flloyd, 'The Challenge of Theorising the Voice', *Modern Drama*, 52 (2009), 405–25

Kershaw, Baz, 'Discouraging Democracy: British Theatres and Economics, 1979–1999', *Theatre Journal*, 51 (1999), 267–83

——, 'Oh for Unruly Audiences! Or, Patterns of Participation in Twentieth-Century Theatre', *Modern Drama*, 42 (2001), 133–55

——, *The Radical in Performance: Between Brecht and Baudrillard* (London and New York: Routledge, 1999)

Kimbrough, Andrew M., *Dramatic Theories of Voice in the Twentieth Century* (New York: Cambria, 2011)

Knowles, Ric, *Reading the Material Theatre* (Cambridge: Cambridge University Press, 2004)

Kristeva, Julia, 'Stabat Mater', *The Kristeva Reader*, ed. Toril Moi (Oxford: Blackwell, 1986), pp. 160–86

Labour Party, *New Labour: Because Britain Deserves Better* (London: Labour Party, 1997)

Labov, William, 'The Social Motivation of a Sound Change', in *Sociolinguistic Patterns*, (Philadelphia: University of Pennsylvania Press, 1972), pp. 1–41.

Lacey, Stephen, 'Staging the Contemporary: Politics and Practice in Post-War Socialist Realist Theatre', in David Tucker, *British Social Realism in the Arts* (Basingstoke: Palgrave Macmillan, 2011)

Lane, David, *Contemporary British Drama* (Edinburgh: Edinburgh University Press, 2010)

Lefebvre, Henri, *The Production of Space*, trans. Donald Nicholson-Smith (Oxford: Blackwell, 1991)

Leonard, Tom, 'Good Style', *Intimate Voices: Selected Work 1965–1983* (Newcastle: Galloping Dog Press, 1984)

Lessac, Arthur, *The Use and Training of the Human Voice: A Practical Approach to Speech and Voice Dynamics* (New York: DBS Publications, 1967)

Ley, Graham, *The Theatricality of Greek Tragedy: Playing Space and Chorus* (Chicago and London: University of Chicago Press, 2007)

Linklater, Kristin, *Freeing the Natural Voice* (New York: Drama Book Publishers, 1976)

——, *Freeing the Natural Voice: Imagery and Art in the Practice of Voice and Language* (London: Nick Hern, 2006)

——, *Freeing Shakespeare's Voice: The Actor's Guide to Talking the Text* (New York: Theatre Communications Group, 1992)

——, 'Women on Eroticism: Vox Eroticus: In Singing the Voice Erotic, a World-Renowned Voice Teacher Lays Bare the Basic Instincts – an Anatomy – of Theatre as Verbal Art', *American Theatre*, 20 (2003), 24–7

Little, Ruth, and Emily McLaughlin, *The Royal Court Theatre: Inside Out* (London: Oberon, 2007)

Luckhurst, Mary, *Dramaturgy* (Cambridge: Cambridge University Press, 2006)

MacDiarmid, Hugh, 'Robbie Burns: His Influence', *Selected Essays of Hugh MacDiarmid* (Oakland: University of California Press, 1970)

Macmurray, John, *Persons in Relation* (London: Faber & Faber, 1961)

Mamet, David, *True and False: Heresy and Common Sense for the Actor* (London: Faber & Faber, 1998)

Martin, Carol, *Theatre of the Real* (Basingstoke: Palgrave Macmillan, 2013)

Martin, Jacqueline, *The Voice in Modern Theatre* (London and New York: Routledge, 1991)

Maslow, Abraham H., *The Maslow Business Reader*, ed. Deborah C. Stephens (New York: John Wiley & Sons, 2000)

Matthews, Hugh, 'Citizenship, Youth Councils and Young People's Participation', *Journal of Youth Studies*, 4 (2001), 299–318

McAndrew, Clare, *Artists, Taxes and Benefits: An International Review* (Arts Council England, 2002)

McCallion, Michael, *The Voice Book* (London: Faber & Faber, 1988)

McCrone, David, Angela Morris and Richard Kiely, *Scotland the Brand: the Making of Scottish Heritage* (Edinburgh: Edinburgh University Press, 1995)

McDonnell, Bill, and Dominic Shellard, *Social Impact Study of UK Theatre* (Arts Council England, 2006)

McEnery, Anthony, and Zhonghua Xiao, 'Swearing in Modern British English: the Case of *Fuck* in the BNC', *Language and Literature*, 13 (2004), 235–68

McGrath, John, *Naked Thoughts that Roam About*, ed. Nadine Holdsworth (London: Nick Hern, 2006)

McLaughlin, Lesley M., *Media Representations of Myra Hindley* (England, 2007)

McKinnie, Michael, 'A Sympathy for Art: The Sentimental Economies of New Labour Arts Policy', in *Blairism and the War of Persuasion*, ed. Deborah Lyn Steinberg and Richard Johnson (London: Laurence and Wishart, 2004), pp. 186–203

Melrose, Susan, *A Semiotics of the Dramatic Text* (London: Macmillan, 1994)

Merleau-Ponty, Maurice, *Phenomenology of Perception*, trans. Colin Smith (London and New York: Routledge, 2002)

Milne, Drew, 'The Anxiety of Print: Recent Fashions in British Drama', in *Crucible of Cultures: Anglophone Drama at the Dawn of a New Millennium*, ed. Marc Maufort and Franca Bellarsi (Brussels: PIE-Peter Lang, 2003)

Milroy, James, and Lesley Milroy, *Authority in Language: Investigating Standard English* (London and New York: Routledge, 1999)

Modern British Playwriting: The 1990s: Voices, Documents, New Interpretations', ed. Aleks Sierz (London: Methuen, 2012)

Modern British Playwriting: the 2000s: Voices, Documents, New Interpretations', ed. Dan Rebellato (London: Methuen, 2013)

Monks, Aoife, '"The Souvenir From Foreign Parts": Foreign Femininity in Deborah Warner's *Medea'*, *Australasian Drama Studies*, ed. Brian Singleton and Anna McMullan, 4 (2003), 32–45

Montgomery, Martin, 'Speaking Sincerely: Public Reaction to the Death of Diana', *Language and Literature*, 8 (1999), 5–34

Moore, Sonia, *Stanislavski Revealed* (New York: Applause Theatre, 1991)

Morash, Merry, *Understanding Gender, Crime and Justice* (London: Sage, 2006)

Muir, Edwin, *Scott and Scotland: The Predicament of the Scottish Writer* (London: Routledge, 1936)

Murison, David, 'The Future of Scots', *Whither Scotland*, ed. Duncan Glen (London: Gollancz, 1971)

Nairn, Tom, *The Break-Up of Britain* (London: Verso, 1981)

Nancy, Jean-Luc, *Listening*, trans. Charlotte Mandell (New York: Fordham, 2002)

National Theatre, *Annual Report and Financial Statements 2008–9* (London: National Theatre, 2009)

Newham, Paul, 'The Psychology of the Voice and the Founding of the Roy Hart Theatre', *New Theatre Quarterly*, 33 (1993), 59–65

Nicholson, Helen, *Theatre, Education and Performance* (Basingstoke: Palgrave Macmillan, 2011)

Nield, Sophie, 'Her Tears Were Sincere: Kate McCann and the Paradox of Mourning', *Contemporary Theatre Review*, 18 (2008), 269–72

Not Whether but How: Teaching Grammar in English at Key Stages 3 and 4 (London: Qualifications and Curriculum Authority, 1999)

O'Higgins, Dolores, 'Medea as Muse: Pindar's *Pythian'*, in *Medea: Essays on Medea in Myth, Literature, Philosophy and Art*, ed. James J. Clauss and Sarah Iles Johnston (Princeton: Princeton University Press, 1997), pp. 103–26

Ong, Walter, *Orality and Literacy: The Technologizing of the Word* (Methuen: London and New York, 1982)

Osborne, Deirdre, '"Know Whence You Came": Dramatic Art and British Identity', *New Theatre Quarterly*, 23 (2007), 253–63

Pao, Angela, 'False Accents: Embodied Dialects and the Characterization of Ethnicity and Nationality', *Theatre Topics*, 14 (2004), 353–7

Pardo, Enrique, 'Figuring Out the Voice: Object, Subject, Project', *Performance Research*, 8 (2003), 41–50.

Parekh, Bhikhu, *The Parekh Report* (London: Profile, 2000)

Peace, Michael, 'Informalization in UK Party Election Broadcasts 1966–1997', *Language and Literature*, 14 (2005), 65–90

Phelan, Peggy, *Certain Fragments: Contemporary Performance and Forced Entertainment* (London: Routledge, 1999)

Pinnock, Winsome, 'Breaking Down the Door', in *Theatre in a Cool Climate*, ed. Vera Gottlieb and Colin Chambers (Oxford: Amber Lane Press, 1999), pp. 27–38

Portelli, Alessandro, *The Text and the Voice* (New York: Columbia University Press, 1994)

Qualifications and Curriculum Authority, *Education for Citizenship and the Teaching of Democracy in Schools: First Report of the Advisory Group on Citizenship* (QCA, 1998)

Rampton, Ben, *Crossing: Language and Ethnicity among Adolescents* (Manchester: St Jerome, 2005)

Rancière, Jacques, *The Politics of Aesthetics: The Distribution of the Sensible*, trans. Gabriel Rockhill (London: Continuum, 2004),

Rebellato, Dan, 'National Theatre of Scotland: The First Year', *Contemporary Theatre Review: An International Journal*, 17 (2007), 213–18

——, 'New Theatre Writing: Dennis Kelly', *Contemporary Theatre Review: An International Journal*, 17 (2007), 603–8

——, 'Playwriting and Globalization: Towards a Site-unspecific Theatre', *Contemporary Theatre Review*, 16 (2006), 97–113

——, *Theatre and Globalization* (Basingstoke: Palgrave Macmillan, 2009)

——, *1956 and All That: The Making of Modern British Drama* (London: Routledge, 1999)

Reid, Trisha, '"From Scenes Like These Old Scotia's Grandeur Springs": The National Theatre of Scotland', *Contemporary Theatre Review*, 17 (2007), 192–201

Reinelt, Janelle, 'Performing Europe: Identity Formation for a New Europe', *Drama Review*, 53 (2001), 365–87

——, 'Toward a Poetics of Theatre and Public Events: In the Case of Stephen Lawrence', *Drama Review*, 50 (2006), 69–87

The Representation of Women in Fiction, ed. Carolyn G. Heilbrun and Margaret R. Higonnet (Baltimore: Johns Hopkins University Press, 1981)

Riche, Adrienne, *On Lies, Secrets, Silence: Selected Prose 1966–1978* (London: Virago, 1980)

Roach, Joseph R., *The Player's Passion: Studies in the Science of Acting* (Newark: University of Delaware Press, 1985)

Robinson, Jo, 'Becoming More Provincial? The Global and the Local in Theatre History', *New Theatre Quarterly*, 23 (2007), 229–40

Robinson, Rebecca, 'The National Theatre of Scotland's *Black Watch*', *Contemporary Theatre Review* 22 (2012), 392–9

Rodenburg, Patsy, *The Actor Speaks: Voice and the Performer* (London: Methuen, 1997)

Rodham, Karen, et al., *By Their Own Young Hand – Deliberate Self-harm and Suicidal Ideas in Adolescents* (London: Jessica Kingsley Publishers, 2006)

Romano, Flavio, *Clinton and Blair: The Political Economy of the Third Way* (London: Routledge, 2006)

Rosen, Harold, *Language and Class: A Critical Look at the Theories of Basil Bernstein* (Bristol: Falling Wall Press, 1972)

The Routledge Language and Cultural Theory Reader, ed. Lucy Bourke, Tony Crowley and Alan Girvin (London and New York: Routledge, 2000)

Sanders, Julie, *Adaptation and Appropriation* (London and New York: Routledge, 2006)

de Saussure, Ferdinand, *Course in General Linguistics*, trans. Wade Baskin (New York: McGraw-Hill, 1959)

Scannell, Paddy, *Radio, Television and Modern Life: A Phenomenological Approach* (Oxford: Blackwell, 1996)

Schechner, Richard, *Performance Studies: An Introduction* (London and New York: Routledge, 2002)

Scottish Arts Council, *Drama Strategy 2002–7* (Edinburgh: Scottish Arts Council, 2002)

Scottish Executive, *Creating Our Future . . . Minding Our Past: Scotland's National Cultural Strategy* (Edinburgh: Scottish Executive, 2000)

Scullion, Adrienne, 'Self and Nation: Issues of Identity in Modern Scottish Drama by Women', *New Theatre Quarterly*, 17 (2001), 373–90

Shaw, Fiona, 'The Irony of Passionate Chaos: Modernity and Performing Medea', *New Theatre Quarterly*, 20 (2004), 237–44

Shellard, Dominic, *Economic Impact Study of UK Theatre* (Arts Council England, 2004)

Sierz, Aleks, '"Art Flourishes in Times of Stuggle": Creativity, Funding and New Writing', *Contemporary Theatre Review*, 13 (2003), 33–45

——, 'Beyond Timidity: The State of British New Writing', *PAJ: A Journal of Performance and Art*, 27 (2005), 55–61

——, 'Cool Britannia? "In-Yer-Face" Writing in the British Theatre Today', *New Theatre Quarterly*, 14 (1998), 324–33

——, 'What Kind of England Do We Want?', *New Theatre Quarterly*, 22 (2006), 113–21

Smith, Chris, *Creative Britain* (London: Faber & Faber, 1998)

Staff, Duncan, *The Lost Boy: The Definitive Story of the Moors Murders and the Search for the Final Victim* (London: Bantam Press, 2007)

Stanford, W. B., *Greek Tragedy and the Emotions* (London: Routledge and Kegan Paul, 1983)

Stanislavski, Konstantin, *An Actors Work*, trans. Jean Benedetti (Routledge: London and New York, 2008)

Susi, Lolly, *The Central Book* (London: Oberon, 2006).

Sutcliffe, David, *Black British English* (Oxford: Basil Blackwell, 1982)

Taavitsainen, Irma, Gunnel Melchers and Päivi Pahta, 'Introduction', in *Writing in Nonstandard English*, ed. Irma Taavitsainen, Gunnel Melchers and Päivi Pahta (Amsterdam: John Benjamins, 1999)

Tait, Peta, *Performing Emotions: Gender, Bodies, Spaces, in Chekhov's and Stanislavski's Theatre* (Aldershot: Ashgate Publishing, 2002)

Taylor, Lib, 'The Experience of Immediacy: Emotion and Enlistment in Fact-based Theatre', *Studies in Theatre and Performance* 31 (2011), 223–7

Trudgill, Peter, and Richard Watts, *Alternative Histories of English* (New York: Routledge, 2002)

——, *Dialects of English* (Oxford: Blackwell, 1990)

——, *Introducing Language and Society* (London: Penguin, 1992)

——, *On Dialect: Social and Geographical Perspectives* (Oxford: Blackwell, 1983)

Turner, Alwyn W., *A Classless Society: Britain in the 1990s* (London: Aurum, 2013)

Ubersfeld, Anne, *Reading Theatre*, ed. Frank Collins and Paul Perron, trans. Frank Collins (Toronto: Toronto University Press, 1999)

UN General Assembly, *Convention on the Rights of the Child 1989*

UNICEF, *An Overview of Child Well-being in Rich Countries* (Florence: Innocenti Research Centre, 2007)

Urban Voices: Accent Studies in the British Isles, ed. Paul Foulkes and Gerard Docherty (London: Arnold, 1999), pp. 3–17

Veltruský, Jiří, 'Dramatic Text as Component of Theater', in *Semiotics of Art: Prague School Contributions*, ed. Ladislav Matejka and Irwin R. Titunik, trans. Jiří Veltruský (Cambridge, MA and London: MIT Press, 1976), pp. 94–118

Verbatim Verbatim: Contemporary Documentary Theatre, ed. Will Hammond and Dan Steward (London: Oberon, 2008)

Verma, Jatinder, 'The Challenge of Binglish: Analysing Multicultural Productions', in *Analysing Performance: A Critical Reader*, ed. Patrick Campbell (Manchester and New York: Manchester University Press, 1996), pp. 193–201

Voice in British Actor Training: The Moment of Speech (London: Central School of Speech and Drama, 2000)

Walton, J. Michael, *The Cambridge Companion to Greek and Roman Theatre*, ed. Marianne McDonald and J. Michael Walton (Cambridge: Cambridge University Press, 2007)

Wandor, Michelene, *The Art of Writing Drama: Theory and Practice* (London: A & C Black, 2008)

Warner, Deborah, 'Tragedy on Abbey Street', *Sunday Tribune*, 28 May 2000

Weimann, Robert, *Author's Pen and Actor's Voice: Playing and Writing in Shakespeare's Theatre* (Cambridge: Cambridge University Press, 2000)

Welton, Martin, 'Seeing Nothing: Now Hear This', in *The Senses in Performance*, ed. Banes and Lepecki (London: Routledge, 2007), pp. 146–55

Werner, Sarah, 'Performing Shakespeare: Voice Training and the Feminist Actor', *New Theatre Quarterly*, 47 (1996), 249–58

Williams, Raymond, *Drama in Performance* (New York: Basic Books, 1968)

——, *Marxism and Literature* (Oxford University Press: Oxford, 1977)

Williams, Roy, in Natasha Tripney, 'Roy Williams', *The Stage*, 10 April 2014, p. 21

Wooding, Bruce (ed.), *The Contemporary Voice: How we Teach Voice in the New Millennium* (London: International Centre for Voice, 2006)

Worrall, Anne, *Offending Women: Female Lawbreakers and the Criminal Law System* (London: Routledge, 1990)

Worthen, W .B., *Shakespeare and the Authority of Performance* (Cambridge: Cambridge University Press, 1997)

Wright, Isabel, 'Working in Partnership: David Greig in Conversation with Isabel Wright', *Trans-global Readings: Crossing Theatrical Boundaries*, ed. Caridad Svich (Manchester: Manchester University Press, 2003), pp. 157–61

Young, Lola, *Whose Theatre? Report on the Sustained Theatre Consultation* (Arts Council England, 2006)

Young, Stuart, 'Playing with Documentary Theatre: *Aalst* and *Taking Care of Baby*', *New Theatre Quarterly*, 25 (2009), 72–87

Zarrilli, Phillip B., 'Senses and Silence in Actor Training and Performance', *The Senses in Performance*, ed. Sally Barnes and Andre Lepecki (New York: Routledge, 2007), pp. 47–70

Zerdy, Joanne, 'Fashioning a Scottish Operative: Black Watch and Banal Theatrical Nationalism on Tour in the US', *Theatre Research International*, 38 (2013), 181–9

Interviews, events and conferences

At the Sharp End, University of Portsmouth, 15 September 2007
Banks, Anthony, interview with Maggie Inchley, National Theatre, 16 June 2008
Between Fact and Fiction, Birmingham University, 13 September 2007
Davies, Hannah, interview with Maggie Inchley, York Theatre Royal, 12 September 2008
Heinan, Dale, workshop, 'Politics and New Writing', Soho Theatre, 20 September 2007.
Horwood, Joel, interview with Maggie Inchley, London, 20 October 2008
How Was it For Us: Theatre Under Blair, Writers' Guild, 9 December 2007
Jancovich, Ben, interview with Maggie Inchley, National Theatre, 10 October 2008
Johnson, Carol, 'Moving Citizenship: Exploring Worlds of Emotional Politics', paper given at the Autumn Colloquium, Birkbeck College, 24 October 2008
Little, Ruth, interview with Maggie Inchley, Royal Court Theatre, 13 October 2008
McGettigan, Caroline, presentation at The Voice Symposium, The Science Museum, 16 November 2012
Phelan, Peggy, lecture, 'Locating Voice', Queen Mary University London, 22 March 2012
Poel, William, Speaking English Classic Drama Event, National Theatre, 31 October 2007
Prebble, Lucy, interview with Maggie Inchley, London, 10 October 2008
Shaw, Fiona, interview with Aoife Monks, London, 15 February 2001
Tiffany, John, talk to Genesis Directors, Young Vic, 24 July 2008
Wallace, Naomi, panel contribution, at Palatine 'Teaching Playwriting' conference, University of York, 17 October 2007
West, Sam, 'Theatre Conversations', Birkbeck College, 11 October 2007
Writernet Conference, Arcola Theatre, 7 December 2008

Selected websites

www.artscouncil.org.uk
www.barnardos.org.uk
www.bbc.co.uk
www.benjaminzephaniah.com
www.bl.uk
www.blackhistory4schools.com
www.bnp.org.uk
www.britishtheatreguide
www.bushtheatre.co.uk
www.colinmcfarlane.tv
www.cps.gov.uk
www.culturewars.org.uk
www.electoralcommission.org.uk

www.guardian.co.uk
www.hampsteadtheatre
www.hm-treasury.gov.uk
www.independent.co.uk
www.inyerface-theatre.cm
www.ipsos-mori.com
www.leeds.ac.uk
www.nationaltheatre.org.uk
www.ncaction.org.uk
www.nytimes.com
www.oldvictheatre.com
www.ons.gov.uk
www.opsi.gov.uk
www.parliament.uk
uk.reuters.com
www.royalcourttheatre.com
www.rsc.org.uk
www.scotland.gov.uk
www.scotsman.com
www.scottish.parliament.uk
www.sqa.org.uk
www.sueterryvoices.com
www.telegraph.co.uk
www.theatrevoice.com
www.theguardian.com
www.thestage.co.uk
www.timesonline.co.uk
www.writernet.co.uk

Television

The Blair Years (BBC One)
Boys From the Blackstuff (BBC Two)
The Catherine Tate Show (BBC Two)
Front Row (BBC Radio Four)
Harry Enfield's Television Programme (BBC Two)
Imagine (BBC One)
The Kumars at Number 42 (Hat Trick Productions)
Little Britain (BBC One)
Newsnight Review (BBC Two)
Panorama (BBC 1)

Radio

The Routes of English (BBC Radio 4)
Woman's Hour (BBC Radio Four)

Index

Printed and bound by CPI Group (UK) Ltd, Croydon, CR0 4YY